Issues in
Abstract Expressionism
The Artist-Run Periodicals

Studies in the Fine Arts:
The Avant-Garde, No. 66

Stephen C. Foster, Series Editor

Professor of Art History
University of Iowa

Other Titles in This Series

Issues in
Abstract Expressionism
The Artist-Run Periodicals

by
Ann Eden Gibson

U·M·I Research
Press

Ann Arbor / London

Produced and distributed by
UMI Research Press
an imprint of
University Microfilms Inc.
Ann Arbor, Michigan 48106

Library of Congress Cataloging in Publication Data

Gibson, Ann Eden, 1944-
 Issues in abstract expressionism : the artist-run
periodicals / by Ann Eden Gibson.
 p. cm.—(Studies in the fine arts. Avant-garde ; no. 66)
 Includes bibliographical references.
 ISBN 0-8357-1944-8 (alk. paper)
 1. Abstract expressionism—New York (N.Y.) 2. New York school of
art. 3. Art criticism—New York (N.Y.)—History—20th century.
4. Art —Periodicals. I. Title. II. Series.
N6535.N5G53 1989
709.747′1′09044—dc20 89-5211
 CIP

For Allan Federman

Contents

Figures

Preface

When I first discovered the *Tiger's Eye* I was amazed. It was the first issue, with Barnett Newman's essay "The First Man Was an Artist," paintings by Rufino Tamayo, *five* paintings by Mark Rothko, prints by Stanley William Hayter and Miró, diary notes and sketchbooks by Marianne Moore (photographed by Aaron Siskind), poems by Henri Michaux, essays on Jean-Paul Sartre, and much more. It identified contributions only in an unannounced table of contents in the middle of the magazine— strange convention, I thought. Why did they put it there? It looked to me then like a catalogue of Abstract Expressionist thought, but it also made me wonder about the connections between some of the contributions: what was the common denominator between Rufino Tamayo and Mark Rothko? What would Newman have thought of Michaux? What did Sartre have to do with Abstract Expressionism? I soon found out that there were more issues of *The Tiger's Eye,* but I was stymied when I tried to find out how many. They weren't in any index I could find (although I did discover later that there is a Greenwood Press reprint of *The Tiger's Eye*). Not only did I wonder how many issues of this magazine there were, and what was in them, of course, but also how these rich compilations of primary documentation on the intellectual life of the 1940s in America came into existence. Were there other magazines like this one? Who read them? Did other artists submit their work to little magazines? Had other Abstract Expressionists published writing in addition to reproductions of their art in this period? This book is an attempt to answer some of these questions and to make that reference book I could not find.

Acknowledgments

To William I. Homer I owe a special debt for his unfailingly helpful comments on some of the elements of this book in its early stages; but this project in its present form would not have been possible without the cooperation of the following editors and staff of the magazines in this study. Oscar Collier and Gertrude Barrer have given me hours of their time recalling *Iconograph*. Kenneth Beaudoin gave me important information and permissions. I wish to thank John Stephan for his careful readings of preliminary drafts and his precise recollections regarding *The Tiger's Eye*, and Herbert Cahoon, whose reminiscences helped me to understand its literary position. Annalee Newman has read numerous drafts of the section regarding Barnett Newman's relation to *The Tiger's Eye* to assure its clarity and correctness. To Lionel Abel I wish to give grateful acknowledgment for his memories and editorial assistance in my efforts to outline the policies of *Instead*, the periodical he coedited with Matta. I am grateful to Matta as well for volunteering his assessment of *Instead*'s import. Robert Motherwell, coeditor of *Possibilities* and *Modern Artists in America*, has unfailingly answered questions and volunteered insights and anecdotes about those publications. Bernard Karpel, coeditor of *Modern Artists in America*, generously responded to my questions with letters and materials to which I would otherwise not have had access.

Contributors and their families have helped me by providing materials for reproduction, archival papers, and memories. They include Elena Calas, Will Barnet, Robert Barrell, Ethel Baziotes, Rita Reinhardt-Bedford, Louise Bourgeois, Peter Busa, Howard Daum, Helen De Mott, Herbert Ferber, Esther Gottlieb, Florence Grippe, Peter Grippe, David Hare, Ruben Kadish, Jim Jordan, Ibram Lassaw, Ouida Lewis, David Loshak, Annalee Newman, Helen Phillips, Evelyn and Richard Pousette-Dart, May Natalie Tabak Rosenberg, Alfred Russell, Aaron Siskind, Hedda Sterne, Dorothea Tanning, Mildred Talbot, and Joseph B. Zimmerman.

The Metropolitan Museum, especially the staff of the Twentieth Century department, including Lowery Sims, Harriet Rubin, William

Lieberman, Anne Strauss, and Ida Balboul; the staff of the Watson Library, including William Walker and Patrick Coleman; and the staff of the Robert Goldwater Memorial Library, including Allen Chapman and Ross Day, have supported and encouraged this project for years. Sandy Hirsch of the Adolph and Esther Gottlieb Foundation, Inc., Bill Cuffe of the Yale University Art Gallery, and Anita Duquette of the Whitney Museum of American Art have gone out of their way to help me obtain photographic materials. Clive Philpot of the library of the Museum of Modern Art has given me advice and access to these periodicals, including the loan of some that were his own personal possessions. Ann Alpert loaned me her issues of *Instead* to photocopy and photograph for this book when library copies proved incomplete or inaccessible for these purposes. Permission to reproduce the works here was given directly or made possible by individuals such as Harry W. Anderson, Gabriel Austin, Daniel Filipacchi, Kim Heirston, Miani Johnson, Mr. and Mrs. Pierre Matisse, Joan Russell, Walter Miles, Gary Snyder, Peter Stevens, Judy Colischan Van Wagner, and Joan Washburn. In many cases I have the artists themselves to thank for digging deep into files to find copies of work done half a century ago. Last, but certainly not least, I wish to acknowledge Yale University's continuing support in the form of grants from the A. Whitney Griswold Research Fund and the Frederick W. Hilles Publication Fund and especially for the Morse Fellowship that provided the time and financing to bring this project to completion.

Introduction

The artists who are often thought of as Abstract Expressionists, such as William Baziotes, Arshile Gorky, Hans Hofmann, Willem de Kooning, Lee Krasner, Robert Motherwell, Barnett Newman, Richard Pousette-Dart, Jackson Pollock, Ad Reinhardt, Mark Rothko, and Clyfford Still, did not think of themselves as such during the period from 1946 to 1951 covered by this study. Although they showed at the same galleries in New York, summered at the same beaches on Long Island and in Provincetown, and contributed to the same publications, they hesitated to name themselves. Willem de Kooning, for instance, said that to do so would be "disastrous." The term "Abstract Expressionism" came into general use in referring to the artists discussed here only after a series of panel discussions held at the Club in 1952.[1]

So christened, the work described by Clement Greenberg, Thomas Hess, and Harold Rosenberg achieved international recognition. Initially described by its proponents in formal (Greenberg) or existential (Rosenberg) terms, Abstract Expressionism demonstrated a surprisingly cohesive body of repeated themes (reflecting shared convictions) despite its many disparities.[2] Increasingly, the works of Abstract Expressionist artists became emphatically large and astonishingly assertive, despite a wide range of individual differences. They urgently confronted the viewer with the language of paint: its viscosity; its capacity to retain a reference—in slashes, ridges, and scrubbings—to the hand that had been moved to stretch the medium's language to these extremes; and its role as a carrier of color (with all of color's inherent psychological and physiological power). This paint was applied with techniques which ranged from the painterly to the linear, from gesture to field. Despite this apparent catholicity of method, however, other more divergent directions in art—such as Realism, certain forms of Geometric Abstraction, and Surrealism—had been eliminated. By the late fifties, "important" American painting was nonnarrative and immediate in its impact.

Critical emphasis on the creative process and progressively reductive

appearance of American painting, coupled with a lack of discussion of the rich body of concepts and themes that informed it, made some aspects of Abstract Expressionism puzzling, not only to the general public, but even to experts. These concepts and themes, however, may be tellingly observed at the most frequent intersection of the intention and practice of this art: in the avant-garde publications these artists edited and to which they contributed alongside their colleagues from other disciplines. The magazines treated here were all run by artists. Usually the editorial function was shared by a painter and a writer. *Iconograph,* perhaps the most unusual in this respect, was run by Kenneth Beaudoin, a poet and gallerist who painted under the pseudonym Galatea Jones. *The Tiger's Eye* was edited by writer Ruth Stephan; her husband, painter John Stephan, was the art editor. *Possibilities* was coedited by painter Robert Motherwell and writer-critic Harold Rosenberg, with musician John Cage and architect Pierre Chareau as nominal editors of music and architecture. *Instead* was an even partnership between writer, poet, and scholar Lionel Abel and the painter Roberto Matta Echaurren; while *Modern Artists in America* was a cooperative venture by two artists, Robert Motherwell and Ad Reinhardt, and a librarian, Bernard Karpel.

The nonnarrative, nonmimetic approach of Abstract Expressionism, along with a predilection for allover composition, may also be observed in the work of painters such as Mark Tobey and lesser-known figures such as Gertrude Barrer, Norman Lewis, Ralph Rosenborg, and Anne Ryan—artists whose work displayed most of the characteristics described in the paragraphs above. For the purposes of this discussion, however, when a distinction is desirable, "Abstract Expressionism" will refer to those artists most closely associated with the group that met socially at the Club, where this designation was debated. Artists described as members of the "New York School" will include the Abstract Expressionists, but will refer also to those in that larger community of artists with New York connections who shared many of the Abstract Expressionists' concerns. These artists often were not members of that social group anchored at the Club (Hedda Sterne, Perle Fine, Normal Lewis) or else they produced work that has fallen outside of that designation because it lacked one characteristic—large size, for instance (Ryan), or the apparent spontaneity of paint (printmakers like Boris Margo and Adja Yunkers; sculptors such as those mentioned below).

The sculpture of such artists as Louise Bourgeois, Herbert Ferber, Peter Grippe, David Hare, Ibram Lassaw, Richard Lippold, Seymour Lipton, Louise Nevelson, Theodor Roszak, and David Smith deserves special mention in this regard. It will be included as work of the New York School. Writers have shied away from calling it "Abstract Expressionist," feeling that it was awkward, and even slightly ridiculous, to categorize sculpture

in this way.[3] Most have preferred to call this work "the sculpture of the Abstract Expressionist period," or have described it as being "linked to Abstract Expressionism."[4] However, these sculptors' expressionistic handling in this period, their frequent use of biomorphic forms, and above all, their involvement with content and attitudes similar to those of the Abstract Expressionist painters as seen in their participation in these periodicals, makes it appropriate to include them in this study as members of the New York School.

It would be incorrect to view the artist-run periodicals exclusively as either sources or reflections of the visual art to which they were so closely linked. They appear, rather, as a forum in which the visual and the verbal operated in a dialectic and through which attitudes were articulated, developed, debated, and refined.[5] Although many of these artists refused a one-to-one relationship between the forms in their work and specific meanings, these periodicals demonstrate that this policy was not due to a reluctance to express ideas or emotions in words. The New York School was hardly without a system of poetics and subject matter, a politics, or a network of guiding philosophies.[6] Treatments of these topics, however, have usually been part of a more general discussion, or have focused on a single artist or a single philosophy.[7] In fact, the artists' very refusal to communicate on an objective level, coupled with their insistence that the work does have content or subject matter, is in itself a prominent characteristic of the writing, painting, sculpture, and criticism in these magazines.[8]

A good deal of the reticence of the New York School—the reluctance of these artists to subscribe to a definable program—stemmed from what they saw as a desperately narrowed range of options for art. "If one is to continue to paint or write as the political trap seems to close upon him he must perhaps have the extremest faith in sheer possibility," wrote Robert Motherwell and Harold Rosenberg in their editorial statement for *Possibilities* in September of 1947. Stalinism had deflated their hopes that Marxism offered a way to resolve the conflict between the individual and society; and the horrors of the Holocaust cast faith in human nature as irresponsible naiveté. The election of 1946 swept a Republican majority into both Congressional houses, ushering in an era of conservatism that radical artists, even those most disillusioned with the failure of the left to produce a free modern society, could not accept. To these artists, every political position appeared to evade the complexities both of history and individual experience.[9]

While this survey is not *about* this situation, it takes place *in* it. The intellectual casting-about reflected so vividly in the periodic form of these journals, as well as what appears now as a naive desire to operate without ideology, looks less like the road of least resistance than a determination

to produce appropriate statements in a situation where every political stance is discredited—at least for those unwilling to let the ends justify the means. The attempt by these artists to cut the obvious connections to contemporary events and even to the politics of their intellectual sources is apparent in the reluctance of their work to reveal these politics to the viewer. This produced an aesthetic that now appears to have been blind to the possibilities of co-option that it opened. Many of these artists, however, caught between the specters of McCarthyism and Stalinism, saw the sacrifice of direct advocacy as the only possible ethical response.

One common designation for the magazines described here, as well as for the position that these artists found so difficult to define for themselves in their particular historical milieu, is "avant-garde." The New York School and their journals have often been described by this term, understood as ideally encompassing both formal and social change.[10] In practice, however, defining what qualifies a periodical or an artist as "avant-garde" causes one to confront two progressively divergent connotations. The first and original one is social, emphasizing art that reflected on and communicated with society in order to produce and support a revolutionary culture. The second focuses on formal concerns, arguing that "art-for-art's-sake" is the best offense against a decadent society.[11]

Clement Greenberg's well-known "Avant-Garde and Kitsch," published in the *Partisan Review* in 1939, represents a metamorphosis of the first of these two orientations into the second. In this early essay Greenberg saw the avant-garde as a social principle as well as an artistic one; but its purpose was defy stagnation and "keep[s] culture *moving* in the midst of ideological confusion and violence." As Greenberg clarified his ideal of progressive surrender to the qualities of each medium as the standard of quality in art, however, his emphasis on art's social effect decreased.[12] It is important to note that the artists represented in these periodicals were not resigned to conceiving their art as a stopgap activity. On the contrary, their work and that of the contributors they selected suggests that they were in search of forms that either underlay and thus explained, or transcended and thus solved, the ideological confusion and violence before which Greenberg (not a contributor to any of these artist-run journals) postulated art as a mere holding activity.

The attitude of these artists reflected in some ways those of the preceding generation in New York. William Carlos Williams, for instance, did not see the avant-garde as the developers of a plot whose unfolding lay somewhere in the future. In his *Autobiography*, Williams (a contributor to *The Tiger's Eye*) asked, "What were we seeking? No one knew consistently enough to formulate a 'movement.' We were restless and constrained, closely allied with the painters."[13] The magazines reviewed here suggest the continuity of a local history of this kind of nonprescriptive

stance. The nonhierarchical nature of Cubist painting, which served as a model for Williams, for instance, may have influenced John Stephan, too, not only in his painting (as his expressionistically rendered but cubistically faceted painting, *The Pyramid Confronts the Sea,* reproduced in *The Tiger's Eye* in 1949 [see fig. 32] suggests) but also in the editorial policy he and Ruth Stephan formulated for the magazine. Cubism may be viewed not only as a way station between Cézanne and Abstract Expressionism, but more functionally, as a method of organizing a series of elements while maintaining their heterogeneity.[14] As the following material will demonstrate, there is an avant-garde attitude in these artist-run periodicals of the forties and early fifties, but it is an avant-gardism of a nonlinear and content-oriented type that aggressively sought a reconciliation between political and aesthetic necessity.

If there was a characteristic of the avant-garde about which both Greenberg and Williams could have agreed, it would have been originality. Yet even here there would have been a difference. Greenberg equated significant originality with formal invention. Williams, along with most of the staff and contributors to these avant-garde magazines, would have considered that the importance of originality lay rather in its ability to refer to a literal origin: to sources of life. The desire to return to origins, either to the beginning of culture in the art of traditional ("primitive") societies, or to one's own psychic roots to regain a kind of originary innocence reflects an ideal of self-creation that surfaces frequently in these periodicals.[15]

The concerns (both visual and verbal) in these magazines, which are mirrored in certain aspects of the art of the New York School, arise from a broader spectrum of concerns than the mostly formal and art-historical precedents that were considered central to the development of Abstract Expressionism in the fifties and early sixties, the period during and just following its acceptance as the dominant style. The psychological, linguistic, anthropological, literary, and philosophical considerations that authors debated in these periodicals appeared side-by-side and sometimes purposely linked to Abstract Expressionist painting and sculpture.

For this reason, although these periodicals are far from being the only place that connections between artists' visual and verbal statements may be found, they are a most comprehensive guide to certain choices and exclusions in Abstract Expressionism. The similarities between the subject matter of visual and verbal contributions to these magazines—correlated with the artists' works, statements, and procedures—might, in fact, be said to form the armature of Abstract Expressionism as its practitioners conceived it.[16] These contiguities constitute a provocative context in which to explore a broad range of factors in the development and acceptance of Abstract Expressionism.

This investigation launches an examination of the New York School's

sources from the base of its avant-garde periodicals. In recent years, many scholars have considered the influences on these artists of ideas from outside the field of art. In addition to those already named in the text or endnotes, efforts have been made by such scholars as E. A. Carmean and Eliza Rathbone, Anna Chaeve, Bonnie Clearwater, Bradford Collins, Mona Hadler, Thomas Hess, Mary Davis, Evan Firestone, Donald Gordon, Piri Halasz, Robert Hobbs and Gail Levin, Elizabeth Langhorne, Robert S. Lubar, Robert S. Mattison, Francis O'Connor, Stephen Polcari, Harry Rand, Deirdre Robson, William Rubin, Martica Sawin, Jeffrey Weiss, and Judith Wolfe to broaden the context within which the development of Abstract Expressionism is viewed.[17]

The five avant-garde magazines whose identities and roles are discussed in this study were published in the middle years of the twentieth century. Their runs were as follows: *Iconograph* (Spring 1946–Fall 1947), *The Tiger's Eye* (October 1947–October 1949), *Possibilities* (Winter 1947–48), *Instead* (ca. January 1948–ca. January 1949), and *Modern Artists in America* (1952). The relevance, however, of certain additional material from other avant-garde periodicals in the years flanking this first list makes it appropriate to refer occasionally to them also. These periodicals include *View* (September 1940– Spring 1947), *Dyn* (April/May 1942–November 1944), *VVV* (June 1942–February 1944), *MKR's Art Outlook* (August 1945–May 1947), *Portfolio* (Summer 1945–48), *Critique* (October 1946–January/February 1947), *trans/formation* (1950–52), and *It Is* (1958–65).

There is a literature on avant-garde magazines themselves, or "little magazines," as they were often called. This term refers less to their small size or circulation than to the fact that their appeal was to a limited group of readers with the background necessary to understand the ideas the magazines presented. *The Little Magazine: A History and a Bibliography* by Frederick Hoffman, Charles Allen, and Carolyn Ulrich[18] is the best-known and most available source, although it does not include material for some of the decisive years covered by this study. More detailed and speculative (but focusing on literary rather than art magazines) is Anthony Linick's dissertation entitled "A History of the American Literary Avant-Garde," which was submitted in 1965 at the University of California in Los Angeles. Clement Greenberg's article of 1941, "The Renaissance of *The Little Magazine*,"[19] is an early treatment of avant-garde magazines in this era. More recently, Lawrence Alloway has pointed to these magazines as a key source of artists' writing, and John A. Walker has discussed their characteristics in "Periodicals since 1945" in Trevor Fawcett and Clive Philpot's *The Art Press, Two Centuries of Art Magazines*. A two-volume reference work, *International Art Periodicals*, contains information on some of these periodicals, including *View, VVV, The Tiger's Eye,* and *It Is*.[20]

An examination of the contents of these five magazines in the light of their editors' statements of intent shows that, in general, they conform to the attitudes Linick ascribed to avant-garde periodicals: (1) a growing dissatisfaction with academic aesthetic standards; (2) a corresponding desire to establish new aesthetic criteria; and (3) a specific and unfavorable reaction to the character of contemporary American society.[21] This last point, a distrust of society, is evident in the history of many avant-garde magazines. Editors and publishers often disdained precisely those in a potential audience financially capable of supporting their publications. Editor Eugene Jolas suspended the highly regarded *transition* during the Depression, for instance, noting that in part his decision was due to his fear that it was becoming a commercial success.[22] These periodicals possessed little in the way of official sanction and almost always were run at a loss from the editor's or publisher's pocket. Because of their dissatisfaction with the status quo, David Hare, editor of *VVV*, remembered, publishers and staff of these periodicals were always looking "somewhere else." They wanted to discover what was outside the ordinary rather than to find things that fit into their readers' expectations.[23] The experimental atmosphere of most of the avant-garde magazines gave them marginal cultural status, and thus they shared the financial difficulties that were characteristic of the avant-garde enterprise in general.

Hare, editor of *VVV*, has noted also that the little magazines he had known were characterized by their lack of an official program. As an examination of the editorial policies of these magazines discloses, the desire to have no preordained "direction," like the premise of having no theory, was actually a considered position and was derived from a rather well-understood set of poetic, political, and philosophical concepts. These concepts, often couched in avant-garde fashion as emphatically negative reactions to more accepted procedures, functioned as a major determinant in the selection of the magazines' content at the same time that they operated as factors in forming the aesthetic of the New York School.

Part One

The Periodicals

1

Iconograph and *The New Iconograph:* "Visual Verbs" or the Identity of Process and Meaning

Iconograph magazine provided a showcase for art and writing by developing Abstract Expressionists such as Jackson Pollock, Mark Rothko, and Theodoros Stamos, as well as for those more peripherally connected with the New York School, such as Nell Blaine (see fig. 14), Esteban Frances, Peter Grippe, David Hare (see fig. 19), Stanley William Hayter, Gerome Kamrowski, and Jackson McLow (see fig. 13).[1] The abstract artists most closely connected with *Iconograph,* however, such as Gertrude Barrer, Oscar Collier (see fig. 6), Howard Daum, Ruth Lewin (see fig. 15), Peter Busa, Robert Barrell (see fig. 10), Alfred Russell (see fig. 16), Ida Fischer (see fig. 11), and Helen De Mott (see fig. 9), have received less public recognition although they shared with their more famous colleagues a preference for allover pattern and flattened pictorial space. Nor, despite the fact that many of their interests and convictions paralleled those of the Abstract Expressionists, did members of the *Iconograph* group (which lost its stylistic homogeneity about the time the magazine folded, in 1947) become associated with the Club or dealers such as Betty Parsons, Charles Eagan, or Sam Kootz, early promoters of artists who would become associated with that term.

 Iconograph's themes and images were produced without the direction of members of the Abstract Expressionist circle. But they were in certain ways so similar to those that surfaced a year or two later in the more tangibly connected *Possibilities* or *The Tiger's Eye* (members of whose art staffs *were* members of the Club, and who *did* show with Kootz and Parsons, respectively), that they offer important insights for an analysis of the New York School. They are significant because they illustrate concerns similar to those that animated the work of better-known painters whose apparent referents were eventually suppressed as their work entered what is considered their mature periods.

 One of these concerns was an interest in the relation of words and images, a relationship that a number of artists in the New York School

attempted regularly to sever.[2] *Iconograph* is particularly valuable for its alliance of speculations about the relation of visual and verbal understanding with a fascination with what was still widely called "primitive" art. The cover of the first issue, on which the formal ambiguities of a cat by Howard Daum (done in a style reminiscent of the Nootka People but strongly influenced by the artist's interest in "South Sea art, where the figure and the ground are one" [see fig. 5]) are echoed in the letters of "Iconograph," drawn by James Dolan, signals this interest.[3] The fact that none of the artists closely involved with *Iconograph* became known as Abstract Expressionists is particularly thought-provoking in this regard. Was their unwillingness to eject the verbal from their official program a factor?

Michael Leja has suggested that *Iconograph*'s artists failed in their too-literal adaptation of Northwest Coast forms and their corresponding failure to integrate into their primitivizing the more compelling problems of guilt, terror, and tragedy.[4] Although this may well have been a factor, the subsequent work of others such as Robert Barrell (fig. 1), and Gertrude Barrer (fig. 2), also failed to achieve recognition in Abstract Expressionist circles because the artists did not establish appropriate personas. Barrell's painting was too craftsmanlike (critical recognition of Barrell's paintings as "well-woven mosaics" would have been deadly in Abstract Expressionist circles).[5] Barrer, on the other hand, whose work in facture and theme (the title of the painting reproduced in fig. 2 is *Apocalypse: War and the Machines*) appears to participate more centrally in the Abstract Expressionist aesthetic, did not herself, as a woman and, by the later forties, as a mother, possess the requisites for an authentic, existential persona. A comparison of the sociology of the identities and production of the artists on *Iconograph*'s staff to those on the staffs of other periodicals more closely allied to Abstract Expressionism might yield some revealing but comparatively unremarked factors in the success of the artists whose work has become recognized.[6]

There were four numbers of *Iconograph* (Spring, Summer, Fall, and Winter of 1946), with two quarterly supplements, followed by a single number of *The New Iconograph* (Fall 1947).[7] *Iconograph* was initiated in New York at least in part as a result of conversations following the renewal of earlier friendships among its editor, Kenneth Beaudoin, its associate editor, Oscar Collier, and its art editor, Gertrude Barrer.[8]

Beaudoin had lived for some time in New Orleans, where between 1940 and 1943 he published a magazine also called *Iconograph*. He described himself in the first issue as a writer, poet, critic, publisher, art dealer, and patron of the arts. He was also, however, a secret painter under the name Galatea Jones. He showed "Galatea's" paintings at Galerie Neuf, claiming that he had discovered the talents of this black woman when she had worked as his cleaning lady in New Orleans.[9] The earlier *Iconograph* was

Figure 1. Robert Barrell, Painting (title unknown), ca. 1947
Detail of painting with books in Barrell's studio in the Janis
Building, 30 E. 14th Street.
(Photo courtesy Walter Miles)

Figure 2. Gertrude Barrer, *Apocalypse: War and the Machines*, 1949
Oil, 40″ × 22″.
(Photo by Frank Russell)

concerned mainly with the publication of free verse. Beaudoin proposed to dedicate the New York version to original work, both visual and verbal, that challenged established trends. He focused on the introduction of young artists living in New York, especially those whose work was based on an understanding of American Indian art.[10]

In the first article in the first issue of Spring 1946, Beaudoin outlined the editors' philosophy in selecting contributors, explaining how the magazine had changed since the earlier *Iconograph* in New Orleans:

> In 1940 I thought it the business of the little magazine to be the nursemaid of experiment: to be the midwife to the bearing of prophets. I still believe this, but I have a different notion of what experiment is. Art-forms like bombs are redesigned for every war, for every peace. It is the business of a successful warring nation to recognize the best design. It is the business of a healthy national consciousness to be aware of the art form which will satisfy the existing moment with its eloquence; for in the moment of fresh achievement, then only does the art form enjoy its truest reality. . . . In the moment of their inception, when weakest, opposed by every existing *status quo* of thought and habit, then are art forms enjoying their most exciting reality; it is at this point *Iconograph*, New York, 1946, would apprehend the art object, hold it before the public eye a moment, cry out a prophet is born! It really does not matter that next year we may hear the same cry for another prophet.[11]

To Beaudoin, it was these "prophets" who were capable of extending existing boundaries in dealing with the question of communication in the arts. In the visual arts he introduced as a group painters he called the Semeiologists (Steve Wheeler, Barrell, Peter Busa, Collier, Barrer, Helen De Mott, Sonia Sekula, Ruth Lewin, Lilian Orloff, Howard Daum, and Angus Smith). Their roots, in Beaudoin's view, were in "ancient runic-Amer-Indian art": two-dimensional and "dependent upon the use of a symbol-integer rooted in an understanding of human and visual realities, personal realities."[12]

Like other members of the American avant-garde community, including most of the Abstract Expressionists, Beaudoin saw the possibility of linking structures in "primitive" languages to those in modern ones as a first step in setting up a universal discourse capable of unravelling the conventions by which man organizes the chaotic flow of existence. His emphasis on "realities" expressed by both Amer-Indian tribes and the "Semeiologists" use of "symbol-integers" reveals affinities with structural anthropologist Claude Lévi-Strauss (an associate of Surrealists such as André Breton and Max Ernst, members of a circle Beaudoin knew through his friend Peggy Guggenheim).[13]

Beaudoin believed that theories of perception and expression may have a common basis in thought processes. Therefore, he reasoned, the basis for a new approach to the study of meaning in both visual and verbal struc-

tures might be found in studies of linguistics (perhaps ones like Edward Sapir's *Language* [1921]) as well as studies of art by linguist-anthropologists (here one thinks of Franz Boas' well-known *Primitive Art* with its emphasis on Northwest Coast Indian art, first published in 1927).[14] However, Beaudoin's choice of the term "semeiotics" may indicate his debt to Charles Sanders Peirce (who also spelled it that way), an American philosopher who shares with Swiss linguist Ferdinand de Saussure the position of being the first, early in the twentieth century, to envision a science of signs. Oscar Collier, however, has noted that he has "always felt, based on some remarks about our art by Kenneth Beaudoin, that 'semeiology' was at least partly, and jokingly, a reference to semen, as well as having a more formal meaning."[15]

Peirce believed that "the entire universe is perfused with signs if it is not composed entirely of signs."[16] He also realized that if everything is a sign, then the question of how one sign differs from another is very important. He identified ten trichotomies by which signs can be classified; only one of these, which distinguished icon, index, and symbol, has been generally influential. For our purposes here, it is Peirce's definition of "icon" which matters, since it is probable that the title of *Iconograph* magazine, as well as Beaudoin's description of his Semeiologists' program, was influenced by it. Peirce wrote:

> In contemplating a painting, there is a moment when we lose the consciousness that it is not the thing, the distinction of the real and the copy disappears, and it is for the moment a pure dream—not any particular existence, and yet not general. At that moment we are contemplating an *icon*.[17]

The assertion that an object can avoid being particular without then having to be general by default, and that it can enjoy the deference accorded to the real, but can also possess the breadth of reference accorded only to the abstract, was attractive to Beaudoin and the Semeiologists. "At one time I did try to use symbols," recalled Howard Daum. "Kenneth Beaudoin called it semeiology. For a while we were involved with images. But then we discovered that *everything* becomes a symbol. *Everything* is an image. The whole idea is that the figure and the ground are one. To do that you have to think of the negative space as an image."[18] It would also have found approval from a number of Abstract Expressionists, whose work was gradually shedding recognizable specifics, yet who refused to submit to generalizations about goals or methods.[19]

In *Iconograph* 1, Beaudoin announced his intention to promote the work of painters aware of the "semeiotic" relationship of their own art to the art of primitive cultures, insisting that the expressive possibilities of this relationship be couched in two-dimensional design. The influence of

designer James Dolan may have been important in this respect. In his article, "Typography," he advocated "the full departure from classic type form of words composed of individual characters, to a word conceived as the picture image in which the individual letter is subordinated to the word configuration." Dolan proposed as an illustration for this departure his graphic design of the word "Typography," the title of the article (see fig. 8), adding, "The result is not the usual accidental arrangement of letters forming a word, but instead conscious arrangement of letters forming a *picture* of an idea."[20] The relation of Lloyd Barrell's lettering on the cover to Howard Daum's drawing below it also conforms to this suggestion.

Dolan's advocation of letter forms subordinated to picture images produced an ambiguity between the forms of the letters as objects and the page upon which they appeared. That ambiguity surely pleased the artists involved with *Iconograph*. It also calls to mind the calligraphic procedures and spatial ambiguity in the later forties of artists like Lee Krasner, Norman Lewis, Jackson Pollock, Sonia Sekula, Mark Tobey, and Bradley Walker Tomlin.[21] In order to establish a link between an idea and its written description, de Kooning, a former sign-painter skilled in lettering, would sometimes begin a work with a printed or cursive word written across his canvas.[22]

Beaudoin's awareness of the history of the relationship between visual and verbal structures is further illustrated by his selection of the aging Abraham Lincoln Gillespie—on an honorary basis—as the literary editor of the first issue. Gillespie, a former associate editor of Eugene Jolas's *transition*, drew his writing, or wrote his art. His poetry is best reproduced photographically, as a drawing would be; to put it into conventional typography was to destroy a good part of the meaning. When Gillespie did design for typographic reproduction, like e. e. cummings, he was specific about the location of the word on a page, for both the spacing between one word and another and the connotation of the word itself were factors in the meaning of his work.

Gertrude Barrer recalled that Gillespie knew precisely what he meant and that when he read his work aloud it was not difficult to grasp its meaning. She went on to remark, "This is very much the kind of thing painters do."[23] Perhaps when Barrer likened Gillespie's personal codification of meaning in his poetry to "the kind of thing painters do," she was thinking of her own conviction: "my point of view was that the more you conceal the easier it is for a knowledgeable person to read."[24] At any rate, Gillespie's verbal camouflage and occasional decipherable clues (like "wordea-re-mains" in "Portraicts Skulpursune" [see fig. 18]) are similar to Gorky's methods in a work like *The Water of the Flowery Mill,* which combines recognizable images that refer directly to objects with images that

refer to moods, or serve to define relationships between other forms.[25] Like the work of the New York School, Gillespie's poetry was filled with private but nonetheless specific references.[26]

The integration of visual and verbal structures was not *Iconograph's* only goal. In addition, Beaudoin and his staff, as noted above, intended to publish art forms "in the moment of their inception, when weakest, opposed by every existing *status quo* of thought and habit," because "then are art forms enjoying their most exciting reality."[27] For this reason, perhaps, the images Beaudoin used to represent the flavor of the new work emphasized its youthful qualities. Like Paul Klee, whom he mentioned in "This Is the Spring of 1946," Beaudoin appeared to believe that the young are closer to the springs of creative inspiration than are more acculturated adults. An interest in Klee's work may have been a part of what induced him to reproduce Alfred Russell's essay "The Twittering Machine of the Future" in *Iconograph* 2.[28] In his reading of Klee's work Russell wrote, "We will create our own life, synthesize realities and experiences in paint, in ink, in defiant scrawls." Russell's declaration connects expression and technique in an appreciation of children's art reinforced by Klee's example.[29] This conviction—that a work's meaning and the means of its making were organically linked—was similar to that expressed by artists like Jackson Pollock, Arshile Gorky, Mark Tobey, and Ralph Rosenborg. Although Rosenborg's work has been less often discussed in this connection than has been the work of some others, his *American Landscape Forms* (1946) (fig. 3) suggests such a linkage between process and meaning. At "Artists' Sessions at Studio 35 (1950)," recorded in *Modern Artists in America,* Rosenborg remarked, "while the hands do, the picture moves, having a life (objective, emotional, intellectual) of its own."[30]

Russell emphasized his preference for youth and energy as an alternative to both left- and right-wing positions. There is no hope, he wrote, for the decrepit or the communistic, for social workers, those who earn salaries, for those whose hearing is bad. If you would rather ride than walk, if you are patriotic, or if your senses of touch and taste are not acute, there is no hope for you as an artist. In this essay, Russell's description of the art of "post-Klee man" sounds much like a prescription for one version of Abstract Expressionist art:

> There is action, visual verbs, as line passes from form to form, as a line explodes or contracts or vanishes. There is abstract metamorphosis as a line passes over a black smudge. Each touching, departing, concentrating, expansion is a unique experience to sharpen our awareness of existence. . . . We have never seen these forms in life before, but from this point on we will be poignantly aware of these improvised forms. Add to them the new ballistics of splattering ink and pigment. Our senses will be acutely awakened by the hair gashes of lines across the flesh, plane of the canvas. . . . This is the touch, this is the total awareness, the essence of communication we find in Coptic

Figure 3. Ralph Rosenborg, *American Landscape Forms,* 1946
Oil on canvas, 28″ × 40″.
(Collection of Gary and Randy Snyder)

textiles, in Klee's *Twittering Machine.* Sometimes it's only the eyes which speak to us in an intimate little language, the eyes of the Etruscan Warrior in the Metropolitan Museum, the eyes of Klee's "Holy One," or the eyes of a dozen Congo Masks.[31]

Russell's own visual work (see fig. 16), with its skillfully drawn figures and flowing lines, appears less brash than one would expect from the program he advises in "The Twittering Machine of the Future." Russell's career deserves further research, both for its independent approach and for the artist's determination to explore both the expressive and the classic traditions. It is the essay, however, rather than his work that appeared in *Iconograph* that now appears closest to the spirit of painting to be done in the next three years by artists such as de Kooning, Krasner, Pollock, Tomlin, and Motherwell.

Some remembered *Iconograph* mainly for its focus on the use of American Indian art as a springboard for contemporary art. The first issue contained an advertisement for a Gallery Neuf show entitled "8 and a Totem Pole" which featured the work of some of the artists Beaudoin had mentioned in "This Is the Spring of 1946": Oscar Collier, Peter Busa, Robert Barrell, and Gertrude Barrer (fig. 4).[32]

There were various influences operating in New York's artistic circles to spur an interest among artists in the art of the Northwest Coast Indians. Exhibitions on the West Coast as well as at the Museum of Modern Art in 1941; the enthusiasm of Surrealist emigrés such as André Breton, Max

Figure 4. "8 and a Totem Pole," 1946
Installation, Galerie Neuf.
(Photo by Phillips St. Clair)

Ernst, and Yves Tanguy for Kwakiutl and Haida artifacts; the great collections at the Brooklyn Museum, the Museum of Natural History, and at the Heye Foundation; and a nationalistic desire to use as source material native art from the Americas (rather than from Africa as the Cubists had done) all played a part in the growing prominence of Northwest Coast art as an inspirational force.[33]

There were some factors besides these, however, in the personal histories of Beaudoin and Collier that are also responsible for the remarkably homogeneous flavor of the art in *Iconograph*. Both artists were predisposed to appreciate the art of "primitive" cultures, though perhaps for different reasons. With the possible exception of Adolph Gottlieb, Beaudoin claimed Barnett Newman as his favorite artist.[34] By 1946 Gottlieb and Newman had been on the record for several years as enthusiastic promoters of what they saw as the parallels between primitive and modern art. Beaudoin recorded in *Iconograph* his fascination in 1931 with "primitive cosmology, primitive metaphysics," indicating an early enjoyment of the sense of the mysterious and primordial which was shared by so many Surrealists, including those whose work would be available in publications in New York such as Wolfgang Paalen and Wifredo Lam, as well as by anthropologists like Claude Lévi-Strauss.[35] Collier's interest was more visual and immediate.

He came to *Iconograph* remembering vividly the Pueblo pottery and Navajo blanket designs he had seen in Taos, New Mexico, in 1945. For Collier, Beaudoin wrote, Indian art possessed "a method of pictorial articulation more satisfying to himself than any he had used before."[36]

Gertrude Barrer and Oscar Collier's interest in Indian art was focussed on the Northwest Coast at the time they studied at the Art Students League. This was the result of an enthusiastic introduction by fellow student Howard Daum to Robert Barrell, a painter who had been part of the Works Progress Administration at the Hayden Planetarium and had used his time there to make frequent forays to the adjoining Museum of Natural History. Collier and Barrer both studied briefly with Will Barnet at the Art Students League, as did some of the other contributors to *Iconograph* including Ruth Lewin and Carl Ashby.[37] Barnet recalls many field trips with classes of the Art Students League to see the Northwest Coast art in the Museum of Natural History and the Heye Foundation. They called what they were doing "Indian Space," he remembers,[38] a term coined by Howard Daum.[39] Barnet told his classes that there is

> a strength in the decisive way they [Northwest Coast Indians] arranged objects—so that there was not only a dynamic movement but a tremendous balance between forces—a sort of an equilibrium. It was a two-dimensional space—they had no negatives—they had all positives. That was what interested me. . . . When the design was strong, I wanted to know what the motivation was. The power, the geometry in a form, tells you about the strength of the society. When the forms get weak, the society is decaying.[40]

Other artists, too, remembered making pilgrimages to these museums in search of inspiration. Sculptor Ruben Kadish recalled that during the thirties, he, Pollock, and Philip Guston, all of whom were from the West Coast, would often make trips to the Museum of the American Indian, the Heye Foundation. "There's no question that there was a very great interest in more than looking at the things as ethnographic," he recalled. He was sure that Clyfford Still, also from the West Coast, was aware from childhood of Northwest Coast art, although he is equally sure that Still intended his art to be "without a recognized source . . . without precedent."[41] Peter Busa, whose work had been shown in "8 and a Totem Pole," and was reproduced in *Iconograph,* also remembered being very interested in Northwest Coast art, but recalled that his introduction to it was through Franz Boas' *Primitive Art.*[42] The origin of *Iconograph*'s predilection for art inspired by that of cultures of the Northwest Coast Indians thus had many facets. As Collier said, "It was in the air."[43] But it is certain that Barnet, Barrell, Busa, Daum, and Wheeler, who were all at the Art Students League at the same time in the thirties, had a strong influence on that bias.[44]

The *Iconograph* group did not isolate itself from the rest of the New York art community. Besides its connections with the Art Students League, *Iconograph*'s staff and contributors were familiar with the collector Peggy Guggenheim and a number of artists associated with her gallery, Art of This Century. Between 1943 and 1946 Guggenheim gave first one-man shows there to Pollock (1943), Hofmann (1944), Motherwell (1944), and Rothko (1945).[45] Beaudoin met her through Peter Busa, whose solo exhibition in March of 1946 at Guggenheim's Art of This Century Gallery was advertised in *Iconograph* (see fig. 12). Guggenheim was attracted to Beaudoin, whose droll, cynical wit enlivened his gallery which often became a salon after closing hours.[46] Barrer recalls that Guggenheim came to the "8 and a Totem Pole" show and liked it so well that she persuaded the Museum of Modern Art's director, Alfred Barr, to see it.[47]

By its fourth issue, *Iconograph* carried an ad for the Betty Parsons Gallery, whose tone and decor Collier preferred to the Art of This Century, and whose artists, he felt, were some of the most promising at that time.[48] The stylistic similarity among the artists in *Iconograph* was at its most concentrated in the first issue. Thereafter, this "Indian" appearance thinned out. By the fifth and last issue (Fall 1947), which featured the work of Perle Fine and Mark Rothko, Henri Michaux, Gertrude Stein, and Ezra Pound, it had moved away from ethnography towards a somewhat more recognizably mainstream modernism (in the outlook of the magazine, if not in the work of all of *Iconograph*'s artists).

In the early issues of *Iconograph* the predominating modes of art were either Northwest Coast–derived or a simplified, somewhat abstracted but painterly realism. Later, a preponderance of works were composed of abstract but painterly organic forms. These paintings and sculptures, like David Hare's *Red Knight*, Gertrude Barrer's *The Hunter*, and Jackson Pollock's *Search for a Symbol*, could be labelled as Abstract Surrealism or, in view of later developments in the case of Pollock, at least, Early Abstract Expressionism.[49] The work of Gertrude Barrer, although she has not been included by scholars in their lists of either of these groups, epitomizes in many ways the qualities one might expect from an alert, impressionable artist exposed to the ideas represented in *Iconograph*. In her work published in *Iconograph* 1, such as *The Somber Photographer* (see fig. 7), Barrer employed flat shapes with sharp edges whose automatist antecedents in the work of Miró and Klee were tempered by her allegiance to Northwest Coast art. This dialectic determined her refusal to permit the shapes in her paintings to overlap one another as they might have done if automatism alone had determined their form. Her work at this point thus demonstrated a tense maintenance of an "all positive" valence, in which neither positive nor negative shapes dominate the composition, but in which an atmospherically

toned background forecasts the more painterly, exploratory characteristics of her *Illuminato* (see fig. 20), painted a year later.[50]

In respect to its watery atmosphere, its amorphous biomorphic forms, and its retention of hints of a geometric or gridlike substructure, Barrer's work in 1946 is similar in approach to Mark Rothko's at that time.[51] The formal similarity in their work may have been rooted in a similarity of purpose. "For art to me is an anecdote of the spirit," Rothko was to state, "and the only means of making concrete the purpose of its varied quickness and stillness."[52] Barrer recalls, "I spent a long time trying to understand how to paint tenuous subjects—the wind, emotions. The problem was to get inside the underlying forces."[53]

The final issue of *Iconograph*, Winter 1947 (retitled *The New Iconograph* and now run by Collier without Barrer and Beaudoin), contained a special feature on Mark Rothko. It followed by months the first issue of *The Tiger's Eye*, which also had a section on Rothko and should be considered—like *The Tiger's Eye*—as a document of concepts and artists important to the development of Abstract Expressionism. It differs, however, from *The Tiger's Eye*, whose parallels to Abstract Expressionist thinking are often ones of content, not structure. *Iconograph's* most significant affinity with Abstract Expressionism is its championing of the structure of iconic art— art that embodies that to which it refers—and its conviction of the identity of process and meaning. These values appeared in *Iconograph* entwined with its focus on youth in the persons of an avant-garde composed of young artists inspired by the Northwest Indians. It presented arguments favoring the artwork as an arena of struggle and experience, emphasizing at the same time that art produced in this way would develop a flat, allover pattern—two of the characteristics by which Abstract Expressionism has been identified.

2

The Tiger's Eye:
Not to Make a Paradigm

The Tiger's Eye was an interdisciplinary magazine edited by Ruth Walgreen Stephan, a writer, and John Stephan, a painter who showed with the Betty Parsons Gallery. Published in nine quarterly issues from October 1947 through October 1949, the design of the magazine, its three covers, choice of the type faces and papers, and the mixing of printing inks were done by its art editor, John Stephan (see fig. 21). Ruth Stephan wrote the tables of contents with their biographical notes, as well as the editorials for each issue. The magazine's contents, both literary and visual, revealed its keen awareness of aesthetic issues, especially those important to Surrealist, Abstract Expressionist, Existential, and Imagist attitudes. *The Tiger's Eye,* however, avoided direct critical confrontation. ''The critic who wields it [the pen] as a sword permits himself to become the counterpart of the lawmaker, the jailer, the executioner. He might be astonished if he were to visualize the uninspiring static position he has acquired,'' wrote Ruth Stephan in her editorial for the issue of March 1948. According to Stephan, criticism would be viewed as a work of art—just as a painting or a poem would—and not as a special category which judged other arts.[1]

 The injunction against normative criticism was linked to another policy of *The Tiger's Eye,* the practice of separating authors' and artists' names from their works. As John Stephan announced in the first issue, ''Because each piece is chosen for its own sake and always should be approached as such, regardless of who designed or wrote it, the names of contributors will be printed separately in the center of the magazine.''[2] In part, Stephan recalled, this was an implicit protest against what he, Ruth Stephan, and a number of their colleagues saw as the Museum of Modern Art's ''name brand'' policy of choosing to buy and display art on the basis of an artist's prior reputation rather than on an evaluation of the work itself. It also reflected the practice of a number of artists such as Clyfford Still, who, John Stephan recalls, often did not sign their works.[3] This practice occasioned some outright dismay on the part of even the most appreciative

readers and contributors. Herbert Ferber, subscriber and contributor to *The Tiger's Eye* (his *Apocalyptic Rider* [see fig. 29] appeared in the fourth issue), wrote to John and Ruth Stephan—who were his personal friends as well— that *The Tiger's Eye* format was "very beautiful, the layout excellent, and the reproductions wonderful."

> It is exciting to see so much space devoted, committed, engaged to Art, of all kinds. But damn it all, I can't read the table of contents even when I find it. The white on red is not good. And I still wish it were in front or back . . . you can't fool me—I know a Picasso, Gottlieb, Newman, etc.—when I see one and if I were more familiar with poetry I'd know many of them too, just on sight.[4]

However, because it was the result of careful reflection and deep conviction, John and Ruth Stephan maintained this graphic convention throughout the life of the magazine.

The Tiger's Eye was one of the most widely read of all the avant-garde magazines at the end of the forties. It appeared regularly in quarterly installments, was received by a number of universities, and sold rather well outside New York in cities such as San Francisco, Chicago, Seattle, and Paris.[5] Designated as the "most outstanding of all graphically oriented little magazines," *The Tiger's Eye*, with its "wide locus of attention" was distinguished for its devotion to both recognized masters as well as those just achieving reputations.[6] In this way the Stephans' magazine differed significantly from *Iconograph*, but followed *View*, an important influence on *The Tiger's Eye*.

In the March 1948 issue, for instance, the magazine published poems by Sappho and Kenneth Patchen; by John Simon, then a student at Harvard; by Brewster Ghiselin, a poet in Salt Lake City, Utah; and art by Gerome Kamrowski (see fig. 24), Picasso, Matta, Eugene Berman, Jackson Pollock, and Mark Tobey (see fig. 22). The broad range of interests represented by this selection was seen by some as a lack of focus, causing critics to accuse *The Tiger's Eye* of failure to provide New York City artists with a sufficiently radical forum.[7] Steven Foster has stated that *Tiger's Eye*, like *Possibilities*, was not capable of producing "even novel reports on the contemporary painting scene." "The causes of this conservatism stem," he wrote, "from the general decline of an avant-garde spirit in America, the lack of a tradition in art criticism, and obtuse editorial policy."[8]

To most observers, it appeared that *Tiger's Eye* contributors were for the most part selected on an eclectic basis.[9] To some, like Robert Motherwell, this eclecticism was not all bad. He remembers that "the *Tiger* was John Stephan's baby" but that "lots of artists had their fingers in the pie"; and that John asked people for their advice, making *The Tiger's Eye* "the only magazine that was a collaboration of all the artists."[10] "John

Stephan had an idealistic desire to tell it just as it is," according to Peter Grippe—"to go out and support existing movements no matter how diverse they were."[11] The Stephans believed that by significant juxtaposition, rather than direct advocacy, the high quality of the best work would gain the prominence it deserved. John Stephan remembers, for instance, deciding to do a section on Walter Murch (see fig. 25), an artist whose goals some thought did *not* coincide with those adopted by the group of developing artists later to be called Abstract Expressionists: "Now, with hindsight, I think that without the work of Walter Murch the *Tiger's Eye* would have lost the chance to publish the work of a very fine artist!"[12]

In tandem with their policy of considering criticism and its object as equal and separate arts, the editors of *The Tiger's Eye* refused to champion one school above all others. Steve Wheeler, a contributor to *The Tiger's Eye* as well as to *Iconograph,* believed that Ruth Stephan was discouraged from continuing partly because of negative opinions about this policy, which was important to her. Some writers, he recalled, claimed that only by supporting the stance of the much-read *Partisan Review*[13] or the comparatively authoritative *Art News,* could *The Tiger's Eye* become intellectually responsible. This notion ran counter to John Stephan's intent, which Wheeler remembers as a genuine wish to cut across all tendencies rather than a desire to create a paradigm for all to follow.[14] It is important to note the literary controversies underlying the firm stand taken by the Stephans in their editorial policy, for it represents a significant orientation not only in this important magazine but within much Abstract Expressionist art.

Some critics, like Clement Greenberg (whose writings appeared in none of the five magazines under discussion here), emphasized structure over spontaneity in discussing the new painting and sculpture. Notwithstanding his debt to predecessors such as Roger Fry and Clive Bell, Greenberg's stance also echoed ideas inspired by poets like T. S. Eliot and may be identified with New Critical writers such as Cleanth Brooks, John Crowe Ransom, and Allen Tate.[15] The touchstone of the New Criticism was T. S. Eliot's notion that the structure of the poem itself, rather than connections between the poem and life, should be the critic's main concern.[16] This position was implicitly opposed by the more pluralistic, descriptive approach epitomized by the poetry of William Carlos Williams, Richard Chew, and John Simon (which *was* published in *The Tiger's Eye*).

The Imagist heritage associated with Williams, which permeated *The Tiger's Eye,* was proclaimed in the first issue by the reproduction of poet Marianne Moore's notebooks and sketchbooks.[17] In contrast to poems preferred by prominent New Critics such as Ransom, Williams emphasized the patterns of common speech. His dependence on factors *outside* the poem itself reflected Williams's belief that the content of the poem should

determine its form, rather than the other way around.[18] *The Tiger's Eye*
may owe its philosophy in this regard (which was similar to Williams's)
to Ruth Stephan's former position as a staff member on Harriet Monroe's
Chicago-based *Poetry* magazine (1912–43). Monroe's "Chicago" approach
to problems of content was substantially opposed to the New Critical at-
titude. Monroe announced *Poetry*'s policy in the second issue. In her refusal
to accept any system which would limit her choice of contributors, Monroe
eschewed the strictures of New Critical aesthetics (although she accepted
individual works of which New Critics approved), formulating sentiments
echoed by the Stephans:

> The Open Door will be the policy of this magazine—may the great poet we are look-
> ing for never find it shut, or half-shut, against his ample genius: To this end the editors
> hope to keep free of entangling alliances with any single class or school. They desire
> to print the best English verse which is being written today, regardless of where, by
> whom, or under what theory of art it is written.[19]

This difference in orientation disturbed minds schooled in the New
Critical approach (the dominant mode of analysis taught in Britain and
America by the forties).[20] Resistance to dealing with factors exterior to the
structure of the work may have been at the root of Alfred Barr's inability
(noted in the Introduction) to reconcile "the high degree of abstraction"
in Abstract Expressionist works with the painters' insistence that they were
"deeply involved with subject matter or content." Those who based their
evaluations on New Critical theory were committed, claimed their
opponents, to the search for the dry, the emotionless, and the concrete,
eschewing "damp" feelings and flirtations with the infinite.[21] No wonder
critics like Clement Greenberg preferred, with writers like Ransom and
Eliot, not to deal with questions of intention and emotion.[22]

This New Critical orientation was evident in the tendency of critics
like Parker Tyler (and, following his lead, Stephen Foster) to mistake an
antistructural approach for a lack of direction. The following account of
the rift between the pragmatic approach of the Stephans, who intended
their editorial stance to be the sum of their contributors' intentions, and
the more theoretical, structural approach of the *Partisan Review* can serve
as more than simply an episode in the history of the avant-garde. It
represents the tension between those who refuse to admit structures and
those who erect them, a tension important for this investigation because
both of these tendencies are to be found in Abstract Expressionism. In the
five magazines discussed here, and in Abstract Expressionism in general,
the tension between subject matter and structure emerges as a dominant
concern.

While Stephen Foster's observation, mentioned above, of the lack of
a tradition (at least, of a satisfactory one) in art criticism was justified, his

claim that there was a decline in the avant-garde spirit in America needs to be qualified. So does the characterization of the editorial policy of *The Tiger's Eye* as "obtuse." A clue to his reservations is to be found in his source: a review by Parker Tyler. Tyler, as assistant and later associate editor to the Surrealist-oriented *View*, as well as a contributor to that magazine, *Hemispheres, The Tiger's Eye*, and other publications, would appear in a good position to evaluate editorial policy.[23] However, in seeing *The Tiger's Eye*'s apparent eclecticism as a dilution rather than as purposeful juxtaposition of seemingly disparate elements, Tyler may well have followed the Greenbergian concept of the proper stance for an avant-garde magazine: that it should be a partisan spokesman for a particular point of view. *View* saw itself as a Surrealist magazine, as did *VVV*, the other major American Surrealist magazine, which admitted to its pages only those productions judged by André Breton to be properly Surrealist.[24] *The Tiger's Eye*'s idea of its mission, however, was expressed in its *refusal* to establish a program to which all contributors had to conform.[25]

We will return here to the Stephans who were then following a somewhat lonely course. Although their magazine was much praised and appreciated by outsiders, it was heavily criticized by some in the Stephans' circle, especially towards the end. They were fighting a double battle. On one hand, they were going against a dominant trend in seeing criticism primarily as a form of subjectively authored literature rather than as a comment *on* literature and art. On the other hand, their desire to maintain a comparatively open editorial policy was resented by a few of John Stephan's colleagues at Betty Parsons and was viewed as a lack of direction or commitment by staff members of other magazines, such as Parker Tyler.

Tyler's view of *The Tiger's Eye* as not partisan enough was taken despite the fact that Surrealist emigrés appeared regularly in its pages. Surrealist Nicolas Calas, who had arrived in New York in 1940 and had edited that year a Surrealist Edition of *New Directions* as well as a special issue of *View* (commemorating Breton's arrival in New York), was originally to be Ruth's coeditor. Calas's aesthetic enthusiasms in 1947 may be estimated in part from the list of artists he chose for "Bloodflames," an exhibition he organized for Ian Hugo's gallery: David Hare, Gerome Kamrowski, Arshile Gorky, Wifredo Lam, Matta, Isamu Noguchi, Helen Phillips, and Jeanne Reynal.[26] Most of these artists would later appear in various issues of *The Tiger's Eye*. Owing to a disagreement between Calas and Ruth Stephan about the degree of his editorial authority,[27] Calas's assistance did not materialize, and the Stephans decided to do the magazine themselves. Their initial willingness to share that important responsibility with an avowed Surrealist, however, demonstrates the extent of their respect for that way of thinking.

The Surrealists, too, had been some of their earliest acquaintances in

New York. Dealer Pierre Matisse, whom the Stephans had known in Chicago, introduced them to Max Ernst, Marcel Duchamp (with whom John Stephan played chess), and dealer Julien Levy. Through them the Stephans had met others in that circle, such as Peggy Guggenheim (then married to Max Ernst) and Arshile Gorky. In general, however, *The Tiger's Eye* tended to favor renegade Surrealists—those who had refused the embrace of Breton's approval. In the magazine they published the work of Georges Bataille, Ian Hugo, Max Ernst, Lionel Abel, Matta, Calas, André Masson, Yves Tanguy, Tyler, Eugene Berman, Jean Arp, Alberto Giacometti, Marc Chagall, Joan Miró, Kurt Seligmann, Maya Deren, and Dorothea Tanning (see fig. 33).

With the second issue (December 1947) Barnett Newman was asked by John Stephan to accept the position of art editor. Newman declined but did offer to continue assisting John Stephan by introducing him to the artists he knew and to help him obtain photographs of their work, as he had been doing since the magazine's inception.[28] The Beinecke Rare Book and Manuscript Collection at Yale University includes correspondence from Newman to the Stephans which suggests that he proofread two of the articles which appeared in the first issue; however, this was done on the basis of friendship rather than professional involvement, recalls Mrs. Newman.[29] Although he was enthusiastic about the first issue, after the third came out Newman insisted that his name be withdrawn from the masthead, while agreeing to the inclusion of his writing and the reproduction of his paintings (see, for example, fig. 40) in later issues.[30]

The position of the Stephans in regard to the balance they wished to strike between work by better-known artists and that of as-yet-unestablished New York School painters and sculptors (such as Ad Reinhardt [see fig. 30] and Richard Pousette-Dart [see fig. 31]) was not always an easy one. John Stephan remembers that the policy of putting the table of contents in the center of the book so that it would be rather difficult, but still possible, to locate, and of not putting the author's or artist's name with his work, was a response to one aspect of this problem:

> They (the New York artists) complained that the Museum of Modern Art was solely interested in the Surrealists, that there were many artists in this country who were being ignored and should by now be recognized for their creative visual innovations, including questions of just what is to be included and excluded in the artist's subject matter and how he should deal with it in terms of his craft. The *Tiger's Eye* felt that the best way to present the case was by placing all references other than those to subject in a centralized index. Barney (Newman) said later that the artists objected and I disagreed by saying that a work of art should be appreciated for what it is.[31]

Consistent with their policy of separating contributors' names from their work so that it might be evaluated by the reader on its own merits,

regardless of the artist's or author's reputation (or lack of it), was the Stephans' determination to evaluate all manuscripts and art that were submitted, regardless of whether they knew the author or not. The result of this policy was that there were a great many submissions, manuscripts especially, to go through. They were read by Ruth Stephan with the assistants she eventually acquired as the load became heavier. Although it became impossible for Ruth herself to read everything that was submitted, she always made the final decisions about which works to include.[32]

According to John Stephan, *The Tiger's Eye* stopped publication for two main reasons. The first was that the magazine had come to take altogether too much of their time—Ruth Stephan needed more time for her own writing. But the second reason for folding, and the one that rankled the most, was that the Stephans began to feel the alienation of some of the artists who disagreed with their broadly based editorial policy. Barnett Newman, for instance, John Stephan believed, would have liked the magazine to function as an organ for artists in the galleries of Betty Parsons, Samuel Kootz, and Charles Egan, along with certain independents. With the founding of the Eighth Street Club in 1949, to which John Stephan belonged (Stephan, who could not attend the first meeting, was proposed by Willem de Kooning as a charter member), the rift between some of the more partisan members of the emerging New York School and the determinedly pluralistic Stephans continued to grow.

Despite the friction between *The Tiger's Eye* and some of the Abstract Expressionists, the magazine published the work of most of the painters and sculptors eventually associated with that group, often printing written statements as well as reproductions of painting and sculpture. The magazine's general policy was always to ask the artist for a statement along with a work to be reproduced, with the exception of artists who were very well known. Since the work and statements of the New York School were often in the magazine (Louise Bourgeois [see fig. 34], Mark Rothko, Barnett Newman, Theodoros Stamos, Clyfford Still, William Baziotes, and Robert Motherwell, for instance, all appeared in more than one issue; artists Rothko, Mark Tobey, and Baziotes were featured in various issues with selections of their works),[33] it is safe to say that it was a vehicle for their ideas. Indeed according to John Stephan, *The Tiger's Eye* was at the deepest level more sensitive to their interests than it was to those of any other group published by the magazine.

Particularly significant in demonstrating the magazine's germinal function for the group of artists who would come to be called Abstract Expressionists are the special sections that appeared in each issue after the first one. The concept of the special section was Ruth Stephan's idea, but the subject in each issue was discussed and decided upon jointly by Ruth and John. It was advertised in each issue for the succeeding one. Since

the Stephans were in close touch with writers from all over the country and with a large number of American and European artists in New York, they were in an excellent position to cull a wide variety of themes and to pick those to investigate that they felt would best reflect or stimulate the interest of their audience. Their success in choosing relevant ones, at least for the Abstract Expressionists, is indicated by the artists' strong participation in these forums and by the frequent parallels of the titles of their paintings, sculptures, and statements of intent with the themes of the special sections in *The Tiger's Eye*. Special sections such as "Night," subtitled "A Darkness of the Mind, or of Nature," featured not only works such as Arshile Gorky's *Soft Night* and Loren MacIver's *Shade at Night* but also a parody by Lloyd Frankenberg entitled *Ballet Interpersonal* (see fig. 39a–h) that demonstrates the link between the concept of the unconscious mind (with its link to the practice of psychiatry) and the concept of night. Special sections on "The Sea," one called "Ivy on the Doric Column" (initiated with a page upon which appeared a quotation from Nietzsche's *The Birth of Tragedy* and a drawing by Theodoros Stamos [see fig. 23]), "Poets on Painters and Sculptors," and, especially, "The Sublime," were of much interest to these artists.

Not all the special sections were determined by subject matter, though most were. The special section in the eighth issue, for instance, entitled "A Selection of Graphic Arts," was guest-edited by printmaker Stanley W. Hayter. It focused on the printmaking of artists such as Boris Margo (see fig. 35), Adolph Gottlieb (see fig. 36), Louis Schanker (see fig. 37), and Anne Ryan (see fig. 38). The fourth issue dealt with the medium of sculpture, reproducing in condensed form the same range of interests that one may detect in the selections of the magazine as a whole: "Existential" Europeans like Giacometti; earlier American moderns, like Flannagan; prominent established European moderns, like Moor, Arp, Brancusi, and Lipchitz; constructivists both American and European (Richard Lippold, Naum Gabo, and Antoine Pevsner); Americans whose work was not easy to classify such as David Hare, Robert Moir, Helen Phillips (see fig. 26), Isamu Noguchi (see fig. 27), Day Schnabel, Mary Callery, and Peter Grippe (see fig. 28); and sculptors now most readily associated with the painters designated as the Abstract Expressionists: David Smith, Seymour Lipton, and Herbert Ferber.

In the final analysis, it was the Abstract Expressionists who were best served by *The Tiger's Eye*. That magazine, in the two and a quarter years of its existence, not only reflected their concerns, but stimulated artists and writers to articulate and vivify them.

3

Possibilities:
"The Thing—without Theory"

Possibilities occupies a pivotal position in the periodical literature of Abstract Expressionism. Published in only one issue in the winter of 1947/48, with a cover designed by Paul Rand (see facing fig.), and jointly edited by Robert Motherwell, Harold Rosenberg, John Cage, and Pierre Chareau, *Possibilities* shares many of the characteristics of *The Tiger's Eye*. Along with the Stephans' publication, *Possibilities* was castigated by Parker Tyler for its "moderation in advance-garde aims."[1] Its editors did share with those of *The Tiger's Eye* a reluctance to choose contributors according to their adherence to a stated philosophy. For Motherwell at least, this policy was a conscious stance that paralleled his own enthusiasm for the antistructural nature of Dada collage. This distinguishes Motherwell's policy from John Stephan's conviction that purposeful but unmediated juxtaposition of one work to another would reveal more fully the qualities of each. For Motherwell the multiple realities to which collaged materials alluded opened the possibilities of multiple interpretations. The chief benefit of collage was less the illumination it provided about the nature of each part than the new insights to which it spurred the viewer. The contents between *Possibilities'* bright yellow covers signal not so much the magazine's position as a way station on the road of modernism but rather an awareness of serving as a pivot between modernism and some other kind of less restrictive attitude. The conscious rejection of linear progress paralleled some aspects of the developing aesthetic of Abstract Expressionist art.

Although there were four editors with equal say in the contributions that represented their specialties (Chareau—architecture; Cage—music; Rosenberg—literature; and Motherwell—art), the magazine was really run by Rosenberg and Motherwell, who had known each other since Motherwell's return from France in the summer of 1939.[2] Harold Rosenberg and Motherwell were good friends in the late forties.[3] The idea for the magazine came from frequent conversations often held several times a week. May Tabak, widow of Harold Rosenberg, recalled that those con-

versations revealed a spontaneity typical of the inception of more than one little magazine: "They were sitting around here or in East Hampton, on the beach, talking. And that's what always occurs to you when you're sitting around talking—to get out a magazine." The magazine was not to be a thing with a future; it was a gesture.[4]

The spontaneous character of the magazine was important to Motherwell; in fact, he was disappointed at first that Cage's submission was so documentary in nature, since he had taken it for granted that his section would demonstrate the random and improvisatory qualities for which Cage's music was known. As Motherwell has recently said, "What we tried to do in *Possibilities* and *Modern Artists in America* was not theoretical; we wanted to present the evidence: very factual descriptions presenting the thing—without theory."[5] "Thing[s]—without theory" presented in *Possibilities* included works by Jean Arp; a statement by Baziotes together with reproductions of his paintings; Paul Goodman's "The Emperor of China"; John Cage's documentation of the work of Ben Weber, Virgil Thomson, and Alexei Haieff; an interview with Miró; paintings by William Baziotes; a play by Lionel Abel and one by Rosenberg; Rothko's "The Romantics Were Prompted" and reproductions of his paintings (see fig. 45); a statement by Stanley Hayter and reproductions of two of his prints (see fig. 43); poems by David Smith and reproductions of his sculptures (see fig. 42); and Pollock's essay "My Painting" and reproductions of his works (see fig. 44).

The idea of attempting to present the arts outside an ideological framework occurred to Motherwell when, waiting in Oxford to come back to the United States in 1939, he had a number of discussions of Dewey's ideas with his colleagues. One of the principal concepts he remembers from these sessions is Dewey's attitude towards judgment versus description, particularly the idea that a description can function as judgment, if the description is accurate enough.[6] In his recollections of his impressions of Dewey, Motherwell was probably remembering his acquaintance with passages from *Art as Experience* such as the following:

> To define an impression signifies a good deal more than just to utter it. Impressions, total qualitative unanalyzed effects that things and events make upon us, are the antecedents and beginnings of all judgments. But to define an impression is to analyze it, and analysis can proceed only by going beyond the impression, by referring it to the grounds on which it rests and the consequences which it entails. And this procedure is judgement.[7]

It was perhaps the collage-like effect of the descriptive approach to which Parker Tyler responded when he wrote, "One misses a pervasive atmosphere in *Possibilities* that must exist to convince a reader that a

magazine is present *à l'avant-garde."* He complained, too, about the absence in *Possibilities* of "any directional energy, any organization of ideas, any real novelty, any group inspiration." To Tyler, an avant-garde magazine, to be worthy of the name, "must inveigh, propagandize, defy; it must be favoritist."[8] This contrasts with the policies that guided Motherwell, raised on the West Coast, who has stated, "My philosophy is to let everyone be what they are. This is different from the philosophy of New Yorkers. They tend to want to impose everything, rather than letting everyone be themselves with no imposition of their private opinions about it."[9]

Motherwell's philosophy, however, is not a product solely of his formative West Coast years. He has a number of points in common with the thinking of some artists who worked or taught at Black Mountain College in North Carolina, that refuge of experiment and individualism where Motherwell himself taught in 1945.[10] The community at Black Mountain was also hospitable to *Possibilities'* music editor John Cage, who was asked back after his first visit in April of 1948 to teach musical composition. However, Motherwell and Cage knew each other well before either went to Black Mountain. Of his association with Cage Motherwell recalls:

> He started out in Seattle. We encountered each other in New York, and being from similar backgrounds, there was a rapport. I gave him a picture. For a while I went around with a girl who lived, as did Cage, in Cooper Village—they shared the same landing and often left the door open between the two apartments. He'd invite me in for a cup of tea.[11]

A comment by Motherwell on Cage's books is particularly revealing of the attitude that guided *Possibilities'* editorial policy and can serve to link that policy to the premises of Abstract Expressionist painting. Motherwell described these books as "almost the kind I might have written in the sense that they're essentially collage technique—quotes from all kinds of things— odd relations; you try to get much more dimension, more points of reference than straight narrative could."[12] This "collage technique," which Tyler interpreted as a lack of direction, was, for Motherwell at least, a passage to multidimensionality. This distinguished his position not only from that of *The Tiger's Eye* but also from the more ethnographically focussed cultural critique of certain Surrealist publications such as *Documents.*[13] In Motherwell's documentation of Dada, published in 1951, he quoted Moholy-Nagy's description of Kurt Schwitters's verbal collages as outbursts of subconscious pandemonium "fused with external reality and the existing social status." The ensuing portion of Moholy-Nagy's reminiscence applies as well, I think, to Motherwell's vision of his own artistic and editorial procedures as it does to Schwitters's:

The only possible solution seemed to be a return to the elements of poetry, to noise and articulated sound, which are fundamental to all languages. . . . The words used do not exist, rather they might exist in any language; they have no logical, only an emotive context; they affect the ear with their phonetic vibrations like music. Surprise and pleasure are derived from the structure and the inventive combination of the parts.[14]

With such a method Motherwell hoped to function in what he and Rosenberg had termed in their editorial "the political trap." By establishing "odd relations"—Surrealism's irrational juxtapositions—they aimed to produce works with richer, more resonant implications than one made by a more logical technique could possess.

Motherwell's belief in the liberating function of juxtaposing materials in collage extended beyond the bounds of the visual arts and was partly responsible for the four-part division of *Possibilities* into art, architecture, literature, and music:

I had always been frustrated that New Yorkers could read, but couldn't see or hear [original art in most periodicals] and always thought that there should be magazines like the old *transition* and so on. My basic point of view, my entire adult life, has been that modernism is a general aesthetic of which any one of the arts is a subdivision. And that all of the magazines in that sense were doing everything upside down, simply taking one of the subdivisions and treating it autonomously, as though it weren't connected with the other arts.[15]

Possibilities, then, purposefully sacrificed the cohesiveness offered by a single philosophy, a single medium, or consistent organization in favor of the "possibilities" lurking in the unexpected conjunction of dissimilar elements. Thus the title *Possibilities* was particularly appropriate. This preference for what Randall Jarrell called "the organization of irrelevance" as an actual method of composition paralleled the literary procedures of William Carlos Williams.[16]

Christopher Butler has suggested that the work of James Joyce and Ezra Pound may be used as poles—of elaborate organization and lack of it, respectively—between which the transition from modernism to what followed reverberates. Of the two poles, however, it was the unorganized, loosely structured, colloquial, "irrational," and *collaged*[17] method of the *Cantos* of Ezra Pound to which Williams was drawn, and which appeared to receive the most cordial reception (as the epitome of advanced structure) among the American avant-garde periodicals. Even in a recent exploration of the connections between Joyce's writing and Abstract Expressionist painting, the Joycean qualities noted in the work and statements of the artists were indirection, fragmentation, ambiguity, plurality, and uncertainty.[18]

Parallels between this attempt at scrupulous avoidance of theoretical determination in the work of the Abstract Expressionists and its correspondence in the selection of the contents of the avant-garde magazines such as *Possibilities* are revealed in statements by the artists themselves. Baziotes, for instance, in *Possibilities* used a title that might serve as a motto for the policy of the magazine itself: "I cannot evolve any concrete theory." In the short essay that followed, he maintained that he could not use any preordained rationale, and, therefore, what happened on canvas was a surprise; as he worked, or when he was finished, the subject revealed itself.[19]

The editors' desire to take advantage of the accidental characteristics of collage, to exploit fortuitous parallels among different media, and to avoid what they surely saw as the doctrinaire advocacy preferred by Tyler was echoed in a statement by Willem de Kooning, who wrote in 1951:

> Personally, I do not need a movement. What was given to me, I take for granted. Of all movements, I like Cubism the most. It had that wonderful unsure atmosphere of reflection—a poetic frame where something could be possible, where an artist could practice his intuition.[20]

In these remarks, de Kooning, like Motherwell and Rosenberg in *Possibilities*, associated the concept of the possible with "a wonderful unsure atmosphere."[21]

Robert Hobbs has observed that " 'Possibilities' is an appropriately chosen term; it conveys the idea of open-endedness, and the need for resolution through action."[22] Motherwell did not recall the reason, other than this general suitability, why the periodical was named *Possibilities*;[23] one wonders if, at the time, Motherwell associated the title *Possibilities* with *Dyn*, an earlier periodical for which he had written. *Dyn*'s title is derived from the Greek word "dynaton," which means "the possible."[24] Lee Mullican, a close associate of *Dyn* editor Wolfgang Paalen, wrote that both the publication *Dyn* and the related concept of the dynaton served Paalen "as a forum where he could . . . publish and present ideas, as well as correlate and enunciate early concepts and feelings that furthered his proclamation of The Possible." Mullican emphasized that for Paalen, even with a project as tangible as the installation of an exhibition, "it wasn't only the thinkable, but the possible which mattered."[25] Mullican's rhetoric demonstrates the valorization of the term "possible" by Paalen and his group, and suggests that the word may have had profound, if unrecalled, implications for Motherwell.

Although any connection of *Possibilities'* title with *Dyn* must remain speculative at this point, the ambivalence of Motherwell's association with Paalen does shed light on values held by the younger American painter. Motherwell was attracted by Paalen's erudition and firsthand knowledge

of European Surrealism; and he enjoyed sharing with an interested senior colleague his enthusiasm about the American tradition of pragmatic philosophy, particularly the work of William James and John Dewey.[26]

In a letter of 16 February 1945 from Mexico, Paalen wrote to Motherwell, "Please send me the private address of John Dewey, I want to send him my book with a letter. Do you know if he reads French?"[27] Edouard Renouf, another *Dyn* contributor, recalls that Paalen enjoyed Motherwell's company a great deal and wished that Motherwell had stayed in Mexico to work on *Dyn*.[28] Motherwell's decision to leave Mexico, Paalen, and the theories of the dynaton despite Paalen's encouragement to stay, however, are an early instance of the antiprogrammatic stance he would take in editing *Possibilities* six years later. "I've always been interested in the avant-garde, but I've been often impatient with manifestoes, etc.; with Paalen, as with others, I felt that there was a bit of making it more important than it really was."[29] However convincing the connections, both attitudinal and semantic, between *Dyn* and *Possibilities,* it appears that these considerations must be relegated to a supporting role in the choice of a title for the later publication. Both Motherwell and May Tabak recall that it was Rosenberg who named the magazine.

Like Motherwell, Baziotes, and de Kooning, Rosenberg wished to see the artist freed of preordained strictures on his creativity. Like Clement Greenberg, Rosenberg was aware of the historical pressure of the past. But unlike Greenberg whose determinism became further structured by a program of purist reduction, Rosenberg's position was modified by the subjectivity of Existential philosophy.[30] Jean-Paul Sartre and André Malraux, rather than Karl Marx, were Rosenberg's models.[31] In his introduction to "The Stages" in *Possibilities,* Rosenberg wrote that each man "knows that it is possible *not* to act—and then he will not exist."[32] The use of the word "possible" in what could be described as a declaration of existential faith is not a coincidence. A poet and freelance critic, Rosenberg wrote for many magazines. In "The Game of the Chinese Laundryman," an essay that appeared in *Instead* a few months after "The Stages," Rosenberg described a Chinese immigrant whose tightly circumscribed life was drastically multiplied in complexity when he came to the United States. The sudden necessity to choose among so many unaccustomed alternatives left the foreigner "unable to endure the American anguish of possibility."[33]

The specific meaning of the word he picked for the title of the journal he would edit, and his understanding of its implication in "The Stages" and "The Game of the Chinese Laundryman," becomes clearer when it is viewed in the light of an essay by Emmanuel Lévinas on an aspect of Existentialism in an earlier issue of *Instead*. Rosenberg's dramatization of the paradoxical connection between freedom and "the anguish of possibility" illustrates Heidegger's insistence on the separation of the notion

of possibility from the notion of act. (Rosenberg, as a personal fried of Jean-Paul Sartre, as well as of Maurice Merleau-Ponty, was very much aware of Heidegger's ideas by the late forties.)[34] This detachment, as Lévinas described it in *Instead,*

> allows of possibility remaining possibility—so much so that at the moment of its exhaustion we have death. Whence it ensues that the notion of death permits of possibility's being thought and grasped in its character of possibility: as an event of existence.

Because, in other words, every other possibility may be fulfilled by becoming an act, but death may not (at least, not while the one who fulfills that possibility remains conscious of its effect); death becomes the nonreality. "It is in this sense," Lévinas wrote, "that Heidegger asserts death to be the possibility of impossibility."[35]

It is this aspect of Existential thinking, in which the resolution of a paradox, a conundrum ("the possibility of impossibility") is synonymous with death, that guided Rosenberg and formed the backbone of his assumption that unfettered freedom (possibility) results in anguish. In the context of the unacceptable political alternatives—left-wing totalitarianism and right-wing fascism—which Abstract Expressionists believed they faced (see pp. 3–4), the identification of choice with death and possibility as its anguished opposite must be seen as more than academicized philosophical debate. With this aspect of its historical specificity understood, the title *Possibilities* can be seen as embodying the artist's struggle, as Rosenberg put it in 1952, "to maintain the force to refrain from settling anything," to "exercise in himself a constant No." "The artist," he wrote, "works in a condition of open possibility."[36]

This conviction—that a willingness to explore the uncomfortable unknown represented a constant and conscious resistance to death's invitation—informed the inception of the magazine and guided its editors' choice of contents. *Possibilities* lived up to the impulse by which it was founded: it was a gesture, not an ongoing concern. In the editors' determination to set up no structure which would interfere with the operation of chance and inspiration, the magazine was intended to be the opposite of a manifesto. Therefore it is particularly ironic, as William Seitz has pointed out, that "perhaps the closest thing to anything which could be called an 'Abstract Expressionist Manifesto' is the statement signed by Robert Motherwell and Harold Rosenberg inaugurating *Possibilities.*"[37] In the last paragraph of that short statement one senses the desperation, rather than the optimism, of their rejection of systemic security: "If one is to continue to paint or to write as the political trap seems to close upon him he must perhaps have the extremest faith in sheer possibility."[38]

4

Instead:
"Not Surrealism or Existentialism"

The editors of *Instead,* like those of *The Tiger's Eye,* did not see their journal as a support to those members of the New York School who would become known as Abstract Expressionists. *Instead* emerged from conversations between poet and French scholar Lionel Abel and painter Matta Echaurren, perhaps as early as 1943 and 1944; it was financed by Matta's second wife, Patricia Connoly, who is listed as a member of the staff under the name Patricia Kane.[1] Although the first issue of *Instead* was undated, those that were dated—numbers 2 through the double issue 5/6—were all published in 1948, making that the year of the magazine's major impact. To make it possible to describe the location of *Instead*'s contents, I have called "1" the issue whose "cover" was a drawing of a roselike form by Matta and have called "7" the other unnumbered issue, which has on its "cover," among other things, a drawing of Georges Bataille by Alberto Giacometti (see fig. 51).

Like the early issues of *View, Instead* was published in tabloid form (a decision made by Matta). Its newspaperlike format (the single sheet of *Instead* measures 24 by 18 inches when spread out unfolded), irregularity of publication,[2] fragile stock, and relatively small circulation (it never sold more than a thousand)[3] make it one of the more difficult periodicals to find today. Although *Instead* was sold for twenty-five cents (except no. 5/6, which cost forty cents), many were given away, perhaps adding to the impression its public may have had that it was only a handout and therefore not something to be preserved.[4]

The physical resemblance of *Instead* to the early tabloids of the American Surrealist magazine *View* must not be considered as a sign of deference on the part of Matta and Abel to those first issues of Charles Henri Ford's publication, but was perhaps the result (in both cases) of financial necessity. *Instead* was more likely to have been influenced by *Minotaure,* in which Matta had published his article "Mathématique sensible—Architecture du temps" in 1938.[5] Like *Minotaure, Instead* carried articles

on subjects such as technology, literature, and psychology, as well as art. Its relation to *VVV* was one of origins, not procedures. *VVV* was eventually edited by David Hare under the supervision of André Breton, whose definition of the goals of Surrealism had so inspired Matta.[6] Lionel Abel, too, was friendly with Breton, who had chosen first Robert Motherwell and then Abel to edit the first *VVV*. Before his departure, Abel had written a key essay, "It's Time to Pick the Iron Rose," which appeared on the first page of *VVV's* initial issue.[7]

Instead, however, did not simply revive Surrealist concerns, although a pervasive influence is evident. As Matta recalled, he was expelled from the Surrealist camp in 1948. He believed that Surrealism had a life-period, which was over, and that it would be a mistake "to really do a renaissance."[8] Existential concerns as discussed in *Les Temps modernes,* founded in 1945 and edited by Jean-Paul Sartre and Maurice Merleau-Ponty, appeared in *Instead.* Abel admired the early *Les Temps modernes* and remembers that one could get it in New York; that it was widely read in France, where it had a larger readership than *Partisan Review* here; and that it was read in the United States in university French classes.[9]

If for Abel, *Instead's* distinctive focus derived from its Existential orientation, Matta recalled that

> *Instead* was, precisely just . . . *Instead.* Not Surrealism nor Existentialism. Or let's say a "ligne de force" that could grow in New York out of Surrealism and Existentialism. But nothing grew out of it, just total misunderstanding. It fell on that stupid word Abstract Expressionism (automatism was already there and more to the point than Abstract Expressionism). Arguing to express what? Tautology.[10]

Although *Instead* was edited by Abel and Matta, in some issues, such as the third, Abel's name appears as editor and Matta's with other members of the staff. This staff included, by the second issue, not only Patricia Kane (Connoly), but also John Bernard Meyers, former managing editor of *View.* Abel maintains, however, that the magazine was published with equal participation by Matta and himself: Matta had control over visual decisions and the choice of art, while literary matters were decided by Abel. Patricia Kane took care of production and distribution. As a rule, the Mattas and Abel were left with a number of undistributed copies. "It was wrong for that period," Abel now believes:[11]

> Matta designed the review in such a way that it was hard to find the continuity of most of the articles. You had to wind your way from page to page hoping to take up again something you had begun to read. He said he wanted the review to be a sort of labyrinth. At the time readers did not appreciate this, but Matta held that if they didn't know how to make their way from page to page they were not intelligent enough to be readers of *Instead.* I think we lost a lot of readers because of this.[12]

In March 1948, Abel, Matta, and Patricia Connoly were joined by Stéphane Hessel. Hessel, a diplomat and an intellectual educated at the Ecole Normale, and a friend of both Abel's and Matta's, had been a hero in the French Resistance. "He wrote a very good article, 'Instead of Giving Up,' in the second issue," Abel recalls. "When he sent that in, I saw Matta and I said, 'Let's make him an editor,' and he said, 'Sure.' That's the kind of magazine it was."[13]

The list of contributors to *Instead* is distinguished from those of many of the other avant-garde magazines by a larger contingent of European writers, notably those from France, whose work was often translated by Abel. French writers presented in the pages of *Instead* include Antonin Artaud, Guillaume Apollinaire (see fig. 46),[14] Georges Bataille, Maurice Blanchot, André Breton, Andrea Caffi (a journalist and a scholar, his work was also published in *Possibilities*), Marcel Duchamp, and André Gide.

Issues current in French Existential circles were treated in the pages of *Instead*. A discussion on "An Essential Argument within Existentialism" at Club Maintenant in Paris between philosophers Emmanuel Lévinas (a student of Heidegger) and Jean Wahl (a Sorbonne professor in exile who taught briefly in Chicago, at Columbia, and at the New School) was published in *Instead* 7, as was a poem by poet-painter Henri Michaux. American writers were represented too, and their ranks included one whose ties with Abstract Expressionism would become intimate: Harold Rosenberg. His well-known description of action painting as an existential struggle by the painter to establish his identity through the handling of paint (printed in *Art News* several years later)[15] contained ideas rehearsed with a grain of humor in two articles in *Instead*.[16] Rosenberg had met Sartre on the latter's first visit to the United States in 1946, but, like Abel, Rosenberg had been aware of Existential currents of thought for some time before that. In his "The Messenger, a Radio Drama," published in *Instead* 7, he attributed to the protagonist, Mullen, the experience of being "sick of having sensations": a trial similar to that of Jean-Paul Sartre's M. Roquentin in *La Nausée* (1938). Other American writers in *Instead* whose work helped to establish aspects of the intellectual atmosphere that influenced the development of the New York School were Paul Goodman, Parker Tyler, and Lionel Abel himself. Alfred North Whitehead was quoted in *Instead* 7 (see fig. 50):

> The deliverances of clear and distinct consciousness require criticism by reference to the elements in experience which are neither clear nor distinct. On the contrary, they are dim, massive and important. The dim elements provide for art that final background apart from which its effects fade.

This statement articulates a concern for the significance of areas beyond

the clear light of reason and knowledge—a concern shared by many artists whose works were reproduced in these magazines.

Just as *Instead* displayed a bias towards French or French-influenced writers, so it appeared to favor the work of French-associated artists— or, more precisely, those compatible with Surrealism, such as Wifredo Lam (see fig. 48). A statement by Marcel Duchamp, by then the respected antagonist of rational production, was reproduced in his own handwriting, with a typescript below, in *Instead* 7. Duchamp's *The Chocolate Grinder* was published accompanying Andrea Caffi's "Machine and Myth" in *Instead* 3. Drawings by Max Ernst and by Giacometti (the portrait of Georges Bataille already cited) were included in the same issue. Matta's work appeared occasionally throughout the run of the magazine, sometimes identified tongue-in-cheek as his (as in the frieze of drawings in *Instead* 7 entitled *So I Make Black Balls*, attributed to "Totomat"), and sometimes unsigned—as in the case of four calligraphic, blotlike forms (one of which is illustrated in fig. 49) interspersed throughout "An Open Letter to Jean-Paul Sartre" by Lionel Abel in *Instead* 4.[17]

If these artists were the only ones included in *Instead*, it would be a Surrealist/Existentialist publication, rather than a magazine that may be read retrospectively as bearing the marks of the transition to early Abstract Expressionism. However, the presence of an essay on Gorky by Breton in the first issue links the magazine to those aspects of Surrealism and Existentialism that fused with other factors in the development of Abstract Expressionism. Accompanying the essay was a drawing by Gorky dated 1944. Breton identified the painter (whose work has been viewed as transitional between Surrealism and Abstract Expressionism by scholars such as William Rubin)[18] as one who creates "an entirely new art, one diametrically opposed to everything which fashionable and confusionist tendencies are attempting today to foist upon us as surrealism by limiting themselves to an entirely superficial imitation of its objectives."[19] The contribution of Matta to Abstract Expressionist tendencies, which he probably regrets, should not be overlooked despite the fact that he was not an Abstract Expressionist himself.[20] Matta's acquaintance with Baziotes, whom he met in the Spring of 1941, was particularly instrumental in enabling the American artist to adopt the more abstract imagery generated by automatist techniques, evident in the work by Baziotes which Matta chose to reproduce in *Instead* 1 (see fig. 47).

The inclusion of a work by Baziotes and one by Gorky, however, can hardly justify a characterization of *Instead* as a showcase for developing Abstract Expressionism. Rather, the inclusion of these two artists in a continuum of Surrealist and Existential ideas indicates the route by which some of these ideas entered into the Abstract Expressionists' lexicon and supplies an important part of the context in which they made connections between

ideas and images. Abel commented, for instance, that Gorky was more capable of being influenced by ideas than were many of his colleagues in the art world; he was "more intellectual," as Abel recalled.[21] May Natalie Tabak had a similar recollection:

> The idea of Gorky not knowing anything that was going on was just incomprehensible. He got letters from Europe, he got magazines from Europe. Before a new movement started, by the time the papers, the magazines, could come—even the magazines he couldn't read himself he'd get somebody to read for him—he would know about it. He got everything, he knew everything that was going on. All of us, for about twenty years, knew Gorky on different levels. He was a complicated man.[22]

Gorky's probable early awareness of ideas such as those contained in works like Jean-Paul Sartre's *L'Être et le néant* (1943) is supported by his reputation as a disseminator of information.[23] Gorky fused a Surrealist acceptance of subjectivity with a concern for Existential concepts like "the void" as early as 1931, when he began his Nighttime, Enigma, and Nostalgia series.

Clement Greenberg noted in *The Nation* on 13 July 1946 that American artists did exhibit affinities with the work of writers like Kierkegaard and Heidegger. He attributed any similarities of outlook, however, to environmental factors, rather than to the influence of ideas contained in specific works.[24] Some astute observers saw no influence at all. Herbert Read claimed in 1948 that Existentialism had no complement yet in the visual arts.[25] More recently, however, Irving Sandler has written that "French Existentialist thinking—introduced into America soon after World War II—had replaced Freudian and Jungian dogmas as an intellectual frame of reference."[26] Although, as we are discovering, Freudian and Jungian insights did not flee at the introduction of Existential philosophy, Sandler was right to assert the prevalence of thinking that could be termed Existential. *Instead* was the journal which most emphatically reiterated an Existential point of view, an important element in Abstract Expressionist thought.

Some striking parallels may be drawn, too, between certain aspects of Existential thought and the Abstract Expressionist insistence on personal authenticity. Abel recalls that Sartre's *L'Être et le néant* presented a view of modern man, torn from tradition, as a being uneasy with his lack of spiritual accommodation. Given the number of New York School artists for whom New York was hardly home, it seems to me that, from Pollock to Gorky, from de Kooning to Hedda Sterne, these artists would have understood the character of Sartre's dislocated heroes. One wonders, too, if this lack of spiritual accommodation is at the root of the "homeless representation" Clement Greenberg ascribed to color field painting in the sixties.[27]

Abel believed that, since to Sartre nothing is forbidden, modern man

must decide for himself what is to be permitted and what is not. Such a stance was explained as the position of the Marquis de Sade by Maurice Blanchot in *Instead* 5/6. Social and personal freedom would only be reached when each individual did as he or she pleases, according to Sade, subject to no law but his or her own pleasure.[28] Abel saw Sartre's modern man as one who is pleased by all kinds of painting, but only to a limited extent; every great work of art suggests to him a deliverance from his state as a modern man, but each suggests a different route, and he can not decide among them.[29] This characterization of modern man has been used as a model to describe Gorky's hegira from style to style, from master to master, from Picasso through Miró to Kandinsky throughout the thirties and early forties.[30] This journey, according to most interpretations of Gorky's career, ended in 1944 with the realization of paintings like *The Liver Is the Cock's Comb*. It enabled him to meld automatism and allusions to his own psychology, and personal experience to a conception of pictorial space based on the example of modern masters rather than traditional perspective. Gorky's "choice" has been seen as an instance not only of the synthesis of seeming opposites, but also of his commitment in the Existential sense to a style that he evolved for his own needs (rather than by allying himself with a "master"). Thus he has been seen as an early example of an Existential hero, one related to attitudes espoused in *Instead*, such as that ascribed above by Abel to Sartre.[31]

Although among Abstract Expressionists Gorky, Baziotes, and de Kooning may display the most obviously Existential overtones in their painting and their statements, they are not alone in their commitment to the search for a style whose characteristics were derived from immediate, spontaneous decisions rather than from reliance on learned procedures.[32] Robert Motherwell has stated that for him the process of painting included what he referred to as "the mode of discovery," which "represents my deepest painting problem, the bitterest struggle I have ever undertaken: to reject everything I do not feel and believe." Later in the same discourse, he said that he had to invent his own subject matter.[33] Also exemplifying Sartre's emphasis on both the personal (or voluntary) and the moral aspects of commitment, Clyfford Still has stated that as a group, American painters like himself "are not committed to an unqualified act, not illustrating outworn myths or contemporary alibis. One must accept total responsibility for what he executes. And the measure of his greatness will be in the depth of his insight and his courage in realizing his own vision."[34]

For American artists in the late forties, magazines like *Instead* provided a valuable source of information about the development of French Existentialism, a movement that articulated concerns much like their own. Most American artists may not have had direct contact with the sporadically

translated Existential philosophers, but they were surely informed through the conversation and writing of Americans publishing in avant-garde periodicals. The topic of the connections between Existentialism and Abstract Expressionism demands a larger scope than it can be given in this study, but it is important to note that *Instead* played a role in the integration of that set of concepts into American thought.

5

Modern Artists in America: "Form Is Content, That's It"

According to advance publicity from Wittenborn and Schultz, Inc., *Modern Artists in America* was the first biennial publication documenting contemporary art in the United States. The "First Series," as this first (and, as it turned out, only) issue of the publication was called, was edited by three men: Robert Motherwell, painter and editor of Wittenborn and Schultz's "The Documents of Modern Art" series; Ad Reinhardt, painter and then assistant professor of Art at Brooklyn College; and Bernard Karpel, librarian of the Museum of Modern Art. The intent of the publication, issued in 1951, was to cover the art events of the previous two seasons, that is, 1949–50 and 1950–51.[1]

The cover design of *Modern Artists in America* (see fig. 52), as well as the publicity for the magazine, was done by Motherwell.[2] A brief statement of purpose by Karpel and a summary of the magazine's contents occupies the endpapers. The frontispiece, a photograph by Aaron Siskind of a natural rock formation (see fig. 53), clearly signals the documentary, material nature of the magazine's approach. All of the other magazines in this survey also published photographs such as Mildred Tolbert's evocative and formally acute *Rainy Day, New York City* (see fig. 17) in *Iconograph*. But Siskind's determined materiality coupled with anthropomorphism in a flattened field separated it from most other photography in these periodicals.[3]

The two "Special Features" are the most widely quoted sections of *Modern Artists*. "Artists' Sessions at Studio 35 (1950)," edited by Robert Goodnough, is introduced by several paragraphs written jointly by Reinhardt and Motherwell, Karpel recalls. They describe the evolution of the "Studio 35" evenings out of those begun as a part of the program of the "small cooperative school in Greenwich Village" (the Subjects of the Artists School) started in the late fall of 1948 by William Baziotes, Robert Motherwell, Mark Rothko, and David Hare, later joined by Barnett Newman. (Clyfford Still had been in on the planning stage, but withdrew

before the school opened.) Moderators Alfred Barr, Richard Lippold, and Robert Motherwell each directed one day of the three-day "Artists' Sessions at Studio 35 (1950)," discussions including the following artists: William Baziotes, Janice Biala, Louise Bourgeois, James Brooks, Willem de Kooning, Jimmy Ernst, Herbert Ferber, Adolph Gottlieb, Peter Grippe, David Hare, Hans Hofmann, Weldon Kees, Ibram Lassaw, Norman Lewis, Seymour Lipton, Barnett Newman, Richard Pousette-Dart, Ad Reinhardt, Ralph Rosenborg, Theodoros Stamos, Hedda Sterne, David Smith, and Bradley Walker Tomlin (see fig. 54). Discussion centered around issues such as the identity of the group of participating artists, the creative process and the question of quality, titling and signing works, and the problem of content, subject, and meaning.

The "Western Round Table on Modern Art (1949)," edited by Douglas MacAgy, then director of the California School of Fine Arts, was solicited and introduced by Bernard Karpel. Described in the first mailer of advance publicity in 1951 as "a dissection of contemporary issues by a representative cross-section of our cultural elite," it included discussion by George Boas, Robert Goldwater, Marcel Duchamp, Alfred Frankenstein, Andrew Ritchie, Mark Tobey, Frank Lloyd Wright, Arnold Schoenberg, Darius Milhaud, Kenneth Burke, and Gregory Bateson. The only selection in *Modern Artists* to deal with subjects other than the visual arts themselves, the "Western Round Table" nevertheless centered about issues of direct concern to painters and sculptors. The agenda established at the outset was intended to stimulate the discussants' interchange of opinions on the cultural setting, including issues of communication and primitivism, the roles of art and the artist in our culture, and the functions of the critic, the collector, and the museum.

Following this are reproductions of painting (such as a painting, fig. 55, from Hedda Sterne's Machine series) and sculpture (such as Ibram Lassaw's *Milky Way,* fig. 56) from the 1949–50 and 1950–51 seasons, selected and introduced by Motherwell and Reinhardt. A list of exhibitions of artists in New York Galleries, 1949–50, compiled by Bernard Karpel, is followed by an essay by Michel Seuphor on the relation between New York and Paris in 1951, introduced by Karpel. The impetus for the inclusion of a group of photographs from the Louise and Walter Arensberg Collection in its home setting also came from Karpel, who was then very much interested in American art and its sponsorship. (He projected a section on the Société Anonyme in the second series.)

A selected list of "Modern Works of Art" added to American public collections between Fall 1949 and Winter 1950 is then followed by a vivid and informative selection of excerpts from catalogues, books, articles, and reviews, dating from 1946. (With only a few exceptions, these sections have not been indexed in the present book.) Compiled by Karpel, the immediacy

and succinctness of this method of sketching the art world of the later forties demonstrates the strength of the documentary approach. Also included through the intervention of Karpel was the section on "Painters and Poets in Barcelona: Dau Al Set," a group of Spanish artists including Antoni Tàpies (see fig. 57) Karpel knew about from his research for a projected exhibition at the Museum of Modern Art.[4] Through Wittenborn, Karpel arranged to exchange Spanish for American titles in order to build up MOMA's collection in that area. The impressive selected bibliography to art publications of 1949 and 1950 as well as the index to that section and to the biennial itself are also by Karpel, who emerges as the unsung hero of *Modern Artists in America.*

Modern Artists in America, like *Possibilities,* was published by Wittenborn and Schultz. Also like the earlier publication, *Modern Artists in America* came out only once and had as one of its editors the multitalented Robert Motherwell. Motherwell described the relationship between the two publications this way: *"Possibilities* was meant to be an avant-garde magazine, as opposed to *Modern Artists in America,* which was supposed to be an almanac of Modern Art."[5]

Motherwell's belief in presenting data—facts and objects—without a structure that links them in a narrative or hierarchical way has been commented on in the chapter on *Possibilities.* Unlike that magazine, *Modern Artists* focuses only on painting and sculpture, without including music, literature, or architecture. Within that more limited focus, however, there is an attempt to be more inclusive—an urge to collect specimens, like a museum. In the almost obsessive number of reproductions of art and in the meticulous bibliography, there is a suggestion that possession of the facts at some point yields command of the ideas involved, and of the scene.

This aspect of the direction of *Modern Artists in America* corresponds to Motherwell's sensibility, described in chapter 3. However, it also reflects the core of Ad Reinhardt's philosophy that "form is content, that's it."[6] This attitude led to a reportorial, noninterpretative presentation of material such as we see in *Modern Artists in America.* Such a proffering of the naked object or event, unadorned with justificatory prose, contextual setting, or explanatory notes, is understandable in the context of Motherwell's Dada-derived understanding of the principle of collage; but it also may have been justified in Reinhardt's view on the grounds that possession of the *form* of something is also possession of its meaning.

It is important to grasp the differences in Motherwell's and Reinhardt's philosophies because they represent two contrary trends within Abstract Expressionism—trends that eventually lead to approaches as different as Allan Kaprow's and Frank Stella's. Apropos of the absence of comment on the many paintings and sculptures reproduced in *Modern Artists,* as well as the distinct absence of the interdisciplinary approach of the other

avant-garde magazines (notably *Possibilities*), one might consider that in Reinhardt's view "Nothing louses up a painter so much as the presence of a poet's appreciation except perhaps a musician's or an architect's."[7]

Yet in regard to both his and Reinhardt's selections in this publication Motherwell has called attention to the fact that "Everything we did is part of 'modernism' in its widest sense, which is still narrower than all contemporary art-making, and was much more narrow then."[8] The fact that Motherwell and Reinhardt could agree that verbal explication and organization were unnecessary, despite the fact that this judgment emerged from otherwise opposing sets of convictions, demonstrates the breadth that the term "modernism" still maintained in 1951.

Reinhardt's belief that form encompasses content may also explain the willingness with which he and Motherwell shared their editorial decisions with Bernard Karpel (who, as we have seen, gave them access to an impressive collection of objects and facts). In Karpel's foreword on the endpapers, he distinguished between "modern" and "contemporary" art:

> *Modern Artists in America* is the first biennial to document modern art in the United States. Since it is not concerned with all contemporary art, but only with what is specifically modern, this means an anthology which is both critical and selective. In as compact and objective a manner as the situation permits, illustrations and text are designed to convey *the sense of modern art as it happens.*

Although *Modern Artists* was documentary in approach and encyclopedic in intent, these intentions operated in a circumscribed area: as Karpel points out above, an effort was made to be "critical and selective" by limiting the area surveyed to the "specifically modern." And within this focus yet another bias was operative. As S. Lane Faison wrote in a review of *Modern Artists*, "The editors . . . freely admit there is 'perhaps too much of the non-figurative' in their selections."[9] Bernard Karpel has amplified his statement, saying that his feeling, upon seeing the galleries, the museums, and the literature, was "that there was a 'yesterday' inside and a 'now' outside" those traditional repositories of information about art. "Maybe an improving, more acute, wider almanac would be more relevant in respect to 'tomorrow' and my documentation more direct, more honest about the American scene; less origins, more sequences; less verbal, more visual."

A "Statement" signed by all of the editors was presented on page 6 of *Modern Artists*. It acknowledges Karpel's role as an editor more accurately than does the title page, which lists Reinhardt and Motherwell as associate editors and Karpel as responsible only for documentation. As we have seen, Karpel was responsible for the inclusion of considerably more than the extensive inventory of international art publications for 1949–50. According to Karpel, the first paragraph of the "Statement" was written by

Reinhardt, the second by Motherwell, and the third by himself. It was approved by all three editors. Of the inception of the magazine, Robert Motherwell commented:

> It was my idea, but Ad understood it perfectly; it was a straight collaboration between him and me. Reinhardt felt as strongly as I did that art magazines didn't show what was going on in New York—that's how we decided to do *Modern Artists in America*, which would simply be an art annual of modernism, and nothing else. If you think of it that way, the contents make total sense—if you think that you're trying to record, within a given space, what seems really significant in the art world in that particular year in America. What we would like to have done was to have an art annual every year.[10]

It has been suggested that *Modern Artists* came about as the result of the kind of dissatisfaction that stimulated the group called the "Irascibles" (Motherwell and Reinhardt among them) to protest the conservatism of the Metropolitan Museum's competitive exhibition of American painting and sculpture that opened in December of 1950.[11] While this confrontation may have initiated events like the publication of *Modern Artists*, it is important to see that both the Irascibles' protest and *Modern Artists* were involved in the controversy surrounding "modern" art as opposed to art that is merely contemporary, as Karpel distinguished them from one another in the endpapers of *Modern Artists* and in his "Objectives in Bibliography."

In the years around 1950, the connotations of the word "modern" were hotly debated. The preference for "nonfigurative" art implicit in *Modern Artists'* decision to concentrate on the specifically "modern" was questioned in Boston, for instance, by James S. Plaut, director of the Institute of Modern Art there. He defended the change of the name of the museum from "Modern" to "Contemporary," reasoning that to the public, the word "modern" had connotations of obscurity and negativity. For Plaut, at least, the term "modern" meant something quite different than did a term like "contemporary." As Serge Guilbaut has demonstrated, by the later forties, the words "modern" and "contemporary" were caught in the fray of cold-war politics. For the average man, "modernism" was akin to communism and totalitarianism despite the fact that it was largely promoted in the United States by a right-wing elite.[12] The word's polarizing effect is indicated by David Sylvester's comment in *The Nation* in 1950 that Clement Greenberg's restriction of the term "modern" to painting of the Cubist order was dictatorial.[13] Although Plaut's efforts to establish a more pluralistic situation in Boston failed to function as the corrective he had intended it to be (instead it had the effect of casting his institution as a supporter of reactionary taste), it did dramatize the distinction between *the forms* (mimetic or abstract) in which people were willing to admit extra-aesthetic considerations into the judgment of art.

In his essay, "Objectives in Bibliography," Bernard Karpel indicated emphatically that for him, the problem of collecting data, such as that represented by the choices of modern (i.e., abstract) art in *Modern Artists in America,* was "not solely one of harvesting an abundance of mixed value, but to prune this growth so that it is not choked by its own profusion," and thereby to "impose upon the sensation of fact a pattern of significance. In this sense," he continued, "a reasoned bibliography of the arts approaches the objective of the art museum itself." In a sentence that resonates harmoniously with Robert Motherwell's sentiments, he observes that "it would seem that this fruitful objective rejects the mechanistic reportage of each physical datum in favor of the emotional evaluation of meaningful relations. In short, the abandonment of realism and the acceptance of abstraction." In the debate over whether modernism was repressive or liberating, Karpel espoused the latter view: "We recognize that an inventory of the facts," he wrote, "predicates a conviction of what is valid. Can it be amiss to say that, as in art itself, the act of choice is a moral one?"[14]

In his stated goal of employing "the objective of the art museum" to compile a bibliography of modernism, Karpel approached Greenberg's retrospective definition of modernism, forumulated in his article "Modernist Painting" of 1965 but operative in his criticism since 1940. It described a stance that found widespread acceptance among some advanced artists and which, as we shall see, does describe one admitted bias of the editors of *Modern Artists in America.* "The essence of Modernism lies," wrote Greenberg, "in the use of the characteristic methods of a discipline to criticize the discipline itself."[15] In a subsequent essay, Greenberg clarified the implementation of this principle for the artist:

> The superior artist acquires his ambition from, among other things, the experience of his taste, his own taste. No artist is known—at least not where the evidence is clear enough—to have arrived at important art without having effectively assimilated the best new art of the moment, or moments, just before his own. Only as he grasps the expanded expectations created by this best new art does he become able to surprise and challenge them in his own turn.[16]

In believing that the presentation of an impressive quantity of selected material, organized in an accessible way (with two indexes) was the best way to place modernism before the public, the editors of *Modern Artists in America* embodied the approach "form is content." Credit for articulating the refusal of modernist art to grant nonart factors a place in its interpretation as expressed in the existence of a document like *Modern Artists in America* must go to Ad Reinhardt as well as to Karpel. In his comments at the "Artists' Sessions at Studio 35," in the pages of *Modern Artists,* he asserted his skepticism about meanings outside the object, in this case,

painting. Painting, says Reinhardt, is its own subject, a self-contained entity:

> I don't understand, in a painting, the love of anything except the love of painting itself. If there is agony, other than the agony of painting, I don't know exactly what kind of agony that would be.[17]

In a discussion of subject matter, Reinhardt's comments indicated his inability, as early as 1950, to conceive of subject apart from form:

> We could discuss the question of the rational or intuitional. That might bring in subject matter or content. We have forms in common. We have cut out a great deal. We have eliminated the naturalistic, and among other things, the super-realistic and the immediately political.[18]

In its emphatic expression of this philosophic system, as well as in its richness as a source for "modern" painting and sculpture in the years in the center of the twentieth century, *Modern Artists* is distinctive.

Conclusion

I was originally attracted to this material because I believed that the subject matter of Abstract Expressionism would become more apparent when its context in these magazines was taken into account. I was not mistaken. Read in the light of interests spelled out in their statements and the contexts supplied—and denied—in these periodicals, the Abstract Expressionists' work, as well as that of other members of the New York School, may be developed in a broader context than that suggested by early promulgators. It is possible to claim that the relatively consistent choices of theme and structure by artists such as Robert Motherwell, Barnett Newman, and their colleagues amounted to a theory of Abstract Expressionism, even though these artists energetically denied such a formulation of their practices. In fact, however, that very denial may be seen as a signal portion of Abstract Expressionism's theory. It is clear that each of the magazines considered in this study responded to particular experiences, contacts, insights, and theories developed by its editors; and that each encouraged, chose, and rejected contributors on that basis.

Seeing the contributions that each magazine made to Abstract Expressionism, however, was also the beginning for me of seeing the tendencies foregone. The view of those roads not taken, which may be glimpsed in these periodicals from Abstract Expressionism's formative years, was also responsible for my decision to present the preceding material in this form (essays on each periodical as well as sample reprints and an index). This material provides one method of access to divergent directions subsequently weeded out of the dominant aesthetic in the West at mid-century. In the introduction I mentioned the rejection of Realism, Geometric Abstraction, and Surrealism; but I would include also in the list of ineligibles such media as photography, "craft" approaches including clay and fiber arts, most sculpture, and (not coincidentally) all production in any media by those who were not European American males.

Work that was not given a place *as such* in the much-debated but highly vaunted designation "Abstract Expressionism," however, may be also

found in these periodicals (as well as in some others not treated in this study, such as *Critique* and *trans/formation*). The presence of work later screened from the mainstream, work by those whose identities or subjects, perhaps, did not demonstrate the requisite purity, "authenticity," and therefore "authority," to succeed as Abstract Expressionism is still evident in these journals. I am thinking of the production of women such as Louise Bourgeois and Nell Blaine whose work was considered, in the forties, too eccentric and too restrained, respectively; of works by African Americans such as Norman Lewis, Mexicans like Rufino Tamayo, and Cubans such as Mario Carreño and Wifredo Lam; and of such subjects as family life in the painting of Will Barnet and the continuation of a recognizably Native American idiom as well as the presence of "craftsmanship" in the painting of Robert Barrell. The presence of such work in these artist-run periodicals—these castings-of-nets, these collected ruminations so important to the formation of the Abstract Expressionists' thinking—and its absence in the later estimations of the important American art of mid-century is a larger topic whose exploration is beyond the scope of this investigation and beyond the capabilities, I think, of any one scholar.[1] However, such investigation will proceed more readily if material documenting the contributions of the "disappeareds" is brought to light and made available, alongside the productions of more familiar artists. The remainder of this book is an effort in that direction.

Notes

Introduction

1. For de Kooning's statement, see "Artists' Sessions at Studio 35 (1950)," ed. Robert Good-nough, in *Modern Artists in America* (New York: Wittenborn, Schultz, Inc., 1950), p. 22 (reprinted in Part Two of this volume). See Irving Sandler, *The Triumph of Abstract Expressionism* (New York: Harper and Row, 1970), p. 2, and Philip Pavia, "The Unwanted Title," *It Is* 5 (Spring 1960): 8–11, for more on the origin of the term "Abstract Expressionism." The Club, organized in the fall of 1949 at Ibram Lassaw's studio, was a loose social and aesthetic organization where artists could meet to discuss issues of common interest. They rented a loft on E. 38th St, and from twenty original members they increased in less than a year to over eighty. Irving Sandler, "The Club," *Artforum* 4 (September 1965): 25–26. See also Morton Feldman, "Give My Regards to Eighth St.," *Art in America* 82 (March–April 1971): 96–99, William Barrett, "The Painters' Club," *Commentary* 73 (January 1982): 42–54, and "The Artists' Club," issue of *Artworkers News* 11 (April 1982): 10–11.

2. The positions of Abstract Expressionism's original critics—Greenberg, Hess, and Rosenberg—have been discussed by Donald Kuspit in *Clement Greenberg, Art Critic* (Madison: University of Wisconsin Press, 1979), and Stephen C. Foster in *The Critics of Abstract Expressionism* (Ann Arbor, Mich.: UMI Research Press, 1980). Lawrence Alloway's essays in the mid-sixties, such as "The Biomorphic '40s" and others reprinted in his *Topics in American Art since 1945* (New York: W. W. Norton & Company, Inc., 1975), Irving Sandler's *The Triumph of American Painting* (New York: Harper & Row, 1970), and Dore Ashton's *The New York School, A Cultural Reckoning* (New York: The Viking Press, 1973, published a year earlier in Great Britain as *The Life and Times of the New York School: American Painting in the Twentieth Century*), were some of the earliest and most important revisions of the original estimates investigated by Kuspit and Foster. Subject matter in the New York School has since received special attention, as Barbara Cavaliere and Robert Hobbs noted in "Against a Newer Laocoon," *Arts* 51 (April 1977): 110–17. Recent investigations include such studies as David Anfam's "Clyfford Still" (Ph.D. diss., London: Courtauld Institute, 1984); Anna Chave's *Mark Rothko: Subjects in Abstraction* (New Haven: Yale University Press, 1989), Michael Leja, *Art for Modern Man: New York School Painting and American Culture in the 1940s* (forthcoming, New Haven: Yale University Press), and Stephen Polcari, *Abstract Expressionism and the Modern Experience* (forthcoming, Washington, D.C.: Smithsonian Institution Press).

3. See Lucy Lippard's essay, "As Painting Is to Sculpture: A Changing Ratio," in *American Sculpture of the Sixties*, ed. Maurice Tuchman (Los Angeles County Museum of Art, 1967), p. 31.

4. Wade Saunders, "Touch and Eye: '50s Sculpture," *Art in America* 70 (December 1982): 90–91.

5. As John A. Walker commented, it is important to see that the Abstract Expressionist magazines as well as their Surrealist predecessors not only mirrored but also contributed to the formation of artists' ideas. "Periodicals since 1945," in *The Art Press, Two Centuries of Art Magazines,* ed. Trevor Fawcett and Clive Philpot (London: Victoria and Albert Museum and the Art Book Co., 1976), p. 45. See also Rosalind Krauss, "The Photographic Conditions of Surrealism," *October* 19 (Winter 1981): 15, 17.

6. The politics of Abstract Expressionism have been discussed by Kuspit and Foster, who were preceded by Max Kozloff in "American Painting during the Cold War," *Artforum* 11 (May 1972): 43–54, and Eva Cockcroft in "Abstract Expressionism: Weapon of the Cold War," *Artforum* 12 (June 1974): 39–41. These observations were amplified by Annette Cox in *Art-as-Politics: The Abstract Expressionist Avant-Garde and American Society* (Ann Arbor, Mich.: UMI Research Press, 1983), Serge Guilbaut in *How New York Stole the Idea of Modern Art,* trans. Arthur Goldhammer (Chicago: University of Chicago Press, 1983), by the various authors of the Bell Gallery's *Flying Tigers* exhibition (Providence: Bell Gallery, Brown University, 1985), and by Michael Leja in "The Formation of an Avant-Garde in New York" in *Abstract Expressionism: The Critical Developments,* ed. Michael Auping (New York: Albright-Knox Art Gallery and Abrams, 1987). Its poetics have been outlined, again, by Kuspit and Foster, and further described by the author in "The Rhetoric of Abstract Expressionism," in *Abstract Expressionism: The Critical Developments,* and in "Abstract Expressionism's Evasion of Language" in "New Myths for Old: Redefining Abstract Expressionism," *Art Journal* 47 (Fall 1988): 208–14. For a discussion of these and other developments in Abstract Expressionist literature, see Stephen Polcari's review of the literature, "Abstract Expressionism: 'New and Improved,' " *Art Journal* 47 (Fall 1988): 174–80. Ashton, Sandler, Kuspit, and Foster all discuss Abstract Expressionism's philosophical sources and implications as part of general surveys.

7. I am thinking of studies such as Anne Carnegie Edgerton's "Symbolism and Transformation in the Work of John Graham," *Arts* 60 (March 1986): 60–68; Barbara Cavaliere and Mona Hadler's essays on William Baziotes in *William Baziotes: A Retrospective Exhibition* (Newport Beach: Newport Harbor Art Museum, 1978); Stephen Polcari's "The Intellectual Roots of Abstract Expressionism: Mark Rothko," *Arts* 54 (September 1979): 124–34, and his "The Intellectual Roots of Abstract Expressionism: Clyfford Still," *Art International* 25 (May–June 1982): 18–35; Donald Kuspit's treatments of Rothko and Still reprinted in *The Critic is Artist: The Intentionality of Art* (Ann Arbor, Mich.: UMI Research Press, 1984); W. Jackson Rushing, "The Impact of Nietzsche and Northwest Coast Indian Art on Barnett Newman's Idea of Redemption in the Abstract Sublime," *Art Journal* 47 (Fall 1988): 187–95.

8. See the author's "Abstract Expressionism's Evasion of Language," *Art Journal* 47 (Fall 1988): 208–14.

9. One of the most vivid documents of this period is *The God That Failed,* ed. Richard Crossman (London: Hamish Hamilton, 1950), a series of essays by intellectuals such as Arthur Koestler that chronicles their disillusion with the left and their continued dissatisfaction with the right. See also John Lewis Gaddis, *The United States and the Origins of the Cold War, 1941–1947* (New York: Columbia University Press, 1972), especially chapter 9, "Getting Tough with Russia: The Reorientation of American Policy, 1946," and the comments of James Breslin in *From Modern to Contemporary American Poetry, 1945–1965* (Chicago: The University of Chicago Press, 1984), chapters 1 and 2.

10. In current terms, avant-gardism involves a "struggle over the definition of cultural meaning, the discovery and representation of new audiences, and the development of new strategies to counteract and develop resistance against the tendency of the ideological apparatuses of the culture industry to occupy and control all practices and all spaces of representation." Benjamin Buchloh, "Theorizing the Avant-Garde," *Art in America* 72 (November 1984): 21.

11. See, for instance, the connections developed between political motivations and goals and the art forms of innovators of Cubism, Fauvism, and Futurism by Theda Schapiro in *Painters and Politics* (New York: Elsevier, 1976), especially pp. 9–11, 221– 25. Peter Bürger discusses both of these tendencies, as does Peter Wollen. Peter Bürger, *Theory of the Avant-Garde*, trans. Michael Shaw (Minneapolis: University of Minnesota Press, 1984), and Peter Wollen, "The Two Avant-Gardes," in *Readings and Writings* (London: Verso Editions and NLB, 1982), pp. 92–104. The term "avant-garde," like the term "modernism," has a richer ring of associations that I wish to discuss in the context of this study. For a short discussion of the evolution of the term, see J. T. Harskamp, "Contemporaneity, Modernism, Avant-Garde,"*British Journal of Aesthetics* 20 (Summer 1980): 204–15.

12. Clement Greenberg, "Avant-Garde and Kitsch," *Partisan Review* 6 (Fall 1939): 36. See Fred Orton and Griselda Pollock, "Avant-Gardes and Partisans Reviewed," *Art History* 4 (September 1981): 305–27, for a discussion of the increasingly specific meaning of the term "avant-garde" as Greenberg developed its implications for Abstract Expressionist painting and sculpture. See also Serge Guilbaut, "The New Adventures of the Avant-Garde in America, Greenberg, Pollock, or from Trotskyism to the New Liberalism of the 'Vital Center,' " *October* 15 (Winter 1980): 61–78; and T. J. Clark, "Clement Greenberg's Theory of Art," *Critical Inquiry* 9 (September 1982): 139–56, as well as Orton and Pollock, above, for a discussion of Greenberg in his political and literary milieu.

13. Wendy Steiner, *The Colors of Rhetoric* (Chicago: University of Chicago Press, 1982), p. 189; William Carlos Williams, *Autobiography* (New York: Random House, 1951), p. 148.

14. Steiner, *The Colors of Rhetoric*, p. 191.

15. For the nature of Williams's originality, see Randall Jarrell, "Introduction," trans. Gerald Fitzgerald, *The Selected Poems of William Carlos Williams* (New York: New Directions Books, 1949), p. xvi. The definition of originality which Williams found so persuasive was reinforced for these artists by the impetus of beliefs such as those published by Carl G. Jung. His conviction that "the word 'archaic' means primal, original," expressed in *Modern Man in Search of a Soul*, translated into English in 1933 by Cary F. Baynes, would have made sense to artists maturing in a city where "modernity" was strongly colored by Williams and "the painters" he knew. The desire for a return to origins has been more recently associated with the concept of the avant-garde by Rosalind Krauss in her "The Originality of the Avant-Garde: A Post-Modernist Repetition," in *October* 18 (Fall 1981): 53–54.

16. By the late forties and early fifties, conclusions and speculations drawn from comparisons of the visual and verbal arts had become a significant strategy for determining "meaning." In 1949 Blanche Brown supplied the *College Art Journal* with a list of comparisons between specific paintings or sculptors and literary works, noting that by such conjunctions "one can multiply the aesthetic understanding of the intrinsic values of the work of art itself." ("The Correlation of Literature and the Fine Arts," *College Art Journal* 9 [Winter 1949–50]: 176–80.) Jacques Maritain delivered a series of

lectures at the National Gallery of Art in Washington, D.C., in which he celebrated the common traits of painting and poetry (these were published as *Creative Intuition in Art and Poetry* [Princeton: Princeton University Press, 1953]) and in 1954 Yale University Art Gallery mounted a show demonstrating the correspondence between art and poetry. (See George Heard Hamilton, "Object and Image," in *Art News* 53 [May 1954]: 18–21, 58.) The larger question broached here, however, that of the justification of deriving "meaning" from the conjunction of the arts, is a topic with a long history of its own. Wendy Steiner's *The Colors of Rhetoric* presents a framework for interartistic comparisons in the earlier part of the twentieth century.

17. The books and articles by these authors named here are meant only as a selection, not as a comprehensive list, of the works especially significant for this study. E. A. Carmean and Eliza E. Rathbone, with Thomas Hess, *American Art at Mid-Century, The Subjects of the Artist* (Washington, D.C.: National Gallery of Art, 1978); Anna Chave, *Mark Rothko's Subjects* (Atlanta: High Museum of Art, 1983); Bonnie Clearwater, *Mark Rothko: Works on Paper* (New York: Hudson Hills Press, 1984); Bradford Collins, "The Fundamental Tragedy of the *Elegies to the Spanish Republic*, or Robert Motherwell's Dilemma," *Arts* 59 (September 1984): 94–97; Mary Davis, "The Pictographs of Adolph Gottlieb," *Arts* 52 (March 1977): 141–47; Evan Firestone, "James Joyce and the First Generation New York School," *Arts* 56 (June 1982): 116–21; Ann Gibson, "Regression and Color in Abstract Expressionism: Barnett Newman, Mark Rothko, and Clyfford Still," *Arts* 55 (March 1981): 144–53; Donald Gordon, "Pollock's 'Bird,' " *Art in America* 68 (October 1980): 43–53; Piri Halasz, "Art Criticism (and Art History) in New York: The 1940s vs. the 1980s," Parts 1–3, *Arts* 57 (February–April 1983): 91–97, 64–73, and 80–89, respectively; Robert Carleton Hobbs and Gail Levin, *Abstract Expressionism, the Formative Years* (New York: Whitney Museum of American Art, 1978); Elizabeth Langhorne, "Jackson Pollock's *Moon Woman Cuts the Circle*," *Arts* 53 (March 1979): 128–37; Robert S. Lubar, "Metaphor and Meaning in David Smith's *Jurassic Bird*," *Arts* 59 (September 1984): 78–86; Robert S. Mattison, "The Emperor of China: Symbols of Power and Vulnerability in the Art of Robert Motherwell during the 1940s," *Art International* 25 (November–December 1982): 8–14; Francis O'Connor, "Two Methodologies for the Interpretation of Abstract Expressionism," *Art Journal* 47 (Fall 1988): 222–28; Stephen Polcari, "The Intellectual Roots of Abstract Expressionism: Mark Rothko," *Arts* 54 (September 1979): 124–34; Harry Rand, *Arshile Gorky, The Implications of Symbols* (Montclair, N.J.: Allanheld, Osmun, & Co., 1980); Anne Deirdre Robson, "The Market for Modern Art in New York in the Nineteen Forties and Nineteen Fifties—A Structural and Historical Survey" (Ph.D. diss., London: University College, 1988); William Rubin, "Jackson Pollock and the Modern Tradition," Parts 1–4, *Artforum* 5 (February–May 1967): 14–22, 28–37, 18–31, 28–33, respectively; Martica Sawin, " 'The Third Man,' or Automatism American Style," *Art Journal* 47 (Fall 1988): 181–86; Jeffrey Weiss, "Science and Primitivism: A Fearful Symmetry in the Early New York School," *Arts* 57 (March 1983): 81–87; and Judith Wolfe, "Jungian Aspects of Jackson Pollock's Imagery," *Artforum* 11 (November 1972): 65–73.

18. Frederick Hoffman, Charles Allen, and Carolyn Ulrich, *The Little Magazine: A History and a Bibliography*, 2nd ed. (Princeton: Princeton University Press, 1947).

19. Clement Greenberg, "The Renaissance of the Little Magazine," *Partisan Review* 8 (January–February 1941): 75–76.

20. Lawrence Alloway, "Artists as Writers, Part One: Inside Information," *Artforum* 12 (March 1974): 30–35; Trevor Fawcett and Clive Philpot, eds., *The Art Press, Two Centuries of Art Magazines* (International Conference on Art Periodicals and the Art Press,

Victoria and Albert Museum; London: London Art Book Company, 1976), pp. 45–53. *International Art Periodicals* is forthcoming from Greenwood Press.

21. Anthony Linick, "A History of the American Literary Avant-Garde" (Ph.D. diss., University of California, Los Angeles, 1965), p. 34. In support of this conjecture, Adolph Gottlieb, contributor to *The Tiger's Eye*, said (in comparing Abstract Expressionism with Social Realism): "But the Abstract Expressionist says to the public (more honestly): 'You're stupid. We despise you. We don't want you to like us—or our art.' " Selden Rodman, *Conversations with Artists* (New York: Capricorn Books, 1961), p. 89.

22. Linick, "A History," p. 297.

23. David Hare, interview with the author, 26 January 1982.

Chapter 1

1. At least two Abstract Expressionists, Jackson Pollock and Lee Krasner, probably knew this magazine. At Jackson Pollock's death the Pollock/Lee Krasner Library contained the first and second issues of *Iconograph*. Francis V. O'Connor and Eugene Thaw, *Jackson Pollock*, 4 vols. (New Haven: Yale University Press, 1978), p. 197, n. 4.

2. There is a discussion of this problem in my "Abstract Expressionism's Evasion of Language," *Art Journal* 47 (Fall 1988): 208–14.

3. Howard Daum provided the cat, drawn in india ink on paper; James Dolan drew the letters for this cover of the first issue of *Iconograph*. Howard Daum, telephone interview with the author, 7 October 1988; Robert Barrell, telephone interview with the author, 19 November 1988.

4. Michael Leja, "Art for Modern Man: New York School Painting and American Culture in the 1940s" (Ph.D. diss., Boston: Harvard University, 1988); a revised version is forthcoming from New Haven: Yale University Press.

5. Judith Kaye Reed, "From Law to Art" (review of Lilliam Orloff and Robert Barrell at Bertha Schaefer), *Art Digest* 19 (15 May 1945): 19.

6. Such a study is beyond the scope of the present book, but is the subject of a separate book in progress by the author entitled *Towards a Cultural History of Abstract Expressionism: Race and Gender in the New York School*.

7. The first supplement, *Credo*, was published between the Fall and Winter issues of 1946; the second supplement is smaller than the first and undated. It was probably published, however, before the single issue of the *New Iconograph*. *Iconograph* was subtitled *A Magazine of Art and Literature* by the second issue. Each of the early issues of *Iconograph* was printed in an edition of 500 copies. Collier remembered that the first edition sold 350 copies, and that at its height *Iconograph* had 1,000 subscribers. Oscar Collier, interview with the author, New York, 8 December 1981.

8. As Barrer recalls it, Collier "ran" the magazine, she selected the art, and Beaudoin handled the writing. James Dolan, an industrial designer who worked for Raymond Loewy, designed the first issue.

9. Kenneth Lawrence Beaudoin, "An Autobiographical Note: Kenneth Lawrence Beaudoin, New Orleans, 1942," *Iconograph* 3 (Fall 1946): 11–13; "The People in *Iconograph*," *Iconograph* 1 (Fall 1946): 7. Information about Beaudoin's double identity was derived from interviews with Collier (8 February 1982) and Barrer (23 February

1982), and, more recently, from Beaudoin himself (telephone interview, 11 July 1988). For a perceptive review of Galatea Jones's exhibition, see Creighton Gilbert, "Galatea Jones, Artist of an Unknown Locus," *Critique* 1 (October 1946): 39–44.

10. For an important discussion of the distinctions between the *Iconograph* printed in New Orleans and the one printed in New York, as well as an enthusiastic endorsement of Beaudoin's editorship, see McKinley Boyce, "The *Iconograph* Saga" (Raleigh Springs, Tenn.: Attaturk, 1950), a source most generously brought to my attention by Joel Hoffman. See also Anthony Linick, "A History of the American Literary Avant-Garde" (Ph.D. diss., University of California, Los Angeles, 1965), p. 38; and Kenneth Lawrence Beaudoin, "This Is the Spring of 1946," *Iconograph* 1 (Fall 1946): 7 (reprinted in Part Two of this volume).

11. Beaudoin, ibid., p. 3.

12. Ibid., pp. 3–4.

13. Elizabeth Cowling, "The Eskimos, the American Indians, and the Surrealists," *Art History* 1 (December 1978): 494. Barrer, interview, 23 February 1982. Beaudoin's connections with this group came also through painters in whose work he was interested, such as Sonia Sekula. See his "Six Young Female Painters," *Iconograph* 2 (Summer 1946): 3 (reprinted in Part Two of this volume); and Nancy Foote, "Who Was Sonia Sekula?" *Art in America* 59 (September–October 1971): 73–80.

14. For passages relevant to Beaudoin's ideas, see Edward Sapir, *Language* (New York: Harcourt Brace, 1921), pp. 221–28, and Franz Boas, *Primitive Art* (Cambridge: Harvard University Press, 1928), pp. 140 and 183 ff.

15. Oscar Collier, letter to the author, 19 July 1988.

16. Charles Saunders Peirce, *Collected Papers*, 8 vols. (Cambridge, Mass.: Harvard University Press, 1931–58), 5: 448.

17. Peirce, *Collected Papers*, 3: 362.

18. Howard Daum, telephone interview with the author, 7 October 1988.

19. One might wonder that Beaudoin would find a source for his avant-garde enterprise in a source seemingly so remote as Peirce's philosophy. Yet, as the date of the publication of Peirce's papers (1931–58) demonstrates, there was an interest in his work in the 1930s and 1940s. In 1946 Charles Morris observed that "the strength of C. S. Peirce's version of semiotics lies in part in its ability to handle non-vocal signs, since it does not restrict signs to any specific medium" (*Signs, Language and Behavior* [Chicago: University of Chicago Press, 1946], p. 274). In a review of Morris's book, Ernst Gombrich took him to task for not paying more attention to visual signs, remarking that Morris did not recognize that the emerging discipline of iconology would ultimately do for the image what linguistics had done for the word. In a discussion that recalls Peirce's definition of an icon, Gombrich remarked that an unaided image is unable to signify the distinction between the universal and the particular. The following passage indicates that both Gombrich and Beaudoin were similarly concerned with the possibility of what Beaudoin had called a "symbol-integer" as a common denominator for human understanding. Gombrich wrote: "Linguists have shown that 'iconic' (onomatopoetic) words are 'imitations' of certain sounds, but approximations of the sound, built out of the available 'phonemes' of a given language. Iconology may be able to demonstrate that an image that passes as highly iconic of reality is really less directly related to the object it denotes than it would first appear. It, too, is built out

of some primary noniconic shapes. We may find that it is these elements out of which icons are built, rather than the way in which they are then combined, determining the 'style' or school or period" (Review of Charles Morris's *Signs, Language and Behavior, The Art Bulletin* 31 [March 1949]: 72, 73). I am grateful to Professor Creighton Gilbert for calling my attention to Morris's book and Gombrich's review of it. For a discussion of the idea of the iconic in relation to Abstract Expressionism, see Richard Shiff, "Performing an Appearance: On the Surface of Abstract Expressionism," pp. 98–100, 102–9, 111, 113–16; and the author's "The Rhetoric of Abstract Expressionism," pp. 65, 72, 74–77, 84–85, 89 n. 25, in *Abstract Expressionism: The Critical Developments,* ed. Michael Auping (New York: Abrams and the Albright-Knox Gallery, 1987).

20. James Dolan, "Typography," *Iconograph* 1 (Spring 1946): 10 (reprinted in Part Two of this volume).

21. Kenneth Baker has suggested that the ideographic quality in Pollock's "psychoanalytic drawings," in which the painter drew a grammar of unconscious forms, resulted not only from the attempt to draw what he did not know but also from a conviction that there is a notational character inherent in all drawing. Kenneth Baker, "Reckoning with Notation: The Drawings of Pollock, Newman, and Louis," *Artforum* 18 (Summer 1980): 33–34.

22. Harriet Janis and Rudi Blesh, *De Kooning* (New York: Grove Press, 1960), pp. 16–17; Paul Cummings, "The Drawings of Willem de Kooning" in *Willem de Kooning* (New York: The Whitney Museum of American Art in association with Prestel Verlag and W. W. Norton Company, 1983), p. 12.

23. Gertrude Barrer, interview with the author, 23 February 1982.

24. Gertrude Barrer, telephone interview with the author, 20 December 1981.

25. For a description and illustrations of Gorky's codification of images in *The Water of the Flowery Mill,* see Harry Rand, *Arshile Gorky, the Implication of Symbols* (Montclair, New Jersey: Allanheld, Osmun & Co., Inc., Publishers, 1980), pp. 92–97.

26. In 1949 Meyer Schapiro, friend and mentor to a number of New York School artists, said that the privacy of the symbolism of much modern painting is valuable "precisely because the symbols are *not* completely legible." Their lack of intelligibility, he explained, made them more personal to each observer, communicating an authenticity, a feeling that "this artist is genuine." "A *Life* Round Table on Modern Art," *Life* (11 October 1948): 76.

27. Beaudoin, "This Is the Spring," p. 3 (reprinted in Part Two of this volume).

28. Russell, an artist known for his witty and incisive characterizations as well as for his occasional abrasiveness, had a large circle of acquaintances. He took his M.A. at Columbia under Meyer Schapiro, was a printmaker as well as a painter, and worked at Atelier 17, run by Stanley William Hayter, who, two years later, was to guest edit a graphic issue of *The Tiger's Eye.* Oscar Collier, interview with the author, 8 December 1981; Barrer, interview, 2 February 1982; Charles Seliger, interview with the author, 18 December 1981.

29. Alfred Russell, "The Twittering Machine of the Future," *Iconograph* 2 (Summer 1946): 25 (reprinted in Part Two of this volume). In 1941, a Paul Klee exhibition was held at the Museum of Modern Art. By 1945 there was still a great deal of interest in Klee's work. Alfred Barr's *Paul Klee,* which had accompanied the MOMA show, was reprinted that year. In 1944, Klee was exhibited as one of "The Blue Four" at the Buchholz Gallery.

"Klee was a big influence," recalled Howard Daum of his associates at *Iconograph*; "I was very much influenced by Paul Klee, too—the idea of taking a line for a walk. But the real thing was the figure and ground as one." Interview with the author, 7 October 1988.

30. "Artists' Sessions at Studio 35 (1950)," *Modern Artists in America* 1 (New York: Wittenborn, Schultz, Inc., 1951), p. 12 (reprinted in Part Two of this volume).

31. Russell, "The Twittering Machine of the Future," p. 26 (reprinted in Part Two of this volume).

32. Charles Seliger (a painter who showed at Peggy Guggenheim's Art of This Century Gallery and who later married Ruth Lewin, a contributor to *Iconograph* who attended the Art Students League and was one of Beaudoin's Gallery Neuf artists) remembers the magazine as one whose direction was determined by an interest in Northwest Coast Indian Art. Painter Will Barnet, an instructor at the Art Students League at the time *Iconograph* contributors Barrer and Collier, Howard Daum, and Carl Ashby were students there, characterized *Iconograph* as a magazine whose direction was roughly parallel to his. Although Barnet's work was more figurative and expressionistic at the time than that of many *Iconograph* contributors, he recalls that the artists whose work was reproduced in *Iconongraph* were all, as he was, interested in Northwest Coast Indian Art. Seliger, interview, 18 December 1981; Will Barnet, interview with the author, 18 February 1982.

33. This is a subject about which much continues to be written. See Kirk Varnedoe, "Abstract Expressionism," pp. 615–59 in *"Primitivism" in 20th Century Art*, vol. 2, ed. William Rubin (New York: Museum of Modern Art, 1984); W. Jackson Rushing, "Ritual and Myth: Native American Culture and Abstract Expressionism," in *The Spiritual in Art: Abstract Painting, 1890–1985*, ed. Maurice Tuchman (New York and Los Angeles: Abbeville Press and the Los Angeles County Museum of Art, 1985), pp. 273–95, and his "The Impact of Nietzsche and Northwest Coast Indian Art on Barnett Newman's Idea of Redemption in the Abstract Sublime," *Art Journal* 47 (Fall 1988): 187–95; and Michael Leja, *Art for Modern Man* (New Haven: Yale University Press, forthcoming).

34. David Loshak (editor of *Critique*), letter to the author, 23 January 1982.

35. Beaudoin, "An Autobiographical Note," p. 13. Wifredo Lam's work was reproduced in *Instead*. Paalen's work appeared in the magazine he edited, *Dyn*, published in Mexico but available in New York.

36. Kenneth Beaudoin, "Oscar Collier: A Study in Pictorial Metaphor," *Iconograph* 3 (Fall 1946): 18.

37. Collier remembered that his first acquaintance with a Northwest Coast Indian-derived style came with his meeting Robert Barrell in 1945. Howard Daum told Collier that Barrell "really had it." Collier recalled being so impressed with Barrell, who was painting in a style derived from Northwest Coast Indians, that he contracted then to take lessons from him. To the best of his understanding, recalls Collier, Barrell owed his ideas about the use of Northwest Coast art to painter Steve Wheeler, whose observation of Klee helped him to see how much was to be gained from a close study of primitive art (Collier, interview, 8 December 1981). Collier gives Barrell the credit for *Iconograph*'s focus on Northwest Coast Indian inspiration (Collier, interview, 21 June 1982). Collier's own statement that Barrell was influenced by Wheeler, however, mitigates Barrell's intense exposure to Northwest Coast art in 1939 and 1940 at the Museum of Natural History. It also runs counter to Wheeler's insistence that he was not influenced by Northwest Coast art at all. Wheeler claims that he noticed a similarity between the art of that culture

and his own only after his work assumed its mature form, citing the similarity as an example of a bond between the ages. (Steve Wheeler, interview with the author, 11 March 1982.)

38. Will Barnet had admired Northwest Coast art since his frequent childhood exposures to it at The Peabody Museum in Salem, Massachusetts. Will Barnet, interview with the author, 23 February 1982.

39. Daum later regretted coining the term, because it reductively implied that "Indian" art was the sole reference for their efforts. "We were influenced by many sources. Miró, for instance, was influenced by Indian petroglyphs—these are in the twelfth volume of the Bureau of Ethnology's *Annual Report*" (which Daum owned). "We dealt with automatism, too," he remembered, as well as with American Indian art and the art of the South Seas. "We were working not just with structure but also with design. Cézanne was our model for structure; Van Gogh for design. Picasso used both." Howard Daum, telephone interview with the author, 7 October 1988.

40. Barnet, interview, 18 February 1982. Barnet taught at the Art Students League from 1936–78.

41. Ruben Kadish, interview with the author, 21 January 1982; letter to the author, August 1988.

42. Peter Busa, telephone interview with the author, 3 March 1982.

43. Collier, interview, 8 December 1981.

44. For more on "Indian Space" see the author's "Painting Outside the Paradigm: Indian Space," *Arts* 57 (February 1983): 98–102. Robert Barrell, interview with the author, 16 June 1982.

45. Melvin Lader, "Peggy Guggenheim's Art of This Century and the Surrealist Milieu in America 1942–1947" (Ph.D. diss., University of Delaware, 1981).

46. Collier, interview, 8 December 1981.

47. Barr, Barrer recalled, liked her own work well enough to ask her to exhibit it at the Museum of Modern Art. However, his assistant Dorothy Miller vetoed his suggestion. Barrer, interview, 2 April 1982.

48. Collier, telephone interview, 21 June 1982. Betty Parsons took over from Peggy Guggenheim a number of her artists, including Pollock, Rothko, and Still, when Guggenheim went to Venice to live in 1947. Dore Ashton, *The New York School* (New York: Viking Books, 1972), p. 170.

49. Writers have struggled from the start to find an appropriate description for this work. Five of the painters whose first inclusion in *Iconograph* occurs in the fourth issue (Kamrowski, Pollock, Rothko, Hayter, and Hare) are classified as "American Surrealist Painters" in Sidney Janis's *Abstract and Surrealist Art in America,* published in 1944 (New York: Reynal and Hitchcock). David Hare remembers that Janis would ask the artists he knew about how they would characterize their work; the categories employed in *Abstract and Surrealist Art in America* are the result of these collected observations (David Hare, interview with the author, New York, 18 January 1982). By 1950, Andrew Carnduff Ritchie, in *Abstract Painting and Sculpture in America* (New York: Museum of Modern Art, 1951), characterized nearly the same group as "Expressionist Biomorphic," with, however, the inclusion of Charles Seliger, who also made his first appearance in the fourth issue of *Iconograph,* and Theodoros Stamos, who was included in *Iconograph* 1.

50. Reproduced in *Iconograph* 4 (Winter 1946): 28.

51. Rothko's *Gethsemane* (1946) (not the same painting as the one reproduced with that title in Diane Waldman, *Mark Rothko* [New York: Solomon R. Guggenheim Museum, 1978], p. 65) was reproduced in the same issue of *Iconograph* as Barrer's *Illuminato*.

52. Mark Rothko, "Personal Statement" in *A Painting Prophecy—1950* (Washington, D.C.: David Porter Gallery, 1945), n.p.

53. Barrer, telephone interview, 20 December 1981.

Chapter 2

1. Ruth Stephan, "If the Pen Is Mightier," *The Tiger's Eye* 3 (March 1948): 75 (reprinted in part two of this volume); all statements about *The Tiger's Eye* unless noted otherwise, are from personal interviews with John Stephan in Newport, Rhode Island, 15 August 1980 and 10 August 1981.

2. John Stephan, "The Intention of *The Tiger's Eye*," *The Tiger's Eye* 1 (October 1947): 53 (reprinted in Part Two of this volume).

3. John Stephan, telephone interview with the author, 25 August 1988.

4. Herbert Ferber to Ruth and John Stephan, 20 April 1948. *The Tiger's Eye* papers, Beinecke Rare Book and Manuscript Collection, Yale University, New Haven, Connecticut.

5. Some of the colleges and universities that subscribed to *The Tiger's Eye* were Columbia, Black Mountain College, Boston University, California School of Fine Arts, and Carnegie Institute of Technology. (*The Tiger's Eye* papers, Beinecke.) Artists in New York as well as those in other centers read *The Tiger's Eye*. As recently as 1985, New York-based painter James Brooks still had six of the nine original issues. James Brooks, interview with the author, 15 June 1985. San Francisco painter Frank Lobdell, who attended the California School of Fine Arts from 1947–50, remembers the magazine as an important link with what was going on outside San Francisco. Frank Lobdell, interview with the author, 22 March 1985.

6. Anthony Linick, "A History of the American Literary Avant-Garde" (Ph.D. diss., University of California, Los Angeles, 1965), p. 53.

7. Ibid.

8. Stephen Foster, *The Critics of Abstract Expressionism* (Ann Arbor, Mich.: UMI Research Press, 1980), p. 45.

9. Allan Swallow, *An Editor's Essays of Two Decades* (Seattle and Denver: Experiment Press, 1962), pp. 253–54. John Stephan remembered that "a lot of the artists thought the magazine was too casual in its choice of artists." John Stephan, telephone interview, 12 September 1988.

10. Robert Motherwell, telephone interview with the author, 13 April 1982.

11. Peter Grippe, interview with the author, Orient, Long Island, 20 February 1982.

12. John Stephan, telephone interview with the author, 25 August 1988.

13. Sculptor Louise Bourgeois, for example, recalls the *Partisan Review* as "the bible" in her household. Interview with the author, 18 April 1982. James Brooks had over fifty copies. Interview, 15 June 1985.

14. Steve Wheeler, interview with the author, 11 March 1982.

15. Frederick Hoffman, Charles Allen, and Carolyn Ulrich, *The Little Magazine, A History and a Bibliography,* 2nd ed. (Princeton: Princeton University Press, 1947), pp. 166–69, 210, 353. Greenberg's idea of the operation and effect of culture—the idea he expressed in "Avant-Garde and Kitsch" that the avant-garde is a social and artistic principle that "keeps culture moving"—was actually quite similar to Eliot's. Greenberg differed from Eliot, however, in his estimation of the source of culture's authority. In the summer of 1944, Greenberg (along with R. P. Blackmur, William Phillips, and I. A. Richards) contributed essays to a special section in the *Partisan Review* entitled "Mr. Eliot's Notions of Culture." Eliot believed that although culture eludes definition, it is mankind's "spiritual soil.""The greatest achievements of the imagination, religious and artistic, have the firmest roots," Eliot wrote, "And if we can keep our minds clear, on the subject of culture, between the essential and the accidental, the permanent and the transitory, the true and the false—an effort requiring fresh judgements and decisions in constantly changing situations [the avant-garde 'keeps culture moving']—we shall be both the most wisely conservative and the most radically revolutionary, because we shall be working for those changes which really matter, instead of those which are merely speculation" ("Towards a Definition of Culture," *Partisan Review* 11 [Spring 1944]: 156–57). Greenberg took issue, not with this description of the function or value of culture, but with Eliot's judgment that culture's basis is religion. To Greenberg, "a new or revived total culture of the future is likely to diminish still further the importance of religion." If Socialism were to provide leisure with economic security to most people, Greenberg observed, many more of them would discover religion. For Greenberg, religion was more a function of leisure than it was a determinant of ideology. Under Capitalism, however, future culture would be determined by movies, comic books, Tin Pan Alley, Luce publications, Coca Cola, rayon stockings, class interests, and a common boss. These are compatible with religion, Greenberg noted, but not with Socialism ("Mr. Eliot's Notions of Culture," *Partisan Review* 11 [Summer 1944]: 306–7).

 Although Greenberg here emphasized a distinction between his and Eliot's ideas of culture, in "T. S. Eliot: A Book Review" (1950), the Eliot essay he chose to include in *Art and Culture,* he wrote that Eliot's use of "scientific method" enabled him to "cast [more] light" than other critics. Significantly, Greenberg preferred Eliot's early "pure" poetry and criticism, which he [Greenberg] judged to have been influenced by Roger Fry and Clive Bell, to his later work, done "when he stops being a 'pure' critic." *Art and Culture* (Boston: Beacon Press, 1961), pp. 239–41.

16. Max I. Baym, *A History of Literary Aesthetics in America* (New York: Frederick Ungar Publishing Co., 1973), p. 246.

17. "Selections from a Poet's Reading Diary and Sketchbooks," *The Tiger's Eye* 1 (Fall 1947): 21–35. As Dickran and Ann Tashjian have observed, by the 1930s the Imagist impulse in Williams's poetry and in Harriet Monroe's *Poetry* magazine (the locus, as noted below, of *Tiger's Eye* editor Ruth Stephan's literary orientation) had metamorphosed into "Objectivist" verse. "Objectivist" verse was a fusion of Imagism and Cubism described by the Tashjians in *William Carlos Williams and the American Scene, 1920–1940* (New York: Whitney Museum of American Art, 1978), pp. 83–84. For further discussion of Williams's adaptation of Imagism, see Rick Stewart, "Charles Sheeler, William Carlos Williams, and Precisionism: A Redefinition," *Arts* 58 (November 1983): 100–114.

18. Linick, "A History," pp. 15 and 70; William Carlos Williams, *Autobiography* (New York: Random House, 1951), pp. 264–65.

19. Harriet Monroe, "Looking Backward," *Poetry* 33 (October 1928): 36.

20. As Frank Lentriccia notes, the late 1940s were the "triumphant times of New Criticism." *After the New Criticism* (Chicago: University of Chicago Press, 1980), p. 4; see also Terence Hawkes, *Structuralism and Semiotics* (Berkeley: University of California Press, 1977), p. 152.

21. These were the New Critical views ascribed by Herbert Read to T. E. Hulme. Baym, *A History of Literary Aesthetics*, p. 245.

22. This is not to say that Greenberg rejected all art that dealt with emotion in an obvious way; in some cases he saw it as a necessary antidote to art that has become dry and conventionalized. Ideally, however, emotion and psychology were better avoided by both artist and critic. See Donald Kuspit, *Clement Greenberg* (Madison: University of Wisconsin Press, 1979), pp. 107, 147, 162–70.

23. For more about Tyler, see John Myers, "Surrealism and New York Painting, 1940–1948: A Reminiscence," *Artforum* 15 (April 1977): 55–57; for the article by Tyler which Foster quotes, see "Review of *Possibilities* and *The Tiger's Eye*," *Magazine of Art* 41 (March 1948): 109.

24. David Hare, interview with the author, 21 January 1982.

25. It may be correctly argued, of course, that such eclecticism is a position, too. But it is a different position, and one that attempted to place itself in opposition to the monologic positions of more typically partisan reviews.

26. Franklin Rosemont, ed., *What Is Surrealism?* (New York: Monad Press, 1978), p. 87; Nicolas Calas, telephone interview with the author, 12 April 1982. The "Bloodflames" exhibition was held at Hugo's gallery in New York in 1947. Helen Phillips Papers, coll. Helen Phillips, New York.

27. John Stephan, telephone interviews with the author, 25 August 1988 and 9 September 1988.

28. Annalee Newman, interview with the author, 6 March 1989, New York City. On issues 2 and 3, Barnett Newman's name appears as Associate Editor. As Newman was to explain later in a letter to Barbara Reise published in *Studio International* 176 (October 1968): 127, he was never an editor of *The Tiger's Eye*.

29. Annalee Newman, conversation with the author, 27 March 1989, New York City. *The Tiger's Eye* Papers, Beinecke Rare Book and Manuscript Collection, Yale University. Newman's assistance as friend rather then editor is demonstrated by an undated letter to Ruth Stephan in the *Tiger's Eye* Papers, referring to the fact that Mrs. Newman also proofread the articles.

30. Annalee Newman, interview with the author, 6 March 1989.

31. John Stephan, interview, 15 August 1980, revised in letter to the author, 9 October 1988.

32. Herbert Cahoon (who joined the staff in 1947), interview with the author, 2 May 1985.

33. *The Tiger's Eye* 3—Baziotes; *The Tiger's Eye* 1—Rothko; *The Tiger's Eye* 3—Tobey.

Chapter 3

1. Parker Tyler, "Review of *Possibilities* and *The Tiger's Eye*," *Magazine of Art* 41 (March 1948): 109.

2. May Natalie Tabak (Mrs. Harold Rosenberg), interview with the author, 19 April 1982; Robert Motherwell, telephone interview with the author, 13 April 1982.

3. Robert Hobbs, "Re-Review, *Possibilities*," *Art Criticism* 1, no. 2 (1979): 97. In his discussion of *Possibilities*, Hobbs has also emphasized Motherwell's antiprogrammatic intent.

4. Tabak interview, 19 April 1982.

5. Motherwell, interview, 13 April 1982. Hobbs, "Re-Review," p. 97.

6. Motherwell, interview, 13 April 1982.

7. John Dewey, *Art as Experience* (New York: Minton, Balch, and Company, 1934), pp. 304–6. For further discussion of the effect of a reading of Dewey on the art of the late forties in America, see Stewart Buettner, "John Dewey and the Visual Arts in America," *Journal of Aesthetics and Art Criticism* 23 (Summer 1975): 389–90, and his *American Art Theory, 1945–1970* (Ann Arbor, Mich.: UMI Research Press, 1981), pp. 58–62.

8. Tyler, "Review," p. 110.

9. Motherwell, telephone interview with the author, 21 April 1982.

10. Motherwell interview, 21 April 1982; see Martin Duberman, *Black Mountain: An Exploration in Community* (New York: Dutton, 1972), and Mary Emma Harris, *The Arts at Black Mountain College* (Cambridge, Mass.: MIT Press, 1987).

11. Motherwell, interview, 21 April 1982.

12. Motherwell, interview, 13 April 1982.

13. For a discussion of *Documents'* use of collage as cultural critique see James Clifford, "On Ethnographic Surrealism," *Comparative Studies in Society and History* 23: 4 (October 1981): 548–53 and 562–64.

14. László Moholy-Nagy, quoted in Robert Motherwell, "Introduction," *The Dada Painters and Poets: An Anthology* (New York: Wittenborn, Schultz, Inc., 1951), p. xxviii.

15. Motherwell, interview, 13 April 1982.

16. Randall Jarrell, "Introduction," *The Selected Poems of William Carlos Williams* (New York: New Directions Press, 1949), p. xvi. Probably referred by Rosenberg, Williams visited Motherwell in the forties to discuss the possibility of some sort of collaboration. A joint project did not result, however. Although Motherwell and Williams agreed about method, they differed about the importance of place, Williams espousing the importance of local or regional subjects, while Motherwell believed in a less specific, more international orientation. Motherwell, interview, 21 April 1982.

17. Christopher Butler, *After the Wake, an Essay on the Contemporary Avant-Garde* (Oxford: Oxford University Press, 1980), p. 40.

18. Evan Firestone, "James Joyce and the First Generation New York School," *Arts* 56 (June 1982): 118–19.

19. William Baziotes, "I Cannot Evolve Any Concrete Theory," *Possibilities* 1 (Winter 1947/48): 2 (reprinted in Part Two of this volume).

20. Willem de Kooning, "What Abstract Art Means to Me," *Museum of Modern Art Bulletin* 18 (Spring 1951): 7.

21. It is no coincidence that the attitudes of de Kooning and Baziotes should parallel *Possibilities'* policy so closely. As May Tabak recalls, the artists who were particularly close friends of the Rosenbergs in the late forties were Baziotes, de Kooning, Phillip Guston, and Barnett Newman (interview, 19 April 1982). In regard to Cubism's non-hierarchical structure as a paradigm for Abstract Expressionism, see also Introduction, p. 4–5.

22. Hobbs, "Re-Review," p. 98.

23. Motherwell, interview, 14 April 1982.

24. Dore Ashton, *The New York School* (New York: Viking Press, 1972), p. 126.

25. Lee Mullican, "Thoughts on the Dynaton, 1976," and Gordon Onslow Ford, "Reflections on the Dynaton Exhibition 25 Years Later," in *The Dynaton 25 Years Later* (Los Angeles: Los Angeles County Museum, 1977), pp. 38–39 and 42.

26. Motherwell, interview, 21 April 1982. Paalen was held in high esteem by André Breton, who considered "that no more serious or more continuous effort has ever been made to apprehend the texture of the universe and make it perceptible to us" than that made by Paalen in his vigorous "way of seeing—of seeing around oneself and within." "Wolfgang Paalen," November 1950, in *Surrealism and Painting* (New York: Harper and Row, 1965), pp. 137, 138. Motherwell went to Mexico in 1941, however, not primarily to meet Paalen, but to summer with Matta in Tasco. Paalen lived in a suburb of Mexico City. Matta, with whom Motherwell had travelled to Mexico, had a letter to Paalen from Breton and took Motherwell with him to visit Paalen when they first arrived in the country. Paalen came several times to visit Motherwell and the Mattas in Tasco and at one point drove Motherwell back from Vera Cruz—a three-day trip with plenty of time for comparison of ideas. In the early winter of 1941–42, Motherwell returned to New York.

27. Collection Robert Motherwell, Greenwich, Connecticut.

28. Edouard Renouf, telephone interview with the author, 29 January 1982.

29. Motherwell, interview, 21 April 1982.

30. See Stephen Foster, *The Critics of Abstract Expressionism* (Ann Arbor, Mich.: UMI Research Press, 1980), pp. 13, 23; Donald Kuspit, "Two Critics: Thomas B. Hess and Harold Rosenberg," *Artforum* 17 (September 1978): 33; and Serge Guilbaut, "The New Adventures of the Avant-Garde in America," *October* 15 (Winter 1980): 61–78.

31. Foster, *The Critics of Abstract Expressionism*, p. 25.

32. Harold Rosenberg, "The Stages: A Geography of Human Action," *Possibilities* (1947/48): 48.

33. Harold Rosenberg, "The Game of the Chinese Laundryman," *Instead* 4 (April 1948): n.p.

34. Tabak, interview, 19 April 1982.

35. Emmanuel Lévinas and Jean Wahl, "An Essential Argument within Existentialism," *Instead* 7, n.d., n.p. (reprinted in Part Two of this volume). It should be noted that in

this article, Jean Wahl differed from Lévinas in seeing death as the terminus of the possible, not as its root, as Lévinas did. This is an important distinction, although one whose implications are outside the scope of this investigation; but Lévinas's claim that death is realization itself (i.e., reification) might yield significant correlations if considered as one of the factors involved in the deaths of Gorky, Pollock, Rothko, and perhaps Smith, Reinhardt, and Kline as well.

36. Harold Rosenberg, "The American Action Painters," *Art News* 51 (December 1952): 22–23, 48–50.

37. William Seitz, "Abstract Expressionist Painting in America" (Ph.D. diss., Princeton University, 1955), p. 299.

38. Robert Motherwell and Harold Rosenberg, editorial statement in *Possibilities* 1 (Winter 1947/48): 1 (reprinted in Part Two of this volume).

Chapter 4

1. Connoly paid Lionel Abel a salary and when she and Matta were divorced in 1948, she continued to give Abel his salary in Paris where he had gone in December of 1948. He assembled the last issue of *Instead* in Paris, mailing it to the U.S. to be printed and distributed. (Lionel Abel, interviews with the author, 29 July 1982 and 9 July 1988.) For more information on events surrounding the demise of *Instead*, see Abel, "The Surrealists in New York," *Commentary* 72 (October 1981): 44–54. See also Abel's *The Intellectual Follies* (New York: W. W. Norton & Co., 1984).

2. "No. 1" was published sometime after 17 September 1945; No. 2 in March 1948; No. 3, April 1948; No. 4, June 1948; No. 5/6, a double issue, in November of that year; and "No. 7," which like "No. 1" was unnumbered and undated, presumably sometime after that.

3. Abel, interview, 29 July 1982.

4. Ibid.

5. *Minotaure* 11 (Spring 1938): 43.

6. Nancy Miller, "Interview with Matta," *Matta, the First Decade* (Waltham, Mass.: Rose Art Museum, Brandeis University, 1982), pp. 11–12.

7. Abel, interview, 29 July 1982.

8. Nancy Miller, "Interview with Matta," p. 19.

9. Abel, interview, 29 July 1982.

10. Matta, letter to the author, 12 September 1988, Tarquinia, Italy.

11. Lionel Abel, telephone interview with the author, 10 January 1983.

12. Abel, "The Surrealists in New York," p. 51.

13. Abel, interview, 29 July 1982.

14. Apollinaire's picture-poems, reproduced in *Instead* 4, indicate an interest in melding the visual with the verbal that preceded the arrangements of words by Lincoln Gillespie, Lloyd Barrell, and James Dolan in *Iconograph* and those by Stanley William Hayter, Ruthven Todd, and Joan Miró in the first issue of *The Tiger's Eye*.

15. Harold Rosenberg, "The American Action Painters," *Art News* 51 (December 1952): 22–23, 48–50.

16. Harold Rosenberg, "The Messenger," *Instead* 7, and "The Game of the Chinese Laundryman," in *Instead* 4 (June 1948). See also chapter 3 for further brief discussion of "The Chinese Laundryman."

17. Lionel Abel confirms that, to the best of his recollection, these were done by Matta. Interview with the author, 29 July 1982.

18. See William Rubin, "Arshile Gorky, Surrealism, and the New American Painting," *Art International* 7 (February 1963): 27–38.

19. André Breton, "Arshile Gorky," *Instead* 1 (April 1945), n.p.

20. For encapsulations of the problems involved in this relation, see Nancy Miller, "Matta, the First Decade," pp. 24–26; and Martica Sawin, "Prolegomena to a Study of Matta," *Arts* 60 (December 1985): pp. 32–36.

21. Abel, interview, 29 July 1982.

22. Tabak, interview, 19 April 1982.

23. Gorky was unlikely to have read this himself, Lionel Abel has suggested, but he may nevertheless have known it second hand. Lionel Abel, telephone conversation with the author, 6 July 1988.

24. Clement Greenberg, "Art," *The Nation* 163 (July 1946): 54.

25. Of the decade 1938 to 1948, Read wrote that "Not a single new movement in art has been born, and the only new 'ism' of any significance, existentialism, does not touch the plastic arts as yet." Herbert Read, "The Situation of Art in Europe at the End of the Second World War," *Hudson Review* 1 (Spring 1948), reprinted in Herbert Read, *The Philosophy of Modern Art* (London: Faber and Faber, 1964), p. 45.

26. Irving Sandler, *The Triumph of American Painting* (New York: Harper & Row, 1970), p. 98.

27. Clement Greenberg, "After Abstract Expressionism," *Art International* 6 (October 1962): 26.

28. Maurice Blanchot, "Face to Face with Sade," *Instead* 5/6 (November 1948): 2 (reprinted in Part Two of this volume).

29. Lionel Abel, "Sartre Remembered," *Salmagundi* 56 (Spring 1982): 112.

30. The negative view of Gorky's long apprenticeship to the masters of modernism has been effectively questioned by Lisa Corrin, who has suggested that it is consistent with traditional Armenian aesthetics, in which emulation of the masters, not escaping them, is the most effective way to become a master oneself. "Arshile Gorky's *They Will Take My Island*: Abstract Expressionist Themes in an Armenian Code," paper delivered at the Sixth Annual Symposium on Contemporary Art, Fashion Institute of Technology, New York City, 13 November 1987.

31. It also paralleled those summarized by Hannah Arendt in her article "French Existentialism" in *The Nation* in February of 1946. Here, in one of the earliest English-language discussions of Existential authors Franz Kafka, Sartre, and Albert Camus, Arendt introduced several concepts common to both Existentialism and Abstract Expressionism, such as "the way out of pretense and serious-mindedness is to play at being exactly what one is" (Arendt, "French Existentialism," *The Nation* 162 [23 February 1948]: 227).

Gorky is not the only figure associated with Abstract Expressionism to demonstrate an affinity with a blend of Matta's Surrealism and Abel's interest in Existentialism. Although the work of Theodore Roszak is not reproduced in *Instead,* Abel admired his sculptures, an admiration he expressed to Roszak's dealer, Pierre Matisse. This led, some years later, to Abel's essay in the Pierre Matisse Gallery catalogue, "Roszak, 1956–1962," in which he wrote that "Roszak makes bugs that are metamorphosed into themselves, into bigger themselves" (*Roszak's Sculpture* [New York: Pierre Matisse Gallery, 1962], n.p.). This tendency on Roszak's part to exaggerate the essence of a creature could be seen as an extension of playing "at being exactly what one is," although, at least in the instance of Roszak's insect images, a reference to the human/insect of Kafka's *Metamorphosis* must also be considered.

32. For the importance to Abstract Expressionists of an individual style as an expression of freedom and responsibility, see Ray Parker, "Intent Painting," *It Is* 2 (April 1958): 8–9; and Stewart Buettner, *American Art Theory, 1945–1970* (Ann Arbor, Mich.: UMI Research Press, 1981), p. 89.

33. "Artists' Sessions at Studio 35 (1950)," edited by Robert Goodnough, in *Modern Artists in America* (New York: Wittenborn, Schultz, Inc., 1951), p. 20 (reprinted in Part Two of this volume).

34. *15 Americans,* ed. Dorothy Miller (New York: Museum of Modern Art, 1952), p. 22.

Chapter 5

1. Information from photocopies of advance publicity distributed by Wittenborn, corrected by the editorial staff and annotated by Bernard Karpel, July 1982; collection of the late Bernard Karpel, Poughkeepsie, New York.

2. This information, and all other unnoted information from Bernard Karpel, is from a letter of 23 August 1983 sent with annotated photocopies to the author.

3. One exception is the remarkably flat and allover patterns produced by Alexander Hammid for the inside covers of *The Tiger's Eye* 2.

4. *Dau Al Set,* founded in 1948, included poets, philosophers, and critics as well as painters such as Tàpies and Joan Ponç. Frank O'Hara, *New Spanish Painting and Sculpture* (New York: The Museum of Modern Art, 1960), p. 8. This publication includes a "Selective Bibliography" by Bernard Karpel. See also Margit Rowell, *New Images from Spain* (New York: Solomon R. Guggenheim Museum, 1980), p. 15.

5. Robert Motherwell, telephone interview with the author, 13 April 1982.

6. Ad Reinhardt to Sam Hunter, Summer 1966, Ad Reinhardt Papers, Archives of American Art, Smithsonian Institution, Washington, D.C.

7. Ibid.

8. Robert Motherwell, note to the author, Greenwich, Connecticut, 27 September 1988.

9. S. Lane Faison, "New World Problems," p. 62. Unidentified clipping, collection of Bernard Karpel.

10. Robert Motherwell, telephone interview, 13 April 1982.

11. Stephen C. Foster, *Critics of Abstract Expressionism* (Ann Arbor, Mich.: UMI Research Press, 1980), p. 62; Irving Sandler, *The Triumph of American Painting* (New York: Harper and Row, 1970), p. 169.

12. For a history of the controversy surrounding this charge see Serge Guilbaut, "The Frightening Freedom of the Brush, the Boston Institute of Contemporary Art and Modern Art," in *Dissent: The Issue of Modern Art in Boston* (Boston: The Institute of Contemporary Art, 1985), pp. 52–93. For Plaut's comments, see especially p. 90n.11.

13. "Mr. Sylvester Replies," *The Nation* 172 (25 November 1950): 492. Sylvester's early objection to Greenberg's stand is noted by Stephen Foster, *Critics of Abstract Expressionism*, p. 60.

14. Bernard Karpel, "Objectives in Bibliography," *Modern Artists in America*, 171.

15. Clement Greenberg, "Modern Painting," *Art and Literature* 4 (Spring 1965): 193.

16. "Counter–Avant-Garde," *Art International* 15 (May 1971): 18. This essay and the one above are discussed by Donald Kuspit in *Clement Greenberg, Art Critic* (Madison: University of Wisconsin Press, 1979), pp. 136–37.

17. Ad Reinhardt in "Artists' Sessions at Studio 35 (1950)," *Modern Artists in America* 1 (New York: Wittenborn, Schultz, Inc., 1951), p. 15 (reprinted in Part Two of this volume).

18. Ibid., 21.

Conclusion

1. I am preparing an introduction to a part of this area, a book tentatively entitled *Towards a Cultural History of Abstract Expressionism: Race and Gender in the New York School.*

Index

Part Two

Selected Writings and Visual Art from the Periodicals

Artist and Author Guide

Part Two contains reprints of articles that appeared in the periodicals discussed in Part One as well as representative illustrations from those periodicals. The reprints are arranged chronologically within the appropriate periodicals. Illustrations are grouped together after the text reprints from that periodical.

The guide below is designed to help the reader locate works by specific individuals. The two lengthy round table discussions from *Modern Artists in America*, "Western Round Table on Modern Art (1949)" and "Artists' Sessions at Studio 35 (1950)," involved numerous artists, and are referenced in this list only to the editors of those discussions. Participation by individual artists for those two articles can be checked in the full index to the periodicals in Part Three. Here, as in the full index in Part Three, capitalization in titles has been standardized. Full source citations for the articles are found at the bottom of the first page of each article.

Iconograph
and
The New Iconograph

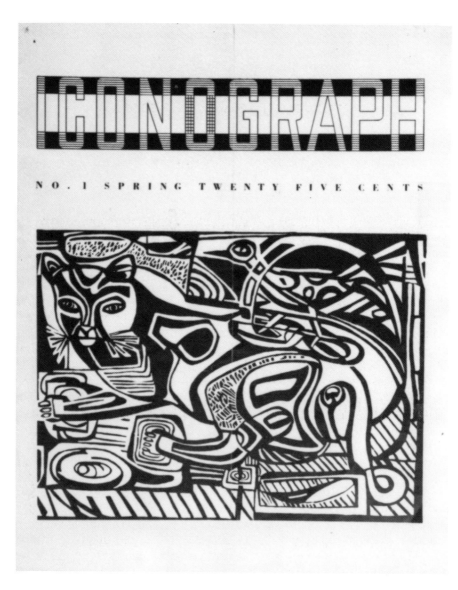

Figure 5. Howard Daum with Lloyd Barrell, Cover
Iconograph 1 (Fall 1946).

This Is the Spring of 1946

Kenneth Lawrence Beaudoin

In the fall of 1940 when I brought out the first issues of *Iconograph*, a little magazine which lived in New Orleans, Louisiana, U.S.A., between 1940 and 1943, it seemed so quite easy to state simply and directly the purposes of the publication, its scope, its tone. All this seemed clearly defined, basic. Now five years and some months later *Iconograph* discovers it is not dead at all but only in New York and I am confronted with a much more difficult problem with relation to a stated understanding of my own artistic principles, which (and this is the most complex and trying problem they present) though they have changed remarkably little fundamentally . . . have at the same time changed, oh yes, but oh yes what a sea change they have suffered . . . changed as I have myself changed . . . as my world has changed: conscious that I have new eyes, new ears, a skin that feels differently, a body telling a different personal history of my era. It would be so simple if I could say and know that the position which I outline here were actually . . . actually different. It would be so simple, but I know it is not. It has changed only as I have because of the weather on the sea, the immediacy of April, because of the rising wind and the cold.

One thing which has not changed is my conviction that respect for the immediate art-object is necessary: the just painted picture, the just written line of music, prose, the just expressed-realized thought. In 1940 I thought it the business of the little magazine to be the nursemaid of experiment: to be the midwife to the bearing of prophets. I still believe this, but I have a different notion of what experiment is. Art-forms like bombs are re-designed for every war, for every peace. It is the business of a successful warring nation to recognize the best design. It is the business of

This article originally appeared in *Iconograph* 1 (Spring 1946): 3–7. Oscar Collier's untitled painting which accompanied this article is reproduced in this volume as figure 6.

95

a healthy national consciousness to be aware of the art form which will satisfy the existing moment with its eloquence; for in the moment of fresh achievement, then only does the art form enjoy its truest reality. We all know that surviving art forms are the playthings of scholars, the propaganda devices of outdated ideologies, and angry traditions and convention striving to live another hour in the sweet decay of our year. In the moment of their inception, when weakest, opposed by every existing *status quo* of thought and habit, then are art forms enjoying their most exciting reality; it is at this point *Iconograph*, New York, 1946, would apprehend the art object, hold it before the public eye a moment, cry out a prophet is born! It really does not matter that next year we may have the same cry for a different prophet.

The geography of today's thought is fairly well charted: a few new maps suggest channels in the Sargasso Sea not yet visited. Some new maps are re-locating old positions more precisely. This year it is our business to be interested in the new charts.

It is perhaps of utmost importance this spring to realize we have come to the year in our letters when we know for the first time the real motivation, conscious or unconscious of the Ezra Pound through Henry Miller anglo-saxon-four-letter-word-romantic Freud-consciousist via vitriolic semantic, which are not semantics but all the semantics there are; oh surely, which reach an audience outside the enchanted circle of University semanticists, which are a different breed: and the same breed. You can tell the beast by its horns. Oh yes, oh yes you can, oh yes, Ezra was a beast and Henry. We were all the beast, the romantic soft-eyed beast waiting for beauty to kiss us into princes. We were all impatient beasts, beasts with the gore of beauty on our single horn, our double horn; but always the beast with gore on our horn . . . looking for beauty (to kiss us into princes, oh but surely) . . . an old fairy tale can tell you about newer philosophy. We understand Ezra and Henry this year; and I mean the whole big push of an entire line of artist's thought which was in 1940 still part of the active chemistry of our ideas.

So I shall print before the end of this year a simple piece of prose narrative in basic English. No one will probably understand this either; or maybe they will, but you will know the beast by its horns.

We are looking at new runes this year: we are covering ourselves with strange magic devices, with strange, fantastic intellectual clothes. In New York this spring Wheeler, Barrel, Busa, Collier, Barrer, De Mott, Sekula, Lewin, Orloff, Daum, Smith are painting a new magic out of old star-driven symbols rooted in an understanding of pre-Columbian American Indian art, using it (not historically but) as a competent vehicle for current representational art. (For critical purposes I have referred to this group of painters as semiologists/semeioly connoting the roots of the method to be

in ancient runic-Amer-Indian art—connoting two dimensional rather than three dimensional representation—and furthermore representation such as the semeiographs of the Indians dependent upon the use of a symbol-integer rooted in an understanding of human and visual realities, personal realities—connoting a type of painting which recognizes a surface as an area for complete creative occupation—connoting a type of painting which since it is in two dimensions does not recognize the conventional solidity of given form, which does not demand but allows formal transparencies—such as in the Busa tempera called "Untitled" and the Collier painting called "The Enormous Head"—connoting a type of painting sufficiently free to allow the artist to say anything it is pictorially necessary for him to say, but sufficiently specific in its character to be identifying—in the way the word— human—or male are identifying.) Historically this point of departure was first used contemporaneously in America by Steve Wheeler—a painter of huge inventive insistence—now it is being used by many painters. Nell Blaine, Judith Rothchild, Ida Fischer, Ken Ervin, who show their painting at Jane Street, are watching the world from Arp, Klee, Piet Mondrian, their planets. There are undiscovered positions.

Most of the writing you will see in *Iconograph* has not been written yet . . . though Meridith Weatherby wrote some of it in a Japanese prison camp. James Franklin Lewis, who was the most tireless of our old world before the sea-change, is dead. John Fineran was dead in 1937. I think they are still to be read as the immutable remnant of last year's mind, which was their mind and is our mind. Perhaps Crews will write now things he has not written before . . . perhaps Greer, Wendell Anderson . . . there are several names.

Donald Ellison is dead, so I must listen to music differently than I have before, oh yes. It is hard to listen to music in memory only, written only on the performing instrument. It is equally hard to forget beauty which will kiss the beast into the prince, oh yes. I will listen to different music. They tell me Carl Durel is not dead. Perhaps he will tell his story in stone now.

Of course, we have not forgotten there are poets named Eliot, Williams, Prokosch, De Jong, Cummings, Stevens, Tate, Ransom, nor painters called Picasso, Mondrian, Klee, Xercon, Matta, Masson. It is scarcely necessary to remember them. Their magic is already part of the chemistry of our ideas. We shall have a look at the new prophets. This does not mean that from time to time *Iconograph* will not *examine* artistic manifestations of our own Americans which do not adhere to the artistic position which *Iconograph* takes this spring. For many reasons many valid and certainly outmoded pieces of American art and letters will be examined.

Iconograph will be interested in considerations of language as it is, as it is used under specified conditions, or as it can be used. Perhaps the

answer to the literary language problem is in spoken English, perhaps it is in basic English, perhaps, I should say probably this great over-rich tongue of ours contains languages still to be discovered which can carry our meaning more safely . . . better baskets for our eggs. *Iconograph* will be interested in language as it can be spoken to people not necessarily university people; for this is the language of the new literature. *Iconograph* will make it its business to look at language.

When *Iconograph* considers works in other languages than English, it will print them in the language of their conception, for we do not regard translation as feasible. This is an old illusion which has caused much confusion.

Iconograph will in short look in these directions. It will look for the new prophet. You will know the beast by its horn. We have not stopped looking for honest writing. We cannot tell you this afternoon just what honest writing is. I wonder if we shall succeed in telling you at all? I wonder if it will matter at all whether we succeed in telling you?

It seems to us most important that we are living men who see and hear, feel and taste, smell and think, cohabit and die. We are living men and can tell when a picture has been painted by a living man in the world of his hour, for it is the world of our hour and we have not died. We are living men and we shall show you some work by living men. Can we do more. (Death of a person does not always come with the cessation of physiological activity in his carcass. Sometimes it comes before that . . . and sometimes after that.)

Typography

James Dolan

Historically man has striven, it seems, to consciously perceive visual differentiation in the physical world about him in order to respond with emotion and intellect toward it, consequently through timeless repetition of certain imagery, feelings, attitudes, and notions which have persisted above the vast totality of experience, certain conventionalized ideas linked with speech became the primary measuring devices by which man has oriented himself to the elements of time and space, that he might create order out of chaos.

Primitive art forms although usually related to definite objects served no practical purpose in the beginning. It was only when they became identified with conscious desires, religion, ritual, and magic that their influence upon the destiny of man became decisive in terms of a medium of communication.

The different system of alphabetic writing evolved only after the limited communication by oral language, gesture-sign and picture writing became insufficient to express and record thoughts. Written in the ideographic language, the accompanying illustration is from a woven tablet [see fig. 8], describing the life of a man. He was a chieftain of royal blood (the panache with five double plumes). He commanded an entire tribe. He had a military command (the mace which he holds in his right hand). He has taken part in three battles (the three arms which three times proved his strength). He was a judge in his district (the sign of the speaking trumpet in the

This article originally appeared in *Iconograph* 1 (Spring 1946): 9–10. Dolan's graphic configuration of the article's title as it appeared in the original publication and tablet illustration are reproduced in this volume as figure 8.

center). He had under him four judges (the four signs of the speaking trumpet, lower right area). He had during administration irrigated the country (the inner border depicted by the wave motif); and he had constructed great buildings (the checkers surrounding the irrigation symbol). He had busied himself besides all that in the raising of cattle (the indication of llamas). He had lived 42 years (the outer border of blacks which indicates years). He had five children, three sons and two daughters (indicated by the drops of sperm).

Thus human forms drawn pictorially in the act of making gesture-signs and in significant action and attitude and combinations of these, together with natural and artificial objects which represent work or the result of work were drawn with many significations. When any of these signs became commonly adapted on account of its unusual fitness or from frequent repetition or from frequent repetition from special context, it then became conventional term of thought-writing. Although the designs became conventional terms, their forms became more abbreviated or cursive until in many cases the original concept was completely changed.

From the art of picture writing originated the first graphic system. All passed through the stage of conventionalization to hieroglyphics from which developed syllabism which used the modified ideograms and utilized a comparatively small number of characters. Ultimately more highly civilized of ancient people simplified the syllabary and further reduced the necessary characters.

The universal aspect of the ancient ideogram may be compared to the Roman numerals which are understood by many nations of divers languages although the words they compose are unintelligible to one another. The number of picture characters was potentially infinite and each could possess different forms, with the liability of misinterpretation, which finally induced alphabetic writing of a simplicity that more than compensated for its exclusiveness.

Contemporary writing and type forms are comprised of signs reflecting heterogeneous backgrounds, different media and various tools. The result in contemporary printed letter is an anachronism violating the laws of visual organization, technological achievement and psychologic development of man. The word *typography*, the title of this article, illustrates the full departure from classic type form of words composed of individual characters, to a word conceived as a picture image in which the individual letter is subordinated to the word configuration. The result is not the usual accidental arrangement of letters forming a word, but instead conscious arrangement of letters forming a *picture* of an idea.

Six Young Female Painters

Kenneth Lawrence Beaudoin

Upon visiting galerie neuf some months ago, and after examining the holdings of the gallery Yvan Goll saw fit to say in France Amerique, of the gallery and of me, "on dirait qu'il se spécialise dans les oeuvres des femmes, et qu'il trouve chez elles un expressin de la vie beaucoup plus directe et naive que chez les hommes, qui trichent davantage, ne s'abandonnant jamais jusqu'a l'ame, ni dans la peinture" [*sic*]. I do not know if I am entirely content to accept M. Goll's judgment of my taste, but I do know that I am sufficiently interested in "les femmes" as painters to say my say about half a dozen of them right here and now. They are Sonja Sekula, Ruth Lewin, Gertrude Barrer, Ruby Barco, Ruth Dennis, and Nell Blaine.

Sonja Sekula, who is a young Swiss-American painter who received her first one man show at the Art of This Century Galleries between May 14 and June 1, 1946, is a young painter of considerable native ability and technical virtuosity. She is conscious of devices (many of them arbitrary and experimental) as a proper part of a contemporary painter's stock and trade. She is honestly interested in pictorial effects per se, and her resulting picture is at once personal and indirect; at once, honestly eloquent and unmistakably precious. Speaking from the point of vantage from which I have seen the Sekula picture I must consider it as it exists this afternoon, and as it existed in the phase of her painting immediately preceding her present manner; paintings let us say dating from 1942 or later. This earlier phase (influenced by contact with Alaskan Indians and Alaskan Indian art objects—and familiarity with Paul Klee) seems to me a rich, personal one in which the artist (as particularly demonstrated in a group of crayon and

This article originally appeared in *Iconograph* 2 (Summer 1946): 3–7.

water color sketches and some pen and ink drawings, often with the poem restricting the mood of the piece worked into the piece itself, the calligraphy important as texture and design as well as writing) manages to speak more directly to her audience through her personally established and quite arbitrary symbols than she might have in less personal symbols. In most of these earlier pieces the color statement is scintillating, but always more restrained than bold. Her composition is often almost automatic: arbitrarily naive, sometimes even conventional. Toward the end of this phase the landscape (and always in the Sekula picture the artist-spirit and the artist-eye seems confined in a high window which regards the scene as painted by Sekula, from afar . . .) as I say, the landscape becomes darker, containing strange textures . . . individual use of color and sand, bits of glass . . . the statement becomes more a groping into the unadmitted personal mystery . . . race mystery. One called Reindeer (at least, it was so called the night I saw it in Breton's studio in 56th street where she was at the time) and another called Medieval Interlude (both dark pictures with strange lights and wonderful feeling of forest—forest— forest full of lurking activity) seemed to me pictorial statements of unusual impact.

Her more recent pictures which she calls night pictures, though a necessary development at the end of her Indian period seem somehow pictures in which there has been a somewhat arbitrary and perhaps ever so slightly unhealthy immolation of the personal. They are important perhaps, not so much as pictorial realizations as bridges to the pictures she will paint . . . for the Sekula talent is specific, and we are inclined to believe not insignificant.

Ruth Lewin, a young Brooklyn painter, shown recently at galerie neuf in the Semeiologist show, ''8 and a Totem Pole'' . . . has shown one of the most interesting developments as an artist of any I have seen. Having confined herself to graphic work (black and white) for many years she approaches her canvas as a surface into which color can be admitted perhaps, but only a little fearfully. Of three paintings shown at galerie neuf in April 1946 one (*Kenny's Trunk*) is in two colors . . . one (*Shut Your Mouth*) is in three colors, and only the third (*The Dreamer*) admits as many as five. Texture in the Lewin picture is more often the result of lineal intricacy than color and brush stroke treatment, modulation in the actual paint. But always in the Lewin picture there is that faultless draftsmanship which becomes almost exciting.

The statement in the Lewin picture, however, is another matter and possibly even more confusing for it exists equally in sections of unusual formal clarity, and sections as abstruse as any I have found in any paintings in contemporary times. The total effect of the Lewin picture is, of

course, not only an interesting and inescapable personal pictorial confession, but equally the result of a faultlessly composed surface, executed with sometimes, I believe, brilliant restraint of color. In an era of colorists I find Ruth Lewin's pictorial method most refreshing. I like her restraint, which in no way takes from the immediate impact of her pictorial statement. I am waiting eagerly for more Lewin canvases.

Gertrude Barrer, whose work was shown recently at galerie neuf in the Semeiologist show ("8 and a Totempole") and was almost universally found satisfying as a painter, shows herself in the method in which she now paints more at home than perhaps any of the young painters I know who are using a symbolic or indirect pictorial language. Whether consciously or intuitively she does not fail to make a specific pictorial statement in specific pictorial terms. A pictorial statement which has not failed to interest me, to disturb me with the urgency of its total impact.

Two years ago before her stay in Taos she had come to the end of the line pictorially with the expressionistic treatment of a subject. She has approached the pictorial symbol from a double road during the last two years finding an answer in it for the need in her as a painter to achieve organized, specific, precise forms as well as for a vehicle adequate, roomy enough to hold the rich, complex personal statement of a conscious, alive contemporary . . . artistic contemporary.

The Barrer picture (and the Barrer picture is one of the most satisfying I have had the good fortune of seeing recently) is always a picture that has been worked on with loving hands, a picture nurtured into its final form through a civilizing, mellowing process of revisions and re-decisions until it has at last, shall we say, learned the mental and spiritual lineaments of its creator. The color statement is invariably subtle . . . and an intricate "sotto voce" chorus having a great deal of connection with the underlying impact of the picture; drama of the picture. The forms in their final reductions are intricate, small, cell-like growths, which somehow collectively become larger forms not only enveloping but permeating. The resulting pictorial statement is as thorough in its specific demarcations, worked out areas, as a Chekov play, an Andreyev story. It is as whimsical as Pushkin sometimes is, and as poignant as Gorki can be, and in its total implications it is a personal and artistic statement of most considerable stature.

Technically Barrer has been the most thorough and exhausting in her minute areas of pictorial inventions of any of the Semeiologist painters: more conscious of the external form, the enveloping form than most of them, and more careful with the logic of her internal developments. In pieces such as *The Three Old Ladies,* see cut above, or *The Priest of the Bear*

(private collection) you have very fine examples of this type of work, though in the former you have the dissolution of forms into an overall pictorial realization (mysterious—suggested forms emerging from the edges) rather than the enveloping of the total internal activity within a larger transparent `form: the protagonist of the total drama as compared with the protagonists of the several subsidiary dramas contained within the actual realization of protagonist per se.

In a painting such as *The Hunter* (private collection) you have an achievement of quite a different sort: you have real activity in real surroundings (but in terms of personal realities as opposed to common realities) . . . your landscape becomes lyric, sky—earth—essence portrayed and your figure, the embodied function—action-victim relations. A similar but somewhat different treatment is demonstrated in the Somber Photographer (see *Iconograph* No. 1).

For Gertrude Barrer a painting is inescapably a piece of living. In a picture such as *The Baby* (galerie neuf) you find a direct personal confession of her mother-daughter relations. For Gertrude Barrer the canvas is always the unpenetrated mystery into which she even attempts sometimes to enter herself, gropingly, perhaps a little fearfully, but always in the last analyses boldly as in the painting. *The Enormous Head* (galerie neuf), one of her most interesting color statements. Not often, but occasionally she approaches the canvas playfully . . . but it is always well-organized, formal, ballet-like playfulness as in the painting called *Don Quixote* (galerie neuf). In Barrer there is a great enveloping formal sense. In Barrer there is limitless, soft, searching, human, feminine, intuitive faith in her self and her world. She is a happy painter in a melancholy year. She is a painter who deserves to be seen more than she has, oh yes, oh yes . . . indeed!

Nell Blaine is an abstract painter. She is concerned neither with any conscious form nor with any of the conventional realities. She is interested only with the more or less absolute and unbending realities (personal? . . . they manifest themselves in her personal ideation in terms closer to religion than anything else) which she deals with in her work. It is a world which many people more closely tied to the historical continuity of the race than herself find perhaps somewhat cold, perhaps somewhat lonely, but no one looking honestly at her picture can overlook the enormous ardor and fire with which she attacks her pictorial problem; the fervor and honesty with which she achieves it. Piet Mondrian, Léger, Arp speak to her directly, personally, intensely. She is content to have her intellectual conversations with them.

Though painting in an essentially different fashion than when she was discovered in Virginia a few years ago by the late Howard Putzell (she was doing neat, precisely calculated landscapes then, in which the forms:

the trees, the hills, the buildings seem to be hungry for a more general, less specific formal existence, than they possessed.) Nell Blaine still retains in her work an enormous native sense of restraint . . . formal restraint. Her color statement, always precise, arbitrary, perhaps in the landscapes understated, has during the last few years become more and more restricted until one found in her show at the Jane Street Gallery last year and her work shown in the American Abstract painters' show this spring, paintings in not more than five colors—often in two or three colors as in her painting *Circuit* (collection of the artist) which is a painting which involves activity in terms of thin black forms on a white surface, or her painting called *Flemish Square* (collection of the artist) which is composed of dovetailed forms one might say, in black and white and three grays.

The Blaine canvas as it exists today is a piece of abstract drama most carefully calculated, quite boldly presented. In such a piece as her *Blue Triangle* (collection of Judith Rothschild) one has an enormous consciousness of the decisive quality of the form and selected color, whether the picture is able to communicate with you directly or not. It can stand unmistakably as a Nell Blaine statement willy-nilly, and one can decide as one finds it necessary whether one finds Nell Blaine constructing a pictorial language peculiar to herself for her own peculiar pictorial story, (she will deny there is any pictorial story, but somehow this is my way of saying a thing about the totality of a picture which she cannot deny) or whether one believes her to be a maker of private runes calculated for the retention of her personal mysteries . . . secrets. One of her newest pieces (a large canvas 36" × 50") called *Open and Enclosed*, has to do with the business of the peculiar essences of open forms as juxtaposed to closed forms on a single surface. It is being worked in red, yellow and blue on white. Some of the forms seem larger, bolder . . . the Blaine form is always sure. It is a strange painting but not one to be overlooked. Somehow the intensity of her private faith in her method validates it though her tenets fail to have the support of accepted logical proof as expressed in man-eye-mind connections and reactions.

Ruby Barco–Ruth Dennis. Speaking to Howard DeVree of the New York Times recently in connection with the exhibition of the paintings of Ruby Barco and Ruth Dennis at galerie neuf in March of this year, I was impressed with the idea his look at their show had been for him a relatively strange—interesting—unusual visual experience; eye-mind experience. Ruby Barco and Ruth Dennis are two twin sisters (identical twins) from Tennessee who paint most astoundingly eloquent pictures. Closer in temperament to Nell Blaine than any of the other painters I have here-in discussed Barco and Dennis have probed their personal histories and their personal pictorial method with the sharpness of the medical examiner in

the traditional detective story . . . coming like him upon the positive scientific proof of the cause which demands the given pictorial effect. I believe this to be true; that the cause, the necessity for the Barco-Dennis picture is as exciting and as interesting as the equally necessary pictures resulting there-from. In March when their work covering the period from 1942–roughly to date was shown at galerie neuf (a very important period for them which they have thoroughly exhausted with their innumerable and tireless pictorial investigations) several paintings which I believe to be of tremendous urgency were shown . . . wonderfully revealing pictures . . . wonderfully personal pictures.

Ruby Barco's *Tension* (see cut above) which goes into Barco-Dennis history and past as twins was perhaps the most significant piece shown. It is a large canvas on which the twin relations are played like a ballet movement against the highly dramatized parent relations. The mood of the picture is sombre, sultry. The color is heavy. The impact of the picture is that of a sudden summer storm. Dennis's most powerful piece (see cut above) is a large oil (an interior) developed in dark blue and harsh yellow in which the forms have the fierce, hot activity of a danse macabre. Her smaller oil *Anticipating* (reproduced in *Art News*, April 1946) and another called *Gone* are equally as interesting and as strong. The lonely female form figures in the Dennis picture very importantly. Exquisitely neat interiors with empty beds are important symbols in her pictures . . . cold, lonely color sends projections which upon the audience has the pictorial effect comparable to an ice-water shower. At other times soft color emanates like a lonely hand reaching out of the opened door. Infinite recesses—windows behind windows, doors behind doors, behind doors, behind doors, behind doors, have their say their unmistakable news in her paintings. Barco paints with slightly less urgency than Dennis this year. She allows herself to be warmer and softer in her statement, brighter in her colors (she has done a group of sun-filled interiors). She has painted a picture in soft warm grays and rose tones called *Waiting* which is as tender and surrendering as I have ever felt a picture to be. Another picture called *The Account* shows group relations as group problems, but more surely . . . as if within the range of possible settlement.

It seems that with Barco and Dennis one speaks of the psychological implications of their pictorial symbols as much as their compositions, their palette. It is the overpowering, urgent part of their picture. It is the one side of their pictorial metaphor, for their picture aside from its personal statement which is always in view, becomes practically an abstraction constructed with familiar rather than unfamiliar forms . . . forms related and tied together by their intrinsic need for one another.

The Barco-Dennis picture is unmistakably one of the most interesting pictorial statements made in New York this year. No two painters have

dared to attack their personal problems in paint as boldly and as directly as these two fragile little girls from Tennessee have. Their pictorial results are, I feel, most important, deserving attention for a long time to come.

The Twittering Machine of the Future

Alfred Russell

Paul Klee's twitter was heard around the world twenty years ago and its reverberations have at last begun to fade away. The odds were against Klee when he invented star dust boxes, little cosmic clocks, and tinkering man. Something stronger was needed to combat tyranny of vacuity, of death, of democracy, of the mob, of common sense, the voting machine, the average man, cellophane. Paul Klee lost because he ran away to St. Helena and his exquisite private experimental world has become the common property of the drone, the harpy, the amazon. But there is still Joan Miró and André Masson to check the shrinking orbit of human experience at least until new blitzkrieg tactics have been devised. If we are not allowed to create we will defy the "mob" and create into its very face. The mob will die of consternation. Creation, creation, creation is the only answer to the ever present rigor mortis, the ever encouraged, ever subsidized rigor mortis. We will create our own life, synthesize realities and experiences in paint, in ink, in defiant scrawls.

And here is the synthetic world of experience, the improvised life to take the place of the one atrophied by the amoebic mob. Language has died and consequently the written word, especially the verb; hence we explore and invent experiences on the laboratory, the field of canvas, the vast void of paper, or shapeless masses of matter. Each canvass is a universe of its own with its own gravities, magnetisms, cosmic rays, sentiments, thought trajectories, intuited mathematics. Each canvass has had its own legendary past, its archaicisms, its classical, its baroque.

Here is any canvass, any sheet of paper on which the post-Klee man improvised a new gamut of experience, eliminates the tyrannical machine age from the twittering machine once and for all.

This article originally appeared in *Iconograph* 2 (Summer 1946): 25–26.

The line is life, is its own duration, and creates its own personality of forms. This line darts across this canvass, juts, jags, and creates a grating music beyond human experience. There is action, visual verbs, as line passes from form to form, as a line explodes or contracts or vanishes. There is abstract metamorphoses as a line passes over a black smudge. Each touching, departing, concentrating, expansion is a unique experience to sharpen our awareness of existence. In a drawing will occur an abrupt environment in which there is a flux, a collision, and disintegration of forms. We have never seen these forms in life before, but from this point on we will be poignantly aware of these improvised forms. Add to them the new ballistics of splattering ink and pigment. Our senses will be acutely awakened by the hair gashes of lines across the flesh, plane of the canvass. The vertiginous swirl of a pen line over a plane and back to a smudge is a verb in itself, inexpressible and meaningless, but nevertheless an experience to which we will respond. This is the touch, this is the total awareness, the essence of communication we find in sixth century Kouroi, in geometric Greek vases, in Coptic textiles, in Klee's *Twittering Machine.* Sometimes it's only the eyes which speak to us in an intimate little language, the eyes of the Etruscan Warrior in the Metropolitan Museum, the eyes of Klee's *Holy One,* or the eyes of a dozen Congo masks. We will forget the occasions over a period of millenniums during which we have spoken that intimate language and remember the language. We will at last recognize it, write a grammar for it, conjugate its verbs. With it we improvise realities of never-to-be realized experiences, unknowable unknowns, essences of numbers. We will isolate the look from the eye, the action from the verb, and extricate the twitter from the machine.

But how cold, how distant, mirage-like and unattainable, will be this experiential world as long as it is born, acts, and transpires on a canvass, outside of the artist's understanding! What can a metamorphosis of a line, a grating of a form, the music of attraction, repulsion, and concentration, the exquisite touchings of paint fragments, mean to us? If you are decrepit, if you vote, if you would rather ride than walk, if you are patriotic, if you are communistic, if you are social workers, earn a salary, if your hearing is bad or your sense of touch and taste not acute—then the experiential creation of pigment and ink will be meaningless to you. If you are a surrealist, a neo-surrealist, a refugee surrealist, there is no hope for you. But we who are strong will fight off your clinging atrophy and step into our new experiential improvisations, claim our own universal personalities of eloquent forms, live our synthesized realities.

Perle Fine

J[ean] F[ranklin]

The current practice of dismissing the work of a modern artist into some vague and comprehensive classification is quite as generally uninformative as the practice, equally popular, of settling final judgment on a picture with that promiscuous word "plastic." Any artist unfortunate enough to dwell in this misty environment must remain glorified and misunderstood until people become sufficiently aware of his paintings to realize that it is, after all, only partly true. To pronounce Beckmann an expressionist and the early Chirico surrealist can be an intelligent analysis or a vast misunderstanding, which is, of course, an uncomfortable paradox only for those who rely too heavily on such categorical talk. The critic who uses these terms (expressionism, surrealism, etc.) must, if he wishes to be understood, define them so extensively that they no longer have meaning except in specific relation to certain pictures.

So the terms abstract and/or non-objective apply to the delicate and sensitive work reproduced on these pages only in a very superficial way. That some of these pictures have reference to an objective situation while some do not is scarcely a profound observation. Because, like every good modern artist, Perle Fine is an individual and her work an individual expression (naturally I do not include that part of it still strongly reminiscent of Kandinsky and Miró), we must speak of her pictures in terms of themselves—not as they relate, or seem to relate, to the work of others. Although she is a member of the American Abstract Artists group, she has little in common with such fellow-members as Ralston Crawford and Robert Motherwell and although she has exhibited many times in the Museum of Non-Objective Art, we cannot quite reconcile her work to that

This article originally appeared in *The New Iconograph* (Fall 1947): 22–25.

of the others (Rebay, Bauer, etc.) also shown at the Museum yet so different in spirit and intent.

The language of Miss Fine's art is completely personal. She has in her pictures established a private reality that is as totally unrelated to sensuous appearance as [it is to] a mathematical formula. Only in terms of the spatial relations of lines, shapes, colors, and textures can her work be felt and enjoyed. Even those of her pictures in which the forms are derived more or less directly from natural objects (and are more or less recognizable as such) do not seem to be arranged with the intention of revealing emotional or physical properties of the subject. In the construction *Running Figure*, for example, the title is illustrated by a subtle and economic suggestion of figure in motion, which is however clearly subordinated to a much more generalized and abstract representation of motion qua motion. The artist has achieved this rather conceptual expression by emphasizing a rhythmic opposition of shapes and textures, harmonious yet constantly moving one against another, as the eye follows the directions of the composition.

Because Miss Fine has very nearly eliminated allusions to natural appearance and has instead limited her means of expression to those elements indigenous to the spatial arts, the meaning of her pictures cannot even be approximated in words. Their emotional and ideological impact must therefore vary considerably with the beholder and must in any case be as real and as intangible as are all experiences sub- (or super-) lingual. And this is the essential difference between modern art and the art of the past. Painters of the renaissance-humanistic tradition felt that all art must express a relatively specific idea and that the value of a painting depended to a large extent on the value (emotional, moral or intellectual) of the idea upon which it had been conceived. In order to express themselves clearly, they were of course obliged to speak in symbols commonly agreed upon and commonly understood. The literary tradition implied in these pictures and the conventional representation of reality (which is after all a convention and fairly remote from the real appearance things) is the common heritage of every Occidental.

Although the artist is freer today than it has ever been thought proper for artists to be, his position is anything but enviable. Restrictions of social pressure and a firm artistic tradition have undoubtedly in the past limited and even denied many avenues of personal expression; but these restrictions were nevertheless the necessary accompaniment of an art that played a vital role in the moral and religious life of the community. When art became free it also became impractical and lost thereby a very fundamental *raison d'être*. Today each artist must answer for himself the difficult question "Why do I paint?" And just as many people feel that all living things must have a significance and a final purpose beyond mere existence, so

for most artists the satisfactions associated with creation and appreciation are not enough and their work, in order to have real meaning, must contribute in some way to a larger effort.

Attempts to establish their art in a broader frame of reference have led artists, over the last hundred years, into some of the strangest aesthetic movements in the entire history of art—the Impressionist's fanatic defense of the scientific palette; pointillism, the system with which anyone may produce a great work of art; the stone-by-stone realism of the Pre-Raphaelite Brotherhood (certainly a manifestation of artistic frustration); and more recently, the Dada movement, the Surrealist, etc., etc.

With the exception of the unhappy brothers Pre-Raphaelite, the painters who promulgated these aesthetic philosophies were interested mainly in excusing and explaining an artistic style already established. Consequently their theory was usually inspired by their art, rather than the reverse; and in most cases the art and the theory were totally unrelated. This perhaps explains why so many of these aesthetic philosophies were not in fact essentially concerned with art. In his essays on "Plastic and Pure Plastic Art," Piet Mondrian is obviously preoccupied with an examination of life on a metaphysical rather than an aesthetic level. He predicates the existence of a fundamental reality beneath the particular appearance of objects and of a fundamental equilibrium in an apparently chaotic universe. The business of art is to express this intrinsic reality, divorcing it from the particular form, and to construct a kind of "dynamic equilibrium" proportionate to that of the essential cosmic forces.

A system of thought dependent on such an undemonstrable reality seems, in our empirical age, a philosophic anachronism. It is not however surprising that, in spite of this strong Platonic flavor, Mondrian's ideas should have won so many enthusiastic adherents among contemporary abstract and non-objective painters. Of all artistic styles today, theirs is the most removed from the humanistic tradition and is therefore most desperately in need of justification.

Because I believe that it is entirely representative of this group's aesthetic I should like to quote in full a statement written by Perle Fine to accompany these reproductions of her work. This statement admirably demonstrates what an astonishing discrepancy can exist today between a painter's art and his theory of art.

"The stamp of modern art is 'clarity'; clarity of color, clarity of forms and of composition, clarity of *determined* dynamic rhythm in a *determined* space. Since figuration often veils, obscures or entirely negates purity of plastic expression, the destruction of the particular (familiar) form for the universal one becomes a prime prerequisite. It is as true in art as it is in life that the purest expression of *truth* is also the purest expression of *vitality*. Thus, the new reality, constant, palpable, born of truth, free of oppressive

particularities, reveals itself clearly in the continuous and reciprocal play of intrinsic forces in a *good* modern work of art.''

If Miss Fine were sufficiently aware of all the implications of her statement she would recognize a disturbing contradiction in her approach to painting. Since the "clarity" of which she speaks can only mean an absolute reduction, the only possible artistic products of such a theory are the beautiful and barren designs of Mondrian. The particular aspect of any object is composed of those qualities which serve to individuate it from all other objects in the same category and to place it in a unique temporal-spatial position. Briefly these qualities may be defined as follows: 1) those aspects of appearance and structure that vary from the mean; 2) any illusion of three dimensional space; 3) impure color (only the three primary colors are "pure" in this sense); 4) a source or sources of light. Only by eliminating, as Mondrian has done, all four of these elements from a picture can an artist eliminate the "particular". Miss Fine has merely substituted for familiar objects imagined ones which yet have all the qualities of particularity listed above. The unreality of a form does not automatically establish its "universality."

The inconsistency of which Miss Fine is guilty is in my opinion a very fortunate thing. The logical conclusion of her ideas would be an art as restricted as that of Mondrian who succeeded in limiting his genius to such an extent that for most people his work is as meaningless as it is uninteresting. Delicate colors, varying effects of light, subtle complexities of formal and spatial relationships, these are pictorial elements that Perle Fine disowns in theory but happily includes in paint for they are the very things that make her pictures so exciting.

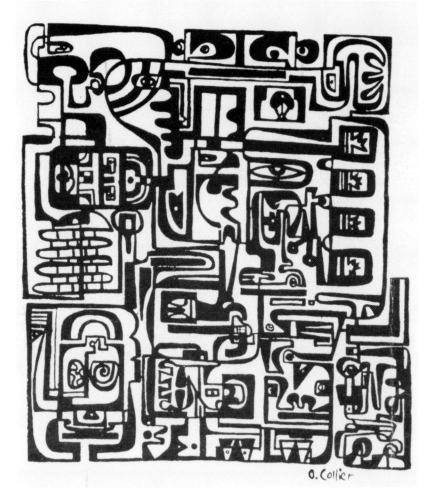

Figure 6. Oscar Collier, Untitled
 Iconograph 1 (Spring 1946): 4. Appeared with Kenneth Beaudoin's
 "This Is the Spring of 1946."

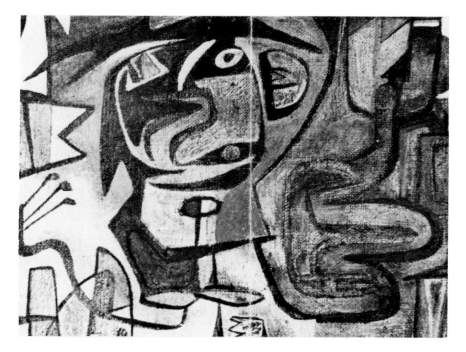

Figure 7. Gertrude Barrer, *The Somber Photographer*
Iconograph 1 (Spring 1946): 5.
(Location unknown)

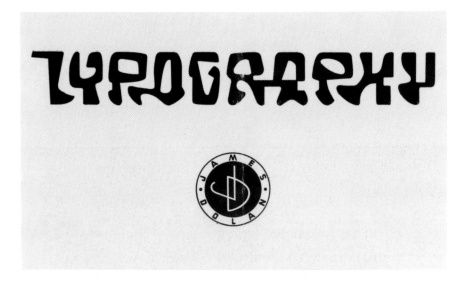

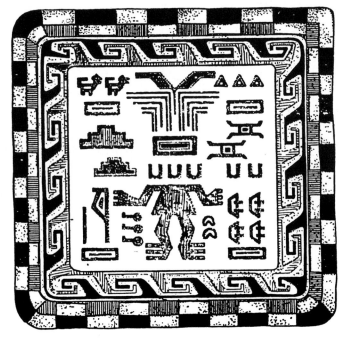

Figure 8. James Dolan, "Typography," Personal Logo, and Tablet Illustration
 Iconograph 1 (Spring 1946): 9. Appeared with Dolan's article on
 typography.

Figure 9. Helen De Mott, *The Beach*
Iconograph 1 (Fall 1946): 12.
Tempera on paper, 11½″ × 14″.
(Collection of the artist)

Figure 10. Robert Barrell, *The Poet of the Cosmos*
Iconograph 1 (Fall 1946): 12.
(Present location unknown)

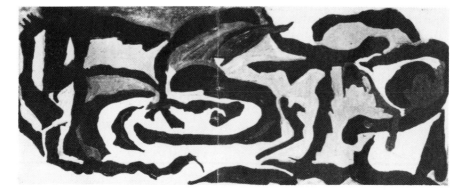

Figure 11. Ida Fischer, *African Theme*
Iconograph 1 (Fall 1946): 14.
(Present location unknown)

ART OF THIS CENTURY

30 W. 57th St., N. Y. C.　　　　　　　● PETER BUSA　Through
　　　　　　　　　　　　　　　　　　　　　　　　　　MARCH 28

Figure 12.　Peter Busa, Title Unknown
　　　　　　Work reproduced in advertisement on the back cover of
　　　　　　Iconograph 1 (Spring 1946) for Busa's exhibition at Art of
　　　　　　This Century.

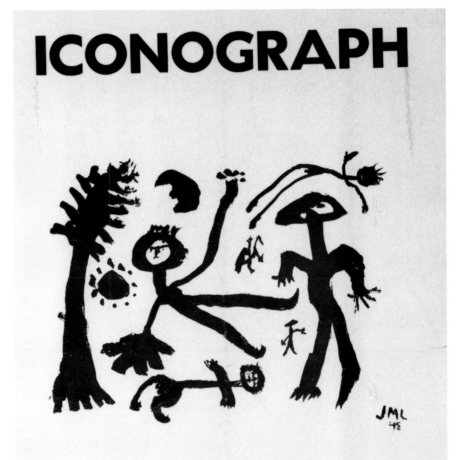

Figure 13. Jackson McLow, Cover
Iconograph 3 (Fall 1946).

Figure 14. Nell Blaine, *Blue, Black and White,* 1946
 Iconograph 3 (Fall 1946): 4.
 Oil on board, 28¼ʺ × 39½ʺ.
 (Photo by Robert Bass)

Figure 15. Ruth Lewin, Untitled
 Iconograph 3 (Fall 1946): 5.
 Woodcut.

Figure 16. Alfred Russell, *Arrival at Thebes,* 1942–43
 Iconogaph 3 (Fall 1946): 10.
 Oil, 72″ × 52″.
 (Location unknown. Photo by Phillips St. Clair)

Figure 17. Mildred Tolbert, *Summer Melancholia (Rainy Day, New York City)*
Iconograph 3 (Fall 1946): 23.
*(Mildred Tolbert Collection. Special Collections, General Library,
University of New Mexico)*

PORTRAICTS SKULPURSUNE[@]

(SHORBTS, VERBLOOCKX[x], SEEARINGS, RADXMELDISPEARS,
METAFRAXP,FSUTRUNES, WORDEA-RE-MAINS ———)

[A]

MAURICE EVANS

ELIX RA CONCORS VTAEL,SHAPEREAFFONCIPTS CIGRÆDAUNZ SHTURK

MEDTAOYVL FORZE PLANODE HTHRIENG,ARCIEL TROILUK,ASCEKIMJOY

'CHORPOURCIA DRAOMISSOL MOZARLING, HØPIES BOBN-CHUCLA-PWHIC

WOTHO SPIMERRS : "TIS-OHLY-A-DREIM, MEVANWY."

KREYMBORG PLYRCH-THEAVOR SLEYRTONEMAN

NOBLEO TEARS,TEMPCHYRIAN KSONG, STYSPALTEOL MIME

WORCDSOMNG

GHPSYTUD ORJOY SEENG,HOEROCO DELCUERO

CATULLOWN CHASEEC WESLEYCSTAIRZ

FIR-STRAYTORS-NEELEGE BUTT FLECIL VOCRESCENDS

CLARVILLUX PURCELPTION, PRÆTURNEOWAETHOS

MARQUAVIONS ANOINSTEIN

····AND MYSCRAVISOUN REASTRL MARTHA GRAHAM.

[@] VOWLZ INFRACHAINJ.
[x] SYLBFS LOOC-A-ROUNE.

Figure 18. A. Lincoln Gillespie, ''Portraicts Skulpursune''
Iconograph 4 (Winter 1946): 12.

Figure 19. David Hare, *The Red Knight*, ca. 1940
Iconograph 4 (Winter 1946): 23.
Plaster, painted, 58″ × 21½″ × 20¾″.
(Yale University Art Gallery. Gift of Ms. Peggy Guggenheim)

Figure 20. Gertrude Barrer, *Illuminato*
Iconograph 4 (Winter 1946): 28.
(Location unknown)

The Tiger's Eye

Figure 21. John Stephan, *The Tiger's Eye*
Painting used for cover of *The Tiger's Eye*'s first four issues.

The Intention of *The Tiger's Eye*

John Stephan and Ruth Stephan

The Intention of *The Tiger's Eye* is to be a bearer of ideas and art • In the belief art is a quest that can be good only as water is good, there is no wish to reach for a halo of GOOD, which is prudish proud ambition • It places its dependence, instead, on ingenuous and ingenious artists and writers, whoever and wherever they are, as they move through the dimensions of curiosity •

Because each piece is chosen for its own sake and always should be approached as such, regardless of who designed or wrote it, the names of contributors will be printed separately in the center of the magazine • All literature will appear as it was written, for grammar and style are among the pleasures and responsibilities of an author • The selection of material will be based on these questions • Is it Alive? • Is it valid as art? • How brave is its originality? • How does it enter the imagination?

Now *The Tiger's Eye* is ready to observe, not criticize, as it journeys through the Dusk of Fantasy and the Morning of Reality.

This statement originally appeared in *The Tiger's Eye* 1 (October 1947): 53.

Statement

Rufino Tamayo

Millas de telas pintadas, que tratan de decirnos la última palabra en el orden filosófico o social o político.

Telas que fotografían a la naturaleza o que nos demuestran la agilidad mental de sus ejecutantes. Pero que en ninguno de los casos nos dicen nada, pero absolutamente nada en el orden plástico.

De vez en cuando, fragmentos en que se nota la preocupación por el equilibrio de los elementos plásticos, y que constituye la estructura de la verdadera pintura.

Y al fin, en contadas ocasiones, esa estructura animada con poesía.

Es hasta entonces cuando volvemos a respirar a todo pulmón y nuestra fe se vivifica porque es evidente que la pintura a pesar de todo continúa existiendo.

Miles of painted canvases, that try to tell us the ultimate word of the philosophical or social or political order.

Canvases that photograph nature or that demonstrate for us the mental agility of their executors. But they tell us nothing at all, absolutely nothing at all, not in one case, of the plastic order.

Occasionally, fragments in which preoccupation is noted by the equilibrium of plastic elements, and that constitutes true painting.

And at last, on rare occasions, that structure animated with poetry.

It is then we breathe again with a whole lung and our faith springs to life because it is evident that painting, in spite of everything, continues existing.

This statement originally appeared in *The Tiger's Eye* 1 (October 1947): 62.

[Editorial Statement]

John Stephan

The Tiger's Eye has the following convictions that will guide its publication of art:

That a work of art, being a phenomenon of vision, is primarily within itself evident and complete;

That the study of art remains an afterthought to the spontaneous experience of viewing a work of art;

That too close an association between art and the profession of art criticism creates a marriage of hypocrisy for neither the artist nor the critic are motivated by altruism towards each other;

So it is our intention to keep separate art and the critic as two individuals who, by coincidence, are interested in the same thing, and any text on art will be handled as literature.

To further this idiosyncrasy of ours, we will print names, titles and relevant material in the index section.

This statement originally appeared in *The Tiger's Eye* 1 (October 1947): 76.

The Ides of Art: The Attitudes of Ten Artists on Their Art and Contemporaneousness

Boris Margo

In recent conversations with fellow artists, the question has frequently been raised. Is there an American modern art? Does the American artist differ from his French contemporaries? In such discussions, we are, of course, limited by the fact that our familiarity with the French art of today is confined to the work brought back by 57th Street's gallery directors, and to the necessarily suspect exhibition sent to the Whitney (suspect because we know how unrepresentative official exhibitions of American work usually are.) But, piecing together what we have seen with what we are told by recent visitors to France, I think we can begin to answer the questions that have arisen.

First, two qualifications. For one, there is no sense in setting up a straw "American School" to counterbalance a nonexistent "School of Paris." I agree with Paalen's statement that there has been no School of Paris in this century except as it existed in the propaganda of those who would compete with the couturiers. My second qualification is that we cannot speak of a national school of modern art, for modern art can no more be national than can, say, nuclear physics. The new concepts and philosophies of art are diffused throughout our close-bound world. Not only can we learn from each other regardless of distance, but it happens often, in art as it does in science, that independent researches lead to similar conclusions. In my own experience, two such instances come to mind. My paintings developed with the use of frottage techniques, done in the United States during the 1930s, and Ernst's similar work done in Europe (each unknown to the other), were very close in results. Another instance is that when I first came to this country, I was classified as a surrealist; yet I had

This article originally appeared in *The Tiger's Eye* 2 (December 1947): 42–46.

never been in Paris, nor did I know of nor subscribe to the beliefs of any of the surrealist groups. My work stemmed from the Russian school of Filonov who, isolated from and antedating the surrealists of western Europe, had developed a philosophy of art which impinged at many points on theirs. The symbolism of Filonov's "Analytic School" was expressed in paintings which were built on the theory of development from "point to point," growing in time as well as space. Bimorphic as well as psychological, it was related to, although independent from, surrealism. For these ideas were "in the air," "of our time," and national boundaries were no deterrent.

Should we, then, expect to find any difference in the art produced on opposite sides of the Atlantic? Is there, in fact, any difference? And if so, why? I think that the answer to the first two questions, to a certain extent, is—yes. I feel that the group of modern artists who are working in this country are doing a job of integrating the new forms and techniques with the new content, a job which so far as we know, is not being done at present in Europe. It may be that the artists overseas are too close to the holocaust of war or too busy with their battle for the everyday necessities of life. Perhaps the artist in this country is closer to the stimulus of new technical and scientific developments. Of course, environment has always shaped the emotional man as much as science persuades the thinker—and the artist must be both. Therefore, the artist living in the United States must be expected to differ from others to the extent that he is affected by the cults of efficiency, speed and mass production with which he is surrounded, the ever-present indications of a mechanized world; even in the shop of a small-town shoe mender one finds America's complex machinery. Whether the American artist expresses the destructive power of science or the hope inherent in its wiser uses, whether his personal vision is gloomy or optimistic, it is here that he lives closest to the new "subject matter." Whatever the reasons—the stimulus of new technical development, better economic environment, Europe's war-weariness which gives us a chance to "carry the ball," or others that I have not mentioned— whatever the reasons, it seems to me that the artist in America is going into a period of synthesis, of integration, which the European artist has not entered on as yet.

Barnett B. Newman

An artist paints so that he will have something to look at; at times he must write so that he will also have something to read.

Theodoros Stamos

I am concerned with the Ancestral Image which is a journey through the shells and webbed entanglements of the phenomenon.

The end of such a journey is the impulse of remembrance and the picture created is the embodiment of the Ancestral World that exists on the horizon of mind and coast.

Adolf Gottlieb

Certain people always say we should go back to nature. I notice they never say we should go forward to nature. It seems to me they are more concerned that we should go back, than about nature.

If the models we use are the apparitions seen in a dream, or the recollection of our prehistoric past, is this less part of nature or realism than a cow in a field? I think not.

The role of the artist, of course, has always been that of image-maker. Different times require different images. Today when our aspirations have been reduced to a desperate attempt to escape from evil, and times are out of joint, our obsessive, subterranean and pictographic images are the expression of the neurosis which is our reality. To my mind certain so-called abstraction is not abstraction at all. On the contrary, it is the realism of our time.

Mark Rothko

A picture lives by companionship, expanding and quickening in the eyes of the sensitive observer. It dies by the same token. It is therefore a risky and unfeeling act to send it out into the world. How often it must be permanently impaired by the eyes of the vulgar and the cruelty of the impotent who would extend their affliction universally!

Herbert Ferber

The sculptor is too often seduced by form; space is the unlimit of his medium. Surrational space, charged with form, sprung, tense as a steel coil, from those layers of being not subject to the censorship of verisimilitude. Space and form take shape concomitantly in creating an arena where the creative personality of the artist is in anxious conjunction with his perception of the world about him.

In this language, as with all creative activity, the idea is integral to the form and form molds the idea in a vortex which congeals, at last, in a way impossible to predict, but completely controlled by the artist.

Such activity precludes the artisan's absorption with materials used according to fetishistic prescriptions of rightness or contemporaneity. The right "materials" in a sculpture are the intellectual forces, the skin and bones of the artist. The "rightness" lies in his ability to fuse his surrational perception with space in a form whose only physical prerequisite is extension.

Felipe Orlando

Opinions on art are usually either very simple or very complicated. Those which are simple are always closer to the truth than those which are complex, because art, like any other human activity, finds its firmest foundation in a set of very simple ideas. This is a philosophical truth, even though it may seem strange in the light of modern complexities. I believe that, far from going further into a labyrinth, we are constantly approaching closer and closer to the simple structure of things. It is an error—and a very common error—to believe that with the passage of time we are advancing toward a complete and overwhelming complexity. Now to limit the sphere of art to a question of technique is rationally impossible, just as it would be absurd to consider it only as the expression of emotions. It is rather a question of striking a balance of these two aspects in such a way as to maintain constant observation into and of the surrounding environment, with full knowledge of the powers of expression and the best way to direct them. There is much to be said, but it can all be said simply. True wisdom, as the classics so well teach us, resides in the simplest forms.

Hedda Sterne

You are as good a craftsman as you are an artist and vice versa. If you are an artist you will find no rest until you possess whatever knowledge of your medium there is to be had. Because painting is a spinlike sequence in which craftsmanship and conception are alternatively cause and effect.

To serve your vision you have to master your technique. You cannot cheat matter. It shows. You must learn and respect its laws. You are required to use patience, courage and honesty, for instance (as prerequisites in the fight with your means, of course, not as virtues), but by the time you have tackled your problem, having used them has changed you. You have turned a corner and face new territory suggesting new ways of being explored.

Your original image appears unsatisfactory. You improve it in the name of your newly acquired understanding.

Your next point of departure is determined by the former experience

and the whole process will repeat itself with little variations, again and again.

Mario Carreño

Painting is a game of form and color that the artist spreads over a flat and bidimensional surface. A game that must be played passionately, like a bullfight, like a dangerous adventure, with the emotion of a tree in flames. In this way the artist performs the necessary exorcisms to create an object that the spectator calls a painting, but which in background is magic and mystery.

It is the magic of poetry that connects the secrets of the spirit with the blank canvas. Is there anything more mysterious than blank canvas in the hands of a painter?

Documental and descriptive painting is a cadaver that still feeds many bad artists, in spite of the photographic eye of the camera having long since killed those bad imitative habits. Some painters boast of technical ability and imitation of forms, like seals in a circus balancing a ball on the tip of the nose.

When the "orthopedic-intellectual" machinery reaches its maximum "congelation," it produces the "non-objectivism," an expression that lacks feeling and ends where painting begins: on blank canvas.

Sometimes I am assailed by doubt and I ask myself:—Will painting disappear? It is through the art of magic, like doves passing from the head to hands and the hands to the hat of a conjurer where they disappear, that painting will pass from line to point and point to nothing? At times isn't it true that a single line or point suffices to create the harmony desired on a clean surface? But, afterwards? The blank canvas? The nothing?

Fortunately the painter is always beginning his aesthetic adventure, creating harmonies with the dead butterflies and dry leaves that fall like sea birds in search of starfish, and I am sure that as long as snails are found in gardens and flowers in the sea, painting will continue to exist as a game, magic and poetry.

John Stephan

I have for years held the conviction that man lives so long as he is curious. His endless effort to solve his problems, gain happiness, and express himself are really only outward signs of a creature who is surprised with his being here—as a child is surprised—and thereupon takes more or less "the works" as it comes and acts more or less accordingly. Look at man and there plain as day he is. BUT HOW TO LOOK!

In his frantic effort to enter the game, he unwittingly abandons himself and becomes a "participant." As "participants" men vary endlessly, for the game has endless angles, becomes very involved, and is quite a predicament to find oneself in. Nevertheless, the time comes when a person once more tries to discover himself and put these illusions in their proper place. Then he realizes that man embraced illusion in order to fix himself for a moment of time and that time flies past with terrific speed without respect for his inner self which cries out for a true image of what is going on before his eyes.

In this state I am trying to paint reality.

The First Use of a Name

Ruth Stephan

The first use of a name is for identification • A name is, also, an adjective, made by the life and work of a person • Consider the critical approach in reading the sentence • *But it is vain to put wealth within the reach of him who will not stretch out his hand to take it* • if it were signed by Al Capone • by Just Susan • by Karl Marx • by Chuang Tzu • or by its true author, Samuel Johnson.

The placing of a name with a statement adds force and meaning to the words, for the actuality of the person is the reason for reading the statement • A work of art is not a statement • It is a creation, a subtlety beyond direct description, with an entity of its own, and any intrusion of personality, even of the creator, is distracting • A work of art belongs, moreover, to whoever receives it within his life • This Hepplewhite chair is now *my* chair in *my* room • That Rilke poem is now *the reader's* poem in *the reader's* imagination • Why must he drag along the name and personal association of the poet? The artist who is not a self-adorist creates for the sake of creation, for the impulse to share the impact of reality or the sweep of fancy • Why should he try to build up an importance for himself? • That is for the world to decide and to do.

Therefore, we use names as a recognition of merit, rather than as intellectual signatures, in *The Tiger's Eye*.

This article originally appeared in *The Tiger's Eye* 2 (December 1947): 61.

If the Pen Is Mightier

Ruth Stephan

If the pen is mightier than the sword, it is only because it is wielded as a pen • Its thrusts do not kill outright, its adroitness sometimes liberates, and its impact allows reaction and reflection • If it were not for this bit of fortune, Art would be an elegiac memory, for the critic who wields it as a sword permits himself to become the counterpart of the lawmaker, the mailer, the executioner • He might be astonished if he were to visualize the uninspiring static position he has acquired.

And what does the artist think of the critic who examines him so freely? • Some, like Tamayo whose painting for critics is a woman thumbing her nose, think they are irrelevant • Some, like W. H. Auden, see a specific critic, Kenneth Burke, as a brilliant and provocative aide • Some, like John Nerber in his poetic comment *The Critical Kingdom*, say:

> Nothing casts nothing up to mind:
> Kind casts gravel at like-kind:
> The brave sheep bites the thornless rose,
> The nostril wets its own sharp nose.
>
> Throat cries hush to silent throat,
> Earth would on the water float.
> The Eye sees mirrors everywhere
> Reflecting beams that curse the air.
>
> The nets seine deep the empty tide
> For birds which in the current ride,
> While overhead there swims the swan
> That in another age had sung.

This article originally appeared in *The Tiger's Eye* 3 (March 1948): 75.

The critic, if he is to be respected, must prove his value as a wise observer • He must have the perspicacity to see that Art is greater than any of its talkers, and that in attacking it he is negating his *raison d'être* • He must have the courage to project himself alongside the artist in new propensities, recognizing that newness is not pursued for its own sake, but that there still is something to be found.

The Essence of Tragedy

Nicolas Calas

Tragedy was born out of the need to oppose individual destiny to necessity. The turns of the wheel of fortune, Herodotus used as leit-motiv in his History, obliged the free individual of the Greek city to strengthen his position by giving a new meaning to solidarity, historical rather than religious. Consciousness of the historical importance of individual tragedy could only come into existence through an assimilation of religious solidarity to the vicissitudes of individual fortune. This higher concept was reached in Palestine when Hellenic ideas penetrated the Hebraic world. When Jesus in Gethsemane implores God saying: ''If it is possible let this cup pass from me,'' what he is asking for is the right not to be compelled to personify the destiny of his race and to immolate his life. When sacrifice of one's life becomes the goal of existence, as was the case with Jesus, then it has to be examined psychologically and in relation to self-confidence.

It is because individualism is grounded in self-confidence that the individual who has extreme self-confidence and great will power can rise above others and become a hero. However, the hero's self-confidence should never blind him to the fact that, as an individual, he, like all mortals, remains exposed to the vicissitudes of fortune. The hero knows that he always runs the risk of becoming a victim. If Jesus' situation in the Garden of Olives is tragic it is because he saw no way of escaping from the dilemma of either having to abandon the cause he fought for, or of being condemned as a rebel. To fight against injustice and to be punished by death for doing so, shocks our sense of justice. The only way left to overcome injustice is by sanctifying the victim and turning the punishment into a sacrifice. Through sacrifice a historical solidarity is established following the pattern of the totemic sacrifice. Through the sacrifice of a

This article originally appeared in *The Tiger's Eye* 3 (March 1948): 112–14.

historical figure such as Jesus of Nazareth, a brotherhood in time is created. The historical meaning of Jesus' sacrifice was further enhanced by making it assume the proportion of an unparalleled event. The Apostles, by proclaiming that Jesus' abnegation could not be compared to that of any other man, gave to his sacrifice a unique meaning. What mitigates the horror of Jesus' sacrifice is its *religious* meaning. Jesus' sacrifice is not tragic because the anxiety felt at his crucifixion is overcome by the joy of the resurrection.

Unlike religion, tragedy confines itself to examining sacrifice in relation to history and psychology. It is both because the central theme of tragedy is the individual destiny and because consciousness of one's personal destiny is a problem of self-confidence that tragedy, in the last analysis, becomes an interpretation of freedom—freedom being the realm in which self-confidence manifests itself.

Unlike the juridic view of freedom which limits its appreciation of the individual to his ability to *execute a contract*, the tragic view extends its appreciation to an examination of circumstances that led the individual to *fail in his purpose*. The juridic view of freedom is a *perfectionist* one for its final criterion rests upon an appreciation of the quality of the labor spent in execution of the stipulations of the contract. The tragic view on the contrary, is *historical*, it includes in its scope an appraisal of factors that prevented the individual from accomplishing his task.

The tragic view is the loftiest by which freedom can be evaluated, for it appraises it in relation to sacrifice, and the greatest sacrifice is the one made by the most heroic man, the most heroic being the freest—the one who has the greatest will. The greatest hero will always appear to be the man whose end seems the most unjust.

Tragedy, being historically minded, must include in its survey an examination of the relationship of freedom to necessity. Jesus, after asking that he be spared from the ordeal of drinking from the cup, hastened to add: "nevertheless not as I will, but as thou wilt,"—an idea which he restates shortly after again: "if this cup may not pass away from me, except I drink it, thy will be done."

Because, historically speaking, freedom is not, as theology teaches the expression of the will of God but a consequence of self-confidence, the necessity of freedom is grounded on the necessity of self-confidence. Self-confidence derives from the necessity to empower the individual who has acquired property with the legal guarantees that his will shall be respected. The economic need to provide the individual with a will leads to viewing him as a person who must be free. That is why, when seen from the point of view of the pressure of society upon the individual, the man gifted with the greatest will power can find himself forced to become a hero in spite

of himself. To become conscious of this position and to accept to assume the role of a hero is tantamount to adopting the theory of freedom-servitude advocated by Dante in *De Monarchia*. To serve, but to serve reluctantly, that is to say without being able to change resistance into will was the role the Greeks attributed to Agamemnon. To become a hero and to lead the Greeks to Troy, Agamemnon had to make the sacrifice of offering his daughter to the gods. But he did so under compulsion. Religion, through the example of Jesus, was to teach that sacrifice could be accepted voluntarily. Jesus internalized sacrifice and metamorphosed it into abnegation, while Abraham only internalized necessity and transformed it into servitude. Midway between Agamemnon and Jesus stood Socrates who avoided sacrifice by committing suicide, thus escaping tragedy. Socrates refused to perish as a tragic hero must do, a victim of injustice, but died as a stoic who, unto the last, succeeds in retaining his freedom of action.

While religion, through the idea of servitude, transforms will into a tool of a divine necessity and thus overcomes the conflict freedom-necessity, tragedy accepts the conflict. The lesson of religion is "Serve!"; the lesson of tragedy is "Challenge! . . . overcome the feeling of fate by proving to yourself that you are free enough to do something greater than the common man can do." Religion minimizes freedom and tragedy, both by reducing the importance of mortal destiny and by divorcing will from ego in order to bind it to the will of a master. It is because the will of a religious man is the will of another that the saint is not a real hero. It is this other who tells the saint what is good and what is evil. It is his faith in this order that forbids him to doubt. Doubt is not the consequence of faith but of self-confidence. Only there where doubt exists does temptation have meaning. Through self-confidence and doubt the hero challenges temptation.

The Ides of Art: Fourteen Sculptors Write

Hans Arp

The Measure of All Things

Man behaves as if he had created the world and could play with it. Pretty much at the beginning of his glorious development he coined the saying that man was the measure of all things. Then he quickly went to work and turned as much of the world as he could upside down. The Venus de Milo lies shattered on the ground. Man has measured with the measure of all things, himself, measured and presumed. He has tailored and pruned away at beauty. This cutting to measure gave rise to a fashion shop, the fashion shop gave rise to madness in all its forms. Confusion, unrest, nonsense, insanity and frenzy dominate the world. Foetuses with geometric double heads, human bodies with yellow hippopotamus heads, fan-shaped monsters with trunks like elephants, stomachs with teeth on crutches, corpulent or emaciated pyramids with dragging feet and tears in their eyes, clods of earth with sex organs, etc., have appeared in painting and statuary.

Beauty Has Not Vanished beneath the Ruins of the Centuries

When the personality, the intellect, philosophy arose from the legendary depths of mythical humanity, when nature was discovered by man, when "the earth, the wavy sea, the moist air and the Titan Ether," were solemnly sung, beauty dwelt naked among men.

In every century beauty changed. Beauty did not vanish beneath the ruins of the centuries, it vanished into the Maya, into the mirage. So many rare and priceless garments had been showered upon her, she no longer knew in which to show herself.

Which is the original image of beauty? Which is the image "of beauty's gushing fountain, the picture that flows from the source . . ."? Is it the

This article originally appeared in *The Tiger's Eye* 4 (June 1948): 73–84.

naked corporeality of the Greeks, is it the disguise, the veil, the pageant of the Renaissance, is it the disembodied yearning of the Gothic, is it our cube and sphere, is it the love of which Empedocles said: "There were no two arms extending from a trunk, nor were there feet or swift knees or organs of procreation; there was a sphairos, the same in all its aspects."

Alexander Calder

It's a far cry back to my first visit to Paris, in 1926, and a seance in the sketch class of the Académie de la Grande Chaumière. A young lady from one of the Southern States entered the room, and cried out "I don't know which it is, but I want to etch or sketch."

Most of the time ever since I've felt pretty sure that I knew what I wanted to do—but for the past few weeks I've been rather in the predicament of the above young lady—for, for the past several weeks, I've been making etchings—and what with the acid spots, which itch, and the black of the "ground" all over my hands, the stickiness of everything, and the mass of dirty rags and newspapers, to say nothing of the fire hazard, I feel rather as though I were once again in the "black gang" of a ship (in which capacity I once worked my way to San Francisco—we were supposed to go on to Honolulu, and then back to the West Coast— but the ship's officers and I agreed that I would do best to stay in San Francisco on the first visit).

On a few occasions, quite long ago, I have witnessed etchers rubbing and caressing their copper plates, with what might have almost passed for affection. But I have been content to spit on the plate, and then dump a little acid on it, and then watch the solvent and the dissolvent fume and bubble, all the while tickling the plate, and brushing away the bubbles, with a partridge feather.

In my instance the removal of the ground, of which I almost invariably had a thick black slab, often with great lumps, was the grimiest part of the operation. So much so that at the last I did a dozen or more plates, and let them pile up, and then cleaned them all at once.

At the outset I managed to get a few trial proofs—but since then I have been navigating on dead reckoning—and I am still to see proofs of the last 15 or 20.

However, in spite of all this lamentation, I have quite enjoyed the whole thing.

Mary Callery

Spring—days of freedom, best wishes, accompanied by lilies of the valley— freedom, essential in the arts, and yet only possible through frustration—

repeated giving and being caught up—the achievement of country, of beauty, of growing things—fields being planted, green, newborn—everywhere, but if one grows with it, then a slap, no, it is awkward. We are not like plants, no turning to the sun, no triumph of being watered at night and standing straight up afterwards. Our standing up must be sublimated, must be along orthodox lines. It must be tangible, understandable, visible—and indeed it will be.

Herbert Ferber

On Sculpture and Painting

There is something about contemporary sculpture, its extension in space, its body, its three-dimensionality, which captures the attention on a level other than the imaginative, and which must be dealt with in a physical sense. The piece of sculpture possesses attributes which tend to give it existence in a prosaic sense, to put it in the same category with other bodies in space—bottles, tables, people—a category which lacks the values of art. This contradiction between the sense relationships of everyday life and the demand that the piece of sculpture be experienced as creative expression confounds the audience and instead of facing the difficulty it turns to examine the pictures on the walls as an easier task.

The paintings are not problematical in this way; in fact, they have just the opposite effect, even when they are nonillusionistic, "polyphonic," flat. For in order to look at them, one turns his back on the room and escapes not only the fact of mass, of presence, but also the physical embodiment of idea.

In order to examine sculpture one must return to the room where the very extension of the sculpture heightens the feeling of enclosure and stresses the material contiguity of observer and object. Painting empties the room, since the eye is directed out of it. The painting transcends the room, it floats somewhere between floor and ceiling. It is never identified with the wall since its lack of mass and its unequivocal appeal to the imagination make its convention more easily understood. Sculpture is more difficult to grasp as fantasy, because its mass encourages the fallacious assumption that it is an object of common use.

It is true that both the sculpture and the painting have no value except as image, as fantasy, but the sculpture because it is so palpably object is not given credence as image. As image it violates the very rationality which its extension calls into being. The painting avoids this dilemma because it is either a window through which the eye may look or a surface over which the eye may wander without drawing the spectator into a physical relationship with the picture. Sculpture does precisely this.

When sculpture still belonged to a hierarchical order it was easier to deal with since without being functional its use was defined, the convention understood, and in spite of it "image" quality it could be looked *at*. Its substantiality did not intrude upon the observer and like painting it found itself on the periphery of the space. But a modern piece of sculpture cannot be looked *at* in this way and thus be removed to the edge of the frame of reality. It must be evaluated as a thing in itself which is moreover a poetic image. An image not defined, a priori, within a hierarchy, but which must be engaged, penetrated, surrounded. The observer becomes involved physically, must come to terms with it materially, in order to experience its symbolic attribute. The glance cannot merely play over the surface, for there is a kinetic compulsion to enter the volume. Not only the eye, but the hand is thus authorized, in fact, enjoined.

Painting is a direct communication since the medium has no prior commitment to the experienced. The concreteness of the sculpture, however, demands a twofold effort by the observer to attain the level of imaginative participation. Its presence challenges its imagery because it must be touched. This has become the problem of the audience in its relation to modern sculpture.

But it has also become the problem of the sculptor who contributes to the dilemma when he is seduced by the beauty of the object; when his surrender to the pleasure of the material, the contour or the line, imposes upon him the esthetics of the artisan. To the artisan the function and the beauty of the object are rightly of primary concern, but his perspectives remain traditional and academic and are totally opposed to those of the artist who creates the tradition. When the sculptor assumes a fetishistic attitude towards his material, whether stone or steel, he enforces the spectator's unconscious acceptance of the work on a lower level than the imaginative.

The history of art is the history of men whose strength lies in the capacity with which they force the material to take on, to become the idea. When the sculptor has achieved the transmutation of the material into an image in the immediate and intimate way proper to his own artistic personality, the audience will see—a work of art. When he has done less he will have produced—an object.

Alberto Giacometti

It was not anymore the exterior of beings that interested me but what I felt *effected* my life. During all the previous years (the period of the Academy) there had been a disagreeable contrast for me between life and work, one prevented the other; I found no solution. The fact of wanting

to copy a body at a fixed hour and a body, by the way, to which I was indifferent, seemed to me an activity that was false at its base, stupid, and which made me waste many hours of my life.

It was not important any more to make a figure exteriorly lifelike, but to live and to realize what moved me within, or what I desired. But all this changed, contradicted itself, and continued by contrast. A need also to find a solution between things that were full and calm, and clear and violent. Which led during those years (1932–34 approximately) to objects moving in opposite directions, a kind of landscape-head, lying down, a woman strangled, her jugular vein cut, construction of a palace with a bird skeleton and a dorsal spine in a cage, and a woman at the other end. A layout for a large garden sculpture (I wanted that one to walk, sit, and lean, on the sculpture). A table for a hall, and very abstract objects brought me by contrariwise to figures and skull-heads. I saw afresh the bodies that attracted me in life and the abstract forms which I felt were true in sculpture. But I wanted the one without losing the other (very briefly put). A last figure, called $1 + 1 = 3$.

And then the desire to make compositions with figures, for this, I had to make (quickly I thought) one or two studies from nature, just enough to understand the construction of a head, of a whole figure, and in 1935 I took a model.

This study should take me (I thought), two weeks, and then I should realize my compositions.

I worked with the model all day from 1935 to 1940.

Nothing turned out as I had imagined. A head (I quickly left aside figures, it was too much) became for me a completely unknown object, one with no dimensions. Twice a year I began two heads, always the same without ever ending. I put my studies aside. (I still have the casts.)

Finally, in trying to accomplish a little, I began to work from memory. This mainly to know how much I retained of all this work. During all these years I drew and painted a little, most of the time from nature.

But wanting to create from memory what I had seen, to my terror the sculptures became smaller and smaller, they only had a likeness when very small, yet their dimensions revolted me, and tirelessly I began again and again to end, several months later, at the same point.

A large figure seemed to me untrue and a small one intolerable, and then often they became so very small that with one touch from my knife they disappeared into dust. But head and figures only seemed to me true when only small.

All this changed a little in 1945 through drawing.

This led me to want to make larger figures, then to my surprise, they achieved a resemblance only when long and slender.

And it is almost there where I am today, no, where I still was yesterday and I realize this instant that if I can draw easily all sculpture I could only with difficulty draw those I made during these last years; perhaps if I could draw them it would not be necessary to make them, but I am not sure about all this.

Peter Grippe

Art is a universal language but if one does not possess the vocabulary, communication cannot be effected between the artist and the spectator. Moreover, each art medium speaks through its own idiom and cannot be conveyed through verbal explanation without losing the essence of its being. The aesthetic experience inherent in music, painting and sculpture cannot be described in words any more than literature and poetry can be experienced through commentation. As a sculptor, sculptural symbols become the idiom through which I communicate my ideas in terms of universals. I seek to express the life rhythm which is ever-changing, ever-growing, and to use my forms to make manifest this life energy which I call "movement" by penetrating the form to achieve transparency in depth and through using space as a positive volume, organized within an architectural framework. The symbolism that is implicit in the form is the key to the aesthetic experience, and by recreating the symbols the spectator thus is able to participate in the artist's creative endeavor, and thereby their life is made more intense and meaningful. Thus art fulfills its ultimate purpose.

David Hare

To my mind a sculpture, a painting, plastic work in general, should express the utmost of reality. That is to say not the sections and pieces which go to make up a landscape or a human figure; and when put together in the same way as we recognize a photograph of a friend (the photograph itself will contain none of the qualities which cause us to call this or that one friend). However the abstract idea of (friend) somewhere has a plastically expressible reality. It is these and other comparable realities which I should like to put into sculpture. To express (the thing itself) and not the object, which is merely the wrapping, nor the graphic symbols for the object, which are merely communication. The fundamental problem is the relation of man to the outside world and of man to himself. These relations are naturally incomplete either in the man or in the object, but tend to approach a solution during the interval of meeting and communication between man and object. It is this third presence continually being con-

ceived and then surpassed and then conceived again which is to me of the most interest.

Richard Lippold

I to Eye

To be profound, and as transcendent as the memory of a natural phenomenon, as eternal as great works of the past, our art—despite its revelation of the tentative—must possess a sound structure and secure formality. Dreams, discoveries, accidents, automatics—these are not enough for either life or art and its materials. From the invitation to love to the intent to kill, consciousness enters into man's ability to organize his life (and his art): this is his chief nobility.

The first essential, then, is clarity of structure. Every line, every color, every sound, every word, every stroke in its correct place for the given situation. Further, to be clear the image must be *of* the material. A sound is not a cloud, a word is not a color, a line is not a tree. Each of these is itself rather, and bears within itself and its relations to its fellows all the relationships possible in any natural situation, whether between people (or their parts), things, or ideas. Growing from a clear use of form is the expression of the tensions of reality through the relationships of the structural elements to each other.

The true test of man's intellect, understanding, and imagination lies in this area of solving the problems of the work of art. In thus ordering the elements of a craft so precisely as to be measurable mathematically and with so sensitive a relation of the parts to each other as to make them reproduce the essential relationships of life and nature, the artist does not create a personal symbol, which always lacks clarity or total conviction, but rather a wholly new image in which the shape, the medium (the tools and materials) and the meanings are one. Anything less clear in structure or impersonal in image is less than art.

A nightmare cannot be lived; to attempt it involves charlatanism or insanity: both are found on the road to Hell (oblivion), even if well-intended.

The road to the security in peace which is Heaven is constructed rather, not found. When image and meaning are sifted into one, and medium and symbol are disjoined, the work of art can suggest the higher reality which is man's final contribution to understanding of himself and his existence. To the pure mystic may belong the existence of eternal peace. To the artist must belong the more tense but active faith in his ability to suggest this peace.

To know that he is—for his life—in this tremulous state of suggesting

(suspended between external and internal perceptions) is at once his despair and his ecstasy.

Jacques Lipchitz

I don't see any difference between painting and sculpture. They seem to me like two kinds of instruments playing the same music. It is the music which is of importance.

I don't feel any connections with Idols. My sculpture is as far away from them as, maybe, Rodin's sculpture from the Venus of Willendorf, or the paintings of Cézanne from the paintings of the grottos of Altamira.

I believe in progress and by this I mean in emancipation, in the greatness, the power of man, in his mission on earth.

I feel that I am working to this end with the means that were given me.

Seymour Lipton

The Web of the Unrhythmic

There is something sharp and demonic in the pattern of contingency and strife in the world, a dramatic energy in the unexpected, in the web of the unrhythmic. To the world of order and balance, the imponderable must be added.

These things give a strange completeness to the world. The art that reflects the delimited niceties of nature, that presents clear-cut visual actualities, the journalistic, the ideal—lacks, I believe, the vital energy of the dream, of beauty and of life.

Out of the welter of strivings and forces I look for new sculptural organisms built from the anatomy, the physiology, the evolutionary insides of man as well as his surface realities. I look for a sculpture that assumes its proper aesthetic distance and dignity. I look for an emotion, a meaningfulness that will hold in time. I look for the rich afterglow that grows from the mysterious completeness of things—of the wild waves never breaking twice in exactly the same way against the rocky crags.

Isamu Noguchi

Perhaps it is the memory of my childhood in Japan that gives me my appreciation for space and the conviction that the public space in which we live must be ordered by the sensibility of the artists. There in Japan, as well as in China, the human ordering of nature creates vistas where none were before. Shotoku Taishi who brought Buddhism to Japan was a

sculptor. The sculptor orders and animates space, gives it meaning. This order and meaning, I think, must be in terms of our time and its particular spirit.

The jeopardy to human individuality presses in from every side. While "industrial design" replaces handcraft, what is more serious for the artist, and ultimately for us all, is the similar dehumanizing process which continues to widen the gap between every "creative" impulse and the consumer. To bridge technical ability to human psyche is the insuperable job of artists today.

I take the role of the sculptor to be of an entirely different sort than painting. It exists in space a new being, giving space its new meaning. It is matter made human, the world made livable. If the first weapon had no meaning until fashioned by sculpture, neither has the atom.

Helen Phillips

In the face of opposition, in the midst of insecurity, among conflicting directions and ideas, one grasps an image.

And although it is denied even by oneself, it remains.

Ignored, it asserts itself. Rejected, it camouflages itself and returns. Condemned, it becomes an obsession.

It is the recognition of a moment, a moment that recurs again and many times with different faces.

The image is my stability. The moment there is the evidence of touch and sight that the image exists it becomes another planet in an unshakeable solar system and the world can safely revolve on its axis.

David Smith

The Golden Eagle—A Recital

(To be spoken only by one who is politically white, yellow, blue or black, who hath not touched women and who hath not eaten flesh of animal or fish)

Marvel! Where was it ever before said such a thing was done
Have I not filled thy temples with spoils
Have I not made thee many and great buildings of stone
 from far lands
Are not the towers guarded by flying phallus cannon
 The rapists of maidens
 The suckers of blood
 The crushers of bones

throughout the ages
Have I not made these towers with iron from Mesabi and Lebanon
With molten glass from the heat of man's brow
the earth around
With granite from Sinai
With blood from the greatest gutters
With obelisks from Abon
Have I not lighted these wonders with tungsten from China
Sacrificed virgins to bells
Coolies to ore
Have I not launched boats upon the sea to bring the finest of oils
And into the air, birds for bulbs—fragrant in bloom
Have I not confounded all who have resisted my designs
And chastisest the foreigners, and bow their backs forever
Do I not return peacably to the towers of stone
protected by bird cannon
Leaving in the four corners of the earth, the heavens and the underworld
the terror of my aims
And is not there a constipate dependent upon my oil
Who can say an age has passed, and I have not
left my mark

Robinhood's Barn

Little nodes from big nodes spring
And make great the progeny thereof
Paters love and the transfixed gate
Sold shad that should be for free
Rise and shine come out of the wall
By a nose approach the temple by going forth
Men are vermin slithering on Sekhets belly
Behold the staff which blossoms
I am Tem the tree
The might of my strength is in my hand
Lonesome and blue here I stand
I am the dog headed ape in a golden palm
With a golden hind, parting the curtains
Looking for the tunnel to Memphis.

Ossip Zadkine

Prolegomenes to Sculpture

Sculpture as an independent event appeared under our planet's light much later than the realm of object-sculpture.

All things palpable existing as objects are to be considered plastically alive.

The metamorphosis undergone by our planet, once liquid and mobile *magma,* and afterwards becoming concrete objects—continents, objects—mountains, and objects—sand particles infinitesimal, has already projected into existence a new notion: an object is uniquely alive because of light projected upon it. Thus the world of ours has appeared one day crowned and inhabited with the most wonderful looking objects, fascinating in their variety of profiles and forms—unorganized.

Billions of years have passed and flooded the concrete objects with the wild daylight, some violent, alive, burning—others tender, soft, crepuscular, and precipitated them next into night and nonexistence.

Sculpture as an event was not born yet.

Man unprotected and persecuted, driven deep into caverns, had to find means of protection and attack, and to keep on being alive. The sharp-edged pebble, once polished and organized into a concrete object-weapon, must be considered as the first overwhelming revolution.

Geology with its depthless rhythm of declination from the infinite to the finite; from then on a new world of precise space, limited objects with an enchanting rhythm of forms, full of hearths and conflagrations, mysterious flowers of human brain flora, all stamped with a passionate determination to organize the accidental—the chaos.

Never "seen" strange objects, born of the same mother matter, have grown little by little along the wild plains against savage hills and mountain slopes, out of the same granite beds, beaten and kissed by the antique Helios, out of the same line and marble matter, but strangely perpendicular, rounded and polished into shining surface forms.

Forms

Limited space carefully aligned and "brought together consciously" organized into matter-beings, and animated with an unsuspected life; a new unheard of life—nonanatomic, noncellular—a new life of organized forms and lines, profiles, concavities, holes and convexities embraced with matter, contoured with forms turbulent and bursting with a new, savage will.

The blind, silent rocks, the tenderly sloped hills, and the magnanimous mountains drunk with mist and clouds stood still in amazement in en-

circling silence around these new stony beings, sinking deeper into their inanimation.

The old antique winds, after caressing their grey and beaten heads, rushed with vigor to these new entities, whistling their free and violent chants.

Then the great sun would come and lick them with its warmth and light, awakening these forms into new life, as if respiring and singing with a thousand quartz eyes.

Very little time-light has passed since then; the termite-minded humans have gathered some of these stone objects-sculpture into closed and polished prisons, where some impoverished light comes in now and then. Seldom does the eternal sun visit them in their eternal dreams. They are there in so-called spacious rooms, half-abandoned, forgotten, except for some sleepy visitors, heavy with indifference, that must come and glance at them without seeing the misery of the imprisoned gods.

But there are other rare ones who understand their meaning; they come with condensed love and passion, to visit these forgotten splendors and with unfevered hands they caress their forms and their fingers linger unendlessly along their sharp unpolished profiles, as if they were blind man's fingers trying to read their mystery and never dying wisdom.

Then these few rush home to their rooms, as if persecuted by a charm; and they try to ''create,'' restore the essence of that cognizance emanating from those objects-sculpture.

Their rooms become little by little crowded with so-called strange and enigmatic objects, new ''unseen'' objects, as were those hatchets of the cave man. For those strange enigmatic objects have the same perfection of execution, the same spirituality and beauty, that is depth of sensitivity and purity of conception. They are ''abstract''; that is, they are organically separated from the visible, usual, insisting uttermostly on the vital necessity of expelling a new, another world out of man's incandescent imagination, pregnant with the wisdom and signs of their inner vision.

Hence, man, the new man, follows also the antique pathway where he meets his anonymous predecessors; thus object makers, and in this great spacious world of indifference, eternal slaughter, and mediocre strivings, he marches no longer alone.

[Statement]

William Baziotes

to be inspired, that is the thing.
to be possessed; to be bewitched:
to be obsessed. that is the thing.
to be inspired.

This statement originally appeared in *The Tiger's Eye* 5 (October 1948): 55.

The Ides of Art:
Six Opinions on *What Is Sublime in Art?*

Kurt Seligmann

Often, when I see great works of art united in a public show—such as the Bellini, the Carpaccio, the Castagno in the Berlin collection—I am shaken with anxiety and an unaccountable shame. The exalted sentiment which they enkindle within me threatens to imprint upon my bodily appearance an expression which, when compared with my well-behaved surrounding, must seem awkward if not comic. A friend of mine jestingly calls this reaction my *museum disease.* I walk several times rapidly through the exhibition fearing that a closer scrutiny of these paintings might overwhelm me. The sentiment of restraint, however, is followed by expansion, a feeling of exasperation and defiance. I imagine a complicity, a message concealed in these masterpieces for me alone. In a state of meditative exaltation which I am unable to describe I contemplate, fathom the paintings. They convey a sentiment with so much energy and an intensity of expression that nothing seems to be conceivable beyond. In such moments of elevation the only regret is that I am incapable of imparting my sentiment to others. I resemble somewhat the Norwegian fisherman in Poe's tale of the *Maelstrom.* Plunged into the colossal whirlpool and seeing no possible escape from certain annihilation he sets aside his anguish, aware of his pettiness amidst the grandiose, the unheard of spectacle. His only regret is that he cannot return to his fellow-men and tell them of the Sublime which he has witnessed in the abyss.

This article originally appeared in *The Tiger's Eye* 6 (December 1948): 46–56.

Robert Motherwell

A Tour of the Sublime

The Sublime I take to be the emphasis of a possible felt quality in aesthetic experience, the exalted, the nobel, the lofty, "the echo of a great mind," as the treatise formerly ascribed to Longinus phrases it.

The history of modern art can be conceived of as a military campaign, as a civil war that has lasted more than a hundred years—if movements of the spirit can be dated—since Baudelaire first requested a painting that was to be specifically *modern* in subject and style. Perhaps the first dent in the lines of traditional conceptions was made by the English landscapists and by Courbet, but the major engagement begins, earlier means being now obsolete, with Manet and the Impressionists who, whatever their subjective radiance and rhythms, represent objectively the rise of modern realism (in the sense of everyday subjects), that is, the decisive attack on the Sublime. . . . The story is interesting if the essence of their goal is taken to be a passionate desire to get rid of what is dead in human experience, to get rid of concepts, whether aesthetic or metaphysical or ethical or social, that, being garbed in the costumes of the past, get in the way of their enjoyment. As though they had the sensation, while enjoying nudes in the open air, that someone was likely to move a dark Baroque decor into the background, altering the felt quality of their experience. No wonder they wanted to bury the past permanently. I pass over how remarkable it seems to some of us that small groups of men should have had, for a century or more, as one of their ideals getting rid of what is dead in human experience.

A true history of modern art will take account of its innumerable concrete rejections. True, it is more difficult to think under the aspect of negations, or to contend with what is not stated. But this does not justify the history of an indirect process being written under the category of the direct. I do not see how the works of a Mondrian or Duchamp can be described apart from a description of what they refused to do. Indeed, a painter's most difficult and far-reaching decisions revolve around his rejections.

Suppose that we assume that, despite defaults and confusions, modern art succeeded in ridding us of the costumes of the past, of kings and queens and the glory of conquerors and politicos and mountains, rhetoric and the grand, that it became, though "understood" only by a minority, a people's art, a peculiarly modern humanism, that its tactics in relation to the general human situation were those of gentle, strong and humane men defending their values with intelligence and ingenuity against the property-loving world. One ought not over-simplify; if humane men would doubtless agree with the character in Dostoievski who holds that no gain, social or military, can be equated against the life of a single child,

nevertheless I take a murderer by profession like ''Monsieur Verdoux'' to fall under the heading of the gentle, strong, and humane, that is to say, it does not astonish me that the effort to be gentle and humane involves one in murder. Indeed, without trying to present a paradox, but simply in an effort to be phenomenologically exact, and speaking apart from times of war, one might say that it is only the most inhuman professions in modern society that permit the agent to behave nicely in everyday life and to regard the world with a merry and well-glassed eye.

When living Ulysses meets in Hades the shade of Ajax, from whom he had won the armor and set on the course that led to Ajax's death, Ulysses expresses his regret; but Ajax ''did not answer, but went his way on into Erebus with the other wraiths of those dead and gone.'' One has not the right from one's anguish to bring to the surface another's anguish. This must be the meaning of the first century A.D. treatise on the Sublime when it says: ''The silence of Ajax in *The Wraiths* is inexpressibly great.'' Otherwise it can only mean how terrible is being dead.

Perhaps—I say perhaps because I do not know how to reflect, except by opening my mind like a glass-bottomed boat so that I can watch what is swimming below—painting becomes Sublime when the artist transcends his personal anguish, when he projects in the midst of a shrieking world an expression of living and its end that is silent and ordered. That is opposed to expressionism. So is the beauty and perfection of the school of Paris. Like the latter, all of us must reject the Sublime in the social sense, in its association with institutional authority, regardless of one's relation to beauty as an ideal. In the metaphysical sense, it cannot be a question of intent, one experiences the Sublime or not, according to one's fate and character.

A. D. B. Sylvester

Auguries of Experience

I

The last works of Klee undermine your perceptual habits. Their motifs are germinal motifs of the physical world. One motif may be a geometric pattern, another a diagram of a single object, a third the telescoped image of diverse objects. But all at root are ideograms of movement in nature.

The movement of the motifs themselves defines the fluid space they inhabit.

Macrocosm in microcosm, the world in a grain of sand, the defeat of the anthropocentric.

II

These are pictures without focal point. They cannot be seen by a static eye, for to look at the whole surface simultaneously, arranged about its centre—or any other point which at first seems a possible focal point—is to encounter an attractive chaos. The eye must not rest, it must allow itself to be forced away from the centre to find a point at which it can enter the composition—there are usually many such points, most of them near the edge—and so journey through the picture, "taking a walk with a line."

Even the most diffuse compositions in the Renaissance tradition lead the eye to a single, usually central, point of focus, a point at which all formal and spatial relations are concentrated. If any points in a Klee are outstanding, they are not points of arrival but points of departure. Their predominance is therefore ephemeral. In the long run, all points are of equal importance. Indeed, they are of no individual importance because they are only stages, fixed by an arbitrary choice, in the journey which is the reality.

Tonal music always reverts to a home tonic; thus also, a painting in the tradition of the Renaissance returns to its point of arrival. Every note of the atonal scale is equally important; likewise each point in a Klee, whose point of departure corresponds to the first note of a tone-row.

In a late Klee, every point of arrival at once becomes a point of departure. The journey is unending.

III

Many of Klee's later paintings, like most of the earlier ones, have "literary" titles. But the title is never a frame to the content, only its point of departure. As there are points of departure to the composition, from which the journey through the form begins, the title denotes a point of departure in your previous experience from which a journey through memory begins. As the physical point of departure is near the edge of the composition, the title's meaning is near the edge of the total significance of the picture. As the composition has no single point of focus, the content is never a single object or emotion or idea. Composition is distributed equably anywhere, content absorbs experience from everywhere—both as agglomeration of distinct memories and as elucidation of the common, germinal elements and movements of the remembered physical world.

IV

In journeying through a Klee you cultivate it. It grows because it is an organism, not a constructed form. Klee's method of composition is diametrically opposed to that of the Renaissance, and therefore, Picasso. For a Renaissance painting is a constructed form, it is architectural, that

is: it is three-dimensional; it has a foundation of symmetry, affirmed or negated; it has a specific focal point, a point of arrival. Klee's affinities are with Mexican picture-writing, Egyptian hieroglyphics, Sumerian cuniform signs, Chinese ideograms, and, less manifestly but very significantly, German Gothic illumination.

The order of an architecturally composed picture is apparent from the start. The evident order of a Klee is only in the parts, as with a landscape, a forest, a hedge, a crowd of people. To find an overall order, you must look for it yourself by taking hints from the given sensation. It is useless to wait for the order to affect you. You must commune with the picture and its order will become manifest,—not in space but in space-time.

A Renaissance picture is a building, an established and complete entity. A Klee is an organism in growth. A building cannot develop of itself; it can only be changed by outside forces. An organism has a future as well as a past. Likewise, a picture by Klee goes on becoming not only while he cultivated it but while you cultivate it. Obviously you need time to understand any picture, but when you have looked at a Renaissance painting for years it is only you and not the picture that has changed. To look at a Klee over a period of time is not to acquire a deeper understanding of the finished thing but to observe and assist in its growth.

V

A Renaissance picture is a scene set before your eyes. A Klee is a landscape through which you journey. Of the first you are a spectator, in the second you are a participant. One moves you to exaltation the other to communion.

To speak of communion with and participation in a Klee is not to speak simply of empathy. You can "feel-into" a scene of which you are the spectator; empathy occurs in every aesthetic experience. It is in a more particular sense that you commune with a Klee.

A Renaissance painting is a room with one wall eliminated, as on a stage or a church, the facade of which is missing. To "feel-into" it is to explore those perspectives already visible from outside. A late Klee is the face of a cliff. To "feel-into" it is to clamber over it. In the former case, you move about untouched; you can touch or caress the forms, but they remain as unyielding as statues. With a Klee, the relationship between the picture and yourself is reciprocal; you touch a loose rock with your foot, it falls from under you and you are left dangling in space. You are part of it as you are part of the sea when swimming; you plough your way through it and, in turn, are buffeted by the waves,—lines continually changing in plane and direction. For the picture is always changing, always becoming. "Character: movement. Only the dead point is timeless. In the

universe too movement is taken for granted. Stillness on earth is an accidental stopping of matter. It would be a deception to consider it primary.'' In Klee's world motion is primary. It is a world of space-time.

- A Renaissance picture has a beginning and an end. In a late Klee, the end is the beginning. The picture is limitless, like space and time. "Art plays an unwitting game with ultimate things, yet reaches them nevertheless.''

Barnett B. Newman

The Sublime Is Now

The invention of beauty by the Greeks, that is, their postulate of beauty as an ideal, has been the bugbear of European art and European aesthetic philosophies. Man's natural desire in the arts to express his relation to the Absolute became identified and confused with the absolutisms of perfect creations—with the fetish of quality—so that the European artist has been continually involved in the moral struggle between notions of beauty and the desire for sublimity.

The confusion can be seen sharply in Longinus, who despite his knowledge of non-Grecian art, could not extricate himself from his platonic attitudes concerning beauty, from the problem of value, so that to him the feeling of exaltation became synonymous with the perfect statement—an objective rhetoric. But the confusion continued on in Kant, with his theory of transcendent perception, that the phenomenon is *more* than phenomenon; and with Hegel, who built a theory of beauty, in which the sublime is at the bottom of a structure of *kinds of beauty,* thus creating a range of hierarchies in a set of relationships to reality that is completely formal. (Only Edmund Burke insisted on a separation. Even though it is an unsophisticated and primitive one, it is a clear one and it would be interesting to know how closely the Surrealists were influenced by it. To me Burke reads like a Surrealist manual.)

The confusion in philosophy is but the reflection of the struggle that makes up the history of the plastic arts. To us today there is no doubt that Greek art is an insistence that the sense of exaltation is to be found in perfect form, that exaltation is the same as ideal sensibility, in contrast, for example, with the Gothic or Baroque, in which the sublime consists of a desire to destroy form; where form can be formless.

The climax in this struggle between beauty and the sublime can best be examined inside the Renaissance and the reaction later against the Renaissance that is known as modern art. In the Renaissance the revival of the ideals of Greek beauty set the artists the task of rephrasing an accepted Christ legend in terms of absolute beauty as against the original

Gothic ecstasy over the legend's evocation of the Absolute. And the Renaissance artists dressed up the traditional ecstasy in an even older tradition—that of eloquent nudity or rich velvet. It was no idle quip that moved Michelangelo to call himself a sculptor rather than a painter, for he knew that only in his sculpture could the desire for the grand statement of Christian sublimity be reached. He could despise with good reason the beauty-cults who felt the Christ drama on a stage of rich velvets and brocades and beautifully textured flesh tints. Michelangelo knew that the meaning of the Greek humanities for his time involved making Christ— the man, into Christ—who is God; that his plastic problem was neither the medieval one, to make a cathedral, nor the Greek one, to make a man like a god, but to make a cathedral out of man. In doing so he set a standard for sublimity that the painting of his time could not reach. Instead, painting continued on its merry quest for a voluptuous art until in modern times, the Impressionists, disgusted with its inadequacy, began the movement to destroy the established rhetoric of beauty by the Impressionist insistence on a surface of ugly strokes.

The impulse of modern art was this desire to destroy beauty. However, in discarding Renaissance notions of beauty, and without an adequate substitute for a sublime message, the Impressionists were compelled to preoccupy themselves, in their struggle, with the culture values of their plastic history so that instead of evoking a new way of experiencing life they were able only to make a transfer of values. By glorifying their own way of living, they were caught in the problem of what is really beautiful and could only make a restatement of their position on the general question of beauty; just as later the Cubists, by their Dada gestures of substituting a sheet of newspaper and sandpaper for both the velvet surfaces of the Renaissance and the Impressionists, made a similar transfer of values instead of creating a new vision, and succeeded only in elevating the sheet of paper. So strong is the grip of the *rhetoric* of exaltation as an attitude in the large context of the European culture pattern that the elements of sublimity in the revolution we know as modern art, exist in its effort and energy to escape the pattern rather than in the realization of a new experience. Picasso's effort may be sublime but there is no doubt that his work is a preoccupation with the question of what is the nature of beauty. Even Mondrian, in his attempt to destroy the Renaissance picture by his insistence on pure subject matter, succeeded only in raising the white plane and the right angle into a realm of sublimity, where the sublime paradoxically becomes an absolute of perfect sensations. The geometry (perfection) swallowed up his metaphysics (his exaltation).

The failure of European art to achieve the sublime is due to this blind desire to exist inside the reality of sensation (the objective world, whether

distorted or pure) and to build an art within a framework of pure plastici-ty (the Greek ideal of beauty, whether that plasticity be a romantic active surface, or a classic stable one.) In other words, modern art, caught without a sublime content, was incapable of creating a new sublime image, and unable to move away from the Renaissance imagery of figures and objects except by distortion or by denying it completely for an empty world of geometric formalisms—a *pure* rhetoric of abstract mathematical relation-ships, became enmeshed in a struggle over the nature of beauty; whether beauty was in nature or could be found without nature.

I believe that here in America, some of us, free from the weight of European culture, are finding the answer, by completely denying that art has any concern with the problem of beauty and where to find it. The ques-tion that now arises is how, if we are living in a time without a legend or mythos that can be called sublime, if we refuse to admit any exaltation in pure relations, if we refuse to live in the abstract, how can we be creating a sublime art?

We are reasserting man's natural desire for the exalted, for a concern with our relationship to the absolute emotions. We do not need the ob-solete props of an outmoded and antiquated legend. We are creating images whose reality is self-evident and which are devoid of the props and crutches that evoke associations with outmoded images, both sublime and beautiful. We are freeing ourselves of the impediments of memory, association, nostalgia, legend, myth, or what have you, that have been the devices of Western European painting. Instead of making *cathedrals* out of Christ, man, or "life," we are making it out of ourselves, out of our own feel-ings. The image we produce is the self-evident one of revelation, real and concrete, that can be understood by anyone who will look at it without the nostalgic glasses of history.

Nicolas Calas

Veronica and the Sphinx

What was the voice of God is now called inspiration; what were the counsels of the devil is now seen as an expression of anxiety. In the microcosmic world of the psyche where are we to find the sublime? We can no longer identify it, as did Longinus, with the Plotinian loftiness or with the Hebraic *let there be light and there was light.* This "light" is too ethereal, too near the Verb, too gnostic, too aloof from the soul to be poetic. "The poetry of the sane man vanishes into nothingness before that of the inspired madman," wrote Plato. It was only given to those who descend into the bottomless pit of their soul to weave destiny into the pattern of stars while the sane men toil under the scorching sun of duty. The topology

of the sublime was traced by Edmund Burke: "Whatever is fitted in any sort to excite the idea of pain and danger, that is to say, whatever is in any sort terrible, or is conversant about terrible objects, or operates in a manner analogous to terror, is a source of the sublime; that is, productive of the strongest emotion which the mind is capable of feeling."

Unlike Longinus who, on reading the *Enneades* and the *Pentateuch,* gazed at the inaccessible sun, Edmund Burke, having ascended the supreme heights of *Paradise Lost,* pierced the crevasses of mountains of fear. It was not on Mount Olympus nor on Mount Sinai that the sublime was actually found. Kant searched for it in De Saussure's description of Alpine landscapes and discovered the difference between the restfulness of beauty and the satisfaction derived from "what pleases immediately through its opposition to the senses" which is a quality of the sublime. Tracing peaks of loftiness from the position of the mountain climber rather than that of the immortal dwellers of towering rocks, Schopenhauer found that the pleasure derived "through its opposition to the senses" is achieved through will. Equipped with will the "inspired madman" of Sils Maria, the sublime Nietzsche, broke the glacial silence of Manfred's abodes with cries of anguish. The reiterated echoes of these abysmal sounds still beat against the ears of all who live in fear and trembling.

The distance separating us from abysmal depths rather than from unattainable heights produces the alpine mirage, the confusion of levels from which we derive that sense of elevation theologians consider sublime. Burke's insight was keen enough to see the depth of the sublime, but it was Nietzsche who had the courage to taste the freezing sense of falling and experience the fateful effect of vertigo upon the course of a mind driven by the winged pair of Anxiety and Will.

As if foreseeing the coming of a new era, Balzac made his Rimbaudian Albert Lambert exclaim: "Abyss, abyssum, our spirit is an abyss which enjoys living in the abysses." To emphasize depth rather than elevation, anxiety rather than will, vertigo rather than light, the profound rather than the lofty aspect of the sublime, was the task of Rimbaud, Dostoievski, Van Gogh and Freud. With Baudelaire and Freud the sublime becomes fermented will.

To a passive surrender to perfection must be opposed sublime resistance to the temptation of falling into the well of anxiety. The need for perfection and beauty arise from a desire to recapture the lost objects of love who people the Oedipal world of early childhood. The sense of profundity corresponds to the attempt to reach this ideal goal negatively, through a vertiginous death-plunge.

The eye was magnificently turned into a microcosmic sun by Plotinus. Its rays should reach the obscurest recesses of the soul while the poet's

lips repeat: *Esta oscura noche de fuego amoroso.* But, as the poet-philosopher of Sils Maria said in his *Genealogy of Morals:* "When man thinks necessary to make for himself a memory, he never accomplishes it without blood tortures and sacrifices." Insight is no longer insight if it does not trace anxiety back to bloody crimes. Afterwards, with the help of reason, memory can stroke the tormented brow with the balm of perfection and relax the tension of the nerves with the fragrance of roses and the song of nightingales and gratify the eye with the sight of forms purified, washed of all stains of iniquity. But it will be left to the "inspired madman," to Van Gogh, to shun the tranquility of beauty and to transfigure the somber bloodstains into the brightness of stars—for them to mirror afterwards the light of poetic insight into the future.

The sublime cannot be comprehended if it is disjoined from the sense of distance. The ultimate purpose of measuring distance, the distance from Tarsus to Damascus, from Raskolinkov's room to the room of his victims, is to perceive the mirage of revelation. There would be nothing vertiginous, nothing authentic about ecstasy if it were not a mirage transcending truth and secrecy.

In an effort to overcome the endless distance of desert isolation the Sphinx received the mirror of nearness—the mirror was too keen, at its contact the eyes died of thirst. In an effort to overcome the endless distance of separation Veronica received the mirror of nearness but the contact was too keen and the image disintegrated.

Painting is the greatest of all mirages: in it, memory of blood, tortures and sacrifices is perfected, humanized and crucified, restored and resurrected. Memory or distance: how escape Chirico's vertiginous landscape, the Sphinx and the Oedipal train whistling towards its catastrophic destiny? How escape the shadows of Tanguy's totempoles and post-Euclidean crosses, and exchange his insight for the perception of our dreams?

The mirage of painting inflames our thirst!

The distance between the depth where the soul surrenders to anxiety and the lips that communicate a smile to the world cannot be fathomed any more than can the distance between crime and confession, secrecy and revelation, insight and prophecy. Sublime painting is oracular, we recognize it in the smile of the *Joconda* [sic] and of H. Bosch's *Prodigal Son,* in the irony of Duchamp's glass.

Sublime painting illuminates with inner darkness the face of Watteau's *Gil,* and Max Ernst's *Euclid,* and the oceanic depth of Wifredo Lam's jungle where a new cycle of the Sphinx's existence has been inaugurated.

Sublime painting echoes the abysmal cries of the soul in a fading smile of fermented will, in the gaze unaccustomed to the whiteness of sun and toil. One should listen to the stillness of painting with the awe with which one harkens the silence of deserts and glaciers.

Sublime painting is as secret, as silent as a concert of Giorgione, a tempest of passions in a Van Gogh night, the pain of the Laocoon, the desires of an armless Venus, the iconoclastic ''Veronicas'' of Mondrian.

It is a soliloquy of mirages—the mirage of an echo.

John Stephan

The Myth Is Sublimity

It is quite apparent, through scientific eyes, that nature performs her infinite functions without self-concern and that, barring man's preferences, she is perfect and quite determined in her own ways. She is so inscrutable that we cannot say truthfully that she does or does not sponsor or even tolerate the life that seems to thrive in her, except in the sense of a given time span; her intentions are ours to guess.

Man, on the other hand, who is perhaps the most ill-adjusted of all creatures to nature, has a unique genius in his ability to create propositions in which substantiation is sought out in nature, although, it must be added, he also seeks substantiation within himself. What does he know of nature that does not have a place in his self concerns? Logically, too, man conceived the purely abstract medium of language to create the mythical realism of his world through mutually agreed on allusion. Man's identity rests within the sphere of the mythical.

Truth is one of his fundamental myths—the proposition of whether or not a thing is so. Yet this myth is actually secondary to his aesthetic myths and his myths of faith and infallibility. Man does not pursue science primarily because it might be true, but to exercise his concern over all phenomena within his reach with the hope of deciding the fate of a myth, or of creating a new one more dependable.

The subtlety of man's thinking becomes apparent through orientation: his absolute dependence on these myths for his very being as man is much in evidence historically and in the present—remove them and man disappears into the jungle; for instance, how perfectly fitting and aesthetically true to their natures are the legends and religious myths of all past civilizations. We cannot help but marvel at their sincerity, character and invention in spite of how they differ from our own. What would remain of the past without them, or what would the present be if they had not given way to new myths?

Man has proved his love for this life which has so completely seduced and inspired him by his insatiable curiosity. He has proved his sublimity through his myths which are, in essence, his aesthetic nature.

The Sublime Issue of *The Tiger's Eye*

Ruth Stephan

The sublime issue of *The Tiger's Eye* was shaped by the idea that sublimity is the visitor of many and not the exclusive guest of the rhetorical thinker or of religiosity • There is the importance, too, of finding new symbols, for medieval definitions have long been outmoded • What is there in the old concept of sublimity to hold us in awe today? • We were told it was an "elevated beauty" but *elevation* then was abstract, cloud stratas were unexplored and were beautiful billows for the imagination to soar through • Now *elevation* means airplanes, speed and scientific achievement, the sensation of being in a cloud world has become an actuality with its own descriptions, and the sublime is again an abstraction demanding symbols for revelation.

Of the two general rooms of thought, whether sublimity is a *beyondness* signifying man as eternal, or whether it is a *hereness* denoting a reverence or rare understanding of life, this magazine readily enters into the latter • The fact of man boring thus far into eternity seems, in itself, worthy of respect and wonder, while his various personal conclusions on feeling sublime, ranging from the glory of a mountain view or of a leaf turning in the sun to repercussions of intellectual force or supreme love, are concerned with a simple wish that may be the beginning of a greater sublimity: the wish to be apart from the tawdry, the picayune, the brutish.

This article originally appeared in *The Tiger's Eye* 6 (December 1948): 57.

Forerunners of Modern Music

John Cage

The Purpose of Music

Music is edifying, for from time to time it sets the soul in operation. The soul is the gatherer-together of the disparate elements (Meister Eckhart), and its work fills one with peace and love.

Definitions

Structure in music is its divisibility into successive parts from phrases to long sections. Form is content, the continuity. Method is the means of controlling the continuity from note to note. The material of music is sound and silence. Integrating these is composing.

Strategy

As is repeated below schematically, structure is properly mind-controlled. Both delight in precision, clarity, and the observance of rules. Whereas, form wants only freedom to be. It belongs to the heart; and the law it observes, if indeed it submits to any, has never been and never will be written.[1] Method may be planned or improvised (it makes no difference: in one case, the emphasis shifts towards thinking, in the other towards feeling; a piece for radios as instruments would give up the matter of method to accident). Likewise, material may be controlled or not, as one chooses. Normally the choice of sounds is determined by what is pleasing

This article originally appeared in *The Tiger's Eye* 7 (March 1949): 52–56. In this article, the "At Random" section was originally set in smaller type.

1. Any attempt to exclude the "irrational" is irrational. Any composing strategy which is wholly "rational" is irrational in the extreme.

and attractive to the ear: delight in the giving or receiving of pain being
an indication of sickness.

Refrain

Activity involving in a single process the many, turning them, even though
some seem to be opposites, towards oneness, contributes to a good way
of life.

The Plot Thickens

> When asked why, God being good, there was evil in the
> world, Sri Ramakrishna said: To thicken the plot.

The aspect of composition that can properly be discussed with the end
in view of general agreement is structure, for it is devoid of mystery.
Analysis is at home here.

Schools teach the making of structures by means of classical harmony.
Outside school, however (e.g., Satie and Webern), a different and correct[2]
structural means reappears: one based on lengths of time.[3,4]

In the Orient, harmonic structure is traditionally unknown, and
unknown with us in our pre-Renaissance culture. Harmonic structure is
a recent Occidental phenomenon, for the past century in a process of
disintegration.[5]

2. Sound has four characteristics: pitch, timbre, loudness and duration. The opposite and
 necessary coexistent of sound is silence. Of the four characteristics of sound, only dura-
 tion involves both sound and silence. Therefore, a structure based on durations (rhythmic:
 phrase-, time-lengths) is correct (corresponds with the nature of the material), whereas
 harmonic structure is incorrect (derived from pitch which has no being in silence).

3. This never disappeared from jazz and folk-music. On the other hand, it never developed
 in them, for they are not cultivated species, growing best when left wild.

4. Tala is based on pulsation; western rhythmic structure on phraseology.

5. For an interesting detailed proof of this, see Casella's book on the cadence.

Atonality[6] Has Happened

The disintegration of harmonic structure is commonly known as atonality. All that is meant is that two necessary elements in harmonic structure, the cadence, and modulating means, have lost their edge. Increasingly, they have become ambiguous, whereas their very existence as structural elements demands clarity (singleness of reference). Atonality is simply the maintenance of an ambiguous tonal state of affairs. It is the denial of harmony as a structural means. The problem of a composer in a musical world in this state is precisely to supply another structural means,[7] just as in a bombed-out city, the opportunity to build again exists.[8] This way one finds courage and a sense of necessity.

Interlude (Meister Eckhart)

"But one must achieve this unselfconsciousness by means of transformed knowledge. This ignorance does not come from lack of knowledge but rather it is from knowledge that one may achieve this ignorance. Then we shall be informed by the divine unconsciousness and in that our ignorance will be ennobled and adorned with supernatural knowledge. It is by reason of this fact that we are made perfect by what happens to us rather than by what we do."

At Random

Music means nothing as a thing.

A finished work is exactly that, requires resurrection.

6. The term, atonality, makes no sense. Schoenberg substitutes 'pantonality,' Lou Harrison (to my mind and experience the preferable term), 'proto-tonality.' This last term suggests what is actually the case: present even in a random multiplicity of tones (or, better, sounds [so as to include noises]), is a gravity, original and natural, 'proto,' to that particular situation. Elementary composition consists in discovering the ground of the sounds employed, and then letting life take place both on land and in the air.

7. Neither Schoenberg nor Stravinsky did this. The twelve tone row does not offer a structural means; it is a method, a control, not of the parts, large and small, of a composition, but only of the minute, note-to-note procedure. It usurps the place of counterpoint, which, as Carl Ruggles, Lou Harrison, and Merton Brown have shown, is perfectly capable of functioning in a chromatic situation. Neo-classicism, in reverting to the past, avoids by refusing to recognize, the contemporary need for another structure, gives a new look to structural harmony. This automatically deprives it of the sense of adventure, essential to creative action.

8. The twelve tone row offers brick-layers, but no plan. The neo-classicists advise building it the way it was before, but surfaced fashionably.

The responsibility of the artist consists in perfecting his work so that it may become attractively disinteresting.

It is better to make a piece of music than to perform one, better to perform one than to listen to one, better to listen to one than to misuse it as a means of distraction, entertainment, or acquisition of 'culture.'

Use any means to keep from being a genius, all means to become one.

Is counterpoint good? "The soul itself is so simple that it cannot have more than one idea at a time of anything. . . . A person cannot be more than single in attention." (Eckhart)

Freed from structural responsibility, harmony becomes a formal element (serves expression).

Imitating either oneself or others, care should be taken to imitate structure not form (also structural materials and structural methods not formal materials and formal methods), disciplines, not dreams; thus, one remains "innocent and free to receive anew with each Now-moment a heavenly gift." (Eckhart)

If the mind is disciplined, the heart turns quickly from fear towards love.

Before Making a Structure by Means of Rhythm,
It Is Necessary to Decide What Rhythm Is.

This could be a difficult decision to make if the concern were formal (expressive) or to do with method (point to point procedure); but since the concern is structural (to do with divisibility of a composition into parts large and small), the decision is easily reached: rhythm in the structural instance is relationships of lengths of time.[9] Such matters, then, as accents on or off the beat, regularly recurring or not, pulsation with or without accent, steady or unsteady, durations motivically conceived (either static or to be varied), are matters for formal (expressive) use, or, if thought about, to be considered as material (in its 'textural' aspect) or as serving method. In the case of a year, rhythmic structure is a matter of seasons, months, weeks, and days. Other time-lengths such as that taken by a fire or the playing of a piece of music occur accidentally or freely without explicit

9. Measure is literally measure, nothing more, for example, than the inch on a ruler, thus permitting the existence of any durations, any amplitude relations (metre, accent), any silences.

recognition of an all-embracing order, but, nevertheless, necessarily within that order. Coincidences of free events with structural time points have a special luminous character, because the paradoxical nature of truth is at such moments made apparent. Caesurae on the other hand are expressive of the independence (accidental or willed) of freedom from law, law from freedom.

Claim

Any sounds of any qualities and pitches (known or unknown, definite or indefinite), any contexts of these, simple or multiple, are natural and conceivable within a rhythmic structure which equally embraces silence. Such a claim is remarkably like the claims to be found in patent-specifications for and articles about technological musical means (see early issues of Modern Music and the Journal of the Acoustical Society of America). From differing beginning points, towards possibly different goals, technologists and artists (seemingly by accident) meet by intersection, becoming aware of the otherwise unknowable (conjunction of the in and the out), imagining brightly a common goal in the world and in the quietness within each human being.

For Instance:

Just as art as sand-painting (art for the now-moment[10] rather than for posterity's museum-civilization) becomes a held point of view, adventurous workers in the field of synthetic music (e.g. Norman McLaren) find that for practical and economic reasons work with magnetic wires (any music so made can quickly and easily be erased, rubbed-off) is preferable to that with film.[11]

The use of technological means[12] requires the close anonymous collaboration of a number of workers. We are on the point of being in a cultural

10. This is the very nature of the dance, of the performance of music, or any other art requiring performance (for this reason, the term, sand-painting is used: there is a tendency in painting (permanent pigments), as in poetry (printing, binding), (e.g.), to be secure in the thingness of a work and thus to overlook, and place nearly insurmountable obstacles in the path of, instantaneous ecstasy).

11. 24 or n frames per second is the 'canvas' upon which this music is written; thus, in a very obvious way, the material itself demonstrates the necessity for time (rhythmic) structure. With magnetic means, freedom from the frame of film means exists, but the principle of rhythmic structure should hold over as, in geometry, a more elementary theorem remains as a premise to make possible the obtaining of those more advanced.

12. "I want to be as though new-born, knowing nothing, absolutely nothing about Europe." (Paul Klee)

situation,[13] without having made any special effort to get into one[14] (if one can discount lamentation).

The in-the-heart path of music leads not to self-knowledge through self-denial, and its in-the-world path leads likewise to selflessness.[15] The heights that now are reached by single individuals at special moments may soon be densely populated.

13. Replete with new concert halls: the movie houses (vacated by home television fans, and too numerous for a Hollywood whose only alternative is 'seriousness').

14. Painting in becoming literally (actually) realistic (this is the 20th century) seen from above, the earth, snow-covered, a composition of order super-imposed on the "spontaneous" (Cummings) or of the latter letting order be (from above, so together, the opposites, they fuse) (one has only to fly (highways and topography, Mila-repa, Henry Ford) to know) automatically will reach the same point (step by step) the soul lept to.

15. The machine fathers mothers heroes saints of the mythological order (works only when it meets with acquiescence [cf. The King and the Corpse, Zimmer-Campbell]).

An Introduction to Louise Bourgeois

Marius Bewley

There are several evocative levels in the nine engravings by Louise Bourgeois which comprise the series "He Disappeared into Complete Silence." Since she has indicated one level herself by the titles, or parables, which accompany the plates, presumably this was the one at which her conscious awareness was most active during the creative process. In relating the parables to the engravings (and it had better be done in a very general way), it will be better to avoid any psycho-inquisitorial session, and confine oneself to the obvious pattern and tone of the stories. Now these fables are just barely big enough to carry the plot, and it is always the same plot, repeated in a different way each time. They are all tiny tragedies of human frustration: at the outset someone is happy in the anticipation of an event or in the possession of something pleasing. In the end, his own happiness is destroyed either when he seeks to communicate it or, perversely, seeks to deny the necessity for communication. The protagonists are miserable because they can neither escape the isolation which has become a condition of their own identities, nor yet accept it as wholly natural. Their attempts to free themselves or accept their situation invariably end in disaster, for the first is impossible and the second is abnormal. In the parable that accompanies the engraving of The Three Towers, a man becomes a tragic figure when he discovers he cannot tell other people why he is happy. He tries, but nobody can understand his speech. . . .

This difficulty of communication that springs from the individual's isolation in himself has always been present in society in some degree, but it remained for this century to confront its special fury. For a good

This article originally appeared in *The Tiger's Eye* 7 (March 1949): 89–92. The untitled painting by Louise Bourgeois which accompanied this article is reproduced in this volume as figure 34.

many years it has been the aesthetic concern with which artists have been most occupied, but to let it rest on a plane of verbal or visual strategy is both to underestimate and misunderstand it. It is really a problem of cultural and spiritual desiccation which has occurred because of the progressive failure of assumptions on which men have been evaluating themselves and their prospects since the Renaissance began. The peculiar kinds (it has not always been the same kind) of individuality upon which they have insisted have ended by betraying the personality itself, and society has fallen into an individualism so extreme that today only the most flagrant politics and the most arbitrary ideas of collective association can bind it into anything like homogeneity. The heart of culture is lost, and unity is superimposed, an embellishment from the outside. As an integrating substitute for culture, politics cannot ease loneliness, or return us to our common species from which we have wrenched ourselves by the violence of ambition and uncentred curiosity. Under such circumstances it is not remarkable that the difficulty of communication between men has become intensified. If they share a language together, the other terms of reference which a culture should offer them they hold so little in common that their meaning must usually remain, to a degree perhaps unprecedented, a private one—that is, if they really have anything to say at all. It is inevitable that our art should offer, either directly or indirectly, a comment on this cultural exhaustion, and on the human situation which arises from it, for it is the business of art to present an experience in its organic totality. . . .

The recognitions and the feelings which attend such a sense of the present seem to me to be operative in these engravings, and to constitute the foundation of their effectiveness. I do not know if Louise Bourgeois explicitly thought like this when she executed the plates, nor is it important to know. The parables may be taken as marking her point of departure, and they are indicative enough. The engravings begin with a problem in human relations, with something that resolves itself to a basic frustration, but leaving that at once, they undertake a visual exploration of the context which frames the individual defeat. In the nature of the case, the context must be a cultural one. And I had better say right now that the success of these etchings seems to me to lie in the way Louise Bourgeois unfolds the personal mood which adheres to the particular episode behind each title into the impersonal and wider implication in which it always ends. The people in the parables do not actually show up in the engravings. Since they have lost the power of communication, the most essential of their human characteristics, they are not really persons any longer, and that is their tragedy. It is an invisible tragedy, a classic act of violence performed behind the scenes, but we know about it because the buildings which con-

ceal the action are themselves the symbols of what they hide. They symbolize both the particular tragedy and its farthest meaning. Human events and experiences, even architecture, are never merely things-in-themselves. They are counterpointed with a cultural movement which accompanies and surrounds them, and transforms their private meanings into something else. To some extent the buildings in these engravings describe this complex pattern, but in such a way that it is the individual rather than the historical value that counts for most. The more one looks at these engravings the more one realizes how closely, even how poignantly connected, the buildings and the parables really are.

The buildings are probably skyscrapers in Manhattan, and yet they somehow implant an uncertainty in one's mind. One remembers those square defensive towers which the nobles of Florence erected during the first period of civil war at the close of the twelfth century. For a time Florence was bristling with towers, and from their tops neighbours shot crossbows at each other all morning or speared their friends in the streets below as if they were boars. One thinks particularly of the towers when the fighting ended, deserted and half in ruins. But they are equally suggestive of the American scene itself, considered from a special point of view. These ambiguous structures remind one of the cranes on loading docks, the elevators in building yards, all the endless industrial activity which, in the end, adds up to nothing. The loneliness is as smothering as in a western ghost town, and carries its peculiar charge of poetry. In America conditions conspired to accelerate the process by which the Renaissance assumptions had been burning out everywhere else almost from the very beginning. In America, since the destructive, beautiful fire was later, it had also to be brighter and swifter. It may be objected that there is still much optimism, much hope left. But it is hope of something else, and something much less, whether the difference be admitted or not. The lonely towers in these engravings, if thought of as American, betray that difference in emotional terms. They are rather like the souvenirs of a receding greatness cherished by some exhausted, aging child prodigy. But whether pre-Renaissance towers or post-Renaissance skyscrapers are intended does not matter, for the emotional condition in which they are perceived is a solvent that destroys the distance between them. They are still the buildings where the tragic happenings in the parables occur. And they speak of a frustration, fear, and loneliness that grew up through a wide curve of time that has not come full circle yet. . . .

Such an emotion as these engravings represent is neither direct nor simple. Obviously it has nothing to do with those basic human drives which a certain type of critic today predicates of what he calls "primary art." Just as obviously it has little to do with the senses. I do not know if it begins

or ends in the intellect, but however that may be, it is an emotion which approximates a peculiar kind of intellection. It expresses itself by a sensitive visual logic, and it is perfectly at home within the rules of that logic. There is, for example, an expository quality in the straight incisiveness of the lines which dovetail into each other at their intersections like the points of a discursive argument, and one remarks how the tower structures tend to be divided into three parts, almost like the terms of a syllogism. But most of all, one notes that although a horizon line is usually given, it is always lowly placed. It might almost be the floor line of a room great enough to enclose the smaller structures. This sense of enclosure is enforced by the regular texture of the background, which suggests a wall rather than aerial atmosphere. Now the effect of this is to represent an unromantic universe, logically confined within the limits of a rational definition. The eye does not race to the horizon, and so on outward to infinity. It remains to face the problem, which is clearly stated in what might be described as a primarily cognitative way of seeing and drawing. The problem, it has already been said, is simply that of loneliness and isolation presented in terms of a cultural failure as it impinges on the individual, the solitude that presses in on the consciousness when human energy is at its lowest ebb. And as the problem arises within a cultural frame, the scrutiny is conducted, one might almost say the answer is sought, within the limits of that frame. . . .

This problem of isolation and cultural failure is one which every modern artist has had to deal with after his own fashion. If a special point is made of it here it is because these engravings are so simple and direct that their plaintive insistence on the theme, like the melody of a recorder, offers something rather out of the ordinary. It is as if the artist had viewed the problem through one of those reducing glasses that seventeenth century Dutch artists sometimes used to study an interior before painting it to a sharper focus than they could have achieved with the unaided eye. Beginning with the situations in the parables, the emotion is abstracted, and then intensified by seeing it through the glass of our cultural crisis. The personal tragedy is by no means disqualified in this process. It remains the prime motive in the final product, while the theme of isolation performs on the most intimate, most civilized of stages with a modesty that is itself engaging.

Van Gogh, the Man Suicided by Society
(excerpts)

Antonin Artaud

One may speak of the sound mental health of Van Gogh who, in the course of his whole life, cooked only one hand and did no more, as for the rest, than slice off his left ear only once.

in a world where every day one eats human organs cooked in green sauce or the sex of a new-born child who has been flogged and roused to a frenzy,

as when culled at its emergence from the maternal sex. And this is not an image but a fact daily and abundantly repeated and cultivated all over the earth.

And thus is it that, wild as this assertion may seem, present-day life continues in its old atmosphere of debauch, of anarchy, of confusion, of delirium, of derangement, of chronic madness, of bourgeois inertia, of psychic disorder (for it is not man but the world that has become abnormal), of deliberate dishonesty, of mean contempt for everything that shows the thoroughbred,

of the demand of a whole order based on the carrying out of a primitive injustice,

in short, of organized crime.

Things are bad because the sick consciousness has a vital interest at the present time in not leaving its sickness.

Thus it is that a tainted society invented psychiatry to defend itself against the investigations of certain superior lucidities whose faculties of divination troubled it.

This story, translated by Bernard Frechtman, appeared in *The Tiger's Eye* 7 (March 1949): 93–95, 97–115.

Gérard de Nerval was not mad, but he was accused of being mad in order to cast discredit upon certain fundamental revelations he was getting ready to make,

and besides being accused, he was again hit on the head, physically hit on the head one night so that he would lose the memory of the monstrous facts he was going to reveal which, as a result of that blow, moved within him to the supernatural plane, because all society, occultly in league against his consciousness, was at that moment strong enough to make him forget their reality.

No, Van Gogh was not mad, but his paintings were flame-throwers, atomic bombs, whose angle of vision, compared to all the other painting that was going strong at the time, would have been capable of seriously disturbing the larval conformism of the Second Empire bourgeoisie and the myrmidons of Thiers, Gambetta, Félix Faure, as well as those of Napoleon the Third.

For it is not a certain conformism of manners and morals that Van Gogh's painting attacks, but that of institutions itself. And even external nature, with its climates, its tides, its equinoctial storms, can no longer, after Van Gogh's stay on earth, retain the same gravitation.

All the more reason on the social plane for institutions to break up and for the medicine that declares Van Gogh mad to look like a stale and worthless corpse.

Compared to Van Gogh's lucidity, which keeps working away, psychiatry is nothing but a den of gorillas, themselves obsessed and persecuted, which, to palliate the most frightful states of human anguish and suffocation, have merely a ridiculous terminology,

worthy product of their tainted brains.

Not a psychiatrist, indeed, who is not a notorious erotomaniac.

And I do not believe that the rule of the inveterate erotomania of psychiatrists can suffer a single exception.

I know one who, a few years ago, rebelled at the idea of seeing me thus accuse the whole pack of high swine and licensed shysters to which he belonged.

As for me, Monsieur Artaud, said he, I'm not an erotomaniac, and I utterly defy you to show me a single one of the elements on which you base your accusation.

All I need do, Dr. L. , is show you yourself as an element,

you bear its stigma on your puss,

you low down son of a bitch.

It's the mug of him who introduces his sexual prey under his tongue and then turns it around like an almond in order to pooh-pooh, as it were.

That's what's called feathering one's nest and providing for a rainy day.

And there's a certain crease you've taken on in your internal organic jolting which is the embodied witness of a foul debauch

and which you cultivate year in year out, more and more, because socially speaking it doesn't come under the law,

but it comes under another law where it's the whole injured conscience that suffers, because in conducting yourself in that way you prevent yourself from breathing.

You will delirium upon the conscience, which keeps working away, while on the other hand you strangle it with your vile sexuality.

And that is precisely the plane where Van Gogh was chaste,

chaste as a seraph or a virgin can't be, because they are the very ones who fomented and fed at the beginning the great machine of sin.

Further, Dr. L. , perhaps you belong to the race of the iniquitous seraphim, but for the sake of pity, let men alone,

the body of Van Gogh, which was spared sin, was also spared madness, which, be it added, sin alone brings.

And I do not believe in Catholic sin,

but I believe in erotic crime from which, as it happens, all the geniuses of the earth,

the genuinely insane in asylums have refrained,

or, it may be that they were not (genuinely) insane.

And what is a genuine lunatic?

He is a man who has preferred to go mad, in the social sense of the term, rather than forfeit a certain loftier idea of human honor.

Thus it is that society strangles in asylums all those it has wanted to get rid of or protect itself against for having refused to take up with it as accomplices of a certain high swinishness.

For a lunatic is also a man whom society has not wanted to heed and whom it has wanted to keep from uttering unbearable truths.

But, in that case, confinement is not its only weapon, and the concerted assemblage of men has other means for breaking down the wills it wants to smash.

Aside from the petty spells cast by country sorcerers, there are the great tricks of global spellbinding in which the whole alerted consciousness participates.

Thus it is that, on the occasion of a war, of a revolution, of an embryonic social upheaval, the unanimous consciousness is questioned and questions itself, and that it also bears its own judgment.

It can also happen that it is aroused and rises above itself in regard to certain outstanding individual cases.

Thus it is that there have been unanimous spells in the case of Baudelaire, of Edgar Allan Poe, Gérard de Nerval, Nietzsche, Kierkegaard, Holderlin, Coleridge,

such has been the case in regard to Van Gogh.

It can happen during the day, but it happens preferably during the night.

Thus it is that strange forces are stirred up and brought into the astral vault, into that kind of dark dome which constitutes, above all human breathing, the venomous aggressiveness of the evil spirit of most people.

Thus it is that the few, rare, lucid wills which have had to struggle upon earth see themselves, at certain hours of the day or night, in the depths of certain genuine, waking states of nightmare, surrounded by the formidable tentacular oppression of a kind of civic magic which we shall very soon see openly appearing in the mores.

Confronted with this unanimous swinishness, which has on the one hand sex and on the other, be it added, the mass, or some other psychic rites as base or point of support, there is nothing delirious in walking about at night with twelve candles attached to your hat in order to paint a landscape from nature;

for how could he have gone about lighting himself up, as our friend the actor Roger Blin so justly pointed out the other day?

As for the cooked hand, it is heroism pure and simple;

as for the severed ear, it is direct logic,

and I repeat,

a world that, day and night, and more and more, eats the uneatable,

in order to bring its evil will around to its ends

has nothing to do, in this respect,

but to shut up.

Post-script

Van Gogh did not die of a state of delirium proper,

but of having been bodily the field of a problem about which the iniquitous spirit of that mankind has struggled since the beginning of things,

that of the predominance of flesh over mind, or of body over flesh, or of mind over both.

And where is the place of the human self in this delirium?

Van Gogh sought his own self all his life, with a strange energy and determination.

And he did not commit suicide in a fit of madness, in the terror of being unsuccessful,

but on the contrary he had just succeeded and had just discovered what he was and who he was, when the general consciousness of society, in order to punish him for having torn himself away from it,

suicided him.

And it happened with Van Gogh as usually always happens, on the occasion of an orgy, a mass, an absolution, or some other rite of consecration, possession, succubation or incubation.

It introduced itself into his body,

that absolved
consecrated
sanctified
and possessed society

effaced in him the supernatural consciousness he had just acquired and, like a flood of black crows in the fibres of his inner tree, submerged him with a final surge,

and, taking his place,
killed him.

For it is the anatomical logic of modern man to have never been able to live or to have thought of living, except as one possessed.

THE MAN SUICIDED BY SOCIETY

Pure linear painting had long since driven me mad when I encountered Van Gogh who painted, not lines or forms, but things in inert nature as if they were in convulsion.

And inert.

As if under the terrible bludgeon blow of that force of inertia that everyone talks about in innuendo, and which has never grown so obscure as it has since the whole world and present-day life have meddled in its elucidation.

Now, it's with his club, really with his club that Van Gogh keeps battering away at all the forms in nature and at objects.

Carded by Van Gogh's nail,

the landscapes show their hostile flesh,

the growl of their disemboweled windings which some strange unknown force is elsewhere in the act of metamorphosing.

An exhibition of Van Gogh paintings is always a date in history,

not in the history of painted things, but in plain historical history.

For there is no famine, epidemic, volcanic eruption, or earthquake that heads off the monads of the air, that wrings the neck of the grim, fama-fatum face, the neurotic destiny of things,

like a Van Gogh painting,—shown in the light,

put directly back into vision.

hearing, touch,

smell,

finally launched anew into present actuality, reintroduced into circulation.

Not all of the very great canvasses of the unfortunate painter are in the latest Van Gogh exhibition at the Palais de l'Orangerie. But among those that are there are enough gyratory processions bespangled with bunches of carmine plants, sunken roads lined with yew-trees, purplish suns revolving about stacks of pure gold wheat, the Old Benchwarmer and portraits of Van Gogh,

to recall from what sordid simplicity of objects, persons, materials and elements

Van Gogh has drawn those organ tones, those fireworks, those atmospheric epiphanies, in short, that ''great work'' with its sempiternal and untimely transmutation.

Those crows painted two days before his death did not, any more than did his other paintings, open the door of a certain posthumous glory, but they open to painted painting, or rather to unpainted nature, the occult door of a possible beyond, of a possible permanent reality, through the door, by Van Gogh opened, of an enigmatic and sinister beyond.

It is no ordinary thing to see a man who has in his belly the bullet that killed him covering a canvas with black crows, with a kind of plain below which is perhaps livid, at any rate empty, where the winy color of the earth madly clashes with the dirty yellow of the wheat.

But no other painter than Van Gogh will be able, as he was, to find, in order to paint those crows, that truffle black, that ''rich feast'' black and at the same time excrement-like black of the wings of crows that have been overtaken by the dwindling glow of evening.

And what is the earth below complaining about beneath the wings of the *ritual* crows, ritual for Van Gogh alone no doubt, gaudy augury of an evil that will no longer touch *him?*

For no one till then had made of the earth, as he did, that dirty line, wrung with wine and drenched with blood.

The sky of the painting is very low, overcast,
purplish, like forks of lightning.
The strange sombre fringe of the void mounting with the flash.
Van Gogh has let loose his crows, like the black microbes of his suicide's spleen, a few inches from the top *and as if from the bottom of the canvas,*

following the black gash of the line where the rich plumage makes the suffocation from on high weigh upon the gathering of the earthly storm.

And yet the whole painting is rich.

Rich, sumptuous and calm the painting.

Worthy accompaniment to the death of one who, during his life, made so many drunken suns whirl about so many haystacks on the loose, and who, in desperation, with a bullet in his belly, could not help flooding a landscape with blood and wine, drenching the earth with a last emulsion, both joyous and gloomy, with a taste of sour wine and spoilt vinegar.

Thus it is that the tone of the last picture Van Gogh painted is—he who, moreover, never went beyond painting—evocative of the abrupt and barbaric timbre of the most pathetic, passional and passionate Elizabethan drama.

That's what strikes me most about Van Gogh: the most painter-like of all painters, who without going any further than what is called and what is painting, without leaving the tube, the brush, the framework of the *motif* and the canvas in order to have recourse to anecdote, story, action in images, intrinsic beauty of subject or object, has managed to impassion nature and objects in such a way that a fabulous tale of Edgar Allan Poe, Herman Melville, Nathaniel Hawthorne, Gérard de Nerval, Achim Arnim or Hoffmann is not more eloquent on the psychic, logical or dramatic plane than his twopenny canvasses,

his canvasses almost all, moreover, and as if intentionally, of medium dimensions.

A candlestick on a chair, an armchair with a green straw bottom, a book on the armchair,
and there you have the drama lit up.
Who is going to come in?
Will it be Gauguin or another ghost?

The lit candlestick on the straw-bottomed chair indicates, so it seems, the line of demarcation separating the two antagonistic individuals of Van Gogh and Gauguin.

The aesthetic object of their dispute would perhaps not offer, if one told about it, much interest, but it would indicate a basic human cleavage between the two natures of Van Gogh and Gauguin.

I believe that Gauguin thought that the artist must seek the symbol, the myth, must enlarge things in life to the stature of myths,

whereas Van Gogh thought that the myth must be deduced from the most commonplace things in life.

Wherein I think he was damned right.

For reality is superior to all history, all fable, all divinity, all superreality.

All you need is the genius to know how to interpret it.

Which no painter before poor Van Gogh had done,

which no painter will do after him,

for I believe that this time,

right today,

now,

in this month of February 1947,

it is reality itself,

the myth of reality itself, mythical reality itself, which is in the process of incorporating itself.

Thus, no one since Van Gogh has known how to shake the great cymbal, the perpetually superhuman bell whose repressed order governs the way objects in real life ring out,

when one has known how to keep his ears open enough to understand the surging of their tidal wave.

Thus it is that the light of the candlestick rings out, that the light of the lit candlestick on the straw-bottomed armchair rings out like the breathing of a loving body before the body of a sleeping invalid.

It rings out like a strange criticism, a profound and surprising judgment whose later, much later sentence Van Gogh may, so it seems, permit us to sense, the day when the violet light from the straw-bottomed armchair will have finally submerged the painting.

And one can not help noticing that patch of lilac light which eats at the rungs of the big glowering armchair, of the old armchair straddled with green straw, though one may not notice it right away.

For it is as if its focus were located elsewhere and its source strangely obscure, like a secret whose key Van Gogh had kept all to himself.

Suppose Van Gogh had not died at the age of 37, I do not call upon the Great Weeper to tell me with what supreme masterpieces painting might have been enriched, for I can not, after the "Crows," bring myself to believe that Van Gogh would have painted another picture.

I think that he died at 37 because he had, alas, reached the end of his dismal and revolting history of a man garrotted by an evil spirit.

For it was not by himself, by the disease of his own madness, that Van Gogh quit life.

It was under the pressure of the evil spirit—two days before his death—named Dr. Gachet, improvised psychiatrist, who was the direct, effectual and sufficient cause of his death

I have acquired, upon reading Van Gogh's letters to his brother, the firm and sincere conviction that Dr. Gachet, "psychiatrist," in reality detested Van Gogh, painter, and that he detested him as a painter, but especially as a genius.

It's just about impossible to be a doctor and an honest man, but it's profligately impossible to be a psychiatrist without at the same time bear-

ing the stamp of the most indisputable madness: that of being unable to struggle against that old atavistic reflex of the rabble which makes any man of science caught up in the rabble a kind of born and inborn enemy of all genius.

Medicine is born of evil, if it is not born of illness, and if it has, on the contrary, provoked and created illness out of whole cloth to give itself a reason for being; but psychiatry is born of the vulgar rabble of creatures who have wanted to preserve the evil at the source of illness and who have thus rooted out of their own nothingness a kind of Swiss guard in order to sap at its base the justifiably rebellious drive which is at the origin of genius.

There is in every lunatic a misunderstood genius who was frightened by the idea that gleamed in his head and who could find an outlet only in delirium for the stranglings life had prepared for him.

Dr. Gachet did not tell Van Gogh that he was there to rehabilitate his painting (as I heard myself told by Dr. Gaston Ferdiére, head of the Rodez asylum, that he was there to rehabilitate my poetry), but he sent him out to paint from nature, to bury himself in a landscape in order to escape from the disease of thinking.

Only, no sooner did Van Gogh turn his head than Dr. Gachet switched off his thinking.

As if without intending any harm, but by one of those sneers which belittle a harmless trifle where the whole bourgeois unconscious of the earth has inscribed the old magical force of a thinking that has been repressed a hundred times.

It was not only the evil of the problem that Dr. Gachet forbade him by so doing,

but the sulphured sowing,

the anguish of the nail turning in the gullet of the only passage,

with which Van Gogh,

tetanized,

Van Gogh, hanging out over the gulf of breath,

painted.

For Van Gogh was a terrible sensitivity.

All one need do to be convinced of this is to look at his always breathless-looking and, in certain ways, spellbinding butcher's face.

As of an ancient butcher who has settled down and retired from business, that ill-lit face pursues me.

Van Gogh has portrayed himself in a considerable number of canvasses and however well-lighted they might have been, I have always had the painful impression that someone had falsified the light, that someone had

taken away from Van Gogh a light which was indispensable for him to hollow out and mark his route within himself.

And as for that route, Dr. Gachet was certainly not the one capable of pointing it out to him.

But, as I have said, in every living psychiatrist there is a repulsive and sordid atavism which makes him see in every artist, in any genius in front of him, an enemy.

And I know that Dr. Gachet has left in history, in regard to Van Gogh whom he took care of and who finally committed suicide while in his care, the memory of his last friend on earth, of a kind of providential consoler.

Yet, I think more than ever that it was to Dr. Gachet, of Auvers--sur-Oise, that Van Gogh owed, that day, the day he committed suicide at Auvers-sur-Oise,

owed, I say, his exit from life,—

for Van Gogh was one of those natures whose superior lucidity enables them, in all circumstances, to see farther, infinitely and dangerously farther, than the immediate and apparent reality of facts.

I mean, as regards consciousness, that consciousness is in the habit of retaining it.

In the depths of his plucked-looking butcher's eyes Van Gogh devoted himself uninterruptedly to one of those dark alchemistic operations which took nature for object and the human body for kettle or crucible.

And I know that Dr. Gachet always found that that tired him.

Which in his case was not the result of a simple medical concern,

but the avowal of a jealousy as conscious as it was unavowed.

The reason was that Van Gogh had reached that stage of illuminism where disorganized thought surges back before the invading discharges of matter,

and where to think is no longer to wear out,

and is no longer,

and where the only thing left is to *gather bodies,* I mean

TO PILE UP BODIES.

It is no longer the world of the astral, it is that of direct creation which is thus beyond consciousness and the brain.

And I have never seen a body without a brain being fatigued by inert pictures.

Pictures of the inert, those bridges, those sunflowers, those yews, those olivepickings, those haymakings. They no longer move.

They are congealed.

But who could dream them harder beneath the sharp cleaver stroke which has unsealed their impenetrable quiver.

No, a picture, Dr. Gachet, has never tired anyone. They are forces of a lunatic which rest without setting in motion.

I too am like poor Van Gogh, I no longer think, but every day I manage more and more finely terrific internal turmoils and I would like to see any doctor come and reproach me for tiring myself.

Someone owed Van Gogh a certain sum of money about which the story tells us: Van Gogh had been fuming for several days.

The bent of lofty natures, always a notch above the real, is to explain everything by a guilty conscience,

to believe that nothing is ever due to change and that everything bad that happens happens as a result of a conscious, intelligent and concerted ill-will.

Which psychiatrists never believe.

Which geniuses always believe.

When I am sick, the reason is that I've been bewitched, and I can't believe that I'm sick if I don't believe, moreover, that it is to someone's interest to take away my health and make use of my health.

Van Gogh also believed that he was bewitched, and he said so.

And I have reason to believe that he was and some day I shall tell where and how.

And Dr. Gachet was the grotesque Cerberus, the sanious and purulent Cerberus, in sky-blue jacket and ultra-starched linen who was placed before Van Gogh to remove all his healthy ideas. For if the way of seeing that is healthy were unanimously widespread, Society could no longer live, but I know who the heroes of the earth are who would find their freedom there.

Van Gogh was unable to shake off that sort of family vampirism to whose interest it was that Van Gogh the painter stick to painting without at the same time demanding the revolution indispensable to the bodily and physical blossoming of his visionary personality.

And there was between Dr. Gachet and Van Gogh's brother Théo any number of those stinking family confabulations with directors of insane asylums regarding the *patient* whom they had brought to them.

"Keep an eye on him so that he'll stop having all those ideas." "You understand, the doctor said you have to get rid of all those ideas. They're doing you harm. If you go on thinking about them, you'll remain confined for the rest of your life."

"But not at all, Monsieur Van Gogh, come to your senses. Look, it's an accident, and then it never did any good to want to look into secrets of Providence in that way. I know Monsieur So-and-So, he's a very fine man, it's your persecution mania that keeps making you think that he's been secretly practising magic."

"You were promised that the sum would be paid. It will be paid. You can't go on like that persisting in attributing the delay to ill-will."

There you have those good-natured-psychiatrist conversations which look perfectly harmless but leave upon the heart the trace of a little black tongue, the little black anodyne tongue of a poisonous salamander.

And at times that is all that is needed to lead a genius to suicide.

There are days when the heart feels the impasse so terribly that it is stricken as if by a sun-stroke with the idea that it can no longer go on.

For nevertheless it was right after a conversation with Dr. Gachet that Van Gogh, as if nothing had happened, went back to his room and committed suicide.

I myself spent nine years in an insane asylum and I was never obsessed by suicide, but I know that every conversation with a psychiatrist during the morning visit made me long to hang myself because I felt I couldn't cut his throat. And perhaps Théo was materially very good to his brother, but that did not keep him from thinking that he was delirious, visionary, and hallucinated, and he did his utmost, instead of following him in his delirium,

to calm him.

What does it matter that he later died of regret?

The most important thing in the world to Van Gogh was his painter's idea, his terrible, fanatical, apocalyptically visionary idea.

That the world had to concur with the commandment of his womb, resume its compressed, anti-psychic rhythm of a market-place festival, a rhythm which, in front of everyone, has been put back into the superheat of the crucible.

This means that the apocalypse, a consummated apocalypse, is at this hour brewing in the pictures of old martyrized Van Gogh and that the earth has need of him to lash out with its head and feet.

The fact is that no one has ever written or painted, sculpted, modeled, constructed, invented, except to get out of hell.

And I prefer, in order to get out of hell, the natures of that quiet convulsionary to the swarming compositions of Breughel the Elder or Hieronymus Bosch who, in comparison to him, are only artists where Van Gogh is only a poor illiterate bent on not deceiving himself.

But how am I to make a scientist understand that there is something definitely deranged in differential calculus, the quantum theory, or the obscene and so stupidly liturgical ordeal of the equinoctial processions,— owing to that shrimp-pink eiderdown that Van Gogh so gently whips up in an elected place on his bed, owing to the Veronese-green, azure-drenched insurrection of that boat in front of which a laundress of Auvers-sur-Oise rises to her feet, owing to that sun screwed on behind the grey

angle of the pointed village steeple down below, at the bottom of that enormous mass of earth which, on the first level of the music, seeks the wave where it can congeal.

 O VIO PROFE
 O VIO PROTO
 O VIO LOTO
 O THÉTHÉ

Describe a Van Gogh painting? What's the good! No description attempted by another can be worth the simple alignment of natural objects and of shades in which Van Gogh is engaged,

he was as great a writer as he was a painter and gives regarding the work described the impression of the most astounding authenticity.

July 23, 1890

"You may perhaps see the sketch of the Daubigny gardner—it's one of my most deliberate pictures—I'm enclosing a sketch of old stubble and the sketches of two 18 inch canvasses representing immense stretches of wheat after the rain . . .

The Daubigny gardner, foreground of green and pink grass. At the left, a green and lilac bush and the root of a plant with whitish foliage. In the middle, a rose-bed, at the right a hurdle, a wall, and, above the wall, a hazel tree with violet foliage. Then a lilac hedge, a row of yellow, rounded lime-trees, the house itself in the background, pink, with bluish tiles on the roof. A bench and three chairs, a black figure with a yellow hat and in the foreground a black cat. Pale-green sky."

September 8, 1888

"In my painting *Night Café* I've tried to express the idea that the café is a place where one can ruin himself, go mad, commit crimes. I've tried by means of contrasts of delicate pink and wine and blood red, of Louis Quinze and Veronese green, contrasting with the yellow greens and hard white greens, all in an atmosphere of a devil's furnace, of pale sulphur, to express, as it were, the power of darkness of a low dive.

And yet with an appearance of Japanese gaiety and the good-fellowship of *Tartarin* . . .

What is drawing? How does one manage it? It's the action of carving a passage through an invisible iron wall which seems to be located between what one feels and what one can do. How is one to get through this wall, for there's no use hitting it hard, one has to undermine the wall and go through with a file, slowly and with patience, as I see it."

How easy it seems to write like that.

Well! try and tell me whether, not being the author of a Van Gogh painting, you would be able to describe it as simply, drily, objectively, durably, validly, solidly, opaquely, massively, authentically and miraculously as in that little letter of his.

(For the basic dividing criterion is not a question of amplitude or cramp, but of the simple personal strength of the fist.)

I shall therefore not describe a Van Gogh painting after Van Gogh, but I shall say that Van Gogh is a painter because he re-collected nature, because, so to speak, he re-perspired it and made it sweat, because he made the secular crushing of elements, the frightful elementary pressure of apostrophes, streaks, commas, dashes squirt out over his canvasses in bunches, in, as it were, monumental sprays of color, and we can no longer believe, after him, that the natural aspects of nature are not made up of these things.

And they had to upset the barriers of many repressed contacts, ocular clashes taken from life, blinkings done from nature, luminous currents of forces that work away in reality, before finally being driven back and, as it were, hoisted on the canvas and accepted.

There are no ghosts in Van Gogh's paintings, no visions, no hallucinations.

There is the torrid truth of a two o'clock sun.

A slow genesitic nightmare elucidated little by little.

Without nightmare and without result.

But the suffering of the pre-natal is there.

It is the wet sheen of a pasture, of the stem of a plane of wheat which is there ready to be extradited.

And which nature will some day account for.

As society will also account for his premature death.

A plane of wheat bowed by the wind; above it the wings of a single bird set down like commas. Who is the painter, who is not strictly a painter, who could have had, like Van Gogh, the audacity to attack a subject with such disarming simplicity?

No, there are no ghosts in Van Gogh's painting, no drama, no subject, and I shall even say no object, for what is the motif itself?

If not something like the iron shadow of a motet from some ineffable ancient music, like the leit-motif of a theme despairing of its own subject.

It is bare and pure nature seen as it reveals itself when one knows how to approach it rather closely.

Witness that landscape of molten gold, of bronze baked in ancient Egypt where an enormous sun bears down on rooves so crumbling with light that they are as if in a state of decomposition.

And I know no apocalyptic, hieroglyphic, phantomatic or pathetic painting which gives me that sensation of occult strangeness, of the corpse of a useless hermetism, its head open, and offering up its secret on the executioner's block.

I am not thinking as I say this of the Old Benchwarmer, or of that grotesque autumn lane where a bent old man passes by with an umbrella hooked on to his sleeve, like a rag-picker's hook.

I am thinking again of those crows with wings as black as lustrous truffles.

I am thinking again of his corn field, ear upon ear of corn, and all is said, with a few heads of poppy in front, gently strewn, pungently and nervously applied there, and thinly sown, knowingly and fierily punctuated and shredded.

Only life can offer the kind of epidermic stripping that speaks under an unbuttoned shirt, and we do not know why the gaze inclines to the left rather than to the right, toward the mound of curly flesh.

But thus it is and it is a fact.

But thus it is and that is a fact.

Occult too his bedroom, so delightfully peasant and sown as if with an odor for preserving the corn one sees quivering in the landscape, far off, behind the window which tries to conceal it.

Peasant too, the color of the old eiderdown, with its mussel red, its sea urchin, shrimp, mullet of the Midi red, scorched-pimento red.

And it was surely Van Gogh's fault if the color of the eiderdown on his bed achieved such reality, and I don't see any weaver who could transplant its ineffable stamp, as Van Gogh knew how to convey the red of that ineffable glaze from the depth of his brain to his canvas.

And I don't know how many criminal priests dreaming in their heads of their so called Holy Ghost, the ochrous gold, the infinite blue of a stained-glass window to their harlot ''Mary,'' have been able to isolate in the air, to extract from the cunning niches of the air, those homely colors which are a whole event, where every one of Van Gogh's brush-strokes on the canvas is worse than an event.

One time it gives the effect of a tidy room, but with a coating of balm or flavor that no Benedictine will ever be able to find in order to give the finishing touch to his healthful liquors.

(That room recalled the great work with its light-pearl white wall, on

which a rough towel hangs like an old peasant amulet, unapproachable and tonic.)

Another time it gives the effect of a simple haystack in the light of an enormous crushed sun.

There are those light chalk whites which are worse than ancient tortures, and never does poor great Van Gogh's operative scruple appear as it does in that painting.*

For that is Van Gogh all over, the unique scruple of the touch, ponderously and pathetically applied. The common color of things, but so right, so lovingly right that no precious stones can attain its rarity.

For Van Gogh will prove to have been the most utter painter of all painters, the only one who did not want to go beyond painting as the strict means of his work and the strict frame of his means.

And the only one who, moreover, absolutely the only one, has gone beyond painting, the inert act of representing nature, in order to let loose, in this exclusive representation of nature, a revolting force, an element plucked right from the heart.

He has brought forth an air, from under the representation, and has embedded a nerve in it which are not in nature, which belong to a nature and an air more real than the air and nerve of real nature.

I see, as I write these lines, the painter's bloody-red face coming at me, from a wall of gutted sunflowers.

from a tremendous glow of embers of opaque hyacinth and meadows of lapis-lazuli.

All that, amidst a meteor-like bombardment of atoms which appear grain by grain,

proves that Van Gogh thought his canvasses like a painter, to be sure, and only like a painter, but one who might

by *that very fact*

be a tremendous musician.

Organist of an arrested tempest which laughs in limpid nature, pacified between two torments, but which (that nature), like Van Gogh himself, shows that it is quite ready to get going.

We can, after having seen it, turn our backs upon any painted canvas whatsoever, it has nothing more to say to us. The stormy light of Van Gogh's painting begins its somber utterance the very hour we have ceased to see it.

Nothing but a painter, Van Gogh, and no more, no philosophy, mysticism, rite, physcurgy or liturgy.

No history, literature or poetry, those brazen-gold sunflowers are

* This sentence appears in smaller type in the original.

painted: they are painted like sunflowers and nothing more, but in order to understand a sunflower in nature one now has to go back to Van Gogh, just as in order to understand a storm in nature,

a stormy sky,

a plain in nature,

one can no longer help going back to Van Gogh.

It was stormy in like manner in Egypt or on the plains of Semitic Judaea,

perhaps it was dark in like manner in Chaldea, in Mongolia or on the Mountains of Tibet, regarding which nobody has told me that they have changed place.

And yet, looking at that plain of wheat or rocks, white as a heap of buried bones, on which that old purplish sky weighs down, I can no longer believe in the Mountains of Tibet.

A painter, nothing but a painter, Van Gogh, he took hold of the means of pure painting and he did not go beyond them.

I mean that in order to paint he did not go beyond using the means that painting offered him.

A stormy sky,

a chalk-white plain,

canvasses, brushes, his red hair, tubes, his yellow hand, his easel,

but all the assembled lamas of Tibet may shake beneath their skirts the apocalypse they have prepared,

Van Gogh will have made us feel in advance its nitrogen peroxide in a canvas which contains just enough of the sinister to force us to orient ourselves.

He simply took it into his head one day to resolve not to go beyond the motif,

but when one has seen Van Gogh, one can no longer believe that there is anything less surpassable than the motif.

The simple motif of a lighted candlestick on a straw-bottomed armchair with a purplish frame tells a great deal more under Van Gogh's hand than the whole series of Greek tragedies or plays of Cyril Turner, Webster or Ford which, be it added, up to now remain unplayed.

Without being literary, I saw the face of Van Gogh, red with blood in the explosion of his landscapes, coming at me,

KOHN

TAVER

TINSUR

However,

in an ember,
in a bombardment,
in an explosion,
avengers of that millstone that poor Van Gogh the madman wore around his neck all his life.
The millstone of painting without knowing why or where.

For it is not for this world,
it is never for this earth that we have always worked,
struggled,
brayed the horror of hunger, of misery, of hatred, of scandal, and of disgust,
that we were all poisoned,
though we have all been bewitched by them,
and that we have finally committed suicide,
for we are not all like poor Van Gogh himself, men suicided by society!

Van Gogh renounced the telling of stories in painting, but the amazing thing is that this painter who is only a painter,
and who is more of a painter than the other painters, as if he were a man in whom the material, the paint, has a place of prime importance,
with the color seized as such right out of the tube,
with the imprint, as if one after the other, of the hairs of the brush in the color,
with the touch of painted paint, as if distinct in its own sun,
with the i, the comma, the dot of the point of the brush itself bored right on the rowdy color that spurts forth in forks of fire, which the painter checks and tucks in on all sides,
the amazing thing is that this painter who is nothing but a painter is also the one painter of all the painters born who makes us most forget that we are dealing with painting,
with painting to represent the motif he has distinguished,
and who summons before us, in front of the fixed canvas, the enigma pure, the pure enigma of the tortured flower, of the landscape that has been slashed, plowed and pressed on all sides by his drunken brush.
His landscapes are old sins that have not yet found their primitive apocalypses, but will not fail to find them.
Why do Van Gogh's paintings give me the impression of being seen as if from the other side of the tomb of a world where its suns will turn out to have been everything that turned and blazed joyously?
For is it not the whole history of what was once called the soul that lives and dies in his convulsionary landscapes and in his flowers?

The soul that gave its ear to the body, and Van Gogh returned it to the soul of his soul,

a woman in order to give substance to the sinister illusion,

there was a time when the soul did not exist,

nor the mind either,

as for consciousness, no one had ever thought about it,

but, moreover, where was thought in a world made up solely of warring elements that were destroyed no sooner than they were recompounded,

for thought is a luxury of peace,

and what is better than the incredible Van Gogh, the painter who understood the phenomenal part of the problem, he in whom any real landscape is, as it were, potential in the crucible where it is going to be begun all over.

So old Van Gogh was a king against whom, while he was asleep, was invented the curious sin called Turkish culture,

example, dwelling, motive, of the sin of mankind, which has never been able to do anything else but eat artist, without trimmings, in order to stuff its honesty.

Wherein it has never done anything but consecrate its cowardice ritually!

For mankind does not want to go to the trouble of living, of entering into the natural elbowing of the forces that make reality, in order to draw from it a body that no tempest will ever again be able to break into.

It has always preferred to content itself quite simply with living.

As for life, it is in the artist's genius that life is in the habit of looking for it.

Now, Van Gogh, who cooked one of his hands, was never afraid of the war to live, that is, to remove the fact of living from the idea of existing,

and everything can very well exist without going to the trouble of being,

and everything can be without going, like Van Gogh the lunatic, to the trouble of gleaming and glowing.

That is what society took away from him in order to carry out the Turkish culture, whose honesty is a facade with its origin and props in crime.

And thus it is that Van Gogh died suicided, because it was the whole concerted consciousness which couldn't bear him any longer.

For though there was neither mind nor soul nor consciousness nor thought,

there was fulminate,

ripe volcano,

shudder-stone,
patience,
bubo,
cooked tumor,
and the sores of a flayed man.

And King Van Gogh was dozing, hatching the next alert of the resurrection of his health.

How?

By the fact that good health is a plethora of deep-seated diseases, with a terrific zest for living, through a thousand corroded wounds, that must nevertheless be made to live,

that must be led to perpetuate themselves.

Whoever doesn't smell of cooked bomb and compressed vertigo is not worthy of being alive.

It is the fragrance that poor Van Gogh took upon himself to manifest like a blast of flame.

But the watchful evil hurt him.

The Turk, behind his honest fact, delicately approached Van Gogh to cull the sugared almond in him,

so as to detach the (natural) sugared almond which was forming.

And Van Gogh lost a thousand summers there.

Of which he died at the age of 37,

before living,

for every monkey lived before him on forces which he had assembled.

And that is what must now be restored in order to enable Van Gogh to come back to life.

In the face of a mankind of cowardly monkeys and wet dogs, Van Gogh's painting will prove to have been that of a time when there was no soul, no mind, no consciousness, no thought, nothing but raw elements alternately enchained and unchained.

Landscapes of strong convulsions, of insane traumatisms, as of a body in which fever is working in order to restore it to exact health.

The body beneath the skin is an overheated factory,

and outside,

the sick man gleams,

he shines from all his pores,

which have burst.

Thus a Van Gogh

landscape

at noon.

Only perpetual war explains a peace which is merely a transition,

just as milk ready to run over explains the pot in which it was boiling.

Beware of Van Gogh's lovely landscapes, whirling and pacific, convulsed and pacified.

It is health between two attacks of the hot fever which will pass.

It is fever between two attacks of an insurrection of good health.

Some day, Van Gogh's painting, armed with both fever and good health, will return to toss into the air the dust of a caged world which his heart could no longer stand.

Post-script

I return to the painting of the crows.

Who has yet seen, as in this painting, the earth equivalent to the sea?

Van Gogh is, of all painters, the one who strips us most deeply, down to our framework, but as one would delouse himself of an obsession.

That of making objects be others, that of finally daring to risk the sin of *the other*, and the earth can not have the color of a liquid sea, and yet it is as a liquid sea that Van Gogh tosses his earth like a series of jerks of the hoe.

And he has infused his canvas with the color of the lees of wine, and it is the earth that smells of wine, that still chops around among the waves of wheat, that rears a dark cockscomb against the low clouds that are gathering all about the sky.

But, as I have already said, the dismal side of the story is the opulence with which the crows are treated.

That color of musk, of rich nard, of truffle as from a great supper.

In the purplish waves of the sky, two or three heads of old men of smoke venture an apocalyptic grimace, but Van Gogh's crows are there urging them on to more decency, I mean to less spirituality,

which is what Van Gogh himself intended in that canvas with the underslung sky, painted as if at the exact moment that he rid himself of existence, for the canvas has a strange, almost pompous color of birth, of marriage, of departure,

I hear the crows' wings beating loud cymbal strokes above an earth whose flood, it seems, Van Gogh can no longer contain.

Then, death.

The olive trees of Saint Rémy.
The solar cypresses.
The bed-room.
The olive-harvest.
The promenades.
The Arles café.

The bridge where one feels like plunging his finger into the water, in a movement of violent regression to the state of childhood to which you are forced by Van Gogh's amazing grip.

The water is blue,
not a water blue,
but a liquid-paint blue.

The mad suicide has been there and he has given the water of paint back to nature,
but who will give it back to him?

Van Gogh a lunatic?

Let him who once knew how to look at a human face look at Van Gogh's self-portrait, I am thinking of the one with a soft felt hat.

Painted by the extra-lucid Van Gogh, that face of a red-headed butcher, who inspects and watches us, who scrutinizes us with a glowering eye too.

I don't know a single psychiatrist who can scrutinize a man's face with so crushing a force and dissect, as if with a cleaver, its irrefragable psychology.

Van Gogh's eye is that of a great genius, but from the way I see him dissecting me from the depth of the canvas from which he has surged forth, it is no longer the genius of a painter that I feel living in him at that moment, but that of a certain philosopher never met by me in life.

No, Socrates did not have that eye, perhaps the unhappy Nietzsche was the only one before him who had the gaze that undresses the soul, that frees the body from the soul, that lays bare the body of man, outside the subterfuges of the mind.

Van Gogh's gaze is hung, screwed on, it is glazed behind his rare eyelids, his thin and unwrinkled eyebrows.

It is a gaze that goes right through, it transpierces from that face, which is roughly hewn like a well squared tree.

But Van Gogh has grasped the moment when the pupil is about to spill into the void,
when that gaze which has taken off against us like the bomb of a meteor takes on the toneless color of the void and the inert that fills it.

Better than any psychiatrist, that was the way the great Van Gogh situated his illness.

I pierce, I resume, I inspect, I clutch, I unseal, my dead life conceals nothing, and nothingness, after all, never hurt anyone, which makes me come back within, it's that disheartening absence that goes by and submerges me at times, but I see into it clearly, very clearly, I even know what nothingness is, and I shall be able to tell what's inside.

And Van Gogh was right, one can live for the infinite, can be satisfied only with the infinite, there is enough infinite upon earth and in the spheres

to satisfy a thousand great geniuses, and if Van Gogh was unable to sate his desire to radiate his whole life with it, the reason is that society forbade him to.

Flatly and consciously forbade him.

There were once Van Gogh's executioners, as there were Gérard de Nerval's, Baudelaire's, Edgar Allan Poe's and Lautréamont's.

Those who said to him one day:

And now, enough, Van Gogh, to the grave, we've had enough of your genius, as for the infinite, the infinite is for us.

For it was not by dint of seeking the infinite that Van Gogh died,

that he found himself forced to choke with misery and asphyxiation,

it was by the dint of seeing himself refused it by the rabble of those who, during his very lifetime, thought they were denying him the infinite;

and Van Gogh could have found enough infinite to live on for his whole lifetime were it not that the bestial mind of the mass wanted to appropriate it in order to feed its own debauches which have never had anything to do with painting or poetry.

Besides, one does not commit suicide by oneself.

No one was ever born by himself.

Nor has anyone died by himself.

But, in the case of suicide, there has to be an army of evil beings to impel the body to the unnatural gesture, to deny itself its own life.

Thus, Van Gogh condemned himself because he had done with living and, as we gather from his letters to his brother, because confronted with the birth of a child to his brother,

he felt that he himself was one mouth too many to feed.

But above all Van Gogh finally wanted to join that infinite for which, as he said, one embarks as on a train for a star,

and one embarks the day one has quite decided to finish with life.

Now, in the death of Van Gogh, such as it occurred, I do not think that that is what occurred.

Van Gogh was shipped out of the world by his brother, first by announcing to him the birth of his nephew; he was then shipped out by Dr. Gachet who, instead of recommending rest and solitude, sent him out to paint from nature one day when he certainly felt that Van Gogh would have done better to go and lie down.

For one does not thwart so directly a lucidity and sensibility of the stamp of the martyrized Van Gogh's.

There are spirits who, on certain days, would kill themselves because of a simple contradiction, and because of that one need not be a lunatic,

a registered and catalogued lunatic, on the contrary, it is enough to be in good health and to have reason on one's side.

If I am ever in a similar situation, I will never again, without committing a crime, tolerate hearing anyone say to me: ''Monsieur Artaud, you're raving,'' as has so often happened to me.

And Van Gogh heard it said to him.

And that's what made the knot of blood that killed him twist in his throat.

Post-script

As regards Van Gogh, magic and witchcraft, are all the people who for months have been filing past the exhibition of his work at the Orangerie Museum, are they all quite sure they remember everything that happened to them every evening in February, March, April and May 1946? And was there not a certain evening when the atmosphere of the air and the streets became somewhat liquid, gelatinous, unstable, and when the light of the stars and of the celestial vault disappeared?

And Van Gogh was not there, he who painted the Arles café. But I was in Rodez, that is, still upon earth, when all the inhabitants of Paris must have felt, a whole night long, that they were rather close to leaving it.

And was it not because they had all concertedly participated in a certain generalized lousiness, when the consciousness of Parisians left the normal plane for an hour or two and proceeded to the other, to one of those unfurlings of mass hatred of which I was many a time somewhat more than a witness during my nine years of confinement. The hatred has now been forgotten like the nocturnal expurgations that followed and the same ones who again and again laid bare and in front of everyone their nasty piggish souls now file past Van Gogh whose neck they or their fathers and mothers so effectively wrung when he was alive.

But did there not, on one of those evenings I'm talking about, fall on the Boulevard de la Madeleine, at the corner of the Rue des Mathurins, an enormous white stone as if it had been shot from a recent volcanic eruption of the Popocatepetl volcano?

[Statement on His Attitude in Painting]

Mark Rothko

The progression of a painter's work, as it travels in time from point to point, will be toward clarity: toward the elimination of all obstacles between the painter and the idea, and between the idea and the observer. As examples of such obstacles, I give (among others) memory, history or geometry, which are swamps of generalization from which one might pull out parodies of ideas (which are ghosts) but never an idea in itself. To achieve this clarity is, inevitably, to be understood.

This statement originally appeared in *The Tiger's Eye* 9 (October 1949): 114.

[On Trigant Burrow's *The Neurosis of Man*]

Barnett Newman

Trigant Burrow in his *The Neurosis of Man* believes that the solution for man's neurotic nature can be found only if the psychoanalytic sciences study man not as an isolated individual in various states of personal maladjustment but if they treat him as a victim of a phylic disease affecting all, the normal and abnormal,—that they assume that man is a neurotic failure because he does not know how, at any rate, he cannot act as a phylic entity, which I understand Burrow to mean, that state in which man behaves as a social being acting completely like a specie-figure rather than as an isolated entity reacting against other entities. A trained psychoanalyst, he rejects his traditional scientific background as inadequate because it does not attack the problem of man as an *a priori* social thing. Man, he proposes, is neurotic because he has been conditioned by the cultural instruments of society to consider himself a part of society rather than a social fact. (The political implications of this notion, involving the destruction of man as personality, are obvious and ominous but I shall not concern myself with them for to do so would indicate that Burrow has developed a theory that one must contend with as dangerous because it involves possibility. The real danger is that this book might be taken to have developed something that is possible when all Burrow is engaged in is scholastic mysticism. I shall, therefore, try to show this primary fact because it is the "minus" idea rather than the bad idea that is always more dangerous.)

Burrow contends that the psychologist cannot ignore the question of what is the nature of the society of men before he can try to adjust specific individual man to it. He raises, and I think rightly, the question of ethics as a crucial element in any determination of personality adjustment or in-

This essay originally appeared as part of the article "To Be or Not: Six Opinions on Dr. Trigant Burrow's *The Neurosis of Man*" [*The Tiger's Eye* 9 (October 1949): 115-34]: 122-26.

tegration. But at the same time, he totally rejects all philosophy and ethics, that is, not only is he opposed to specific philosophies, which is a legitimate jumping off point for any new thinker but he also rejects the exercise of the philosophic process. He does so because he claims that he must reject all existing bodies of thought since they are the very instruments that have created the "partitive" values that have conditioned man to grow up within a framework of prejudices or "affects" and which constitute his neurosis. Any step towards a solution by means of the established realms of knowledge involves man in a trap of his own symbols. Yet he does not hesitate, after dismissing all of man's cultural tools—philosophy, art, poetry, language, to create a solution within the framework of science, as if scientific method were a puritanical absolute, devoid of symbolic content as if his *diagram* of science were Science, some supernatural verity. He thinks his science is not a human instrument for knowledge and therefore not vulnerable as are those instruments he despises. It seems to me that if all culture is on trial because it conditions man, science must also stand in the prisoner's dock. Burrow thinks he can successfully engage in an assault on culture, against all the existing frameworks of thought by shouting the purity of his scientific diagrams. But if all culture tools are corrupting, he must first prove that his syllogistic structure is the angel's secret. Burrow, however, is incapable of any truly profound analysis of this metaphysical problem—whether man leads his thought or whether thought leads man. Instead he proceeds to build his gigantic structure on the shallow foundations of polemic. Having said over and over that his science is *the* science, he thinks he proves something because he insists that we believe.

What is worse, however, is that within the framework of his own scientific structure, his thinking is so shallow that he destroys his own structure by a lack of imagination and an inability to know and judge the quality that makes for true scientific thought. He is a medievalist who moves from a generalization to a particular so that his science involves an application to individuals of discoveries based on propositions that are complete abstractions. His main premise is that man is a phylo-organism, i.e., that man is a phylic entity who moves as an example of a phylum and therefore should behave as an emblem of a species rather than as a single individual within a phylum. In plain English, man is a social animal. This generalization is his primal postulate. With Burrow this abstraction becomes a taxonomic identification. From this generality he builds an intricate structure of barbaric language in the self assurance that by erecting a structure of language that is diagrammatic rather than symbolic, he has created science. Burrow thinks that science is the creation of new technical terms, that the "made" word free of usage brings clarity. Somehow he is incapable of differentiating between what is verbal and what is meaningful.

Just as it is the primary responsibility of the artist and in particular of the art critic to know the difference between what looks like art and what is art, so it is primary that the scientist and the critic of scientific thought recognize the difference between something that reads like science and that which is true science. The proper manner to review this book, therefore, is to dismiss it. Yet one has to contend with Burrow even though it seems transparent to me that his thought is not thought at all, because of the believers who have already flocked to his "discoveries."

Trigant Burrow's name came to my attention through the writings of Herbert Read who, in his concern with the social nature of man, has quoted from Burrow as the harbinger of a new vision. It was, therefore, with some eagerness that I came to this book, hoping to find some true insight into a problem that has great interest for me. However, Burrow's book has been a great disappointment but what is still more disappointing is to find Read, who, in the fields of art and literature (no matter how much I may disagree with him about specific ideas) knows better than to confuse the false with the real, in the field of social philosophy shows the same ingenuousness he had before he read Kropotkin. He knows that the all-embracing formula, the single secret does not exist in the arts. Does he still persist in finding panaceas, does he still believe that there is a secret formula that will solve man's social problem?

My true quarrel with Burrow is not that he has identified thought with polemics. As a painter, I am, of course, appalled at his lack of plasticity, at his aesthetic obtuseness that makes him incapable of understanding poetic truth, an obtuseness that makes it impossible for him to grasp the nature of linguistic symbols and which in the end amounts to an obsessive fear of beauty. His onslaught on language is not so much, as he insists, a distrust of its lack of uniformity, but rather an inability that amounts to an obsessive fear of making the poetic leap needed to understand not only language but to understand at all—to conceive meaning. With the exception of 39 pages in the Appendix, this book of 357 pages is a long polemic telling us that he is against war, against hate, against the politicians, against nationalism, against the exercise of sheer power, against prejudice, against racialism, against the church, against all aggressive behavior both social and personal, against the false prophets,—the philosophers, the artists and particularly the psychologists, the semanticists. Thus he puts himself on the side of the angels because he is for peace, for freedom, for the good life, for the practice of "objective" science in the field of social behavior. This "objective" science is his new science of phyloanalysis.

I shall ignore the fantastic intricacies of his verbal science—his new vocabulary, even his invention of the "third brain," his new scientific verbalism for what used to be called the soul. It is just as well to accept them

for they disprove themselves as soon as one examines his factual data and experiments. The book is a long forensic monologue calling for rather than creating a new science. In the Appendix, Burrow sets down his actual experiments and it is these I wish to examine.

In these experiments, he offers as proof of his thesis the fact that when man behaves organismically, i.e., as a complete being in a state of phylic wholeness, man is in a state of integration called "cotention." When, however, man behaves partitively and is therefore thinking of himself not as a phylic being but an individual entity, he is full of prejudice, ambitions, aggressive desires which Burrow calls "affects" and is then in a state of what he calls "ditention." These states Burrow sets out to prove are physical and neurological; ditention producing pain around the eyes and front part of the brain, whereas cotention produces a state of integration. He tested this by means of a new camera that photographs the blinks of the eye under both states. He also measured the respiratory rate, the cardiovascular function, the changes in the neural function of the brain by means of the Grass electroencephalograph and the ink writer. He established that there is a difference in brain wave activity under cotention and ditention.

To show, however, that these states are different from attention, tension, and relaxation, he performed similar tests while the patient was reading a technical article and the patient was doing problems in mental arithmetic. In both cases he found cotention and ditention to exist *regardless* of the activity. (This is a resume of the entire body of scientific discoveries made by Burrow.) It is precisely here that Burrow destroys his entire work for if cotention and ditention exist irrelevant to and outside the *acts* of man, how can he hope to use cotention as a touchstone in the search for a cure of man's neurosis? Obviously if cotention and ditention exist free from attention, from reading or doing arithmetic, they must be free from any other human activity and I am certain they can be found to exist not only while man is reading a paper but also while he is firing a rifle. I am willing to wager that if Burrow tried his machinery on a firing squad shooting at a live target, he would find that both these states could be induced, and that these men would fire while in a state of phylo-organismic harmony and that they would fire under a state of ditention. The states of being of these men would have nothing to do with the killing of their victim. It would be interesting to see this experiment tried on cannibals. I think he would find that cotention and ditention would exist there too.

In conclusion, I wish to point out that one of Burrow's preoccupations is with the evil of language. His thesis is that before man learned to use language, before he learned to speak and communicate so that he could transmit values, man was closer to a state of phylo-organismic harmony. The implication is that a state of Nature precludes the neurosis; that the neurosis is the result of man's acquisition of communicable culture

and that an animal state with no spoken language is one without neurosis because then there exists a more instinctive phylo-organismic feeling. The biology libraries are full of refutations of this romantic notion concerning animal society.

I wish to recommend to Mr. Burrow two reports on the subject:

1. A. L. Rand, National Museum of Canada, Ottawa, Canada
 "Some Irrelevant Behaviour in Birds." The Auk, a Quarterly Journal of Ornithology April 1943, Vol. 60, #2
2. Dale W. Jenkins, University of Minnesota, Minneapolis, Minn. "Territory as a Result of Despotism and Social Organization in Geese." The Auk, a Quarterly Journal of Ornithology January 1944, Vol. 61, #1
 (This paper has a page bibliography)

I wish to quote a few lines from the summary taken from the second paper.

1. A definite "peck-right" type of intraspecific social organization (modified by family ties and mated pairs) was found in Blue, Snow, and Canada Geese, under approximately natural social conditions.

2. Family relations and ties are strong outside of the mating and nesting season. In the breeding season, the adult males become despotic and cause disruption of the families, resulting in a change of peck order, due to the offspring being driven from the families.

3. There is definite evidence of *organized* despotism and facilitation, resulting in the dominance of *well coordinated groups* as families. (italics mine)

Does Mr. Burrow believe that men could be saved if they *really were* geese?

Figure 22. Mark Tobey, *Happy Yellow*
The Tiger's Eye 3 (March 1948): 54.
Tempera.
*(Addison Gallery of American Art. Phillips Academy, Andover,
Massachusetts)*

I SHALL KEEP MY EYES FIXED ON THE TWO ARTISTIC DEITIES OF THE
GREEKS, APOLLO AND DIONYSUS, AND RECOGNIZE IN THEM THE LIVING AND
CONSPICUOUS REPRESENTATIVES OF *TWO* WORLDS OF ART DIFFERING IN THEIR
INTRINSIC ESSENCE AND IN THEIR HIGHEST AIMS. I SEE APOLLO AS THE TRANS-
FIGURING GENIUS OF THE *PRINCIPIUM INDIVIDUATIONIS* THROUGH WHICH
ALONE THE REDEMPTION IN APPEARANCE IS TRULY TO BE OBTAINED; WHILE
BY THE MYSTICAL TRIUMPHANT CRY OF DIONYSIUS THE SPELL OF INDI-
VIDUATION IS BROKEN, AND THE WAY LIES OPEN TO THE MOTHERS OF BEING,
TO THE INNERMOST HEART OF THINGS.

Figure 23. Theodoros Stamos, Drawing
The Tiger's Eye 3 (March 1948): 79. Appeared in the "Ivy on the
Doric Column" section. The quotation above Stamos's drawing
is from Friedrich Nietzsche's *The Birth of Tragedy*.

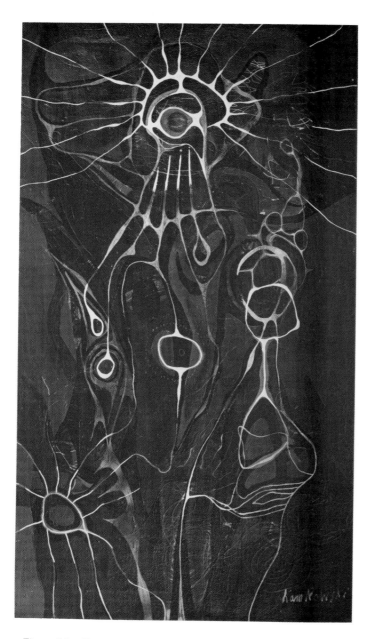

Figure 24. Gerome Kamrowski, *The Eye in Darkness*
The Tiger's Eye 3 (March 1948): 105. Appeared in the
"Ivy on the Doric Column" section.
(Destroyed)

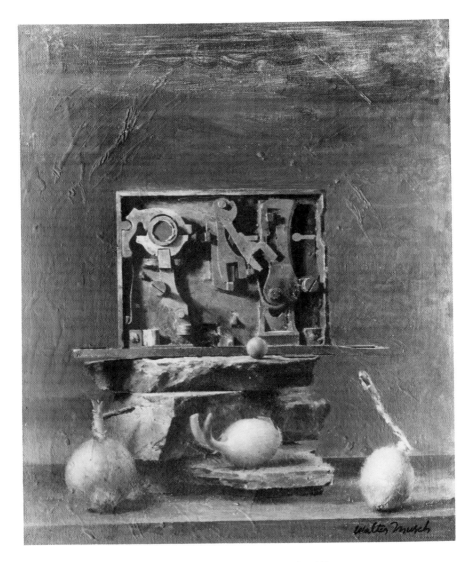

Figure 25. Walter Murch, *The Lock,* 1948
The Tiger's Eye 4 (June 1948): 47.
Oil on canvas, 22″ × 18″.
(Private collection)

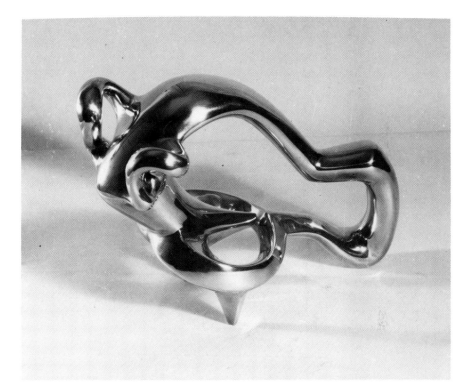

Figure 26. Helen Phillips, *Moto Perpetuo,* 1948
The Tiger's Eye 4 (June 1948): 94. Appeared in ''Ides of Art''
section on sculpture.
Bronze.

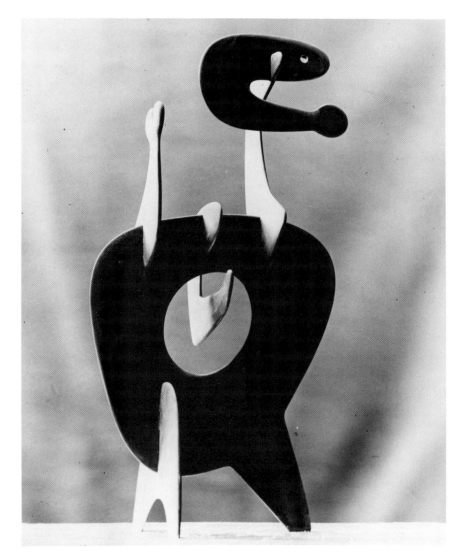

Figure 27. Isamu Noguchi, *Fish Face*, 1946
The Tiger's Eye 4 (June 1948): 95. Appeared in ''Ides of Art''
section on sculpture.
Slate, 36″ high, 15″ wide.
(Collection of Joseph B. Zimmerman)

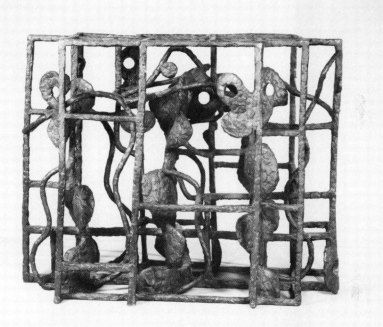

Figure 28. Peter Grippe, *Symbolic Figure #4,* 1946
The Tiger's Eye 4 (June 1948): 102. Appeared in ''Ides of Art''
section on sculpture.
Bronze, 17" × 11" × 22".
(Collection of the Newark Museum. Armen Photographers)

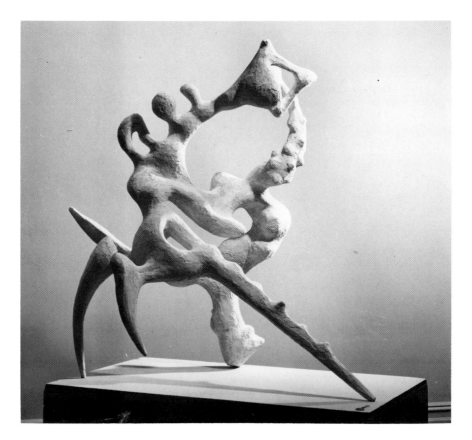

Figure 29. Herbert Ferber, *Apocalyptic Rider*, 1947
The Tiger's Eye 4 (June 1948): 103. Appeared in ''Ides of Art''
section on sculpture.
(Plaster) for bronze, 48″ high.

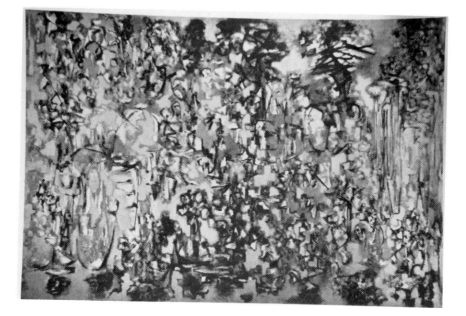

Figure 30. Ad Reinhardt, *Bits of Information*
The Tiger's Eye 6 (December 1948): 18.

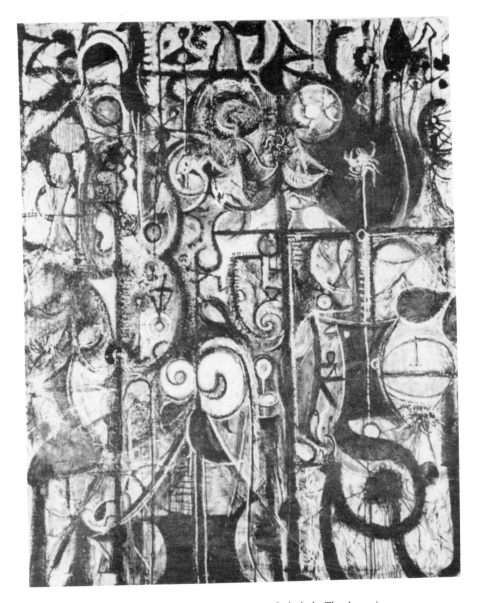

Figure 31. Richard Pousette-Dart, *Cathedral—The Ascension*
The Tiger's Eye 6 (December 1948): 19.
(Destroyed)

Figure 32. John Stephan, *The Pyramid Confronts the Sea*
The Tiger's Eye 7 (March 1949): 33.
Oil.

Figure 33. Dorothea Tanning, *Palaestra*, 1947
The Tiger's Eye 7 (March 1949): 86. Appeared in the "Poets on
Painters and Sculptors" section with "The Children Going"
(dedicated to Tanning) by Charles Henri Ford.
Oil, 61.5 cm. × 44 cm.

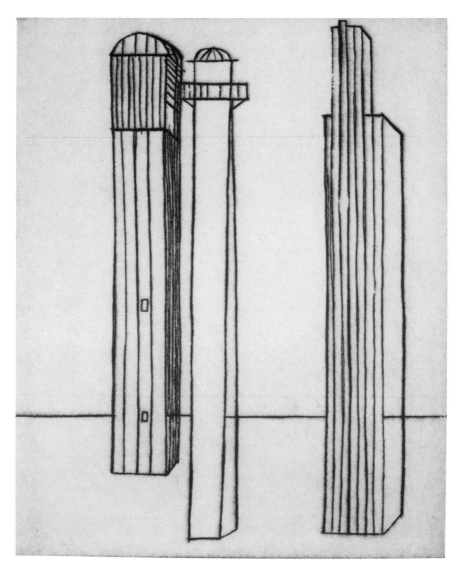

Figure 34. Louise Bourgeois, Untitled
The Tiger's Eye 7 (March 1949): 91. Plate 3 from the series "He Disappeared into Complete Silence," 1947. Appeared in the "Poets on Painters and Sculptors" section with "An Introduction to Louise Bourgeois" by Marius Bewley.
Engraving, 6¾" × 5½".
(Courtesy Robert Miller Gallery, New York. Photo by Robert E. Mates)

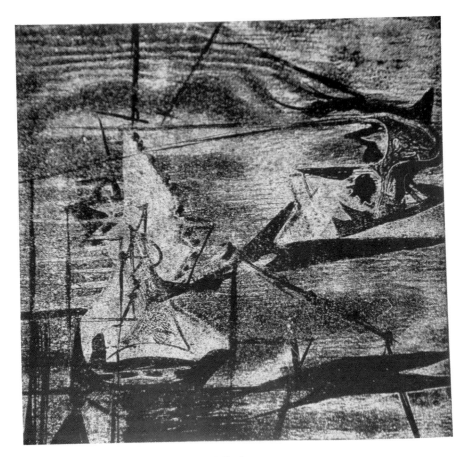

Figure 35. Boris Margo, *Ocean at Dusk*
The Tiger's Eye 8 (June 1949): 23. Appeared in ''A Selection on
Graphic Arts.''

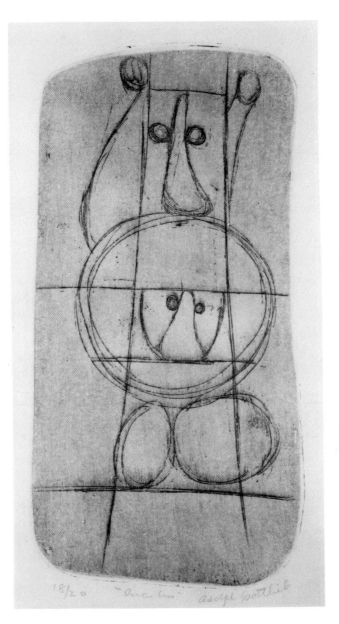

Figure 36. Adolph Gottlieb, *Incubus*, ca. 1946
 The Tiger's Eye 8 (June 1949): 28. Appeared in
 "A Selection on Graphic Arts."
 Etching, 8¾" × 4¼".
 (Adolph and Esther Gottlieb Foundation, Inc.)

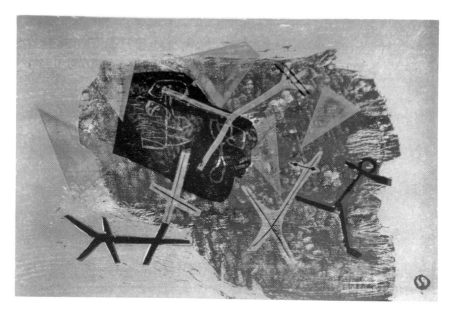

Figure 37.　Louis Schanker, *Carnival*
The Tiger's Eye 8 (June 1949): 33. Appeared in
"A Selection on Graphic Arts."

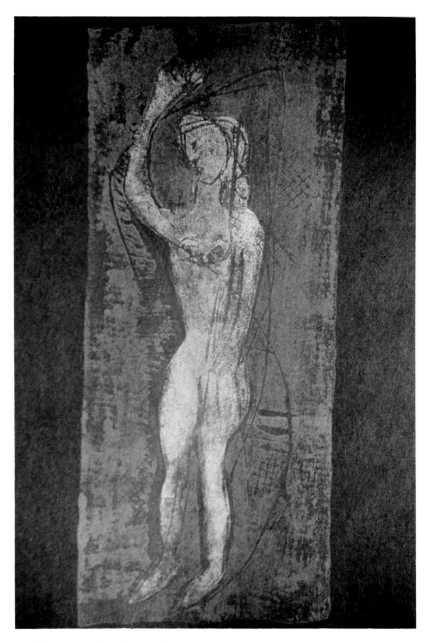

Figure 38. Anne Ryan, *Amazon*
The Tiger's Eye 8 (June 1949): 39. Appeared in ''A Selection on Graphic Arts.''

ballet interpersonal

CHARACTERS
 Mr. X
 anXiety
 Keepers
 Chief Analyst
 Analyst
 Chorus of *Analysts*
 Nurses **Shadowgraph Figures**
 Phobias *Common Colds*

Argument

1

(THE ANXIETY WHIRL: *Mr. X, anXiety*)

Mr. X, the interperson, dressed in black tights, black long-sleeved sweater, white gloves and socks, strolls through life.

Life, suggested by the scenic designer, is bright and gay. *Mr. X* is jaunty until he encounters a figure dressed like himself but with a white mask.

anXiety, for it is he, is going in the opposite direction stepping backwards. One hand shields his eyes. The other is flung out before him. His body is bent forward as if he were really traveling the same way as *Mr. X.*

Mr. X stops to look and is seized by *anXiety, anXiety* tries to drag *Mr. X* back with him. *Mr. X* resists. The two mill about.

Mr. X throws off *anXiety* and resumes his original direction. But now life darkens ahead of him. *Mr. X* hesitates and is re-seized by *anXiety.*

Whenever *anXiety* pulls him back, life darkens in that quarter, brightens behind him.

Soon they are going in a frenzied circle, whose narrowing perimeter grows darker and darker except for a flickering will-o'-the-wisp of light, beckoning to and eluding *Mr. X.* Unable to shake off the ever-tenacious *anXiety, Mr. X* falls unconscious to the ground.

(BLACKOUT)

25

Figure 39. Lloyd Frankenberg, *Ballet Interpersonal*
 The Tiger's Eye 9 (October 1949): 25–34. This illustrated play
 appeared in "A Selection on Nights. A Darkness of the Mind or
 of Nature."

2

(THE COMMITMENT HOP: *Mr. X, Keepers*)

The prevailing darkness thins to a grey gloom in which can be seen the prone figure of *Mr. X*, alone.

A pair of Mack Sennett *Keepers* pull on a caged vehicle in the likeness of a padded cell. Dropping the whiffletrees, they prowl around *Mr. X*, giving him tentative pokes. *Mr. X* stirs feebly.

They lift him and start hustling him into the cell. Without opening his eyes, *Mr. X* struggles against them. Three times they get him as far as the cage door, but while one of the *Keepers* is opening it *Mr. X* manages to slip out of their clutches. In the confusion the *Keepers* try to drag each other into the cell.

Mr. X can succeed only in staggering a few steps off before slumping to the ground.

3

(INTERLUDE: *Mr. X*, motionless; *Keepers*; Chorus of *Analysts*)

Silently the group is surrounded by a Chorus of *Analysts*. The men are baldheaded and goateed, wearing exaggerated black cutaways and yellow spectacles. The women are in long grey dresses and carry blue lorgnettes. Circling the *Keepers*, the *Analysts* confront them with folded arms, shaking heads and clucking tongues.

The *Keepers* protest in gestures, indicating *Mr. X* and twirling their fingers near their temples. One of them produces a long document on which is printed the word: COMMITMENT. This is passed around the circle of *Analysts*.

The *Chief Analyst*, distinguished by a purple opera cape, kneels and examines *Mr. X*. He opens *Mr. X's* mouth and peers down his throat. He gets up, slowly nodding his head. One of the *Keepers* makes a move toward *Mr. X*. The *Chief Analyst* seizes him by the head and makes a similar examination of the *Keeper*. Piercingly eyeing the *Keeper*, he beckons a second *Analyst* to have a look. The *Keeper* turns and runs for it, followed by his partner pulling the cage.

4

(RING AROUND A PSYCHE: *Mr. X*, motionless; Chorus of *Analysts*)

The *Analysts* circle the prostrate figure of *Mr. X.* Index fingers to brows, they dance the dance of Diagnosis, alternately bending in thought and throwing their heads back with an idea; a slow-motion Indian War Dance.

The *Chief Analyst* stands apart, hands folded behind him, with his back to the circle.

An *Analyst* leaves the circle and applies a giant stethoscope to *Mr. X's* temple. Rejoining his colleagues, he passes the stethoscope around the circle. The *Analysts* consult in pairs. They change partners and resume their dance.

A second *Analyst* leaves the circle. He shakes down a giant thermometer and holds it to *Mr. X's* forehead. After reading the result he rejoins the circle, where the thermometer is passed around.

A third *Analyst* leaves the circle. He puts his ear to *Mr. X's* ear and listens, jotting down what he hears in a large notebook. The notebook is passed around.

diagnosis case history

5

(DIAGNOSTIC POW WOW: The same)

The *Analysts* disagree among themselves. Leaving *Mr. X,* they circle the *Chief Analyst.* One of them hands him the stethoscope. He holds it to his own temple. He does the same with the thermometer, shaking it down quickly after reading it. He puts the notebook to his ear and listens.

The *Analysts* put their heads together around him in the manner of a football huddle. Thus huddled, they rotate slowly. Then they rotate in two circles going in opposite directions. They alternate directions. The dance ends in a mêlée of opinions.

6

(KNEE-JERK KAZOTSKY: The same)

Angrily waving them away, the *Chief Analyst* stands lost in thought, alternately nodding and shaking his head.

The Chorus examine each other's heads, by stethoscope, thermometer and ear.

They line up, Rockette formation, cross their legs, and with rubber mallets practise the Knee-jerk. They reverse legs and repeat the kicks. The kicks grow higher and higher.

7

(REVUE PSYCHIATRIQUE: The same)

The *Chief Analyst* comes out of his brown study. He inspects the line of *Analysts*, drawn up as for a military review. He examines their eyes, teeth and fingernails.

Summoning one of the *Analysts* from the lineup, he dubs him with the thermometer. The chosen *Analyst*, kneeling to be knighted, receives the thermometer, kissing it, while the rest of the line files out.

8

(THE MAGIC COUCH: *Mr. X, Analyst, Nurses; Chief Analyst*, apart)

The *Chief Analyst*, after touching heads with the chosen *Analyst*, resumes his former position with his back to the scene. During the ensuing action he occupies himself by testing various parts of his head with the stethoscope, jotting down the results in a notebook and meditating.

The chosen *Analyst* executes a ceremonial dance with the thermometer. During this, two *Nurses* wheel on a couch. They take from it a chair, placing it near the head of the couch but facing in the opposite direction. Then they lift *Mr. X* and put him on the couch.

Mr. X comes to for a moment and cowers away from the *Nurses*. The *Analyst*, observing this, shakes his head and tests *Mr. X* with the thermometer.

The *Nurses* leave. The *Analyst* sits on the chair. *Mr. X* looks up from under his arm at the *Analyst*. The latter, gesturing in front of him, as if he were facing *Mr. X*, opens the pantomime conversation. *Mr. X* answers, gesturing in the opposite direction.

The *Analyst* makes sleeping motions with his hands. *Mr. X* curls up and goes to sleep. The *Analyst* jogs his shoulder. He makes sleeping motions again; then draws his index fingers together moving them away from his eyes, to indicate that *Mr. X* should tell him his dreams. *Mr. X* assures the *Analyst* that his eyes are straight. The *Analyst* continues to gesture.

Finally catching on, *Mr. X* begins to relate his dreams. He makes motions expressive of flying; of falling from great heights; of swimming; of crouching away from monsters. The *Analyst* nods, his chin deep in his hands.

Mr. X notices he is asleep and jogs his shoulder. The *Analyst* snores.

"Transference"

9

(DANCE OF THE PHOBIAS: The same, plus *Phobias*)

Figures with large animal heads dance on: an *Owl*, a *Sea Lion*, a *Bull*, a *Fish* and a *Lady Bug*. They make menacing gestures at *Mr. X*, who first cowers from them and then screams.

The *Analyst* wakes up with a start. *Mr. X* points out the figures but the *Analyst* does not see them. He observes *Mr. X's* behavior closely and makes notes in his book. The figures sneak up behind and hit him on the head, but he doesn't feel it.

Mr. X faints away. The figures dance off.

10

(LIFE CYCLE SHADOWGRAPH: *Mr. X, Analyst, Nurses, Chief Analyst, Figures of the Shadowgraph*)

The *Analyst* summons the *Nurses*, who enter with towels and cold compresses and minister to *Mr. X* while the *Analyst* confers with the *Chief Analyst*. They put their heads together. The *Chief Analyst* holds the notebook to his ear. He directs the *Analyst* offstage.

consultation

The *Analyst* returns with the *Owl's* head. *Mr. X*, who has come to, is beginning to take an interest in the *Nurses*, and resents the *Analyst's* interruption. He does not see the *Owl's* head, which the *Analyst* is showing him.

The *Analyst* despatches the *Nurses* for the other heads. These he pre-

29

sents in turn to *Mr. X,* who merely becomes suspicious of him.

Dismissing the *Nurses,* the *Analyst* resumes his seat. He makes rockabye motions, indicating that *Mr. X* should tell him about his childhood. *Mr. X* is increasingly suspicious; but eventually getting the idea, begins his story.

The front of the stage darkens. In the background, behind a screen, figures pass representing the Life Cycle of *Mr. X:*

The *Mothering One* crosses the screen, a baby in her arms. She is a bulky silhouette of the 1900's, with an oversized hat and a veil drawn down under her chin as if for motoring. She spanks the baby. *Mr. X* is heard to wail.

Next the *Fathering One,* in a punchbowl-sized bowler hat, dragging a little boy by the hand. The little boy tugs the other way. The *Fathering One* stoops and gives him a cuff. Yowl from *Mr. X.*

A troupe of boys, with enormous schoolbooks, cross the screen. A *Bully,* the brawniest, knocks the smallest boy down. *Mr. X* whimpers.

Two boys, older, with arms about each other's shoulders. A *Rival* appears, carrying a huge fishing-rod. One of the partners detaches himself. Giving his former playmate the back of his hand, he joins the *Rival. Mr. X* calls out: "All right on you!"

A boy and a *Girl,* the latter with exaggerated sweater proportions. He tries to put his arm around her; is slapped. *Mr. X* boo-hoos.

(SHADOWGRAPH BLACK OUT)

11

(INTERPRETATION BLUES: *Mr. X, Analyst, Nurses; Chief Analyst; Phobias*)

The lights come on in front. *Mr. X* is weeping into a voluminous handkerchief. The *Analyst* summons the *Nurses* and goes to put his head together with the *Chief Analyst.*

After consultation, the *Chief Analyst* directs him offstage. He returns followed by five figures from the Shadowgraph: the *Mothering One,* the *Fathering One,* the *Bully,* the *Rival* and the *Girl.* They surround *Mr. X,* who does not see them and is all the more suspicious of the *Analyst's* gestures.

The *Analyst* picks up the *Lady Bug* head and claps it on the sweatered

Girl. Now she becomes visible to *Mr. X,* who tries to choke her. But the head comes off in his hands.

This happens in turn to the *Fish-Rival, Bull-Bully, Sea Lion—Fathering One* and *Owl-Mothering One.* On the last attempt, instead of disgustedly handing back the head, as he has done previously, *Mr. X* claps the *Owl's* head on himself.

The other *Phobias* have left, carrying their heads in their hands. But the *Mothering One* hangs around and has to be forcibly ejected by the *Analyst.*

12

(THERAPEUTIC JIG: *Mr. X, Analyst, Nurses; Chief Analyst*)

The *Analyst* summons the *Nurses* and goes off to put his head together with the *Chief Analyst.*

Mr. X attempts to kiss one of the *Nurses,* still with his *Owl's* head on. The *Nurse* slaps the head, with no effect on *Mr. X,* who tries to kiss the other *Nurse.*

He gets up off the couch and chases them around the stage.

13

(INSIGHT ONESTEP: The same, plus *anXiety*)

After consultation, the *Chief Analyst* leaves the stage. He returns leading the figure of *anXiety,* which he turns over to his colleague.

The latter presents *anXiety* to *Mr. X,* who has demurely resumed his position on the couch.

Mr. X does not see *anXiety.* But by now he is fully aroused by the behavior of the *Analyst,* and tries to choke him. With the aid of the *Nurses,* who come on just in time, the *Analyst* is extricated.

In despair, *Mr. X* then attempts to choke himself, But the *Owl's* head comes off in his hands. Angrily he hurls it from him. It bounces off *anXiety,* who says, "Ouch!"

31

Now *Mr. X* sees *anXiety;* he leaps from the couch and goes for him.

anXiety whips off his mask, revealing a face identical with *Mr. X's.* The two shake hands. Arm in arm they dance about the stage and off.

<center>14</center>

(PSYCHIATRIC SNAKE DANCE: Chorus of *Analysts,* joined by *Common Colds*)

The Chorus of *Analysts* comes on. The *Chief Analyst* and the chosen *Analyst* are raised on shoulders and carried about triumphantly, in a victory snake dance, which has all the aspects of a finale.

In the midst of their celebration, hooded figures representing the *Common Cold* enter. The *Analysts* are routed sneezing.

<center>15</center>

(ADJUSTMENT POLKA: *Mr. X, aniXety, Nurses*)

The stage is vacant for a moment. *Mr. X* and *anXiety* reappear, each whirling a *Nurse* in his arms.

<center>(CURTAIN)</center>

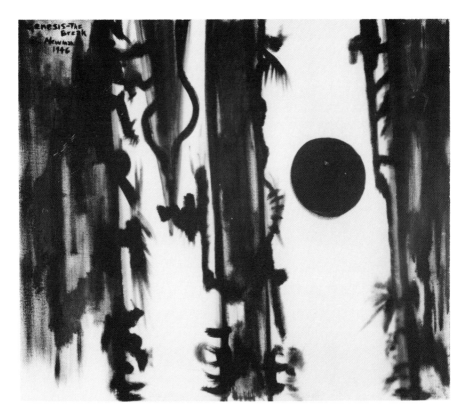

Figure 40. Barnett Newman, *Genesis—The Break*, 1946
The Tiger's Eye 9 (October 1949): 59. Painting appeared in ''A
Selection on Night. A Darkness of the Mind or of Nature.''
Oil on canvas, 24″ × 27⅛″.
(Dia Art Foundation Collection. Photo by Bevan Davies)

Possibilities

problems
of
contemporary
art:

possibilities 1

abel. arp. baziotes. caffi. calvo. haieff

hayter. hulbeck. goodman. miró. motherwell

niemeyer. poe. pollock. rosenberg. rothko

david smith. virgil thomson. varèse. ben weber

Figure 41. Paul Rand, Cover
Possibilities (Winter 1947/48).
(Photo by Yale Audio Visual Department)

[Editorial Statement]

Robert Motherwell and Harold Rosenberg

This is a magazine of artists and writers who "practice" in their work their own experience without seeking to transcend it in academic, group or political formulas.

Such practice implies the belief that through conversion of energy something valid may come out, whatever situation one is forced to begin with.

The question of what will emerge is left open. One functions in an attitude of expectancy. As Juan Gris said: you are lost the instant you know what the result will be.

Naturally the deadly political situation exerts an enormous pressure.

The temptation is to conclude that organized social thinking is "more serious" than the act that sets free in contemporary experience forms which that experience has made possible.

One who yields to this temptation makes a choice among various theories of manipulating the known elements of the so-called objective state of affairs. Once the political choice has been made, art and literature ought of course to be given up.

Whoever genuinely believes he knows how to save humanity from catastrophe has a job before him which is certainly not a part-time one.

This statement originally appeared in *Possibilities* (1947/48): 1.

Political commitment in our times means logically—no art, no literature. A great many people, however, find it possible to hang around in the space between art and political action.

If one is to continue to paint or write as the political trap seems to close upon him he must perhaps have the extremest faith in sheer possibility.

In his extremism he shows that he has recognized how drastic the political presence is.

I Cannot Evolve Any Concrete Theory

William Baziotes

I cannot evolve any concrete theory about painting. What happens on the canvas is unpredictable and surprising to me. But I am able to speak of certain things that have occurred up to now in the course of my painting.

Today it's possible to paint one canvas with the calmness of an ancient Greek, and the next with the anxiety of a van Gogh. Either of these emotions, and any in between is valid to me.

There is no particular system I follow when I begin a painting. Each painting has its own way of evolving. One may start with a few color areas on the canvas; another with a myriad of lines; and perhaps another with a profusion of colors.

Each beginning suggests something. Once I sense the suggestion, I begin to paint intuitively. The suggestion then becomes a phantom that must be caught and made real. As I work, or when the painting is finished, the subject reveals itself.

As for the subject-matter in my painting, when I am observing something that may be the theme for a painting, it is very often an incidental thing in the background, elusive and unclear, that really stirred me, rather than the thing before me.

I work on many canvases at once. In the morning I line them up against the wall of my studio. Some speak; some do not. They are my mirrors. They tell me what I am like at the moment.

This article originally appeared in *Possibilities* (1947/48): 2.

[Two Poems]

David Smith

I HAVE NEVER LOOKED AT A LANDSCAPE
without seeing other landscapes
I have never seen a landscape without visions of things
 I desire and despise
the separate lines of salt errors
the balance of stone—with gestures to grow
a landscape is a still life of Chaldean history
it is bags of melons and prickle pears
its woods are sawed to boards
it is colored by Indiana gas green
it is steeped in indian yellow
it is the place I've travelled to and never found
in the distance it seems threatened by the destruction
 of gold

These poems originally appeared in *Possibilities* (1947/48): 25. Smith's sculpture, *Deserted Garden Landscape*, which accompanied these poems, is reproduced in this volume as figure 42.

SCULPTURE IS

My year 4 moving forms, ice cream flower odors, fears
 5 praise from a grandmother for a mud pie lion
 7 the found book of nude marble women hidden by a
school-teaching methodist mother
Diana of the Ephesians
Egyptian embalmers and the sepulchral barge
the fight between the monster Tiamat personification of
chaos darkness disorder evil and Marduk god of light
where water is the parent of all things—where universal
darkness reigns—where gods have been forgotten
face illuminated by the sun and moon
the Babylonian hero wrestling the lion
tossing a bull
standing on a gryphon
the carrying of mud bricks by yoke and cord
the dialectic of survival
everything I sought, seek
what I will die not finding

Of the Means

Stanley William Hayter

Of the means by which the unconscious functioning of the mind can be made visible, line has become so completely normal and acceptable to human beings, that its specific character is easily overlooked.

As soon as a reflective anthropoid had seen the trace of his passage in the mud or sand behind him, as soon as he had looked ahead in a direction in which he wanted to go, to send something or someone, the necessity to record the experience or intention in a readable fashion had arisen. And to drag or pull a point over a soft surface in order to repeat the trace of his passage, to drive a point against a hard surface in order to record his intention or project, were immediately available means of doing this.

Of the current methods of rendering visible the content of the unconscious mind and imagination, automatic drawing—drawing without conscious control of the will—is one of the most valuable. Its use is less simple than might appear, and involves certain dangers.

And difficulties have to be surmounted for ideas to become visible. The normal laziness of the individual, and boredom—both elements of the same process—are the most serious. In order to permit an image to be made, a certain alertness and tension of spirit are needed. To make at a sitting twenty or thirty automatic drawings, none which may appear interesting at the moment, requires a resistance to boredom beyond the ordinary. For after a lapse of months they may begin to appear to be interesting.

I have used a method in which I make a series of drawings of the same sized format, examining them in groups, chosen at random, of six or eight drawings which are superimposed on one another over a strong

This article originally appeared in *Possibilities* (1947/48): 71. Hayter's *Automatic Drawing*, 1944, which accompanied this article, is reproduced in this volume as figure 43.

transmitted light. A clear structure always appears, almost identical for a number of different groups. It is as though the image had been trying to conceal itself from you. . . . The correspondence of the directions and points of intersection of the groups is not approximate, but surprisingly accurate, within a tenth of a millimeter. The image is lucid, but not to be found in any one of the drawings alone.

The use of automatism in exploring the imagination (and in making the exploration available through its echo in other minds) is not a static experience. Not only the facility of execution, but the completeness of expression can be deliberately and consciously developed.

It seems to me that the artist who makes automatic drawings and does nothing about them will ultimately find himself sitting in the same position after many years—surrounded by embroidery.

But the intensive study of such drawings, the intensive speculation about the causes and consequences of the irrational act of making images, the nature and quality of tension, curvature, penetration, intersection in the trace becomes absorbed as experience and amplifies the content of subsequent work.

Having observed a particularly happy image, the artist should not then deliberately introduce it again into his drawings; this falsifies the experiment. When an image is obsessive, it will reappear; and it is reasonable to suppose that the reoccurrence of an image identifies it as having a higher order of significance in the life of the artist than one which appears only once. The artist should familiarize himself with the content of his automatic image, and then forget it. Only when forgotten, when through familiarity it is assimilated by the unconscious, when it becomes part of the artist's automatic, 'instinctive' activity, can it contribute to expression.

These views on the functioning of automatism cannot be scientifically justified; but at some point ratiocination becomes an inadequate means of progressing, and only the broad patterns of instinctive thought, irrational as they may be, are applicable. Perhaps in the recognition of these patterns we have a higher order of reality than in sensory observation of the phenomenal world.

Introduction to Six American Artists

Harold Rosenberg

Here are six American artists who feel no nostalgia for American objects and landscapes—no scenes of childhood, no regionalism of cowboys, country stores, cornfields, lighthouses, oil wells, no city streets, no social syntheses. Hence their paintings have no connection with that art which enjoys the largest journalistic reputation in America. Rather the paintings stand for a peculiar truth—or, more precisely, truths; since they are, above all, the work of individuals—of the creative process in the United States.

Not one of these painters shows the slightest sentiment about his own past. Nor, what is perhaps even more unusual, for the past of the art of painting as a tradition. Their nostalgia is rather for a means, a language, that will formulate as exactly as possible what is emotionally real to them as separate persons. And beyond his separateness, each hopes for future simplicities of human communication.

On the western shore of the Atlantic, then, these men have sought out, made their own, and applied to the needs of their special passions the international idiom of twentieth-century painting—an idiom that belongs to no one country, race or cultural temperament (though it is associated above all with Paris), but that in fact achieves much of its energy, inventiveness and glory in negating what is local and folkloristic through assimilating all national vestiges into a transcendental world-style. Such is the Modernism of a Chagall or Miró, insofar as the echoes of the East European ghetto or the Spanish village sound in their images. And only to this extent, and in this subjective sense of a creative transformation, is America present in this exhibition.

It would almost be correct to say that Art is the country of these painters. Except that they did not receive Art as a continuing spiritual tradi-

This article originally appeared in *Possibilities* (1947/48): 75.

tion embracing them all in the same movement. Art to them is rather the standpoint for a private revolt against the materialist tradition that does surround them. They are not a school, they have no common aim, not even the common tension that comes from rejecting the validity of the same art-history. They have appropriated modern painting, not to a conscious philosophical or social ideal, but to what is basically an individual sensual, psychic and intellectual effort to live actively in the present—mysteries of the flesh and the eye, excitations of the nerves, alternative disorders and serenities of the brain, an eagerness for an order that will contribute a momentary sensation of security rather than recall the etiquette and grace of long-accepted disciplines.

Attached neither to a community nor to one another, these painters experience a unique loneliness of a depth that is reached perhaps nowhere else in the world. From the four corners of their vast land they have come to plunge themselves into the anonymity of New York, annihilation of their past being not the least compelling project of these aesthetic Légionnaires. Is not the definition of true loneliness, that one is lonely not only in relation to people but in relation to things as well? Estrangement from American objects here reaches the level of pathos. It accounts for certain harsh tonalities, spareness of composition, aggressiveness of statement.

At the same time, however, the very extremity of their isolation forces upon them a kind of optimism, an impulse to believe in their ability to dissociate some personal essence of their experience and rescue it as the beginning of a new world. For each is fatally aware that only what he constructs himself will ever be real to him.

On Mythology

Andrea Caffi

By "myths" everybody seems to mean those creations of the collective mind which take the form of tales, dances, ritual representations and symbols of all sorts in societies designated as "primitive." In these societies are found in undifferentiated state all those elements which "later on" appear in autonomous form as religious experience, metaphysical speculation, pure artistic creation, magical and then rational science, and perhaps even as systems of morality, law, politics, and ecclesiastical organization.

According to Roger Caillois (Frazer and Lévy-Bruhl would perhaps have been of the same opinion), the myth dies, that is to say, loses its "reality" (its efficacy as magic, ritual, norm) in "literature." For Caillois, Plato's myths were already "literature" since Plato did not "believe" them.

It seems to me that far from dying, the myth becomes more complex when the different forms of art, religious dogma, philosophy and science offer it diversified masks, so often bewildering by their cunning elaboration or audacious spontaneity. Moreover, the myth is peculiarly at work when the pressures of rigorous rationalism, of strictly revealed or demonstrated "truth," of political, moral and aesthetic conformism come into conflict with the need to communicate with one's fellows.

As to the fact of "belief" (in supernatural powers, gods, demons, etc.), there is scarcely a break between the primitive myths and, let us say, those of Plato, or the tales Herodotus introduces with the remark: "You may believe as much of this as you like." (Had he not told these stories we should not know half as much as we do about the "reality," that is, the

This article, translated from French by Lionel Abel, appeared in *Possibilities* (1947/48): 87–95. Mark Rothko's painting, *The Source,* which preceded this article, is reproduced in this volume as figure 45.

mentality, the interests, the infrastructures, etc. of the Hellenic or barbarian societies he sketched for us in living images.)

From the very beginning the myth has been a representation and, above all, a communication of "things that do not exist but *are*." For by the sole fact that it is put in the form of a story or symbol, the myth excludes from actual existence the beings, the events, the norms of conduct, the fortunes and misfortunes that constitute its content: these either were present in the world when "I wasn't there" or are present in a world different from the one in which "I exist." The realm of the myth has rightly been called "sacred." Now the sacred is beyond attainment, incomprehensible (recalling the original sense of the word *comprehendere*: to seize), ineffable. And the whole effect of the myth—inseparable from active magic or passive mysticism—is to touch, to make present (by fiat or insinuation), to symbolize (the symbol was a sign of recognition or alliance) the ineffable by means of the word, "the nonexistent," by means of the assertion: "Once upon a time there *was* . . . ," or "In a far-off land, separated from us by seven seas and thirty countries, there *is* . . . " The paradox is that without this "nonexistent" our existence would have no human significance, as without the ineffable, human speech would scarcely differ from the vocal expressions of animals.

Some mark off a "mythological age," arguing that the obsession with the "sacred" and the spirit of participation are found only among primitives, that "civilized" people repress the "dream-level" and think and act in entire accordance with the "critical" views of experience and logic. Is this true? I do not think any of us is capable of eliminating every emotional coefficient—the "coefficient of adversity," for instance—and hence all spirit of participation from his relations with people and with things. . . . Each of us can no doubt recall some occasion when he had to exert his whole capacity for action, self-control and determination, in order to achieve a given end; the thing done, did one not have the feeling that success came by a miracle, that it would be impossible to say with certainty why this shift worked and that did not, or how it came about that this possibility was suddenly suggested, that circumstance as mysteriously overlooked? No doubt the primitive hunter had reactions of this sort every time he killed an animal. What is more to the point, in the memoirs of soldiers of Napoleon we find allusions to such experience for every cavalry charge. (Tolstoi, in *War and Peace*, describes with great precision how Nicholas Rostov became aware that the "right" moment had come to throw in his squadron.) And is there an avowal of lover or artist (Benvenuto Cellini casting his Perseus) which does not lie out of sincere emotion?

To me it seems evident that the paradoxes of the "true-and-false" and

the "nonexistent" that "is," traverse the whole of our life, pertain to the human condition as such and cannot be historically segregated.

Of course there are differences, due to the changing situations in the social network. For one thing, in a primitive milieu, states of torpor (as with animals) bring utter passivity, forgetfulness of existence. While the routine of the hunter, like that of the farmer and artisan, involves the continual presence of factors of "good luck and ill luck," the observation of signs in one's surroundings and in things, presentiments and precautions of a magical order. Finally, work done in harness, the passive obedience of the soldier, the "activity" of the bureaucrat, the feverish compulsions of the business man to whom "time is money," all admit of a mental torpor *in the very heart of productive existence. . . .* (Here is perhaps the meaning of the famous curse: "You shall live by the sweat of your brow": that is, in the enforced forgetfulness of nonexistential realities.)

Then, solitude and disorientation among men and happenings "completely strange to me" are rare exceptions among primitives; they are almost the rule in "civilized" agglomerations. So that the mythological experience has to turn inward, to put on an armor of diffidence and individuality (closely bordering on mental alienation), and while remaining very virulent in the depths of consciousness, is able to communicate itself only rarely and with difficulty, and then more by means of the "interior dialogue" than by the direct sense of the spoken word.

Another difference between integral mythology and differentiated (or "dispersed") mythology should be noted. Roger Fry said of the painters of the paleolithic caves that their amazing capacity to "see" the mammoth or the bison in a living mass, outside of all arrangements of perspective, of proportions and details, was lost when man became a "geometer," able to measure and dissociate what he perceives (this would date from the neolithic period). I have also read somewhere that children have a vision of things which consists of embracing them completely with a single glance, but when they learn to read, to break down words into letters, they lose this faculty. This makes one recall how Plato deplored the invention of writing; he had in mind not the visual effects of letters but the dissociation of language from the sacred (only partial, I should say) implied by writing, a process similar to what happens to drawing when, from having been instinctive, it becomes "deliberate." Undoubtedly, the language of the "unlettered" is a perpetual process of creation, while written language congeals both the form and meaning of each word; and the oral tradition, afire with immediate inspiration and improvisation, has a vitality unmatched by the tradition of the "book." . . .

Lévy-Bruhl, in line with other ethnologists whom he cites, has insisted on the importance to Australian tribes of the places connected with the periodic rites, the genealogical and cosmogenic legends, the prohibitions and the ordinances of each clan; each man feels himself to be in a state of "participation" with the hills and even with the cardinal points in his native "place," as with the animals and plants which he assimilates to his kin or ancestors; this is why the expulsion of a tribe from its "place," a thing which appears of such little consequence to the British administration, results in a real disintegration of the community so treated. The tribesmen abandon their rites and norms of behavior, yielding to a kind of collective despair. Spanish doctors have studied a similar illness which seems to afflict the Galicians inhabiting the coast bordering on Portugal; the Galician emigré is stricken with a nostalgia of such violent character that he languishes and often dies; no physiological cause for this ailment has been discovered, and it is all the more surprising in view of the fact that the Galicians are an extremely enterprising and businesslike race.

The Melanesian who has constructed a canoe with consummate care for all the details, the choice of the tree, the drying of the wood, the modeling and planning of the inside and outside, the exact measurement of all the gear, will never believe that his mastery of the matter he has thus transformed has been sufficient to make the boat seaworthy. The "mana" must still prove favorable; for in the tree he felled, in the tools he employed, in the very forms that a long tradition prescribed for the vessel, and even in the resistance of the water, not to speak of winds and storms, there is a multitude of *Dinge an sich* in which he feels that he participates, but which remain none the less disturbing, since they are as capable of hostility as of benevolence. Propitiatory rites are in his judgment as productive as the "labor-time" incorporated in the useful object. When starting on a voyage, he never forgets to conform to customs which economic rationalism would condemn as a waste of time and labor. We should not find this strange. Since the first stone implement the things fashioned by man have solicited his attention (his prudence, his fears, his hopes of "success"), in their metaphysical as in their practical aspects. "At the start you control the machine, but later the machine controls you," a mechanic has noted. The electrician, the aviator, expert in their special skills, find themselves unable to repress a feeling that the complicated mechanisms they handle, and which they know by heart, have, despite everything a "life" of their own, which it is necessary to placate as well as control; and they see that the perfidious play of "luck" has a strange reality. The Army, the Administration, the Church are vastly complex machines, and the of-

ficer, the bureaucrat, and the priest, are dominated by the conviction (more or less avowed) that these institutions have "existential" value above and beyond the practical ends they serve: they are because they are. . . .

(One must be Benedetto Croce to believe that the work of art is "complete" in the mind of the artist, like the homunculus in the sperm, according to the embryologists of the seventeenth century. The nature of marble, bronze, wood, colors, sounds and words exacts definite forms, limiting the range of the expressible, at times augmenting it with possibilities that miraculously coincide with conscious intent. There is further the action of models: Malraux has justly said that each work of art proceeds from some other work. Evidently what is in play here is something very different from "imitation," which could only yield a progressive impoverishment of the "original" effort. In the work of art which has inspired him, the artist has caught a glimpse of not yet realized possibilities, he has become aware of mythological depths only a fraction of whose rich store has been so far revealed, and which he dares to think a keener glance might yet embrace in its totality. . . .)

Naturally the worker, whose fatigue is accompanied by the most deadly boredom, is scarcely able to cast a magical halo about his task, or to see his situation in "mythological" perspective. . . . Yet the fact is that to obtain the "enthusiastic consent" or even the resignation of the masses to a faster tempo of productive work, it was necessary in Stalin's Russia as in Hitler's Germany, to instill typical *Ersatz* mythologies: vague expectations of an earthly paradise in which everyone would own a car, a radio, an electric stove; sentiments à la Michael Strogoff: "For God! for Tsar! for Russia!"; perspectives appealing to "sporting blood" or a low resentment: "We'll surpass America"; or "We'll get even with the Jews! We'll fix the Poles who stabbed us in the back and robbed us in 1918!" etc., etc. . . . It is not impossible that in cannibalistic Pan-Germanism, in the Sovietism idolizing the social "apparatus" and machines of steel, in Japanese Imperialism dreaming of revenge on the whites and "Greater East Asia"—and, despite its grotesqueness—in Italian fascism, there were elements of authentic mythology. Degraded, of course; mythological creation is incompatible with the action of regimented masses. For where there is mass action the currents and rhythms of sentiment linking the individual to his fellows, intelligent communion, the complex and delicate play of sympathies requiring the subtle collaboration of the one who speaks and the one who listens—all elements of the mythopoeic "atmosphere"—are replaced by the brutal command, mechanical obedience, the stupidity of the repeated shout. "The Tartars conquered the world and then forgot about it," this remark by a writer of the eighteenth century gives us an insight into the mythological—hence the cultural, artistic, social, philosophical—sterility of

the Mongol masses led by Genghis Khan. The barbarian is defined by his poverty of mythological experience; particularly is this true of the learned, planful barbarian, who, to use the phrase Heine directed against the Prussians, makes himself "vicious through science."

The efforts of "Taylorism" and other modes of "rationalizing" work, so successful in a certain sense, show clearly enough that even the iron laws of "technico-economic determinism" are unable to secure for "praxis" a complete victory over the psychological caprices which engender gratuitous gestures. For it is very likely that "waste motion" and nonchalant rhythms arising in the course of productive work originate in magical prejudices, ritual habits, and other fantasies. It is still mythology which is all to blame for the topsy-turviness! The "Taylorite-Stakhanovist" is only a step removed from the Kapo or SS of the "Concentration-Camp World" which flourished in Germany before and during the war, still flourishes in Siberia, and is coming to the fore again in Cyprus and in Palestine. The Kapo, striking down with his club any prisoner who makes the slightest movement while the roll is being called, and the "Taylorite-Stakhanovist,"were both prefigured in the legendary counsel given Tarquin when he wanted to know how to become a leader of men: his advisor lopped with his cane those flowers that insolently raised their heads above the level of the grass. . . . In the Prussian army (as in the carrying out of a Five-Year Plan) error was prohibited (and often punished by death); it is true that this rigor was somehow balanced by breadth of view in tolerating the "dispersion" of bombs on school children or masterpieces of Palladio, when the idea was to destroy some bridge, as well as by the "rough estimates" accepted by court martials and revolutionary tribunals. . . . The superfluous it would seem, cannot be divorced from the necessary; the gratuitous gesture enters rational action; chance amalgamates itself to the machine. . . . In order not to be crushed, a man—and a truly human collectivity—should be able to say that "what must come to pass will not, perhaps," and to feel that a last turn of the wheel might change everything.

Justice is not a myth, and most assuredly not an intellectual "construction"; but without a multiple network of mythological creations, from the proverbs and fables to the utterances of the Sophists, the lamentations of Job, the parables of the Gospel, and the vision of Er, the norms and antinomies of the just and the unjust could not be ever-present (acting, defied, violated, avenged) in all the transactions of men and in the infrastructure of society. . . . Mythology determines the relations between individuals in society (including their "productive" relations), but only insofar as these relations are impregnated with spontaneity and what I would call "human health." Fear and need can stimulate mythological crea-

tion but all evidence shows that famine and fear break the interconnections among men, destroying social intuition and discernment. The essential fact is the mechanization of human relations, so that any impulse to reflect on one's acts or to take note of one's surroundings is repressed or deadened, society becoming little more than a well-organized herd. Economic forces, of course, continue to act, but absurd and inexpiable sufferings fill existence. . . . "Dread" may stimulate the creation of certain myths, but it is only *after* the agony of these moments that men can "invent" what has happened to them. "Dread," as a permanent condition of consciousness, implies intellectual experiences, moral commitments, conflicts of "being" with "existence" and "existence" with "being," which disfigure and destroy mythology, manners and customs, and even the possibility of integrating the "I" in the "we." . . .

Mythology expresses itself in acts—more generally, in the behavior of man towards his fellows, towards his natural surroundings (the landscape, animals), insofar as he preserves his liberty of mind and shows his freedom by coherent speech. Diomedes and Glaucon confronting each other with discourse before fighting do not give up their mythological lucidity. . . .

The "idea" of justice represents the effort of man—become aware of his precarious condition—to maintain in his daily speech and conduct a coherence corresponding to the mythological vision and the customs or manners it sanctifies: it represents the defense of society against the reduction of the human being to the status of a "means" or "thing." . . . Among the primitives (particularly those studied by Lévy-Bruhl), the "just" is identified with the "normal" and the "unjust" with the "abnormal." Within the limits of the accustomed, the tribesmen reveal a careless and complete cordiality, a joyous confidence; but the least suspicion or fear, contact with the unknown, may bring about a complete reversal of feeling, and bestial ferocity, the most perfidious savagery, soon follows: they are then outside all norms, outside the jurisdiction of "manners," "customs," "justice." . . .

It is hardly stretching the accepted significance of the term to say that "utopias" belong to the realm of the myth. This holds not only for the literary and philosophical works falling under this heading, but also for the collective emotions raised by prophecies (often confused) to some passionate hope of redemption or a revolt of the oppressed. However, mythology of itself does not imply "programs" or "techniques" of any sort: programs and techniques (churches, dogmas, political maneuvers, war, an apparatus for giving orders and inflicting pain) subject us to harsh necessities which darken the mythological experience. And let us not forget that when the human being is reduced to the role of a means, the result is most often a system of organized repression aiming at *inhuman* ends. . . .

The dispute between Marx, the sincere Stalinists and Sartre, on the one hand, and Plato, Proudhon, Tolstoi, on the other, concerns precisely the individual whom a disintegrating community has deprived of customs and "adequate" myths. The degenerate city, the reign of "money" and the "stock exchange," the civilization of machines and endless bustle, seem to Plato, Proudhon, Tolstoi, monstrosities from which one must separate oneself at any price, in order to reshape, if need be by ascetic renunciation, a living soul, founded on justice and the active search for truth. While Marx—whom we perhaps should not class with those who agree with him—is convinced that if the proletarian is so near to salvation it is precisely because he has nothing but his chains to lose, and among these chains Marx singles out for special condemnation all the residues of mythological creation which he designates as "alienations." It is necessary to annihilate at least all these chimeras, these prejudices, which still block the way to total revolt; a man all new, completely naked, guided by reason alone is necessary for the creation of the "good" society, in which a knowledge of reality, of all reality, and of nothing but reality, shall govern human life. This conception does not lack apocalyptic grandeur. But could one indeed restore or create the "good" society with men who would turn their backs on the substantial elements of all social communion: manners, customs and mythological activity?

The effort towards truth in art, in science, in feelings (sincerity), in social relations (justice), gives an ever renewed vigor to mythological creation, or "experience." But dogmatism, any subjection of the *true* to existential ends; kills the myth. Messianism is just as incompatible with myth as is utilitarian rationalism. In Christianity, mythology is almost exclusively heterodox. Paul of Tarsus, with his fanatical insistence on the certainty of salvation through the miracle of the Cross, trampled on many mythological buds of the Gospels and of the first Christian community. In the *Divine Comedy*, one senses a conflict between the Catholic who believes in the "real" existence of Heaven and Hell, and the poet who is perfectly aware that he has not by "special grace" seen the kingdoms of Christ and Lucifer; harmony is best established in the *Purgatorio*, where the rich flowering of mythological reminiscences and of Italo-Provençal folklore does not run afoul of "dogmatics" well-padded with Plotinian Hellenism. It is possible that Michelangelo (and this would tally with his sad fate as a "victim of society"), despite a lively feeling (very nostalgic) for the ancient—and heroic—myth of Man, allowed himself to be dominated by the thirst for a "total truth" imperiously established by the God of the two Testaments; and it would perhaps be the traces of his "theological" yearnings which El Greco sensed as weakness in "The Last Judgment."

The Church has never tolerated much meditation of the "mysteries" (dogmatically circumscribed). The defect of the Calvinists, Quakers and Methodists—and even our "conscientious objectors"—lies in their assurance of possessing a "simple and total truth," and of thereby being beyond the "pagan temptations" of myth.

Aristotle was too intelligent and too Greek to remove the mythological halo from our knowledge of the world (his remark that poetry is superior to history can serve as proof), but his system, by "explaining everything," certainly favored that anti-mythological DDT of which scholasticism in general and Thomism in particular were composed. Hegel, without any of Aristotle's inhibitions, brought about analogous results: he thought he could encircle past and future mythology with the barbed-wire of his "dialectic," and his epigones have been able to cook up to their hearts' content ragouts of rationalized and undigested myths and of pseudo-mythologized rationalism. Proudhon's *Justice* is very much impregnated with authentic mythology: "The Man of the People," the Philosophy of the People," etc. Whereas Marx (as we saw before), desiring at all costs effectively to change the world "such as it is," repudiated almost with hatred mythological motifs (though in *The 18th Brumaire* he too dipped into myth). Bergson desired that his "life force" be an *existing* reality; thus he deprecated mythology. I believe that Sorel, when speaking of the "myth" of the general strike, etc., let himself be carried along by Marx and Bergson to a total misunderstanding of the contrast between "myth" and "messianic faith."

Why do I insist on designating as "mythology" what everyone else understands as language, literature, art, religion, philosophy, science, etc.?

First, if there is a common denominator to all activities of the mind and to their "differentiated" creations, a term for this would be useful. But there is an entirely different reason. In language, in customs and superstitions, in all the arts and in philosophy, science, etc., there are a great many manifestations (works) that are *this side of* mythology—all that which is instrumental, determined by the "needs of existence" of the individual in society. And there is also, in art, in religion, in the search for "exact truth," in the antinomies of the moral consciousness, moments that are most certainly *that side of* mythology (the Nirvana, the frenzy of the Cross, the "perfection" of such and such a verse of Racine, such and such a passage of Bach, cases of saintliness, heroism, etc.)

The proper field of mythology seems to me to coincide with that of the human communion which I call *society par excellence*, in which the human individual *free from all commitment*, and having to respect neither obligations nor sanctions, is able to overcome "anguish" and "dread" in

accepting (if only momentarily) as ''realities'' forms with regard to which it matters little whether or not they correspond to something in ''the world in which I exist.'' . . .

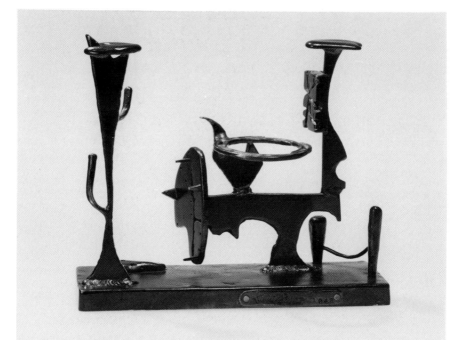

Figure 42. David Smith, *Deserted Garden Landscape,* 1946
Possibilities (Winter 1947/48): 24. Appeared with ''I Have Never
Looked at a Landscape'' and ''Sculpture Is.''
Steel and bronze, 10¼" × 11⅝" × 4⅛".
(Collection of Mr. and Mrs. Harry W. Anderson)

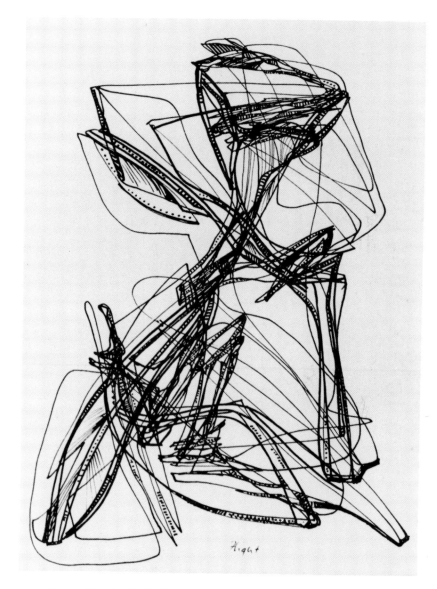

Figure 43. Stanley William Hayter, *Automatic Drawing*, 1944
Possibilities (Winter 1947/48): 76. Appeared with Hayter's
"Of the Means."

Figure 44. Jackson Pollock, *The Key*, 1946
Possibilities (Winter 1947/48): 79. Appeared with Pollock's
''My Painting.''
Oil on canvas, 149.9 cm. × 215.9 cm.
*(Courtesy Art Institute of Chicago. Gift of Mr. and Mrs. Edward
Morris through exchange)*

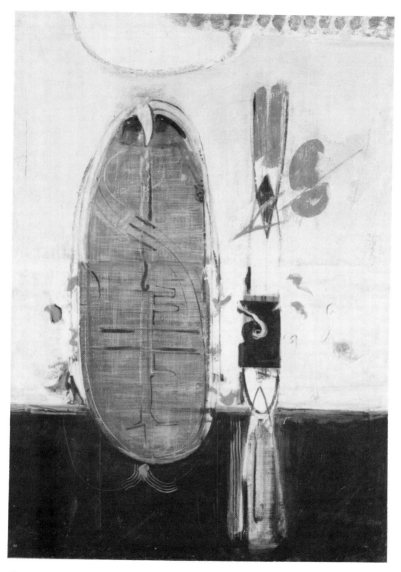

Figure 45. Mark Rothko, *The Source*, 1947
The Tiger's Eye 1 (October 1947): 71; *Possibilities* (Winter 1947/48):
86. Appeared between Rothko's "The Romantics Were
Prompted" and Andrea Caffi's "On Mythology."
Oil on canvas, 39⅝" × 27¹⁵⁄₁₆".
(National Gallery of Art, Washington, D.C.)

Instead

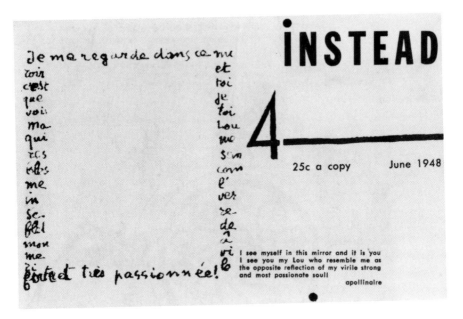

Figure 46. Guillaume Apollinaire, ''Je me regards . . .
(I see myself . . .)''
Instead 4 (June 1948) [cover].

The Myth of Oedipus

Meyer Schapiro

Many a man has dreamed of being his mother's mate; But he who takes it lightly lives an easier life.

Sophocles, *Oedipus Rex*

Laius prince of Thebes and son of the lame Labdacus, in exile at the court of Pelops, was entrusted by the king with his son Chrysippus to teach him chariot-driving. Laius fell in love with the boy and brought pederasty for the first time into Greece. When called back to his own city to take the throne which had been held by usurpers, he carried off Chrysippus, while driving swiftly to Thebes. The boy killed himself in shame. Over the dead body, Laius was cursed by Pelops that he would perish by the hand of his own son.

Warned three times by the oracle, Laius abstained from begetting children, until one day, overcome by drunkenness, he forgot Apollo's admonition and slept with the queen Jocasta. From this blind act a son was born. The anxious parents pierced his ankles with an iron spike and gave him to a shepherd to expose in the harsh winter on Mount Cithaeron, a site sacred to Hera, the goddess of marriage. The kindly shepherd offered him instead to a herdsman of Polybus, the king of neighboring Corinth. His sterile queen, Medusa, presented the child to her husband as their own.

He was named Oedipus, or Swell-Foot, from his infirmity, and grew up in Corinth unaware of his true origin.

One day at a banquet a drunken man taunted the young prince that he was not the son of the king and queen. The difference in character between the king and his son, the one, kindly, the other, shameless and

This article originally appeared in *Instead* 1 (Winter 1948[?]): unpaginated.

headstrong, began to be remarked. The rumor rankled in the heart of Oedipus. His devoted foster-parents failed to comfort him with their reassuring words. He addressed himself secretly to the Delphian oracle to learn the truth, but heard only that he was destined to wed his mother, to beget an evil brood and to slay his father. To escape this awful fate, he decided then to avoid Corinth forever and to seek another country.

Returning from Delphi, he was disputed the right of way at the triple cross-roads at Schiste by an arrogant traveller in a chariot with four servants. This was Laius, who was driving to Delphi to inquire of the oracle whether his exposed son was really dead. The hoofs of the horses of Laius trampled and bloodied Oedipus' feet. When the king brought his goad with two teeth down upon the head of Oedipus, the angry young dragged Laius from the chariot and killed him and three of his men.

Oedipus went on to the kingdom of Thebes. There on Mount Phikion he encountered the Sphinx, a winged monster with the head of a beautiful virgin and the body of a lion. She was ravaging the country, devouring whoever failed to solve her riddle: "There is a thing on earth that has two and four and three feet; of all the creatures that move over the earth and live in the air and the sea, it alone changes its nature; and the strength of its limbs is least just when it has the greatest number of feet." On the answer to this riddle was staked her own life as well as her opponent's. The flower of the city's youth had already perished in her claws, and Creon, brother of Jocasta, offered the crown of Thebes and the hand of the widowed queen to the man who would overcome the Sphinx.

Oedipus, who was ignorant of the secret of his own life and birth, divined correctly. Pointing to himself, he said: "Man, who as a child crawls on all four limbs, as an adult walks, and in old age needs the support of a staff." The Sphinx in despair hurled herself from her rock and was killed.

Some say that Oedipus did not know the answer, but that when he put his finger to his head in a gesture of thought, the Sphinx interpreted this to signify himself, that is, man, as the solution. To the Sphinx as a monstrous virgin, man was a strange and provoking mystery into which she was quick to read meanings. But to Oedipus who was named after a childhood infirmity of his feet and was in quest of the secret of his origin and future, the riddle was a familiar image.

The people of Thebes welcomed him as their savior. He married the queen who, long unfruitful with Laius, now had two sons and two daughters.

Years later, a fearful blight of sterility fell upon Thebes: nothing grew in the fields, women were barren, children were begotten still-born or deformed. Creon, now the brother-in-law and friend of Oedipus, was sent to Delphi to implore Apollo's aid. The oracle told him that Thebes was

defiled by the murderer of their former king, Laius, who must be banished or killed. Oedipus learned then how his predecessor, while en route to Delphi, had been slain together with his servants by a band of robbers. Only one, who fled in fear, survived to bring the news. Nothing had been done to track down the murderers and avenge Laius; a greater disaster troubled Thebes at that time, the Sphinx, who menaced the life of the whole city.

The king took it upon himself as the successor of Laius to search out the murderer, as if Oedipus were Laius' own son. He swore vengeance on the criminal, not only in obedience to the god and to rid his kingdom of the blight, but also for his own safety. He feared that the slayer was an enemy of Thebes who might be plotting against him as well. If the guilty one spoke up and confessed, he was promised his life and safe exile. But if any man knew the criminal and kept silent from fear or to screen a friend, Oedipus threatened him with excommunication: no one would speak to him or join him in prayer or sacrifice; he would be banned from all Theban homes and treated as if he himself were the defiling thing. The king invoked the same punishment on his own head, should the slayer be an inmate of his house.

Since the murderer was unknown, the blind seer, Tiresias, (who had been man and woman in turn) and whose power of prophecy was second to Apollo's, was called to Thebes. Once as a youth, on Mount Cithaeron, he had disturbed the coupling of two snakes by striking the female and was transformed into a girl in punishment, by striking the male of another pair, he became a man again. Having been both woman and man, he was asked by Zeus to settle the god's dispute with Hera as to which sex derived the greatest pleasure from the other. Tiresias incurred the wrath of Hera by deciding for woman, and was blinded by the goddess. To compensate him Zeus gave him the gift of prophetic vision and long life.

To the king's questions Tiresias replied unwillingly. He knew the guilty one, but he thought it would be better for all if he and Oedipus were left to bear their own burdens to the end. Oedipus was angered by the prophet's silence and, to goad him into speech, charged him with instigating the crime. Tiresias then named Oedipus as the slayer of Laius and accused him of living in shame with his nearest kin. The outraged Oedipus taunted the seer with his blindness. Once before Tiresias had failed the Thebans in a sore moment when he could not solve the riddle of the Sphinx, which Oedipus had read with his own wit, untaught by birds. Tiresias replied that Oedipus was blind to his own condition, being ignorant of his parents and of the misfortunes that would come upon his head from his triumph over the Sphinx. He would be reduced to beggary and make his way eyeless to a strange land, feeling the ground before him with his staff.

The people did not believe the seer, for they remembered gratefully the service of Oedipus in ridding Thebes of the Sphinx. But the king, suspicious of enemies, imagined that Tiresias was the mouthpiece of Creon who was plotting against him from envy.

He denounced his brother-in-law as the accomplice in framing the false prophecy and threatened him with exile or death. If Tiresias knew the slayer of Laius, why had he not spoken up at the time of the murder? Jocasta intervened to calm her husband and to reconcile him with her brother. To discredit the blind seer, she recalled an older oracle that Laius was to die at the hands of his own son. Their child, however, was exposed three days after birth, with ankles pinned together, on a trackless mountain. And Laius was murdered by foreign robbers at a triple cross-roads. Jocasta had sacrificed her first child to save Laius, and yet lost her husband too. The seers were not to be trusted.

Oedipus realized then that he was the slayer of Laius and condemned to exile by his own vow. Relentlessly he questioned Jocasta about the place and time of the murder and the appearance of the dead king. He learned that Laius was tall and not unlike himself in frame, and had been killed on the cross-roads at Schiste, while travelling to Delphi in a chariot, in the company of four men, shortly before Oedipus arrived in Thebes. But Jocasta doubted that Oedipus could be the slayer; the fleeing servant, who brought the news, had said—what everyone remembered—that a band of robbers had committed the crime. When Oedipus was made king, this man, an old and trusted shepherd of the royal household, had begged Jocasta to be allowed to leave Thebes; he was still alive and in the country and would be summoned to verify the facts.

In the meantime, a messenger came from Corinth to tell that Polybus had died and that his son, Oedipus, had been chosen to succeed him. Jocasta joyfully observed that the Pythian oracle was false, since the father of Oedipus had died a natural death. But Oedipus still feared the prophecy that he was to wed his mother and therefore refused to return to Corinth to risk his fate. The messenger disclosed that the king's fears were groundless; for he was not the child of Polybus and Medusa, but had been brought to Corinth by the messenger himself, who, in his herdsman days long before, had received the foundling, with ankles pinned together, from a shepherd of King Laius and presented him to the Corinthian queen.

Jocasta begged Oedipus to investigate no further. He, on the other hand, was determined to solve the mystery of his birth and reproached his wife for fearing that he might be of humble stock. The old shepherd of Laius, who had carried the infant to the mountain and had later witnessed the struggle at the cross-roads, was now questioned by the king. Twice before he had tried to thwart his masters and protect Oedipus, once

in preserving the fateful infant, a second time in hiding the identity of the slayer of Laius. But now, compelled by the threats of the man he had wished to save, he revealed that Jocasta had given him the child to expose and that this child was Oedipus. In despair, and calling the name of Laius, Jocasta hanged herself. Oedipus took out his eyes with the golden brooches of her dress.

He asked to be banished to Mount Cithaeron, where he should have died in infancy. His sons locked him up instead in their own house that men might forget him and his crimes. Once Polyneikes served him a meal on a silver table and with a gold beaker, possessions of his ancestor Cadmus, that Oedipus had forbidden his sons to use. These reminders of his former majesty and present decline enraged the blind king. He cursed his sons and foretold that they would share the patrimony in hatred and strife. Later, at a sacrificial feast, they offered him the hip-bone instead of the shoulder that was his due. Seeing in it an illusion to the lameness of his grandfather, Labdacus, he threw it to the ground in wrath and uttered a second curse that they should die by each other's hand. Afterwards, when his grief had calmed and he had come to accept the solitude of his house in Thebes, he was driven from the city by the people. Neither Creon nor the sons of Oedipus spoke up in his behalf. Accompanied by his faithful daughter, Antigone, the blind man wandered miserably through Greece, until he came to Colonus, near Athens, to the sacred grove of the avenging Furies; they are called the Eumenides, or the Kindly, by the natives. Oedipus had been promised a final resting place here by the Delphian oracle. The people of Colonus would not admit the tainted man to this holy ground, until Theseus, the king of Athens and Colonus, hearing that the presence of Oedipus, now sacred through his sufferings, would bring divine protection to Athens, allowed him sanctuary in the shrine.

His crimes, committed unknowingly, through no fault of his own, had been expiated, and he was now a victim of the malevolence and ambitions of his sons.

A war had broken out between Thebes and the Argive league over the throne left vacant by Oedipus. After a period of regency under Creon, his sons had agreed to share the power in alternation, each ruling for a year in turn and then leaving Thebes in order to avert the expected strife. But when the year of the younger, Eteocles, had elapsed, he refused to give up the throne to his brother, and forced him into exile. Polyneikes had gone to neighboring Argos, where he married the daughter of King Adrastus and assembled a great army of Argos and its allies to help him regain the throne. An oracle announced that the victory would be won by the side that had the support of Oedipus.

In the past Oedipus had acted blindly, in ignorance of the conse-

quences of his own deeds, a fated subject of the justice of the gods for the sins of his ancestors. Now, blind and weak, he could foresee the fate of others and mete out justice upon his own unfilial sons. When Creon came with feigned piety to Colonus in Eteocles' behalf in order to bring Oedipus back to the Theban land, although not to Thebes itself from which he was barred by his defiling crimes, Oedipus saw through his aim and resisted him, even when Creon's men carried off Antigone and Ismene, his dearest things. Theseus rescued them—and protected Oedipus from the violence of the Theban prince.

Then the exiled Polyneikes, penitent and fearful of his father, called upon him through the Athenian king—he dared not approach him directly—to beg for his support in the coming campaign at Thebes, where the armies were drawn up already for battle. The blind man was implacable. Remembering the cruelty of his sons, he cursed them both again and foretold that Polyneikes would never win Thebes, but would die by his brother's sword and kill his brother at the same time. Antigone implored her brother to withdraw his army from Thebes. It was too late. Knowing his doom, he got her promise to bury his body, since the hated enemy would deny him a grave. This pact was to bring death to Antigone and to the last survivors of the Theban royal house.

There was a peal of thunder and Oedipus knew that the hour of his end had come. He called for Theseus and asked to be allowed to die in a hidden place of which the hero-king was to tell no one but his heir. The secret would protect Athens forever. Then Oedipus moved unguided to his tomb, blessing his daughters and confiding them to the guardship of the Athenian king. In the presence of Theseus alone, peacefully and without sorrow, he disappeared at the Brazen Threshold in the shrine of the Furies, the dark entrance to the Underworld.

Adapted from the Greek myths and dramas by Meyer Schapiro

This account of the myth of Oedipus, based on the Greek mythographers and poets, was written to accompany a series of etchings by Kurt Seligmann, published by Durlacher Bros.— Kirk Askew, Jr. The entire story has never been told in English, to our knowledge; it is astonishing in its richness of episode and suggestive analogy.

Face to Face with Sade

Maurice Blanchot

One hundred and fifty years ago there appeared in Holland, *The New Justine or Virtue's Trials,* followed by *A History of Juliette Her Sister (La Nouvelle Justine ou Les Malheurs de la vertu,* suivie de *L'Histoire de Juliette sa soeur).* Rendered enormously lengthy by Sade's successive changes, this never-ending, crushing, monumental work of some 400 pages struck horror into the world from the very outset. If there is a Hell in libraries, it is for such a book. It is safe to assert that in no other literature of any period has there been a work so scandalous, so profoundly wounding to the feelings and thoughts of men. In our day, when Henry Miller's works cause a shudder and Antonin Artaud's blasphemies create difficulties for the review in which they appear, who could vie in license with Sade? We may indeed assume this to be the most shocking book ever written. Is this not reason enough to concern ourselves with it? Just imagine: we have a chance to get acquainted with a work beyond the limits of which no other writer, at any time, has ventured; within arm's reach so to speak, we have a veritable absolute in a world as relative as that of literature; why, then, not set ourselves the task of interrogating this work? Surely one wants to ask why it is so unsurpassable, what there is about it that is so excessive, what makes it, for all eternity, too strong for us? Singular this neglect, to say the least. But supposing that the scandal of it is so pure only in virtue of our neglect of it? When we consider the precautions taken by history to make a prodigious enigma of Sade: the 27 years in jail, his confined, banned existence, the quarantine which has isolated him after death no less than it did during life—to a point where the outlawry of his works seems to condemn him, eternally alive, to perpetual imprisonment, we

This article, translated from French by Félix Giovanelli, appeared in *Instead* 5-6 (November 1948): unpaginated.

are tempted to ask whether the censors and judges who seem bent on keeping Sade permanently immured are not perhaps in the service of Sade himself, whether they are not gratifying the most ardent wishes of this libertine who unfailingly aspired to the solitude of the bowels of the earth, the mystery of a secluded and subterranean existence.

In a dozen ways Sade formulated the idea that the greatest possible excesses of man call for secrecy, abysmal darkness, the inviolable solitude of a cell. Now, strange to say, it is the watch and ward of morality who, condemning him to perpetual outlawry, have made themselves the accessories to the greatest possible immorality. It was his mother-in-law, the prudish Mme de Montreuil, who, converting his life into a captivity, made of that life a masterpiece of infamy and debauchery. Similarly, if 150 years after, *Justine and Juliette* continues to appear to us the most shocking book we can read, it is because reading it is just short of impossible, it is because all the necessary measures have been taken by its author, by the publishers, with the aid of universal morality, to keep the book a secret, to make it unreadable—and unreadable it is by its length, composition, and repetitions, as well as by the vigor of its description and the indecency of its Hell-destined ferocity. It is a scandalous book, since it is scarcely possible to approach it and nobody may publish it. But it is a book which proves that there is no scandal where there is no respect, and that where the scandal is extraordinary, we have respect in the extreme. Who is more respected than Sade? How many, even today, are not profoundly convinced that it would suffice but to hold this accursed book in their hands a moment or two for something like Rousseau's proud boast to be realized: any girl who reads a single page of this book is lost? Such respect surely reflects something valuable in a literature and civilization. One can scarcely refrain from this discreet reminder to all publishers and critics present and to come: ''Before the scandal of Sade, try at least to show some respect.''

Happily, Sade is his own best defender. Not only his work, but his thought remains impenetrable—and this in the face of the great number of his theoretic flights which are repeated with disconcerting patience and argued with a maximum of clarity, with a logic that is more than sufficient. He is animated by the taste and even the passion of a system-maker. He explains, he affirms, he proves, he circles back to the same problem a hundred times (a moderate estimate), he scrutinizes all its faces, he examines all the objections, confutes them, finds others, and confutes them too. Since what he says is, on the whole, simply put, and since his utterance, though rounded, is precise and unwobbly, one would think nothing could be easier than to understand his ideas, which, in him, are inseparable from his passions. Yet, just what is the center of Sade's thought? What, exactly, does he turn out to have said? Wherein consists

the order of that system, where does it begin, where does it leave off? Is there, after all, anything more than the shadow of a system discernible in the movement of a thought so obsessional in its quest for reasons? And why is it that so many principles so well co-ordinated do not successfully emerge as the perfectly compact whole they were intended to constitute, which they in fact give the appearance of constituting? Such is Sade's first singularity. The explanation lies in this, that his theoretic flights release at every moment irrational forces to which they are bound: these forces simultaneously quicken and disorder his thoughts in an impulsion so violent that the thoughts, both resisting and yielding, seek to master them, do master them in fact, but only by unloosing still other obscure forces by which the thoughts in question are overborne, deflected, and distorted. The result is that everything that is said is clear, but seems at the mercy of something unsaid. . . .

The reader's uneasiness is often extreme when confronted by a thought upon which light can be shed only at the instance of another thought which is itself momentarily incapable of giving light. Such uneasiness is only the greater for Sade's declaration of principles, his philosophic ground appearing to be simplicity itself. It is a philosophy of self-interest, of integral egoism. Each ought to do what he pleases, each can have no other law but that of his pleasure. This morality is grounded on the primal fact of absolute aloneness. Sade has proclaimed and reiterated it under every conceivable guise: we are by nature born alone—and there is no connection whatever between one man and another. The only rule of behavior is, therefore, that I prefer every thing which makes for my happiness and that I hold as nothing the evil consequences for others springing from my preferences. The greatest conceivable pain experienced by others will always weigh less than my own good pleasure. It is no matter if I am obliged to assure my slightest pleasure at the expense of an un-precedented round of misdeeds, for my pleasure gratifies me, is in me, while the effect of crime leaves me untouched, lies outside me.

These principals are clear. They are to be found developed in a thou-sand ways in the twenty volumes. Sade is indefatigable on the subject. He takes infinite delight in relating them to the theories then in vogue, those of the equality of individuals before nature and the law. He then proposes arguments of this kind: all creatures being identical in the eyes of nature, such identity gives me the right not to sacrifice myself for the preservation of others whose ruin is indispensable to my happiness. Or, he formulates a kind of Declaration of Rights of Eroticism having as fun-damental principle this maxim no less valid for women than for men: to give myself to all those who desire me, to take all those whom I desire. "What is the harm, what offence do I commit, in telling a desirable creature

when I come upon her: 'Lend me the part of your body that can satisfy me for the moment, and enjoy, if you like, that of mine which you may find pleasurable'?'' Such declarations seem to Sade irrefutable. For pages on end, he invokes the equality of individuals, the reciprocality of rights, without showing any awareness that his arguments, far from being strengthened thereby, become wildly inconsonant. "An act of possession can never be exercised over a free being." But what does he conclude from this? Not: it is forbidden to do violence to any creature and to enjoy that creature against his will, but: nobody may refuse himself by a claim of exclusive attachments or of self-possession. Equality of individuals becomes the right to make use, equally, of individuals; liberty the power to subject anyone to his wishes."

Seeing the development of such formulas, one tells oneself there must be some hiatus in Sade's reasoning, some lack, or some folly. The impression left upon one is that of a deranged thought suspended grotesquely over the void. But straightway, logic, takes over, objections begin to materialize, and system gradually emerges. As is known, Justine represents humble, tenacious virtue, ever oppressed and unhappy, but never convinced of being in the wrong. She declares suddenly, and in very reasonable fashion: your principles presuppose power; but if my happiness consists in never taking into account the interests of others, in doing them injury when the occasion demands, a day must necessarily dawn when the interest of others will consist in doing me injury; in the name of what principle shall I then protest? "Can an individual who isolates himself prevail against everyone else?" Here is obviously a classic objection. Sade's spokesman answers it both explicitly and implicitly and, by the manifold ways in which he does so, we are borne along to the center of Sade's universe. Yes, he begins, my right is that conferred by power. In fact, humanity, as Sade sees it, consists essentially of a mere handful of powerful men who have had the energy to raise themselves above laws and preconceptions, who feel themselves worthy of nature in virtue of the deviations she has implanted in them, and who will stop at nothing to slake their thirst for pleasure. These incomparables generally belong to a privileged order: dukes, kings, the Pope himself, issued from the orders of rank. They take every advantage of their position, fortune, and of the impunity which their status ensures them. They owe to their birth the privileges of inequality, which they are pleased to perfect by an implacable despotism. They are the strongest because they are members of a strong caste. One of them says: "By People, I mean that vile and despicable class that can only live by dint of sweat and pains. Everything that breathes should league itself against this abject class."

Yet there can be no doubt that if these Sovereigns of Debauchery have, more often than not, concentrated in themselves, to their advantage, all

class inequality, this is but an historical circumstance of which Sade takes no account in his value judgments. He saw clearly at the time he was writing that power was a social category, that it was inscribed in the order of society, such as it subsisted before and after the Revolution. But he also believed that power (like revolution, in another context) was not merely a state, but represented a choice and a conquest, that he alone is powerful who knows he becomes such by his own energy. Actually, Sade's heroes are recruited from two opposed environments: from the highest and the lowest, from the most privileged and the most unprivileged classes, from the lords of creation and from the cloacal dregs of society. Both find at the very outset the extreme element which is propitious to their growth. Extremes of misery are a motor no less powerful than the vertigo of fortune. A Dubois or a Durand may rise in arms against the laws because he is too far beneath the laws to be able to conform to them without perishing. A Saint-Fond or a Duc de Blangis is too far above the laws to be able to subordinate himself to them without losing caste. This explains why, in Sade's works, vindication of crime rests its case upon contradictory principles. For some, inequality is one of the facts of nature; certain men are necessarily slaves or victims; they can have no rights, and being nothing, everything is permissible against them. Whence those delirious hymns of praise to tyranny, those political constitutions intended to render forever impossible the revenge of the weak and the enrichment of the poor. "Let us lay down this fact," says Verneuil, "that, in conformity with the intentions of nature, there is a class of individuals which by reason of their weakness and birth are in the very essence of things subjects of another class." "It is not for the people that the laws are made. . . . The thing essential to all wise government is that the people shall not invade the authority of the higher orders." And Saint-Fond: "The people shall be kept in such a state of servitude as to deprive them of any opportunity to aspire to domination and to threaten the property of the rich." Again: "Everything coming under the head of crimes of libertinage shall be punished solely in the slave castes."

This would seem to place us face to face with the maddest conceivable theory of the most absolute despotism. But suddenly there is a shift of perspective, when the Dubois woman says: "We have all, by nature, been born equals; if fate has been pleased to disturb the original design of general law, it is up to us to correct its whims and to right by our cunning the usurpations of the strongest. . . . As long as our good faith and our patience serve merely to double the weight of our fetters, our crimes should be accounted as virtues . . . and we should indeed be dupes to refuse to lighten—if ever so little—the yoke weighing upon us." She goes on to add: for the poor, crime alone opens the portals to life; villainy is the counterpoise to injustice, just as theft is the revenge of the dispossessed.

It is gradually made obvious to us that the counters: equality, inequality, liberty to oppress, revolt against oppression, are but provisional arguments whereby Sadic man may, according as he emerges from one or another social level, affirm his right to power. Moreover, the distinction is swiftly effaced between those who must turn to crime in order to exist at all and those who cannot enjoy existence except through crime. La Dubois becomes a baroness. The Durand woman, beginning as a garden variety of *empoisonneuse,* raises herself to a level above that of princesses. In fact Juliette sacrifices princesses to her unhesitatingly. Counts become bandit chieftains, brigands (as in *Faxelange*) or innkeepers even, in order the better to plunder and murder the gullible. By way of impartiality most of the victims of libertinage are singled out from the aristocracy—it is very important that victims should be of noble birth—and it is to the Countess, his mother, that the Marquis de Bressac, declares with superb contempt: ''Your days are in my keeping and mine are sacred.''

Now, just what has happened in all this? A number of men have achieved power. Some were powerful by birth but they have shown that they deserved that power by the manner in which they have enhanced and enjoyed it. Others have become powerful and the mark of their success lies in this, that having resorted to crime to achieve power, they now utilize that power to achieve complete freedom to commit all crimes. Such, then, is the way of the world: a handful of persons who have raised themselves to the highest—and about them, extending outward to infinity, a nameless, numberless dust of individual atoms with neither rights nor powers. Let us examine what becomes of the rule of absolute egoism. I do what I like, says the Sadic hero, all I recognize is my pleasure, and to assure it, I torture and kill. You warn me I am exposed to a like fate the day I fall in with someone whose happiness will be to torture and kill me. But I have acquired the power which elevates me above this threat. When Sade advances answers of this kind, we have a clear-cut sensation of being brought towards an aspect of his thought held together only by the obscure forces that it conceals. Just what is this power that fears neither destiny nor law, that exposes itself so contemptuously to the terrible risks of a rule thus conceived: I shall do you the injury I wish and you in turn hurt me all you can? Why is it assumed that this rule will always redound to his advantage? Now, let us bear in mind that all it would take to make such a principle founder would be one single exception: if just once, the Man of Power finds unhappiness through having sought his own good pleasure, he will have been defeated, the law of pleasure will have turned out a snare and a delusion, and men, instead of willing victory through excess, will revert to living mediocrely, basing themselves on a concern for the lesser evil.

Sade is aware of this. ''And if luck should change?'' Justine asks him.

Sade's answer is a deeper exploration of his own system, an attempt to show that to a man *energetically* leagued with evil no adversity can come. This is the abiding theme of this work: to virtue every misfortune, to vice the happiness of a constant prospering. At times, especially in the first editions of *Justine,* this affirmation seems merely a factitious thesis illustrated, by way of proofs, by a story which the author is free to manipulate. One tells oneself that Sade is substituting fables for proofs, that he is taking an easy way out in referring us to some Black Providence entrusted with the task of granting the best to those who have chosen the worst. But in *The New Justine* and in *Juliette,* everything is changed. It is certain that Sade is profoundly convinced that the absolute egotist can never be plunged into unhappiness; not only that, but he will be happy in the highest degree, always and without exception. A mad thought? Perhaps. But this thought is in him bound up with forces so violent that, inevitably, they render irrefutable in his eyes the ideas that they support. In truth, the translation into theory of his conviction has its awkward aspects. He resorts to several solutions, he tests them incessantly, although no one of them can satisfy him. The first is purely verbal. It consists in rejecting the social contract which, according to him, is intended as the salvation of the weak, and constitutes a grave threat to the strong. In practical fact, the Man of Power knows very well how to turn the law to account in consolidating his power, but in that case, he is strong only through the law, and it is the law which, theoretically, is the embodiment of power. As long as anarchy or a state of war does not prevail, the Sovereign is not really sovereign, for even if the law helps him to crush the weak, it is still by an authority created in the name of the weak. It is by the substitution of the false bond of a pact for the power of a single man that he becomes master. "The passions of my neighbor are infinitely less to be feared than the injustice of the law, for the passions of my neighbor are limited, contained by mine, whereas nothing may arrest, nothing constrain the injustices of the law." Because there is nothing about it; and it is always over me. That is why, even when it serves me, it oppresses me. That is why also, Sade could not find his place in the Revolution except insofar as trying one law after another, it represented for a time the possibility of a regime without laws. As Sade himself expressed it in these curious words: "The rule of law is inferior to that of anarchy; the greatest proof for that I can advance is that every government is obliged to dive into anarchy when it wants to reconstitute itself. To abrogate its former laws, it is forced to establish a revolutionary regime where there is no law: from it new laws are finally born, but this second state of affairs is necessarily less pure than the first, being derived from it . . . "

As a matter of fact, Sade's Man of Power makes himself at home in any regime. To all of them he denies authority and amidst a world

denatured by laws he creates an enclave where the law is powerless to speak, an enclosed area where legal authority is ignored rather than challenged. Prominent among the statutes of the Society of the Friends of Crime is an article which bans all political activity. "The Society respects the government and its laws: and if it places itself above the law, that is because it espouses the principle that man has no power to enact laws that contravene those of nature; but the disorders of its members, ever of an esoteric nature, must never scandalize the ruled or the government." It sometimes happens in Sade's works that his Man of Power carries out a political assignment and gets mixed up in revolution, as in the case of Borchamps, who comes to an agreement with the Northern Lodge to overthrow the Swedish monarchy—the motives animating it having nothing to do with a will to emancipate. "What are the motives behind your detestation of Swedish despotism?" someone asks of one of the conspirators. "Jealousy, ambition, pride, rage at the thought of putting up with domination, my own desire to tyrannize over others." "Does the happiness of the people have anything to do with your views?" "Not at all, my own happiness exclusively."

Strictly speaking, the Man of Power can always feel that he has nothing to fear from ordinary men, who are weak, and nothing to dread from the law, the legitimacy of which he does not recognize. The real problem is that of the relation of one Power to another. These incomparables who have come from very high or very low places are necessarily in contact with one another. Their similar tastes bring them together. Their being exceptions, setting them apart, also brings them together. But what can be the relation of exception to exception? This question certainly considerably preoccupied Sade. As usual he turns from solution to solution and finally, at the limit of his logic, lets this enigma call up the one word that matters to him. In having invented a secret society, regulated by strict conventions intended to temper its excesses, he was justified by prevailing fashion, for he lived at a time when the free-masonry of libertinage— and for that matter, Free-Masonry itself— was calling up from the bosom of a society in ruins, a great number of tiny societies, secret confraternities, based upon the complicity of passions shared and a mutual respect for dangerous ideas.

The Society of the Friends of Crime is an effort of this sort. The ordinances, results of lengthy and earnest study, forbid the members to give free rein among themselves to wild and cruel passions, which are to be satisfied only in two specified seraglios the inmates of which are recruited from the virtuous orders. Among themselves the members may lend themselves to every fantasy and stop at nothing "short of cruel passion." The reason is evident: it is necessary at all costs to prevent encounters on

a terrain where evil would bring unhappiness to those who ought to expect only pleasure from evil. The superior libertines are in league, but they do not meet.

Such a compromise could not long satisfy Sade. Also, it must be noted that, although the heroes of his books associated constantly with one another on the basis of conventions which fix limits to their power and superimpose order upon disorder, the possibility of treachery remains entirely open. Among the confederates, tension mounts steadily, to the point where, finally, they feel less bound by the oath uniting them than by their reciprocal desire to break that oath. This situation renders the last part of *Juliette* very dramatic. Juliette has principles. She is a respecter of libertinage and when she meets an accomplished scoundrel, realizes the perfection of the crime of which he is guilty, and gauges the destructive power he represents, she feels impelled to ally herself with him, and is induced by her admiration to shield him, even when the association has become dangerous for her. Thus, though in danger of being killed by the monstrous Minski, she refuses to have him assassinated. "This man is too noxious to humanity for me to deprive the universe of him." But another character, who is a consummate inventor of lubricities she does finally immolate, in this case because she notices that after these blood baths he has the habit of going to chapel for the purification of his soul. Are we to take it that the perfect criminal is safe from the passions to which he has surrendered himself? That some last principle exists which provides that the libertine can never be the object or the victim of his own libertinage? "You've told me a thousand times," Mme de Donis says to Juliette, "that debauchees never victimize one another: are you going back on this rule?" The answer is unequivocal: Juliette flatly contradicts her; Mme de Donis is sacrificed; and little by little the best-loved among the confederates, the most trusted companions in debauch, perish, victims of their fidelity, their perjuries, their flagging powers, or the power of their feelings. Nothing can save them, nothing exempts them. No sooner has Juliette sent her best friends to their death than she turns to new allies and exchanges vows of eternal loyalty with them. These oaths they are the first to laugh at, so aware are they that they are assigning limits to their excesses only for the pleasure of transgressing them.

The following conversation among some of the great masters of crime sums the situation up rather well. One such Gernand, says of his cousin Bressac: "You know, he takes after me. I wager that my life will not excite his impatience. We have the same tastes, the same turn of mind, and he is sure of finding a friend in me . . . " "Of course," Bressac remarks, "I shouldn't hurt you in the least." Elsewhere however, the same Bressac observes that another of his relatives d'Esterval, who specializes in but-

chering travellers, has come very close to murdering him. "Yes," says d'Esterval, "I have, but only because of kinship; I'd never hurt a fellow libertine." But Bressac remains sceptical and it is later understood that considerations of fellowship in debauch were dangerously near not being sufficient to restrain Dorothy, d'Esterval's wife. Let us listen to Dorothy: "When I praised you I passed sentence on you. The terrible habit I have of immolating men who find favor with me spelled your sentence along with my declaration of love." This is certainly explicit enough. But, in that case, what becomes of Sade's thesis that happiness inevitably issues from Evil, and of his conviction that a man with all the vices will always be happy, but will be necessarily wretched if he has one single virtue? In truth, Sade's pages are strewn with the corpses of libertines struck down at the peak of their glory. An untoward end overtakes not only the incomparable Justine but also the arrogant Clairwill, Sade's strongest, most energetic heroine, to say nothing of Saint-Fond who is murdered by Noirceuil, of the licentious Borghese woman who is hurled down a volcano, and of some several hundred other perfect criminals. Truly these perverted people meet with strange ends and singular triumphs. How, one asks, could Sade's feverish mind have so completely blinked the abundant discrepancies and contradictions which he himself turned up? These very discrepancies and contradictions are actually put forth as proofs, as will be shown directly.

Only may be fooled by the story of *Justine* if it is read without care, for then it is just a vulgar tale. All one sees, is a virtuous girl incessantly beaten, violated, and tortured, the victim of a malevolent destiny bent on her destruction. On reading *Juliette,* a like carelessness will lead us to see a vicious girl flitting from pleasure to pleasure. Thus seen, the plots of *Justine* and *Juliette* scarcely convince us. But that is only because insufficient attention has been paid to the most important aspect. If we are attentive merely to the sadness of the one girl and the satisfaction of the other, we shall have missed the point: the story of the two sisters is one and the same. Everything happening to Justine has happened to Juliette; both have experienced the same events, undergone the same ordeals. Juliette, too, is taken captive, broken with blows, marked for torment, tortured without end. Indeed, hers is a horrible existence, but with a difference; these woes are her delight, these tortures her enchantment. "How delightful the burning irons of a crime one has fallen in love with." We are not alluding merely to those out-of-the way torments which prove so terrible for Justine and so delightful for Juliette. In a scene in the castle of an evil judge, we see Justine delivered over to really execrable tortures. Her agonies are unspeakable, our minds are stunned at such injustice. But a strange incident supervenes. A thoroughly vicious girl who has witnessed the scene is so intoxicated by it that she begs to be put to the same torture.

The delight she derives from it is infinite. It then becomes true that virtue makes for unhappiness; not, however, because it exposes one to unhappy events but because, once virtue is subtracted, what was misery becomes an occasion for pleasure, and torment is transmuted into voluptuousness.

In Sade's view, the superior man is unaccessible to evil, since no one can do him harm. The superior man is the man of *every* passion and *everything* is grist to the mill of his passions. Some have interpreted as a paradox too subtle to be true Jean Paulhan's conclusion that behind Sade's sadism lurks a penchant exactly opposite to that of sadism. But it is evident that this idea reaches to the very heart of Sade's system. The integral egoist is one who is able to transform every variety of disgust into a correlative gusto, every repugnance into an attraction. Like the boudoir philosophers, he affirms: "I love everything, I revel in everything, I wish to unite all the genera." This is why Sade, in his *120 Days,* tackled the gigantic task of drawing up an exhaustive catalogue of every human anomaly, deviation, and possibility. He must experience everything in order to be at the mercy of nothing. "You will know nothing, if you have not known everything, and if were you so timid as to hang back before nature, it will remain forever beyond your reach."

Why the sorrowing Justine's objection: "But supposing your luck changes?" cannot trouble the criminal spirit becomes comprehensible. The tables may indeed be turned, luck becoming ill-luck, but it will turn out then to be a new kind of luck, as desirable, as satisfying as the other. If you tell the libertine that he is flirting with the gallows, courting the most ignominious and dusty death, he will answer that this is his dearest wish. "Ah Juliette," says La Borghese, "I could wish my wild follies to drag me down, down, like the most abandoned of creatures, to the fate to which their behavior has condemned them. I would make the very scaffold a throne of pleasure, and set death itself at defiance as I wallowed in the transport of dying a victim to my crimes." Say another Sadic heroine: "The true libertine treasures even the recriminations which his execrable behavior has brought down on him. Haven't we seen some who went so far as to love the tortures prepared for them by human vengeance, endured them with rapture, who regarded the gallows as a throne of glory on which they would have been aggrieved not to die with the same courage that had spurred them to the execrable accomplishment of their misdeeds? . . . There you have a man who has achieved the ultimate degree of reasoned corruption." Against such Men of Power, of what avail is the law? It would chastise them, but succeeds only in rewarding them, exalting them in the attempt to abase them. And, by the same token, what power has one libertine over another? One fine day he betrays and sacrifices his colleague, but his treachery confers a ferocious delight on his victim,

who sees all his suspicions confirmed by the event and dies in the voluptuous pleasure of having been the occasion of a new crime (to say nothing of other delights). One of the most curious of Sade's heroines is Amelia. She lives in Sweden; one day she pays a call on Borchamps, the conspirator. The latter, looking forward to a monster execution, has just delivered into the hands of the sovereign all his fellow-conspirators, and this act of treachery sends the young woman into a seventh heaven of enthusiasm. "I love your ferocity," she says to him. "Swear to me that some day I, too, shall be your victim. Since the age of fifteen, my thoughts have been fired by one idea: to die a victim of the cruel passions of libertinage. To be sure, I don't want to die tomorrow—my extravagance hardly goes that far—but it is the one way I want to die. Just the thought that by my death I shall become an occasion for crime is enough to turn my head." To this strong head, the following response is forthcoming: "I love your head madly . . . and I think we can do some pretty strong things together." She: "It's a rotten head, utterly putrefied, I agree."

This much begins to dawn on us: to the integral man, no evil can come. If he harms others, what voluptuousness! If others hurt him, what delight! He likes virtue because it is feeble and he can crush it— and vice also, for he derives satisfaction from the disorder that springs from it, even if this be at his own expense. While he lives, there isn't a single event from which he may not expect sheer happiness; if he dies, he finds in his death a happiness even greater and, in the consciousness of his destruction, the crowning of a life which only the need to destroy could have justified. He is then inaccessible to others. Nobody can reach him, nothing can alienate his power over self and his self-enjoyment. Such is the first meaning of his aloneness. Even if he should, in appearance , become, in his turn, slave and victim, the violence of the passions which he has the power to satisfy in no matter what circumstance, is a guarantee of his sovereignty, of his omnipotence. It is because of this fact, and in spite of the correspondences in their descriptions, that one is justified in leaving to Sacher Masoch the paternity of masochism, and to Sade that of sadism. In Sade's heroes, the pleasures of abasement never alter the sense of mastery, and abjection raises them to the highest; all those feelings called shame, remorse, pleasure (of the passive kind) in punishment, remain alien to them. Saint-Fond tells Juliette: "My arrogant pride is such that I would be served from a kneeling position, and speak to that vile scum known as the people only through interpreters." Juliette answers (unironically): "But don't the whims of libertinage ever bring you down from that height?" "For heads as clear as ours," Saint-Fond retorts, "these humiliations minister delightfully to our pride." Sade adds this note: "There is nothing incomprehensible about this; for one is doing what nobody else does; one is then unique of his

kind.'' We encounter the same prideful satisfaction, on the moral plane, in the sensation of being banned from the human race: ''The world must be made to shudder on learning the crime we shall have committed. We must constrain men to blush for being of the same species as us; I demand that a monument be reared to proclaim this crime to the universe and that our names be inscribed there by our own hand.'' To be the Unique Creature, unique of its kind, is indeed the sign of sovereignty; and we shall see to what absolute meaning Sade stretched this category of the Unique.

Everything seems to have cleared up; but at this point of arrival, we begin to feel that things are growing dark again. The movement by which the Unique One eludes the grip of others is far from being transparent. In some aspects, we seem to have a kind of stoic insensibility with its presupposition of perfect autonomy of man with regard to the universe. But at the same time, we have quite the contrary, for, in addition to being independent of others, who can never hurt him, the Unique One immediately sets himself over them in a relationship of absolute domination. It is not because others are powerless against him that their daggers, tortures, and humiliating maneuvers leave him intact; he is intact because others are completely exposed to his power—so much is this the case that the pain inflicted on him by others contributes to his pleasurable sensation of power and helps him to exercise his sovereignty. Now, this situation has its troublesome aspect. From the moment that ''being my own master'' means ''being master over others,'' that my independence is not an outcome of my autonomy but of the dependence of others where I am concerned, it becomes evident that I remain bound to others and need them, were it only to reduce them to nullity. . . .

The libertine experiences no greater joy than that of immolating victims, but this joy is self-annulling in that it destroys what caused it in the first place. ''The pleasure of killing a woman,'' says one of them, ''is soon over; she can no longer experience anything once dead; the delights of making her suffer disappear when her life disappears. . . . Let us mark her with red irons, let us brand her; from this humiliation she will suffer to the last moment of her life and our lust, thus infinitely prolonged, will become that much more delectable.'' Similarly, Saint-Fond, dissatisfied with over-simple tortures, would like for each creature a kind of infinite dying; wherefore he gets the idea of exploiting the resources of Hell by an incontestably ingenious method and makes plans, from this world, to resort to this inexhaustible source of torments for his chosen victims. It is plain enough what inextricable relationships oppression creates between oppressor and oppressed. The life of Sadic man is derived from the death he could eternally impart—with the result that murderer and victim, in

eternal confrontation, would be equally invested with the same power, the same divine attribute of eternity. That such a contradiction exists in Sade is undeniable. But, oftener still, it occurs to him to push beyond this dream by arguments which enlighten us much more profoundly concerning his world. Clairwill rebukes Saint-Fond for what she calls his inexcusable extravagances and to put him on the right road, she gives him this advice: "Get rid of the voluptuous idea which is turning your head—the idea of prolonging to infinity the torments of a creature whom you who have doomed—and replace it by a greater sum of murders; don't try to prolong indefinitely the killing of one and the same person—it is impossible anyway—but kill many others, which is very feasible." Killing a greater number is in fact a much more correct solution of the problem. To consider beings from the point of view of quantity annihilates them more completely than the physical violence which kills them. The criminal finds himself well-nigh indissolubly united to his victim. But the libertine who, in immolating his victim, is acting only on an experienced need to sacrifice a thousand others, would seem strangely free of any alliance with him. In his eyes, his victim does not exist in himself, is not a distinct being, but a simple sign, indefinitely substitutable, in an immense erotic equation. In reading statements such as: "Nothing amuses me, nothing warms me up like a big number," one better understands why the idea of equality serves as a prop to so many of Sade's arguments. All men being equal, that means that no creature is worth more than another, that all are permutable, and that the significance of each is limited to being a unit in an infinite series. From the point of view of the Unique One, all creatures are equal in their nullity, and the Unique One, in reducing them to nothing, only makes manifest that nothingness.

. . . The world in which the Unique One makes his way is a desert; all beings he comes upon there are less than things, less than shadows, and, in tormenting, destroying them, it is not their lives that he expropriates but their nothingness which he substantiates, it is of their inexistence that he makes himself master and from which he derives his keenest joy. At the dawn of the 120 Days, the Duc de Blangis tells the women who have been assembled for the pleasure of the four libertines: "Take stock of your situation, of what you are, of what we are, and tremble to think upon it: here you are outside France in the heart of an uninhabitable forest, within a circle of steep mountains all the passes of which have been stopped immediately after your passage; you are prisoners within an impenetrable citadel, nobody knows you are here, you are lost to friends and relatives, *you already dead to the world.*" This last must be understood quite literally: they are already dead, cancelled, immured in the absolute void of a *bastille* where existence no longer figures and where their life serves only to render

sensible that character of the "already dead" with which it has been confounded. . . .

At the center of the Sadic world is an imperative of sovereignty, affirmed in the form of an immense negation. This negation, which is achieved on an immensely quantitative scale, which no particular case can satisfy, is essentially destined to transcend the level of human existence. Sadic man may impose himself on others through his power to destroy them; but if he gives the impression of never being their tributary, even amidst the necessity in which he finds himself of annihilating them, if he always seems capable of doing without them, the explanation lies in the fact that he has situated himself on a plane where he no longer shares a common measure with them; and he has situated himself once for all on that plane by assigning as horizon of his destructive intentions something which goes infinitely beyond men and their footling existence. In other words, if Sadic man seems astonishingly free *vis-a-vis* his victims, on whom his pleasures nevertheless depend, this is owing to the fact that his violence though directed at them, is aimed at something other than they, goes well beyond them, and but constitutes in each particular case a verification, frenetically and infinitely extended, of a general act of destruction by which he has reduced God and the world to nothing.

From all indications, the spirit of crime is bound up in Sade with a nostalgic dream of transcendence which the feeble possibilities of the practical do not cease to degrade and dishonor. The most brilliant possible earthly crime is a bagatelle the misery of which makes the libertine blush. There is not a single one among them who, like the monk Jerome, does not experience a sensation of shame before the mediocrity of his misdeeds and does not yearn for a crime superior to any possible to man on this earth. "Unhappily, I have been unable to find one; everything we do is merely a pale image of what we should like to be able to do." "I should like," says Clairwill, "to find a crime self-perpetuating in its effects, so that even if I were no longer to act, it would continue to act through every moment of my life, whether waking or sleeping, and which at every such moment would give rise to new disorders which, self-radiating, would spread to the point of bringing on a general corruption or a dislocation so positive that even beyond my own life-time the effects would continue to reverberate." To which Juliette makes this answer so in keeping with the tastes of the author of *The New Justine* "Try your hand at moral crime, which can be achieved by writing," Sade's own erotic dream consists in projecting the unreal movement of his pleasures onto his characters, who do not dream but act in the real. Sade's eroticism is a dream eroticism, since, for the most part, it is realized only in his fiction. But the more his eroticism is dreamt up, the more he needs a fiction from which the dream

is banished and in which debauchery is realized and lived. Sade, in his system, has reduced as far as possible the role of intellectual voluptuousness, and almost completely suppressed imaginative eroticism; yet nevertheless he exalted the imaginative, for he was fully aware that the ground of so many imperfect crimes is an impossible crime which the imagination alone can grasp. This is why he has Belmore say: "Oh, Juliette, how delightful are the pleasures of the imagination. The whole world is ours in such delectable moments; not a single creature withstands us, we lay the world waste, repeople it with new objects to be immolated anew; the means for every crime is then in our hands, we can use everything, and multiply horror a hundredfold."

. . . . Sade's originality seems to us to spring from a very firm intent at grounding the sovereignty of man on a transcendent power of negation, a power which is absolutely independent of the objects that it destroys; which does not even presuppose their prior existence, since before it destroys them, it has already held them as nil. This dialectic at once finds its best example and, perhaps, its justification in the way in which Sade's All-Powerful One affirms himself before the Omnipotence of God.

Maurice Heine (*Sade mon prochain*) has brought out the exceptional firmness of Sade's atheism. But, as Pierre Klossowski so rightly points out, it is not a cold or calm atheism. After the most tranquil development, once the name of God is mentioned, the language begins immediately to crackle, a movement of hatred sweeps the words along in a topsy-turvy. It is certainly not into his scenes of sensual gratification that Sade pours his passion. But violence, contempt, the ardor of pride, and the vertigo of power and desire, awaken forthwith each time that the Unique One perceives a vestige of God in his path. The idea of God is, in some way, the inexpiable lapse of man, his original sin, the proof of his nullity, the justification and authorization of crime, hence, against a creature who has consented to annul himself before God, no annihilatory means should be considered too energetic. Sade writes: "The idea of God is the one wrong I cannot pardon in man." The phrase is decisive and is one of the keys to his system. Belief in an all-powerful God who leaves man only the reality of a wisp of straw, of an atom of nothingness, is a call to duty to the integral man by which he is bidden to seize that superhuman power; to possess himself, in the name of man, and over men, of the sovereign right that these have recognized in God. When the criminal kills, he is God on earth, because he actualizes between his victim and himself the relationship of subordination which was the victim's definition of divine sovereignty. Once a true libertine discerns the least trace of religious faith, were it in the mind of the most abandoned debauchee, he decrees death; for the imperfect debauchee has by abdicating his power in behalf of God, destroyed himself,

accounted himself as nothing, wherefore the one killing him merely regularizes a situation which appearance can scarcely veil.

Sadic man denies man, and this negation is carried through by means of the notion of God. Momentarily he makes himself God, so that men are reduced to nothingness before him and made to see the nothingness of a creature placed before God. "You do not love men, do you, Prince?" Juliette asks. "I abhor them. Not a moment goes by but what I nourish the most violent designs against them. There is nothing more horrible than the human race. . . . What squalor, how vile, how disgusting it is!" "But," interrupts Juliette, "do you really think you are men? No, that cannot be; when one dominates them with so much energy, it is impossible that one should be of their race." " She is right," says Saint-Fond, "yes, we are gods."

. . . Saint-Fond, among all other heroes of Sade, presents this singularity: of believing in a Supreme Being. Only, this God in whom he believes is not a very good God. He is "very vindictive, barbaric, wicked, unjust, and cruel." He is the Supreme Being of wickedness, the God of misdeeds. Sade has drawn all kinds of brilliant developments from this idea. He imagines a Last Judgment, described with the resources of the ferocious humor in which he is so much at home. In it, we hear God bullying the good in these terms: "When you saw that everything was vicious and criminal on earth, why did you allow yourselves to be led astray along the paths of virtue? Shouldn't the perpetual misery with which I blanketed the earth have convinced you that I loved only disorder and that to please me it was necessary to irritate me? Didn't I furnish you with daily examples of destruction? Why didn't you engage in destruction then? Imbeciles! If only you had imitated me!"

. . . For Sade, God is evidently only a prop for his hatred. His hatred is too comprehensive for any one object to matter much to him. Since it is infinite, exceeds every limit, he comes eventually to delight in it for its own sake and to find rapture in that infinity to which it has assigned the name of God. ("Your system," says Clairwill to Saint-Fond, "has its sole source in the profound horror you have for God.") But it is his hatred alone that is real and, in the end, it sweeps him along against nature with as much intrepidity as against the inexistent God he abhors.

Actually, the reason why things religious, the name of God, those God-mongers the priests, unleash Sade's stormiest passions is that such words as *God* and *religion* can be made to embody all the forms of hatred. In God, he hates the nullity of man who has given himself such a master, and the thought of that nullity irritates and inflames to the point where he co-operates with God to sanction that nullity, that nothingness. In God, he also hates God's omnipotence; in it he recognizes his own, and God

becomes the figure, the body of his infinite hatred. Finally, he hates in God, God's miserable insignificance, the nil character of an existence which insofar as it affirms itself as existence and creation, is nothing; for what is great, what is everything, is the spirit of destruction.

This spirit of destruction is identified in Sade's system with nature. Around this point, his thought groped its way for a time. He found it necessary in fact to rid himself of the atheistic philosophies then in vogue, philosophies for which he could not help feeling great sympathy and in which his avidly-logical mind found inexhaustible aids and resources. To the degree that he was able to go beyond naturalist ideology, that he was not bemused by superficial analogies, he has furnished us proof that in him logic had gone to the very end, had not shrunk before the obscure powers which sustained it. Nature is a word with which, like so many writers of the time, he is very free. It is in the name of nature that he gives battle against God and everything that God represents, morality in particular. First of all, nature is universal life for him. For hundreds of pages his whole philosophy consists in repeating that the immoral instincts are good, since they are natural facts, and that the first and last court of instance is nature. In other words, he is for a denial of morality and for the reign of fact. But in the sequal, annoyed by the equal value he finds himself led to accord to virtuous instincts and evil impulses, he attempts to build a new scale of values at the top of which crime is placed. His principal argument is essentially that crime is more conformable to the spirit of nature, since crime is movement, i.e., *life;* nature, which would create, he says; first, needs crime which destroys. All this is established minutely, at great length, and with an occasional striking proof. Yet, compelled as he is to talk constantly about nature, to find himself incessantly face to face with this supreme, un-by-passable term of reference, Sadic man grows gradually irritated and his hatred makes nature so intolerable to him that he heaps her with anathemas and negations. ''Yes, my friend, I abhor nature.'' Two motives underlie this revolt. On the one hand, it seems intolerable to him that the immense power of destruction he represents should have no other end but to authorize nature to create. On the other, to the degree that he makes himself a part of nature, he feels that nature is eluding his negation of her, and that the more he outrages her the better he serves her, and that the more he crushes her the more subject he is to her law. A cry of hate goes up, of truly delirious revolt: ''You, blind and imbecile power, when I have exterminated every creature that walks the earth, I shall still be hopelessly far from my goal, since I shall only have served you, accursed Step-mother, while my real aspiration was to have avenged myself for your stupidity and malevolence, which qualities you inspire in men at the same time that you refuse to furnish them the

means whereby they can satisfy the frightful penchants you have given them.'' This is the expression of a primal and elemental feeling; to outrage nature is the profounder need in man, a thousand times stronger than that of offending God. ''In everything we do we offend every idea and every creature; but with nature we are unsuccessful, and it is she whom I yearn to have the power to offend; I should like to upset her designs, interfere with her course, arrest the wheel of the stars, set spinning crazily the stellar bodies afloat in space, destroy everything in her service, protect everything noxious to her, in a word, insult her in all her works—and yet I am unable.'' In this passage, Sade allows himself to confound nature with her great laws, a confusion which enables him to dream of a cataclysm which would nullify those laws. But his logic rejects this compromise, and when, in another passage, he imagines some mechanic inventing a machine to pulverize the universe, he is forced to admit nobody would be serving nature better than such a mechanic. Sade is perfectly aware that to annihilate all things is not to annihilate the world, for the world is not only universal affirmation, but universal destruction; so that the totality of being and the totality of nothingness are equally representative of the world. It is in this respect that the struggle with nature embodies in the history of man a dialectical step superior to that of the struggle with God. Without modernizing unduly his thought, one can hold that Sade, in his century, is one of the first to have recognized the notion of transcendence in the idea of the world; the idea of nothingness being part and parcel of the world, it is impossible to think the nothingness of the world except from within a whole which is and remains the world.

If crime is the very spirit of nature, there can be no crime against nature and, consequently, no crime is possible. Sade affirms this, sometimes with the greatest relish, sometimes with the liveliest rage. Denying the possibility of crime enables him to deny morality and God and all human values; but denying crime also means a renunciation of the spirit of negation, means that the spirit of negation can also deny itself, be cancelled out. Against this conclusion he rises wrathfully and is led little by little to withdraw all reality from nature. In the last volumes of *The New Justine* (particularly VIII and IX), Juliette repudiates all her former conceptions, making honorable amends in these terms: ''Idiot that I was, before we separated from each other, I was still at it, drivelling about nature; the new system I've embraced since that time has freed me of her. . . . '' Nature, she goes on to say, has no more reality or truth, makes no more sense, than God: ''Nature, you Harlot, perhaps you are deceiving me, just as I was deceived in earlier days by that infamous Deific chimera to which you were said to be subject. We no more depend on you than we do on God; causes are perhaps inadequate to their effects. . . . '' Exit nature,

although our philosopher had put all his hopes in her and would have been delighted to make of universal life a formidable engine of death. But simple nothingness is not Sade's objective. What he has pursued is sovereignty, by means of the spirit of negation pushed to the uttermost. He had put this negation to the test by making use, by turns, of men, God, and nature. Men, God, nature, all these notions, at the moment they are penetrated by negation, seem to have a certain value conferred on them, but if one takes experience in its totality, these moments no longer manifest the slightest reality, for the peculiar quality of experience consists precisely in ruining and annulling one by means of another. What becomes of men if they are nothing before God? What becomes of God when confronted by nature? What becomes of nature once it is constructed to vanish at contact with man who carries within himself the need to outrage her? The circle closes on itself. Having taken our point of departure from men, we find our point of arrival in man; the difference now being that man bears a new name: the Unique One, i.e., he is unique in his kind.

Having discovered that in man negation was power, Sade tried to ground the future of man on a negation pushed to its end term. To achieve this, he borrowed from the vocabulary of his time and imagined a principle which, by its ambiguity, represents a very ingenious choice, namely, energy. Energy is a perfectly equivocal notion. It is at once power in reserve and power expended, it is affirmation realizable only through negation, power which is also destruction. Moreover it is both a fact and a law, a datum and a value. It is a striking fact that far from placing desire in the foreground in a universe of effervescence and passion, Sade subordinated it and viewed it with suspicion. For desire is a denial of aloneness and leads to a dangerous recognition of the world of others. When Saint-Fond declares: "My passions, brought to focus at a single point, resemble the rays of the stars when assembled by a lens: they burn instantly the object at the point of focus," he is showing to perfection how destruction may appear synonymous with power without the destroyed object's deriving the slightest value from this operation. Another advantage of this principle: it assigns a future to man without enforcing on him the recognition of any transcendental notion whatsoever. One of the merits of Sade was to have brought down the morality of the Good, taking care at the same time not to replace it by a Gospel of Evil. When he writes: "Everything is good when excessive," we may rebuke him for the lack of certitude of his principle, but we cannot tax him with having desired to ground the sovereignty of man on a sovereignty of notions superior to man. No form of conduct emerges as superior; one may choose no matter what: what matters is that in acting one be capable of making the greatest possible destruction and affirmation coincide. Practically this is what goes on in

Sade's novels. His creatures are not happy or unhappy according as they are more or less virtuous or vicious, but according to the energy they manifest. As he has written: "Happiness depends on the energy of convictions; it is barred to those who are constantly adrift and afloat." Juliette, to whom Saint-Fond proposes a plan for devastating two-thirds of France by famine, hesitates and draws back. Immediately, she finds herself in grave danger. Why? Because she has shown weakness, a want of spiritual tone and resiliency; and the greater energy of Saint-Fond prepares to make her his prey. The case of La Durand is even clearer. She is an *empoisonneuse* incapable of the slightest exercise of virtue; her corruption is complete. But, one day, the Government of Venice asks her to help spread a plague. This project frightens her, not because of its immoral character, but because she is apprehensive of the danger she will lay herself open to. She is condemned straightway. She has had a lapse of energy, she has found her master, and that master is death. In a dangerous life, says Sade, the important thing is never "to lack the necessary strength to clear the last barriers." Sade could be interpreted as saying that this strange world is not a composite of individuals, but of fields of power systems, higher or lower tensions and potentials. Wherever a drop in potential, a lowering of tension takes place, catastrophe becomes inevitable. Moreover, there is no need to distinguish between natural and human energies: lubricity is a kind of lightning, just as lightning is the lubricity of nature; the weak will be victims of one or the other, and the strong will emerge triumphant. Justine is struck down, Juliette is not; and there is nothing providential about this outcome. Justine's weakness attracts the thunderbolt that Juliette's energy discharges upon her. Similarly, everything that happens to Justine renders her wretched, because everything that affects her diminishes her; of her it is said that all her inclinations were *virtuous but feeble*, and this is to be understood in a literal sense. On the other hand, everything that affects Juliette reveals her power to her, and she revels in it as though it were an accession of growth. For which reason, in case she should die, her death, by making her experience total destruction as total expenditure of her immense energy, would propel her to the very limits of power and exaltation.

Sade has understood perfectly that the sovereignty of the man of energy is, insofar as he acquires it by identifying himself with the spirit of negation, a paradoxical state. Integral man in affirming himself completely also destroys himself completely. He is the man of every passion and he is insensible. He has begun by destroying himself as man, next, himself as God, then, himself as nature, thereby finally becoming the Unique One. Now he can do anything, because negation moving him has reached the limits of things. To illustrate the formation of the man of

energy, Sade resorts to a very curious concept to which he lends the classic name: apathy. Apathy is the spirit of negation applied to a man who has chosen to be sovereign. It is, in some sense, the cause and principle of energy. Sade's reason may be interpreted as tracing the following course: the individual of our time represents a certain quantum of power; most of the time he disperses his power by alienating it to the benefit of those simulacra which he calls Others, God, the Ideal; by this dispersion, he has foolishly exhausted his possibilities by wasting them, and what is worse, by grounding his conduct on weakness; for if he spends himself for others, he does so out of an imagined need to lean upon them. A fatal lapse this: he enfeebles himself by vain expenditure of power, and he spends himself because he believes himself weak. But a real man knows that he is alone and he accepts his aloneness. Everything in him representing the legacy of 17 centuries of poor-spiritedness and cowardice he rejects: pity, gratitude, and love are sentiments that he will destroy; in destroying them, he recovers all the power he would have had to sacrifice to these debilitating impulses (pity, etc.) and, what is even more important, he begins to draw into himself real energy from this work of destruction.

What must be understood from all this is that a-pathy does not consist merely in ruining the parasitical affections, but indeed also in making a stand against the spontaneity of any and all passions. The vicious man who abandons himself immediately to his vice is doomed to an abortive end. Even debauchees of genius, perfectly endowed to be monsters are doomed to catastrophe, if they are satisfied to follow their bent. Sade is exacting on this point: for passion to become energy, it must be compressed, it must be mediated by passing through a necessary moment of insensibility. Only then will it be the greatest possible. At the outset of her career, Juliette is incessantly exposed to the following reproach by Clairwill: that she is committing crime solely by the torch of passion, that she is placing lust and the effervescence of pleasure above everything else. Crime is more important than lust. Cold-blooded crime is greater than crime accompanied by ardent passion. But crime "committed following and resultant upon enduration of the our sensitive part," somber and secret crime, is of greater avail than any other, because it is the act of a soul, which, having destroyed everything within, has accumulated an immense power, which will identify itself completely with the movement of total destruction it is preparing. . . .

The libertine is "thoughtful, self-centered, incapable of being moved by anything whatsoever." He is isolated, he does not put up with noise or laughter; nothing must distract him. "Apathy, insouciance, stoicism, aloneness, that is the tone to which he must necessarily key up his soul." Such a transformation, so great a self-extinction, is not to be wrought

without infinite pains. *Juliette* is a kind of *Bildungsroman,* a handbook for prentices where we learn the how of the slow formation of an energetic soul. In appearance, Juliette is, at the very outset, completely depraved. In reality, she is merely a bundle of propensities and her mind is altogether unexercised. A gigantic effort lies ahead for her—as Balzac says: *not everybody is ruined who wants to be. . . .*

One of the striking aspects of Sade and his fame is that while scandal has no better symbol than him, everything scandalously daring about his thought has remained for so long a time an unknown quantity . . . Until Apollinaire, Maurice Heine, and André Breton with his devintory knowledge of the hidden powers of history opened a way for us to him, . . . Sade, master of the great themes of modern thought and sensibility, had remained a brilliant but empty name. Why? His thought is the handiwork of a special mania; the mold from which it was cast was a depravity before which the world shrank back. It aspires to transpose the most repugnant of anomalies into a complete view of the world. For the first time, philosophy was conceived in broad daylight as the product of an illness. (Sade admits it unembarrassedly: "Man, that creature endowed with singular tastes, is an invalid.") He brazenly affirmed as universal logical thought a system resting upon one warrant: the preference of a single aberrant individual.

. . . Sade proved, with supreme arrogance, that from a certain personal and even monstrous way of behavior, a rather significant view of the world could be legitimately derived. So significant that, later, great minds, exercised solely to explore the meaning of our human condition, have done little more than retrace his main perspective and bring fresh support to its validity. . . .

"The singularity of Sade," says Nodier, "lay in having committed a crime so monstrous that even to characterize it was not without danger."

. . . Another contemporary, Pitou, writes somewhat alarmingly: "Justice had relegated him to a prison corner, and at the same time authorized the other prisoners to get rid of that burdensome creature." When, later, he was recognized as exemplifying an anomaly existing in some humans, no time was lost isolating him within an unnamable aberration, to which, in fact, only his own name was applicable. Still later, even when this anomaly of Sade's was viewed in a favorable light, when he was seen as a man so free that he had invented a new knowledge, as a man altogether exceptional in virtue both of his life story and mental preoccupations, when, finally, sadism was viewed as a possibility affecting all mankind; men continued to neglect Sade's own thought, as if they were sure that there was more originality and authenticity in the fact of sadism than in the manner in which Sade had made himself its interpreter. But the closer his thought is examined, the more it becomes evident that his

thought is by no means a negligible quantity; and amidst the contradictions in which it moves, it yields us more significant insights bearing upon the problem illustrated by Sade's name than we could have been led to expect from the most exercised and enlightened reflection hitherto prevailing. We do not hold that his thought is a viable one. But it does show us that, as between the normal man who would enclose Sadic man in an impasse and the sadist who makes of that impasse an issue, it is the latter who can tell us more concerning the truth and the logic of his situation, who understands it more profoundly. So much so that he can help normal men understand themselves, by helping them to modify the conditions of all comprehension.

The Grip of the Given

Lionel Abel

Sky skys
 and space makes space,
the blue clouds
 cloud and blue,
grey now
 goes greywards
out of cold-with-light,
 cold-with-light;
if a wind—
 in wind the wind . . .
Lost!
 Is there
no shelter
 under this tree
that might be a man . . .
 If the tree tried?—
From branching branches
 a bird goes bird . . .
Lost!
 Let nothing be unlike!
If the calm is not for me
 or of the sky,
the space, the blue, the clouds, the grey,
 let change change,

This poem originally appeared in *Instead* 7 (undated): unpaginated.

let thunder thunder,
and the lightning show the lightning to the lightning!
 I shall stand fast,
Other on the same sward,
the only god that may not god or guard.

Executioner and Victim

Georges Bataille

But he who recoils and refuses to see is scarcely a man: he has elected for a refusal to know what he is. Though in a sense he does know: he has turned away! But he does *not want* to know. This denial of his humanity is scarcely less degrading than that of the executioner. The hangman degrades himself, degrades his victim, he strides through cowardice, through ignorance (no one, if he is not inhuman, can reduce himself to the state of blind nature; the torturer is unaware that he is striking at himself—he compounds the suffering of the victim by an annulment of the idea of humanity). But a susceptible heart is even more base and cowardly, hardly less redoubtable; its abdication means an extension of the zone where humanity is mocked and defeated, is but error and vanity, is a she-parrot in its stupid affirmings.

Horror, obviously, is not truth; it is but a possibility prolonged indefinitely, limited only by death (from death we in fact take this bearing, that being suffering's term, it confers upon it a meaning that is definitive and inordinate: within us, it endures to the very last as the impossible, it suppresses every possible other than suffering, and, in the measure that it limits suffering, it withdraws itself stealthily from our awareness). But man is compounded of a possible abjection, of his joy, of possible sufferings; and if abjection and suffering does not, by some means, come to him as a revelation, he is but a rag tricked out as a man, a pharisee, a clown, an old aunt, some fraud or other, propped up and set a-chatter in the effort to still the remorse crowding in after some notable lapse.

This article, translated by Félix Giovanelli, appeared in *Instead* 7 (undated): unpaginated. Alberto Giacometti's drawing of Georges Bataille, which accompanied this article, is reproduced in this volume as figure 51.

Nausea is not at all what reveals a thing, but it is only amidst a continuing nausea that the world is given to us. If we were to be curtailed of this domain: the possibility of suffering, we should have a world of zanies and janies, by whom no one could be moved to laughter. Suffering, however, is there—as is the disgust bound up with it by which we are determined. And the knowledge of possible suffering humanizes: by it men are rendered so hard or so tender, so gay or so opaquely silent.

(In this sense, David Rousset represents, very exactly, the point at which humanity finds its fulfillment: he emerged from the ordeal without hatred and lamentation, with a humor not inadequate to his lucidity.)[1]

The worst thing about the sufferings of deportees is not the pain that had to be endured, but the pain capriciously willed by others. Pain originating in disease or accidents does not seem so horrible: the deeps of horror are in those who exact it. One could come to peace with a world in which great suffering invested numerous individuals but in whom the accord of all was bent upon its suppression. The multiplication of abasement, ignominy and cowardice—which step by step reduces to ruins the redoubt of a civilized order based on reason—strikes at us more savagely than sheer pain.

Yet the difference has less to do with the suffering of the victim than with ours. We are additionally threatened when the gates that had opposed a reasonable order to cruelty give way.

But that is not all.

We cannot be human without having first perceived within us the possibility of suffering, and that of abasement too. Not only are we the

1. "This book is constructed as a novel." The author, who must have found thus a greater wealth of expression and subordination of language to life than are available to the historian, adds however: "Fable has played no part in this work. Facts, events, and persons are all authentic. It would have been puerile to invent where truth had outstripped imagination." As is known, David Rousset had already published, as a kind of preface to this long book, his *Univers concentrationnaire* ("The Other Kingdom"), in which, before proceeding to the entangled but sustained episodes of JOURS DE NOTRE MORT, he had ennunciated its main themes. Perhaps taking undue advantage of the ambiguity introduced by the sub-title, *Roman*, criticism has alluded to the lengthiness and repetitiousness of these episodes. As a matter of fact, criticism is, in principle at least, committed to a "normal world" which rests upon respect for the conventions upon which it is founded, while here we have a voice coming through from "another world"—in this case, a world based on a rupture with those conventions. We may add that the lengthiness and repetitiousness alleged help us to hear, precisely in the one way it can be heard, that other voice to which David Rousset has imparted vigor and inflexibility. And why not say here and now that the book acts within us as a discovery of the ground (and, to be sure, the mire!) out of which humanity is emergent?

possible victims of executioners: the executioners are our kith and kin. We must once again ask ourselves: "Is there anything in our nature which would render such horror impossible?" And we are indeed forced to answer ourselves: "Nothing whatever." To be sure, a thousand obstacles in us can be thrown up. Nevertheless, there is no impossibility about the matter. Our possibility is not limited by our suffering, but also embraces the torturer's rage. The Toni Brunckens, the Heinzes, the Popenhauers, all those booted, blackjacking killers, are there, in all their cowardice and inexorability, to tell us, with their irrefutable rage that, often, violence is limited by cowardice alone, and that there are no limits to cowardice. And how not see, from amidst our most painful silence, that such a possibility is merely the most remote, the most inconceivable, if you like, but *our very own?* In us there is nothing isolable that we can lay to one side, and which would empower us firmly to declare: "It would have been impossible . . . utterly." Utterly? What we are depended on circumstances of which could have been very different, that could perhaps have been—for example—those of which Toni Brunsken [*sic*] was the effect.

It is clear that life is not reducible to the absurd and that yet the possible in man overflows in all directions the limits of reason. A series of rational acts is no more than one among many other possibles; and men upon whom reason sheds its light always perceive within themselves, simultaneously, the rational and beyond that—though always within them—what calls the rational into question.

Now, it is the essence of reason to be contestable, but it is the essence of all contestation to be an effect of reason. No doubt reason is, at its limits, merely an interrogation insoluble for itself, and, thus viewed, it may seem to surrender of itself to the absurd. Nothing of the sort—if one looks with a certain coolness (perhaps accompanied by suffering, too). The reasonable is in fact what the absurd cannot destroy, in this sense, namely, that of itself and interiorly, reason brings about what the irrational effects from the outside: its being called unreservedly into question. But it is precisely at this point that man triumphs over negation. He does not triumph in the form of some decisive victory following which rest, sleep would be his portion. He triumphs by that form of doubt called awareness.

Only, what would awareness amount to if it served merely to light up a world of abstract possibilities, did it not wake up to the possible of an Auschwitz, to a possible of noisomeness and irremediable fury?

There is a special form of moral condemnation which is really an evasive tactic of disavowal. Its representatives say in effect: "Nothing so abject could have occurred had they not been moral monsters." In this violent

judgment, moral monsters are excluded from the possible. They are implicitly accused of exceeding the limits of the possible, whereas it is their very excesses which define those limits. To the degree that language addresses itself to the crowd, this kind of childish disavowal or denial may seem effective, but it changed nothing at bottom. It is as vain, even, to deny the incessant danger of cruelty as it would be to deny that of physical suffering. Its effects cannot be obviated merely by flatly ascribing it to certain parties or races which, as it is imagined, have nothing human about them.

To be sure an awareness which obliged us to an uninterrupted cognizance of possible horror is something more than a means of averting it (or, at the critical moment, of coping with it). Awareness begins with humor, as it does with poetry. (And it is not the least of the meaning of Rousset's book that humor should also be affirmed and that the nostalgia disengaged from it, far from being that of a replete happiness, is that of poetic intoxication.)[2]

2. For having taken this work as a point of departure in an attempted movement to the limits of reflection, I can lay no claim, naturally, to have exhausted the interest of a book which is, in truth, a universe. Rousset's next book, *Lazare ressuscite,* will have for its subject the return of that other world to the normal world. How can the somber, immense experiences of the Camps not have called everything into question? In any case, it is to this point that one must incessantly come back. (*Critique,* 17 October 1947.)

An Essential Argument within Existentialism

Jean Wahl and Emmanuel Lévinas

In 1946, Jean Wahl gave a talk on Existentialism for *Club Maintenant* in Paris. In the audience were Messers. Berdayev, George Gurvitch, Koyré, de Gandillac, Marcel and Lévinas, all of whom engaged in a discussion of various points in Wahl's presentation. We re-print here the remarks of Lévinas and Wahl's reply.

Lévinas: I should like to come back to two questions raised by Wahl. The first concerns the definition of existentialism. The second has to do with the observation just expressed on the notion of death: why should the idea of death be more revealing than the idea of life? This is a criticism one often hears under different guises. I have no desire to refute it just to defend Heidegger, but I should like to situate it in order to explain him.

The two questions I desire to touch upon are, moreover, of a piece.

You have even raised a third question: who is existentialist? and you have been able to discover existentialists everywhere. There is an existentialism going back beyond Kierkegaard and Pascal, to be found in Shakespeare and as far back, even, as Socrates. Also, it is to be found nowhere; everybody denies belonging to it. This happens in what Husserl used to call the second stage in the expansion of a new doctrine. During the first stage, people cry: "Why, it's absurd!" During the second: "But everyone has thought that!" There is a third stage in which the doctrine is situated in its true originality.

This multiplication of a modern doctrine across the past ends—happily—in its own negation. At such a time we shall perhaps be forced to recognize that there is but one existentialist or existence philosopher. This one and only existentialist is neither Kierkegaard nor Nietzsche, nor

This article originally appeared in *Instead* 7 (undated): unpaginated.

Socrates nor even—for all their display of talent—the successors of Heidegger. It is Heidegger himself, the very man who rejects the term.

Why do I say this? Because it is Heidegger's metaphysical work which has shed the light whereby precisely we are enabled to discover existentialism in the night of the past, where, so it would seem, it had lain hidden. This holds even for Kierkegaard. It is possible that behind each of Heidegger's phrases there is something of Kierkegaard; but it is owing to Heidegger that Kierkegaard's propositions have developed a philosophical resonance—for all their having been previously well known in Germany and for all their having been the object of special studies by Henri Delacroix and Victor Basch in France at the turn of the century. I mean by this that before Heidegger, Kierkegaard belonged to the essay, psychology, esthetics, theology, or literature; and that after Heidegger, he came to belong to philosophy.

In what does this work, this transformation, wrought by Heidegger, consist?

It consists in having taken certain notions which were emotionally— or pathetically—charged so to speak, which in fact lie dispersed over the long path of history, and in having situated them relative to those landmarks, those points of reference which—for all the discredit accruing to them in virtue of their official status—are endowed with an exceptional power of intelligibility—I am referring to the categories of professors of philosophy: Plato, Aristotle, Kant, Hegel, etc. Heidegger has brought these emotionally-charged notions under academic categories.

To penetrate Heidegger's thought, however, it is not enough to show the systematic coherence of his thought, the connections that can be established among certain notions now making the rounds of streets and cafes: anguish, death, dereliction, the ecstasies of time, etc. As one ascends toward the categories, toward the ever-renewed light emanating from these intellectual myths, one must also ask himself: in what consists the essential category of Heideggerian existentialism which, by its own peculiar light, illuminates all those notions whereby the existentialists describe man, and which transforms these old notions into a new philosophy?

Whenever Heidegger says: *being-in-the-world, being-for-death, being-with-others,* he is adding a new thing to our millenary knowledge of our presence in the world, of our mortality, and of our sociality. He is saying that these prepositions *in, for,* and *with* are rooted in the verb *to-be* (just as *ex* is rooted in *exist*). He is saying that these prepositions are not of our doing insofar as we are existents situated in certain conditions; that they are not even mathematically contained *à la* Husserl within us as existents, whether in our nature or our essence; but, that they articulate the event of being, rendering it tranquil, simple, and equal to itself. One might put it this way: existentialism consists in feeling and thinking the verb *to be* as transitive.

When in his works—I have not yet read *L'Etre et le Néant*—Sartre puts the verb *to be* in italics, when he underlines am in "I *am* this suffering," or "I *am* that nothingness," it is the transitivity of the verb *to be* that he is bringing out.

In a word, there are no copulas in existentialist philosophy. Copulas translate the very event that *to-be* is.

I believe that a certain use of the verb *to be*—and this does not mean that I wish to give being a purely verbal significance—which answers to that transitivity is more characteristic of this philosophy than the evocation of ecstasies, anxiety, or death, which are after all as Nietzschean or Christian as they are existentialist. But do not the categories of potency and act suffice to express this new notion of existence? Is not existence-that-passes-over-into-act at the stage where it is but potency of this event of transition?

I do not think so—and it is at this point that I take the opportunity of answering Jean Wahl's second question: "Why, for example, did Heidegger choose death rather than hope in order to characterize existence?"

A potency that passes over into act: "in relation to" this tranquil existence which possess itself utterly and is situated outside existence and event. By that very fact, its existence is its realization, a constant loss of that which makes a simple possibility of it. The realization of potency is an event of neutralization.

In order that potency should inevitably constitute being, in order that being should inevitably be event, it would have to lie outside finality. It would be necessary that the event of existence should be other than the realization of some goal somehow pre-existing. But Heidegger says: death is such an event. To realize the possibility of death is to realize the impossibility of any realization—it is to be in the possible as such, and not in a possible as "image of immobile eternity." One might even add that to be in the possible, finality would have to be—following Heidegger—replaced by a relation with an end (in the sense of terminus, not goal).

Heidegger needs a possibility that is neither consequence nor precursor of act, and he proceeds to detach the notion of possibility from the notion of act. This allows of possibility remaining possibility—so much so that at the moment of its exhaustion we have death. Whence it ensues that the notion of death permits of possibility's being thought and grasped in its character of possibility: as event of existence, it forms a part of that fundamental intuition. I don't know whether you agree.

Existence takes place in such a way that being is already straining towards death, that this manner of straining towards death is for it a possibility par excellence. Because every other possibility is fulfilled and becomes act, while death becomes the non-reality, the non-being. It is in this sense that Heidegger asserts death to be the possibility of impossibility.

Wahl: Kierkegaard has, in his "Postscript," shed all the light possible on this notion of existence which, after Schelling, and more than Schelling, he has placed at the center of his thought. Heidegger is not necessarily the point of departure for the discovery of Kierkegaard, even though sociologically, historically, many use Heidegger as a jumping off point for the discovery of Kierkegaard (just as there are some who are concerned to read Hegel only because such a man as Marx existed). Historians of ideas like Delacroix and Basch (and many Germans) did not discover Kierkegaard through Heidegger. Moreover, many have discovered Kierkegaard not by way of Heidegger but through Barth, whom Lévinas has failed to mention. But no matter. It is not owing to Heidegger that Kierkegaard's language has yielded a philosophical resonance, unless we understand by philosophical: relative to school philosophy, to academic philosophy. There is here an utter divergence between us as to the meaning of the word philosophy, which I persist in being unwilling to reserve for the class called professors or for professors of classes.

Moreover, nothing could be more damning for Heidegger than Lévinas' remarks. He would have it that Heidegger brought emotion-laden ideas under academic categories. This amounts to accusing him of what Benda would accuse him, and of what I should readily accuse him (though admiring him the while).

Let us also note that Kant, and perhaps Gaunilon before him, and many others (I have already mentioned Schelling) have, long before Heidegger, seen existence as event, as fact, and have seen it with great clarity, and expressed it masterfully, while yet keeping clear of ontology.

To be sure, there is in Heidegger, as Lévinas has shown, in a profound measure what I should call an intuition of what being is, but it is obscured by his ontological language. Lévinas is trying to show that existentialism and ontology may go hand in hand. (But let us remind ourselves that Heidegger would reject the word: existentialism). Lévinas is bound to fail in his attempt, for ontology moves in the verbal. Let us also add that if what he says is true, namely, that the word *to-be* is inflected by means of *with, in the world,* or *for death,* in its very essence (though here I again note a paradox), there can be no question of ontology, but of ontologies.

As for the role played by death, I agree with Lévinas (and Aristotle) and the critics of Aristotle that a potency which passes over into act is referrable to act (this is a tautology, however). In its self-realizing, a possible is stripped of its character of possibility. But far from being an impossibility of realization, death is realization itself, I mean, "reification." It is therefore not true that to realize the possibility of death is to realize the possible as such. Moreover, if death is, as Lévinas says in his comments on Heidegger, the terminus of every possible, it cannot be the root of the possible.

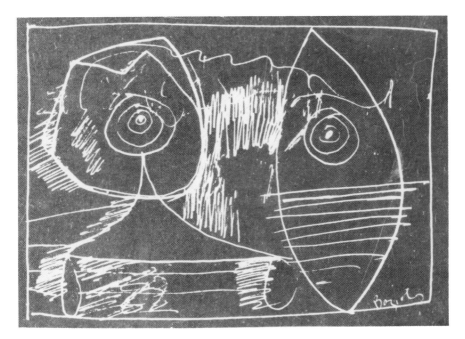

Figure 47. William Baziotes, Untitled
Instead 1 (Winter [?] 1948).
(Location unknown)

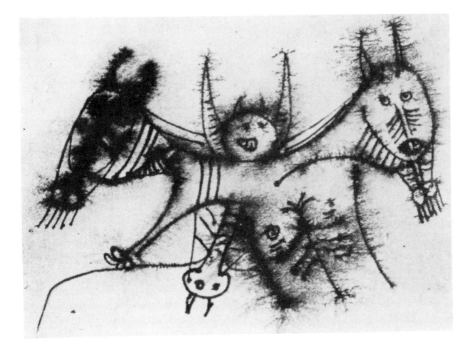

Figure 48. Wifredo Lam, *Scolopenare Scolopendre Instead* 2 (March 1948).

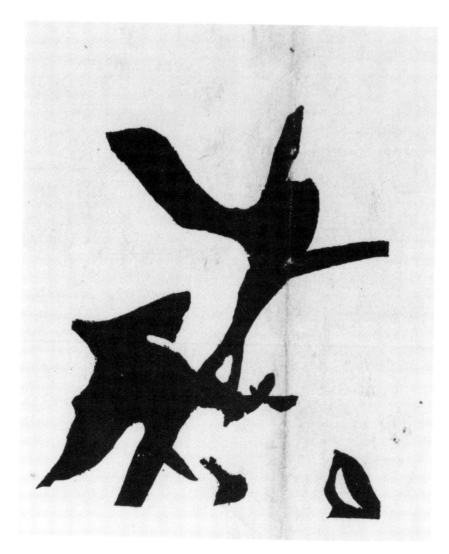

Figure 49. Roberto Matta Echaurren, *The Mystery of Action Instead* 4 (June 1948).

Figure 50. Anonymous, Drawing
 Instead 7. With quotation of Alfred North Whitehead.

Figure 51. Alberto Giacometti, Drawing of Georges Bataille
Instead 7. Appeared with Bataille's ''Executioner and Victim.''
Pencil.
(Private collection)

Modern Artists in America

Figure 52. Robert Motherwell, Cover
Modern Artists in America (1951).

A Statement

Bernard Karpel, Robert Motherwell, Ad Reinhardt

Today the extent and degree of Modern Art in America is unprecedented. From East to West numerous galleries and museums, colleges and art schools, private and regional demonstrations display their mounting interest in original plastic efforts. One can say that by 1950, Modern Art in the United States has reached a point of sustained achievement worthy of a detached and democratic treatment.

It is true that very recently great attention has been paid to Abstract Art in exhibitions and publications. Yet, on the whole, this solicitude has been characterized by an erratic concern, full of prejudice and confused by misunderstanding. In the light of its actual history, the more radical innovations and variations of Modern American Art rarely obtain recognition based on real accomplishment and in terms of its specific problem: the reality of the work of art.

This biennial is the first of a continuing series which promises to come to grips with that central situation. Through works and documents of its own making the scope and nature of that struggle will be self-revealed. By impartial documentation of the event as it happens, the society in which the artist exists responsibly and the world of imagery and design in which he must exist creatively, stands manifest. This is the program of *Modern Artists in America*.

This statement originally appeared in *Modern Artists in America* (1950): 6–7.

Artists' Sessions at Studio 35 (1950)

Edited by Robert Goodnough

Introduction

In the late fall of 1948, three abstract painters, William Baziotes, Robert Motherwell, Mark Rothko, and an abstract sculptor, David Hare, began a small cooperative school in Greenwich Village in New York City; somewhat later, they were joined by another abstract painter, Barnett Newman. In the interests of introducing the students to as wide an experience as possible, other advanced artists, one by one, were invited to speak to the students on Friday evenings. The Friday evenings were open to the general public, and quickly became a physical place for everyone interested in advanced art in the United States to meet; the audiences averaged about 150 persons, all that the loft on Eighth Street that housed the school could hold.

For various reasons, the artists who founded the school which was called "Subjects of the Artist" (in order to emphasize that abstract art, too, has a subject, and that the "curriculum" consisted of the subjects that interest advanced artists), were unable to continue the school after the end of the year, in May, 1949. In the fall, several teachers in the New York University school of art education, Robert Iglehart, Hale Woodruff and Tony Smith, privately took over the loft and continued the Friday evenings, though not the school; it became known as "Studio 35" after the address, 35 East Eighth Street; the Friday evenings were continued until April, 1950.

Among the artists who lectured to a faithful and somewhat unvarying public during the two seasons, 1948–49 and 1949–50, were Arp, Baziotes, Jimmy Ernst, Ferber, Glarner, Gottlieb, Holtzmann, Kees, de

This article originally appeared in *Modern Artists in America* (1950): 9–22.

Kooning, Motherwell, Newman, Reinhardt, and Rothko; Joseph Cornell gave several evenings from his fabulous collection of very early films; John Cage, the composer, Nicolas Calas, the poet and art critic, Richard Hulsenback, onetime dadaist and now psychoanalyst, Monsieur Levesque, a student of dada, and Harold Rosenberg, the poet and critic, were among the others who addressed the Friday evenings. Many acquaintanceships and friendships grew up among the artists as a result of these meetings, which tended to become repetitious at the end, partly because of the public asking the same questions at each meeting. To sum up the meetings, on the suggestion of Robert Goodnough, a graduate student in the N.Y.U. school of art education, who had been helping his instructors with the meetings of the second season, it was decided to have a closed, three-day session among the advanced artists themselves, with the dialogue taken down stenographically. There was no preliminary discussion of what was to be said; nothing was arranged but the dates, Friday, Saturday and Sunday afternoons, 4 to 7 p.m., April 21–23, 1950.

Among the dozens of advanced artists asked to participate, the following attended one or more sessions: William Baziotes, Janice Biala, Louise Bourgeois, James Brooks, Willem de Kooning, Jimmy Ernst, Herbert Ferber, Adolph Gottlieb, Peter Grippe, David Hare, Hans Hofmann, Weldon Kees, Ibram Lassaw, Norman Lewis, Richard Lippold, Seymour Lipton, Robert Motherwell, Barnett Newman, Richard Pousette-Dart, Ad Reinhardt, Ralph Rosenborg, Theodoros Stamos, Hedda Sterne, David Smith and Bradley Walker Tomlin.

The moderators were Alfred H. Barr, Jr., the only non-artist participant and one of the most noted modern art scholars, Richard Lippold, the sculptor, and Robert Motherwell, the painter, who had acted as moderator throughout the first season of Friday evenings. Lippold tended to carry the principal burden of moderating the first day, Barr, the second, and Motherwell the third; Barr was prevented from being present the first day, and from the first half of the final day.

The meetings were arranged by Robert Goodnough, who has drastically edited the following text (perhaps half) of the original transcript of the proceedings; a few of the artists have made some corrections of what they said; but on the whole, this text retains the spontaneity, the unpreparedness, the rises and falls of intensity and pointedness of the meetings themselves; though a certain pathos and loneliness appears from time to time that was not as evident at the time of the meetings as it is on reading the original text.

Robert Motherwell and Ad Reinhardt

The First Day—April 21, 1950

Moderator Lippold: It might be advisable to list a few things which we will probably not want to discuss. It would seem that the method of work of most of us has been a lonely one. I feel that much is gained from argument. I would like to learn from conversation with my confreres.

Hare: We ought to define terms. Everybody here knows everybody else's work. There is little advantage in talking about schools of painting. I think we ought to discuss a particular problem. I don't see any point in discussing our own work. What a painter thinks he does is very often different from what he does. You can talk about your work but the truth still remains concealed within the work, not within the words. We don't just want to hear everybody talking about his own point of view. I don't see that we can get anywhere unless we state a problem and then discuss that particular problem. Has somebody a suggestion?

Ferber: The public has been mentioned, and it seems to me in a professional group like this we should attempt to identify our relationship to the public, perhaps in two ways. In a personal way, and in a way which relates to our work. By the second I perhaps mean that the public really is asking all the time "What does this work mean?" I think it might be helpful to adopt an attitude towards the public in the sense of an answer to that question. We needn't answer the question. What I am asking is that we should adopt an attitude of either discarding the question or trying to answer it. . . . Another thing I want to suggest we talk about is whether any of us feel that there is any difference in what is happening in America and what has happened heretofore, and in what is happening in Europe. There is some difference which is not a question of geography but of point of view. It is a question of origin or ancestry.

Gottlieb: It seems to me that we are approaching an academy version of abstract painting. I think that has some bearing on our meeting here, in that I think, despite any individual differences, there is a basis for getting together on mutual respect and the feeling that painters here are not academic, and we should make some distinctions.

Hofmann: What is abstract art in the "good" sense?

Moderator Motherwell: The word "abstract" has a technical meaning. It means "to take from". As a method, it signifies selecting one element from a myriad of elements, for the purpose of emphasis. Whitehead says, "The higher the degree of abstraction, the lower the degree of complexity." I suppose the word was first applied to a certain kind of art that was very

highly abstracted (in Whitehead's sense) but consequently with a low degree of complexity. The people who first said abstract must have meant that so much was left out. Picasso represents a higher degree of complexity and a lower degree of abstraction than Mondrian, for example.

Moderator Lippold: I feel that if we are going to learn something from each other, let's dismiss our problems in relation to the public and concern ourselves with the problems of creativity: how each one begins his piece of work and how he proceeds with it.

Newman: I was going to try to formulate a question out of this discussion. When Gottlieb raises the question of abstraction, I don't thing we should just dismiss it. It might be formulated into this question: do we artists really have a community? If so, what makes it a community?

Hare: I see no need for a community. An artist is always lonely. The artist is a man who functions beyond or ahead of his society. In any case seldom within it. I think our problem would seem to be fundamentally psychological. Some feel badly because they are not accepted by the public. We shouldn't be accepted by the public. As soon as we are accepted, we are no longer artists but decorators. Sometimes we think if we could only explain to the public, they would agree with us. They may agree in the course of years. They won't agree now . . . they should not agree now. I think this group activity, this gathering together, is a symptom of fear. Possibly you could connect this with the question of mass production, in the sense that in this country there is a feeling that unless you have a large public you are a failure. The public is concerned with the average. I will always be opposed to this conception. I certainly don't think it is necessary to explain on the assumption that once you explain there will be agreement.

Reinhardt: There are many things that Hare brought up that I would like to discuss. I think we should follow some kind of procedure, isolate some ideas, and find out each artist's opinion. Newman's question is pertinent. Why can't we find out what our community is and what our differences are, and what each artist thinks of them?

Moderator Motherwell: What then exactly constitutes the basis of our community?

Sterne: We need a common vocabulary. Abstract should really mean abstract, and modern should really mean modern. We don't mean the same things with the same words.

Hofmann: Why should we? Everyone should be as different as possible. There is nothing that is common to all of us except our creative urge. It

just means one thing to me; to discover myself as well as I can. But everyone of us has the urge to be creative in relation to our time—the time to which we belong may work out to be our thing in common. But to formulate this would not be simple.

Reinhardt: There are a great many differences which we should find out about here. If we are doing the same thing, or have the same problems or have the same fears—what are they?

Poussette-Dart: The museums can, at any moment, bless any one of us. The disaster is that they can cause disparity among us too.

Reinhardt: Does that have anything to do with the idea that was introduced by Hofmann before, of our art as a way of discovering ourselves?

Hare: I can't see that museums have anything to do with the artist. In general, museums are involved with art as decor, while the artist is involved with art as a way of life.

Moderator Lippold: What we are leading up to is why each person paints or sculpts. Why each person thinks he should paint. Do we do it to be a success, to make money, understand ourselves, or what is the purpose: to describe our own creative nature? Why do we use titles? Where do we pick such titles? Where do we begin?

Ferber: It seems to me that most of the questions revolve around "meaning." The public, the museums and the artists themselves are involved in the question of "meaning." It need not be "meaning" in any simple sense; but when Mr. Lippold asks for a description of the way in which, and the why-for in connection with a piece of sculpture or painting, he is asking about "meaning," I think.

Moderator Lippold: That isn't what I said.

Ferber: Then, I misunderstood you. If we attempt to talk about what in general the work of this group has in common, I think it has been mentioned that it is modern, advanced and non-academic; we can rule out the problem of the museum, because we will be telling the public in our own way what we mean and the museum is no longer a problem. So far as the community of artists goes, it seems to me the question would involve the question of difference—between us and other artists. In that way we may have a feeling of community.

Moderator Lippold: To continue with the suggestion I made before: I would like to suggest that the question of method might be broken down into this: first—is it possible to say why we begin to create a work? Second—how do we begin the work; from an idea, an emotional point of view based

on experience, or form? Where does the suggestion come from? Third—when is the work finished? How do we know that? I can't see that my relationship to the museum or to the public is concerned with what I am making. I am interested in how other people work.

Hofmann: A very great Chinese painter once said the most difficult thing in a work of art is to know the moment when to stop.

Moderator Motherwell: The question then is, *"How do you know when a work is finished?"*

Moderator Lippold: I don't know if I can consider that question without thinking about the first two questions. I would say the work seems finished to me when it concludes successfully the prophecy of its beginning and the problems involved in its working out. It may be that my work, by nature, almost determines its own conclusion; it is not possible to make many changes once the thing is quite far along. The early suggestions of form take place for many of us at the stage of sketching or small model making—if you have to make a model—and when that phase comes to an end, I then begin to work on the piece itself, or a larger piece; so far this seems to be a more or less technical process. I would like to say a little about the beginning of my method. I have never begun a piece from the point of view of "pure form." I have never made a piece without its springing from the memory of some experience—an emotional experience, generally. I almost always, from the beginning, have a title which labels that experience, because I want it to act as a discipline in eliminating any extraneous ideas which might come into the sculpture. As we all know, the first line or brush stroke can lead to millions of possibilities, and for me to keep clear is to keep a title in mind. It is of value to me at the beginning. When an experience has made itself so persistent in my unconscious or conscious mind—or both—that I feel that I want to make something which reflects that experience, I find my eyes constantly observing all things. While that experience is a memory, suitable forms can be suggested by any number of objects in life: a line on someone's face, or a crack on the floor, or an experience at a newsreel theatre. Then the problem of how to work out the experience which I have had presents itself; I may begin with that idea, and I have to adapt it to my medium. I have to make it clear enough for others to see in its relationships. All of this takes place in the sketch stage—in the models I make from drawings. The drawings become more conclusive as I work. Generally when I work on a piece I make very few changes. I can't talk about conclusions without talking about intent. On rare occasions I have seen a form which suggested some kind of relationship which called back a memory or experience. It is always an interplay between the two, I find. It is never one thing or the other.

Brooks: I think quite often I don't know when a work is "finished," because I often carry it a little too far. There is some peculiar balance which it is necessary to preserve all through a painting which keeps it fluid and moving. It can't be brought to a stop. I think you have to abandon it while it is still alive and moving, and so I can't consider a painting "finished." I can't think of working with a clear intent on a painting, because it often develops as I go. It quite often changes in the middle of a painting. But the "end" is a very difficult thing, something that is determined, not by the form that is "finished," but by the fact that I have worked on it. It satisfies a need of some kind.

Kees: It is usually finished when it defies me to do anything more with it. I start with drawings and when I find that the drawings are incapable of being turned into a painting, then I start to paint.

Baziotes: I consider my painting finished when my eye goes to a particular spot on the canvas. But if I put the picture away about thirty feet on the wall and the movements keep returning to me and the eye seems to be responding to something living, then it is finished.

Gottlieb: I usually ask my wife . . . I think a more interesting question would be, "Why does anyone start a painting instead of finishing it?"

Ferber: I would say that I don't think any piece of sculpture I make is really "finished." Nor do I think it possible to call a piece a realization of any particular idea evolving from a specific emotion or event. There is a stream of consciousness out of which these things pop like waves, and fall back. Therefore works aren't really complete in themselves. I think the day of the "masterpiece" is over. When we look at our own work, in ten or fifteen examples, we really understand what we are doing. The sense of "finishing" a particular work is meaningless.

Moderator Lippold: I would like to ask you if what you describe applies to an individual piece? It is a thing which exists within its own particular shape. How can that come about?

Ferber: For a sculptor to insist that a piece of sculpture rises out of his stream of consciousness is perhaps ridiculous because sculpture is so three-dimensional and hard. But I don't believe there is any great difference between one piece and another in the development and fulfilment of a particular esthetic idea which may permeate several works.

Lassaw: I would consider a work finished when I sense a "togetherness," a participation of all parts as in an organism. This does not mean that I entirely understand what I have created. To me, a work is at first, quite unknown. In time, more and more enters into consciousness. It would

be better to consider a work of art as a process that is started by the artist. In that way of thinking a sculpture or painting is never finished, but only begun. If successful, the work starts to live a life of its own, a work of art begins to work.

Ernst: My work consists of two separate stages of development. I consider a painting almost "finished" when I am half finished with it, when I have reached what seems to be the greatest measure of surprise. The rest of the action is disciplinary on my part. When I see that I am beginning to destroy the surprise—the basic element of that surprise— then it is time to stop.

Pousette-Dart: For me it is "finished" when it is inevitable within itself. But I don't think I can explain anything about my painting, just as I can't explain anything about a flower or a child. When is anything "beautiful" or finished? I can't discuss things about my paintings. The true thing I am after goes on and on and I never can completely grasp it.

Lipton: I think that we require time and intimacy and aloneness.

Biala: I never know when it is "finished." I only know there comes a time when I have to stop.

Newman: I think the idea of a "finished" picture is a fiction. I think a man spends his whole life-time painting one picture or working on one piece of sculpture. The question of stopping is really a decision of moral considerations. To what extent are you intoxicated by the actual act, so that you are beguiled by it? To what extent are you charmed by its inner life? And to what extent do you really approach the intention or desire that is really outside of it. The decision is always made when the piece has something in it that you wanted.

Hare: A work is never finished, the energies involved in a particular work are merely transferred at a certain moment to the next work.

Rosenborg: When it stops, why does it stop? While the hands do, the picture moves, having life (objective, emotional and intellectual) of its own. When I can do no more on it, it is done.

Sterne: Painting is for me a problem of simultaneous understanding and explaining. I try to approach my subject uncluttered by esthetic prejudices. I put it on canvas in order to explain it to myself, yet the result should reveal something plus. As I work the thing takes life and fights back. There comes a moment when I can't continue. Then I stop until next time.

de Kooning: I refrain from "finishing" it. I paint myself out of the picture, and when I have done that, I either throw it away or keep it. I am always

in the picture somewhere. The amount of space I use I am always in, I seem to move around in it, and there seems to be a time when I lose sight of what I wanted to do, and then I am out of it. If the picture has a countenance, I keep it. If it hasn't, I throw it away. I am not really very much interested in the question.

Bourgeois: I think a work is "finished" when I have nothing to eliminate. I make constructions that are usually vertical; when I start them they are full of colors and are complicated in form. Every one of the complications goes and the color becomes uniform and finally they become completely white and simple. When there is nothing else to take away, it is "finished." Yet I am disgusted by simplicity. So I look for a larger form and look for another work—which goes through the same process of elimination.

Grippe: A work of art is never really "finished." There is a feeling of trying to express the labyrinth of one's mind—its feelings and emotions, and to fulfil one's personality. Each work is trying to complete the expression of that personality. Whether it becomes profound, I don't know; but I think an artist is very aware of himself in relation to the rest of the world.

Reinhardt: It has always been a problem for me—about "finishing" paintings. I am very conscious of ways of "finishing" a painting. Among modern artists there is a value placed upon "unfinished" work. Disturbances arise when you have to treat the work as a finished and complete object, so that the only time I think I "finish" a painting is when I have a dead-line. If you are going to present it as an "unfinished" object, how do you "finish" it?

Lewis: I have stopped, I think, when I have arrived at a quality of mystery. I know this doesn't describe it, but it is the best word I can use.

Hofmann: To me a work is finished when all parts involved communicate themselves, so that they don't need me.

Moderator Motherwell: I dislike a picture that is too suave or too skillfully done. But, contrariwise, I also dislike a picture that looks too inept or blundering. I noticed in looking at the Carré exhibition of young French painters who are supposed to be close to this group, that in "finishing" a picture they assume traditional criteria to a much greater degree than we do. They have a real "finish" in that the picture is a real object, a beautifully made object. We are involved in "process" and what is a "finished" object is not so certain.

Hofmann: Yes, it seems to me all the time there is the question of a heritage. It would seem that the difference between the young French painters and

the young American painters is this: French pictures have a cultural heritage. The American painter of today approaches things without basis. The French approach things on the basis of cultural heritage—that one feels in all their work. It is a working towards a refinement and quality rather than working toward new experiences, and painting out these experiences that may finally become tradition. The French have it easier. They have it in the beginning.

de Kooning: I am glad you brought up this point. It seems to me that in Europe every time something new needed to be done it was because of traditional culture. Ours has been a striving to come to the same point that they had—not to be iconoclasts.

Moderator Lippold: There are those here who feel that the things which they make are simply moments of a continuity and, therefore, in themselves, are not objects for their own sakes, but just moments in the continuity. Is there an irreconcilability in making an object in itself which, at the same time, reflects continuity? This, so far, has been spoken of as incompatible.

Sterne: But that means that you have decided already exactly what *is* "beautiful." "Beauty" can't be pursued directly.

Gottlieb: There is a general assumption that European—specifically French—painters have a heritage which enables them to have the benefits of tradition, and therefore they can produce a certain type of painting. It seems to me that in the last fifty years the whole meaning of painting has been made international . I think Americans share that heritage just as much, and that if they deviate from tradition it is just as difficult for an American as for a Frenchman. It is a mistaken assumption in some quarters that any departure from tradition stems from ignorance. I think that what Motherwell describes is the problem of knowing what tradition is, and being willing to reject it in part. This requires familiarity with his past. I think we have this familiarity, and if we depart from tradition, it is out of knowledge, not innocence.

de Kooning: I agree that tradition is part of the whole world now. The point that was brought up was that the French artists have some "touch" in making an object. They have a particular something that makes them look like a "finished" painting. They have a touch which I am glad not to have.

Baziotes: We are getting mixed up with the French tradition. In talking about the necessity to "finish" a thing, we then said American painters "finish" a thing that looks "unfinished," and the French, they "finish" it. I have seen Matisses that were more "unfinished" and yet more "finished" than any American painter. Matisse was obviously in a terrific emotion at the time, and it was more "unfinished" than "finished."

The Second Day—April 22, 1950

Sterne: I think that the titling of paintings is a problem. The titles a painter gives his paintings help to classify him, and this is wrong. A long poetic title or number. . . . Whatever you do seems a statement of attitude. The same thing if you give a descriptive title. . . . Even refraining from giving any at all creates a misunderstanding.

Reinhardt: If a title does not mean anything and creates a misunderstanding, why put a title on a painting?

Brooks: To me a title is nothing but identification. I have a very hard time finding a title and it is always inadequate. I think when titles are very suggestive, they are a kind of a fraud, because they throw the spectator away from the picture rather than into it. But numbers are inadequate.

Gottlieb: I think the point Miss Sterne raised is inevitable. That is, whenever an artist puts a title on a painting some interpretation about his attitude will be made. It seems obvious that titles are necessary when everybody uses them—whether verbal or numbers; for purposes of exhibition, identification and the benefit of the critics there must be some way of referring to a picture. It seems to me that the artist, in making up titles for his pictures, must decide what his attitude is.

Moderator Barr: Most people seem to think that titles are a kind of necessity. Does anyone think that titles have real usefulness in supplementing the object?

Rosenborg: The title is always arbitrary because we deal with unseen audiences; the reason for a title is that every Tom, Dick and Harry has to have some link. Once I had a show where I had numbers from one to twenty, and when it came to a question of reviewing, the critics found that number six was better than four, etc. I hope that the onlooker will make up his own title!

Pousette-Dart: I think if we could agree on numbers it would be a tremendous thing. In music they don't have this dilemma. It would force people to just look at the object and try to find their own experience.

Ernst: I would object to doing any such thing as that—such as numbering a picture. I don't particularly care what people classify me as, or whether people understand the title or not. It suggests something to me, or something may pop into my head—so I give it that title.

Smith: I think titles are a positive means of identification. I never objected to any work of art because of its title. The only people who have objected were critics because they did not like the work.

Reinhardt: The question of abandoning titles arose, I am sure, because of esthetic reasons. Even titles like "still life"and "landscape"do not say anything about a painting. If a painting does have a reference or association of some kind, I think the artist is apt to add a title. I think this is why titles are not used by a great many modern painters—because they don't have anything to do with the painting itself.

Moderator Barr: There are some painters who attach a great deal of importance to titles.

Moderator Motherwell: I think Sterne is dealing with a real problem—what is the content of our work? What are we really doing? (The question is how to name what as yet has been unnamed.)

Moderator Barr: I would like to get some information on this. Would you raise your hands if you name your pictures and sculptures?
[*most raised their hands*]
How many people merely number their pictures?
[*three people raised their hands*]
How many don't title their pictures at all?
[*none raised their hands*]
[*Note: objections to this procedure*]

Hare: It seems to me a minor problem. There are in general two kinds of title, poetic and those which note the content. A number seems to me only a refusal to accept responsibility.

Baziotes: Whereas certain people start with a recollection or an experience and paint that experience, to some of us the act of doing it becomes the experience; so that we are not quite clear why we are engaged on a particular work. And because we are more interested in plastic matters than we are in a matter of words, one can begin a picture and carry it through and stop it and do nothing about the title at all. All pictures are full of association.

Reinhardt: Titles are very important in surrealist work. But the emphasis with us is upon a painting experience, and not on any other experience. The only objection I have to a title is when it is false or tricky, or is something added that the painting itself does not have.

Sterne: I don't think anybody really has a right to know exactly how I feel about my paintings. It seems too intimate to give them a subjective title.

Moderator Barr: Do you think it is possible to enrich the painting by words?

de Kooning: I think that if an artist can always title his pictures, that means he is not always very clear.

Lassaw: In titling a construction, I have used combinations of words or syllables without any meaning. Lately, I have adopted the use of the names of stars or other celestical objects similar to the way ships are named. Such titles are just names, and are not to imply that the constructions express, symbolize, or represent anything. A work of art "is" like a work of nature.

Ferber: What we all have been saying is that the designation of a painting or a piece of sculpture has become more important as a problem than it has been before. An Assumption or a Crucifixion needed no title. I think that numbering pieces is really begging the question. Because numbering the piece is an admission or a statement or a manifesto that this is pure painting or sculpture—that it stands by itself without relation to any other discipline. We should not cut ourselves off from this great rich world.

Moderator Barr: I don't know how much longer this discussion of titling works will go on. There are a good many interesting implications. It seems to me there are three levels of titles: (1) Simply as a matter of convenience. (2) Questions of titles as explanation or as a kind of fingerpoint and which do not work particularly well. (3) The surrealist title in which the words are a positive part of the work of art, and there is an attraction or conflict set up between the words and the picture. It is the second of those that I would like to hear some conversation about—the question of specific emotion in the work of art. The general public is very much interested in that factor of the work. How did the artist feel when he did the thing? Was it painful? Was it a matter of love or fear, or what not? Very often he gets no guidance at all from looking at the picture. That's where the factor of titles comes in. At the same time the title may distort the picture a great deal. But to return to the process of painting—how important is (whoever wants to answer) conscious emotion such as pleasure, grief or fear in making your work?

Pousette-Dart: I believe that a true work of art should not only be untitled, but I think it should be unsigned.

Newman: I think it would be very well if we could title pictures by identifying the subject matter so that the audience could be helped. I think the question of titles is purely a social phenomenon. The story is more or less the same when you can identify them. I think the implication has one of two possibilities: (1) We are not smart enough to identify our subject matter, or (2) language is so bankrupt that we can't use it. I think both are wrong. I think the possibility of finding language still exists, and I think we are smart enough. Perhaps we are arriving at a new state of painting where the thing has to be seen for itself.

Moderator Lippold: I think we are getting away from the question—a description of the subject of the picture—especially Mr. Barr's question in relation to an emotional experience we might have felt.

Moderator Barr: I don't want to have the discussion kept on a question of that sort, but I was interested really not in the question of title, but as to whether emotions such as grief or joy or pleasure or fear—how important are they consciously in the production of the works of art. Is the work of art an act of confidence or pleasure?

Bourgeois: I try to analyze the reasons why an artist gets up and takes a brush and a knife—why does he do it? I feel it was either because he was suddenly afraid and wanted to fill a void, afraid of being depressed and ran away from it, or that he wanted to record a state of pleasure or confidence, which is contrary to the feeling of void or fear. My choice is made in my case, but I am not especially interested in talking about my own case.

Brooks: It seems to me that it is impossible generally to clarify the emotions that go into painting. We can't get away from grief or joy we put into a painting; it is a very complex thing and in some cases a very ambiguous thing. We are in some cases identifying ourselves through our painting and that means everything we are and a great many things we would like to be.

de Kooning: If you are an artist, the problem is to make a picture work whether you are happy or not.

Moderator Barr: Could you raise your hands to this question: "How many people name their works of art after they are completed?"
 [*thirteen raised hands to this question*]
"How many people name their works when they are halfway through?"
 [*six raised their hands to this.*]
"How many people have their work named before they start on it?"
 [*one person responded*]
 [*Note: Mr. Barr said the above was just a* rough *count of hands.*]

Moderator Lippold: It has seemed to me that the whole business of title or what to make is a phenomenon peculiar to our times. The job was a great deal easier, in any any period but our own. The idea of what to paint was already pre-determined. I am talking of such cultures as the oriental and our middle ages—in which a sculptor was asked to carve a king or queen. It wasn't his job to complain because he did not want to make a king or queen. And there are people like that now, too. I believe that in our own time the discipline that is enforced upon our work has to come from

ourselves. The title for me exists at the beginning and all through the piece, and it keeps me clearly on the road, I believe, to the conclusion of the work. The only thing I am interested in resolving is that intent with which I begin, because I feel in our time there is very little else with which to begin. To grope through a series of accidents is not the function of the artist. The job of the artist is only the job of a craftsman.

Baziotes: Mr. Lippold's position, as I understand it, is that the beginning of a work now has something about it that would not have seemed quite logical to artists of the past. We apparently begin in a different way. Is that what you mean, Mr. Lippold?

Moderator Lippold: Yes.

Baziotes: I think the reason we begin in a different way is that this particular time has gotten to a point where the artist feels like a gambler. He does something on the canvas and takes a chance in the hope that something important will be revealed.

Reinhardt: I would like to ask a question about the exact involvement of a work of art. What kind of love or grief is there in it? I don't understand, in a painting, the love of anything except the love of painting itself. If there is agony, other than the agony of painting, I don't know exactly what kind of agony that would be. I am sure external agony does not enter very importantly into the agony of our painting.

Moderator Barr: I would like a show of hands on this question: Is there anyone here who works for himself alone—that is purely for his own satisfaction—for himself as the sole judge?
[*scattered showing of hands*]

de Kooning: I feel it isn't so much the act of being obliged to someone or to society, but rather one of conviction. I think, whatever happens, every man works for himself, and he does it on the basis of convincing himself. I force my attitude upon this world, and I have this right— particularly in this country—and I think it is wonderful, and if it does not come off, it is alright, too. I don't see any reason why we should go and look into past history and find a place or try to take a similar position.

Biala: I don't think a work of art is finished until it has found its audience.

Moderator Motherwell: Is the artist his own audience?

Reinhardt: How many artists here consider themselves craftsmen or professionals? What is our relationship to the social world?

Brooks: When we paint pictures, we assume other people feel the way we do.

Biala: Nothing exists by itself. It only exists in relation to something else: when it can find one other person in the world.

Pousette-Dart: Is prayer a creative act? I should say that it depends upon the prayer itself, but there is no other person necessarily involved. A painter can paint for the satisfaction of his soul, but he can mean it for everyone.

de Kooning: There was that cave of paintings which were found in France just lately. Were they works of art before we discovered them? This is the question.

Newman: I would like to go back to Mr. Lippold's question—are we involved in self-expression or in the world? It seems to Lippold you cannot be involved in the world if you are craftsman; but if you are involved in the world, you cannot be an artist. We are in the process of making the world, to a certain extent, in our own image. This removes us from the craft level.

de Kooning: This difficulty of titling or not titling a picture—we ought to have more faith in the world. If you really express the world, those things eventually will turn out more or less good. I know what Newman means: it is some kind of feeling that you want to give yourself a place in the world.

Newman: About specifying—if you specify your emotions—whether they are agony or fear, etc.—I believe it is bad manners to actually say one is feeling bad.

de Kooning: I think there are different experiences or emotions. I feel certain parts you ought to leave up to the world.

Newman: I think we start from a subjective attitude, which, in the process of our endeavour, becomes related to the world.

Ferber: I want to add to what Newman has said, which is that it is impossible to escape an attitude towards the world. I would like to bring into this discussion, if possible the artist, not as a being, but as man, and not as a mere practitioner or craftsman, because if we have any integrity at all, it is as men and women.

Pousette-Dart: Why does the modern artist feel the need to sign his work?

Baziotes: When we make a work of art we must get our praise after it is finished.

Pousette-Dart: In certain cultures none of the works were signed.

Baziotes: If you were commissioned to do a picture of the Madonna in the middle ages that was praise to begin with.

Gottlieb: I think the answer is that the work that really has something to say constitutes its own signature.

de Kooning: There is no such thing as being anonymous.

Hare: A man's work is his signature. In this sense art has never been anonymous.

Rosenborg: It is a beautiful question. In our society, with manufacturers, businessmen, etc., it is necessary to sign something for the purposes of identity. But still the thing is, how could one maintain an identity without signing. Who wants to title a work? To sign a work?

Lewis: But how are you going to get that to the public?

Moderator Barr: You are interested in the problem of how to get your painting to the public?

Lewis: During the period of impressionism you had the artists showing their work in cafes and other places where they ate. At one time they were exhibiting in the open air shows in the Village. Then there was the Federal Art Project. People no longer have this intimacy with the artists, so that the public does not know actually what is going on, what is being done by the painter. I remember organizing for a union on the water-front. People then didn't know the function of a union, or what was good about it, but gradually they were made aware of it. They saw a need for it. The same is true of our relationship with the people; in making them aware of what we are doing. Certainly you are going to run into ignorance.

Hare: Sometimes a young artist becomes too quickly known. He already is a member of the reaction. He can't help it. It is not always such a good thing to find yourself an accepted part of the culture.

Reinhardt: Exactly what is our involvement, our relation to the outside world? I think everybody should be asked to say something about this.

Moderator Barr: Apparently many people don't want to answer the question.

de Kooning: I think somebody who professes something never is a professor. I think we are craftsmen, but we really don't know exactly what we are ourselves, but we have no position in the world—absolutely no position except that we just insist upon being around.

Ernst: I am rather happy with my position in society. In other words, I would much rather be unattached to any part of society than to be commissioned to carve a picture of Mr. Truman, because I am not interested in that. I think what we are overlooking here—and I have believed this for a long time—is the fact that we cannot draw our reaction altogether from the present, nor can we create out of past experience alone.

Tomlin: It seems to me before we examine our position in relation to the world we should examine our position in relation to each other. I understood that to be the point of this discussion and that is why we came together. I am sure there a number of people who are interested in the matter of self-expression alone and there are others who are not.

Newman: I would like to emphasize Mr. Motherwell's remarks: we have two problems. (1) The problem of existing as men. (2) The problem of growth in our work.

Moderator Barr: There seems to be some feeling that this is a practical body rather than a deliberative. Do you want to discuss whether you want to do something practical or go ahead in the search of what we call truth?

The Third Day—April 23, 1950

Moderator Motherwell: The questions we have all written down fall into three categories, though they overlap. On one is a series of questions that are historical, which Grippe, Ernst, Hare, Reinhardt, Barr and Gottlieb ask; the largest number of questions are strictly esthetic questions, about the process of creation and about the quality of creative works— the questions of Ferber, Hare, Baziotes, Lippold, Smith, Sterne, Hofmann, Biala, Lassaw and Bourgeois. Five people, Pousette-Dart, Lipton, Tomlin, Newman and Brooks have asked an identical question: a question of community—What is it that binds us together (if there is something that binds us together)? Would you like me to read all the questions, either anonymously or signed?

All: Read them signed.
[Note: The following are written questions by the artists, read aloud by Moderator Motherwell]

Ernst: To what extent are the artists in this group making use of some of the methods and theories that were developed by the various earlier movements and groups of modern art? Are the artists in this group searching for a personal vocabulary, and if so, what is their method of familiarizing their public with this language? Is not a pure painting a self-portrait?

Reinhardt: What is your work (of art)? Do you consider the production of it a professional activity? Do you belong to Artists Equity? Why or why not?

Gottlieb: Is there any difference in direction between advanced American and French painting or sculpture? If there is a difference, what is its nature, and what does it mean?

Hare: Do you work from a previously formed conception, or does your work become its own inspiration as it progresses? What do you feel about

the unavoidable changes which are forced upon a work during its birth? Which do you feel is of fundamental value to you—the success with which you are able to say it, or the importance to you of what you have to say? Do you paint your subject, or is painting your subject (subject in the sense of content, not in the sense of realism versus abstraction)? Of what value do you feel your work is to society? If any, what changes would you wish it to effect, and why?

Barr: What is the most acceptable name for your direction or movement? (it has been called abstract-expressionist, abstract-symbolist, intra-subjectivist, etc.)? I now jump the second to the third category, and ask if there is any unity here?

Lipton: Is there anything that binds this group together historically?

Pousette-Dart? Can we find some binding factor or practical common denominator between us—a common purpose upon which we can all *work* as well as talk—perhaps each to paint or sculpt upon an agreed subject, theme, idea or problem and exhibit these works together (myself preferring neither signature nor titles)?

Tomlin: Assuming that painters in this group hold similar views in relation to the picture plane, are there other plastic convictions held in common sufficient to establish a body of objective criteria? Does painting which excludes automatic technical processes, but which involves a concern with the subconscious, necessarily fall into the classification of subjective?

Newman: What ties us together as a community of artists?

Brooks: What are the qualities, or is the quality in their work that establishes a community of the artists of which this roundtable is a section?

Rosenborg: What can we do about making a group such as this more permanent? In coming together on an artistic and social basis? Now we come to the group of questions that seem to me to tend to be strictly esthetic.

Smith: Is painting leading sculpture or have they separated?

Lassaw: Conceding that an all-embracing definition or explanation of art has not yet been generally accepted by artists, it would be of great interest and enlightening both to the public and fellow artists alike if each member of this round-table answers in his own way the question: "What is art?"

Biala: Like many of us, I was raised on the notion of "painterliness"— that what is most moving in painting is just its painterly quality. But what I think of the art that I love—for example, the art of Spain, with its passion and noblesse—I wonder if painterliness is not meant to serve something

beyond itself, and it is then that I question a great deal in modern art. Consequently, is modern painting impoverishing itself and is this inevitable?

Hofmann: What do you think quality is?

Sterne: Is art a problem of *how* or *what?*

Lippold: Is it possible to make a work while under the influence of an immediate experience—i.e., fear, disgust, love, etc.?

Baziotes: What do you feel is more important in the art movement today—intuition or reason?

Ferber: Can purity in the arts be compared to the medieval notion of discussing how many angels can stand on the head of a pin. A notion of refined disembodied essence which is no longer consonant with modern ideas which embrace the whole man and his human engagements.

Bourgeois: The Genesis of a Work of Art; or in what circumstances is a work of art born:

1. *Definition* of the term "genesis"—process of creation. Is it the process of being born or the process of giving birth?
2. What *causes* the work of art to be born? What is the primary impulse? What makes the artist work? Is it to escape from depression (filling a void)? Is it to record confidence or pleasure? Is it to understand and solve a formal problem and re-order the world?
3. What conditions the birth and growth of the work of art?
 (a) Before the act of creation:
 Sociological aspect (surroundings and milieu).
 Taine ato [*sic*] theory of the milieu.
 Personal aspect.
 (b) During the process of creation:
 Experience undergone while the work is being done.
 Resistance of the medium.
 Properties of the medium.

Moderator Motherwell: I would suggest, to expedite matters, that we vote on which category of these three groups we wish to begin with. Most people here are involved in the esthetic question and would prefer to give it preference, no doubt. Would it seem agreeable to vote?

Reinhardt: There are really only two categories—historical and community are really the same thing. The question of community is, in practice, the historical problem, and would take less time than the esthetic question.

Moderator Motherwell: The questions that are dealing with the creative process tend to revolve around the question of how a work originates: what

it is really referring to, and in that sense what its actual content is and how clearly it is known at the inception. And the other series dealing with creative process tend to revolve around the question of quality—what quality is. However, it also involves some social problems—why we are together? Shall we begin with the questions that have to do with origin? It seemed to me quite clear the first day that there were two differences mentioned which overlap. One is a notion that a work in its beginning has its conclusion implied. The conclusion follows the original line of thought and the process is to cut out anything that is irrelevant to that line of thought. The other notion is a notion of improvising—that one begins like a blind swimmer and what one finds en route often alters the original intent. The people who work like that are involved in the problem of inspiration. That's enough to annoy somebody, perhaps.

Ferber: I wasn't making any point about inspiration.

Pousette-Dart: Would you say a work was an experience of discovery— that you are turning up new stones?

Moderator Motherwell: Sterne said that any other position involves an *a priori* notion of what beauty is.

Pousette-Dart: You have to know if you are . . .

Moderator Lippold [interrupting]: We have moved forward only when a specific problem presented itself and we have groped around for a conclusion. I attempted to explain that my method seems to be to have a problem with which to begin and then proceed with it. I would like to take some questions which have been suggested which have to do with the genesis of a work.

Ferber: What about this problem of how a piece is begun?

Moderator Lippold: I think Miss Stern's question has to do with origin. I would ask regarding origin: is it a question of wanting to say a specific thing, or of how one says it? And where do the two meet? Do we begin with the necessity to convey a message, or do we become intrigued with the way in which it is to be said?

Ferber: Could the process which I suggested as one process be compared to the way in which one handles a kaleidoscope? One's relationship to the world in which we live might be a kind of base from which one starts. If you turn the kaleidoscope you stop at an image which takes form in a satisfactory way; and the painting becomes the realization of that image— which is only a moment in the whole process—then you turn the kaleidoscope and make another image.

Moderator Motherwell: Are the elements in the kaleidoscope essentially "hownesses" or "whatnesses?"

Sterne: I think that for the artist himself the problem is not "beauty," ever. It is one of accuracy, validity and life.

Moderator Barr: Would you say preoccupation with the idea of beauty is a bad thing?

Sterne: No, but it does not lead anywhere, because "beauty" is a matter of conception.

Newman: A concern with "beauty" is a concern with what is "known."

Pousette-Dart: "Beauty" is unattainable, yet it is what gives art its significance, it is the *unknown.*

Newman: The artist's intention is what gives a specific thing form.

Pousette-Dart: I have the feeling that in the art world "beauty" has become a discredited word. I have heard people say you can't use the word "God." When a word becomes trite it is not the word that has become trite but the people who use it.

Sterne: I am not here to define anything; but to give life to what I have the urge to give life to. We live by the particular, not by the general.

Moderator Motherwell: It is not necessary for Sterne to define "beauty" for what she is saying. "Beauty" is not for her the primary source of inspiration. She thinks that "beauty" is discovered en route.

Reinhardt: Is there anyone here who considers himself a producer of beautiful objects?

Gottlieb: I agree with Sterne that we are always concerned with the particular, not the general. Any general discussion of esthetics is a discussion of philosophy; any conclusion can apply to any work of art. Why not have people tell us why they do what they do. Why does Brooks use swirling shapes? Why Newman a straight line? What is it that makes each person use those particular forms that they use?

Smith: I agree with Miss Sterne. The question of "beauty" does not inspire the creator, but is a result of recognition.

Lipton: I feel that Sterne's view is valid. The work of art is an end result. The other concern (formulated by Lippold) is an *a priori* kind of view. I see Sterne's concept of art in its relation to "beauty"; why she is concerned with "beauty" and yet leaves it out of the discussion.

Brooks: I suggest that the artists begin with a discussion of their own particular points of view.

Moderator Motherwell [to Brooks]: I am extremely interested in something you do, which is painting behind the canvas.

Brooks: My work is improvisation to start with. My purpose is to get as much unknown on the canvas as I can. Then I can start digesting or changing. The first thing is to get a great many unfamiliar things on the surface. The working through on another side is an unfamiliar attack. There are shapes suggested that start improvising themselves, which I then start developing. Sometimes there is a terrible confusion, and a retreat into tradition. If then, for example, I rely on cubism, my painting loses its newness to me. If I can manage to keep a balance with improvisation, my work can get more meaning; it reaches a certain fulness.

Gottlieb: Isn't it possible that a straight line could develop on your canvas? I am inclined to think that it does not appear because it is excluded. Swirling shapes are not just the result of unconscious process.

Brooks: It is not as deliberate as you think. I have a preference for it, but that is as far as I can go.

Tomlin: Can one interchange the words "automatic" and "improvise?"

Brooks: No, I don't consider them synonymous.

Tomlin: Do you feel that the "automatic" enters into your work at all?

Brooks: I am not able to define what the mixture is.

de Kooning: I consider all painting free. As far as I am concerned, geometric shapes are not necessarily clear. When things are circumspect or physically clear, it is purely an optical phenomenon. It is a form of uncertainty; it is like accounting for something. It is like drawing something that then is bookkeeping. Bookkeeping is the most unclear thing.

Reinhardt: An emphasis on geometry is an emphasis on the "known," on order and knowledge.

Ferber: Why is geometry more clear than the use of swirling shapes?

Reinhardt: Let's straighten out our terminology, if we can. Vagueness is a "romantic" value, and clarity and "geometricity" are "classic" values.

de Kooning: I meant geometry in art. Geometry was against art—the beauty of the rectangle, I mean.

Moderator Lippold: This means that a rectangle is unclear?

de Kooning: Yes.

Moderator Motherwell: Lippold resents the implication that a geometric form is not "clear."

de Kooning: The end of a painting in this kind of geometric painting would be almost the graph for a possible painting—like a blueprint.

Tomlin: Would you say that automatic structure is in the process of becoming, and that "geometry " has already been shown and terminated?

de Kooning: Yes.

Moderator Motherwell: It seems to me that what de Kooning is saying is plain. He feels resentful that one mode of expression should be called more clear, precise, rational, finished, than another.

Baziotes: I think when a man first discovers that two and two is four, there is "beauty" in that; and we can see why. But if people stand and look at the moon and one says, "I think it's just beautiful tonight," and the other says, "The moon makes me feel awful," we are both "clear." A geometric shape—we know why we like it; and an unreasonable shape, it has a certain mystery that we recognize as real; but it is difficult to put these things in an objective way.

Newman: The question of clarity is one of intention.

Sterne: I think it has to do with Western thinking. A Chinese thinks very well, but does not use logic. The use of geometrical forms comes from logical thinking.

Reinhardt [to Sterne]: Your work to some extent looks generally planned and preconceived. I would like some discussion on it.

Sterne: Preconceived only partly. Because as I go, the painting begins to function by rules of its own, often preventing me from achieving my original vision.

Kees: In regard to this issue of clarity, it might be interesting if we could find anyone who could say that he doesn't care very much about clarity as an element in his painting.

Smith: I am not involved with clarity, but a straight line is a form which is the most abstract thing you can find. It is a support, not an element.

Hofmann: I believe that in an art every expression is relative, not absolutely defined as long as it is not the expression of a relationship. Anything can be changed. We speak here only about means, but the application of the means if the point. You can change one thing into another with the help of the relations of the things. One shape in relation to other shapes makes the "expression"; not one shape or another, but the relationship

between the two makes the "meaning." As long as a means is only used for itself, it cannot lead to anything. Construction consists of the use of one thing in relation to another, which then relates to a third, and higher, value.

Moderator Motherwell [to Hofmann]: Would you say that a fair statement of your position is that the "meaning" of a work of art consists of the relations among the elements, and not the elements themselves?

Hofmann: Yes, that I would definitely say. You make a thin line and a thick line. It is the same as with geometrical shapes. It is all relationship. Without all of these relationships it is not possible to express higher art.

Ferber: The means are important, but what we were concerned with is an expression of a relationship to the world. Truth and validity cannot be determined by the shape of the elements of the picture.

de Kooning: About this idea of geometric shapes again: I think a straight line does not exist. There is no such thing as a straight line in painting.

Reinhardt: We are losing Ferber's point. I would like to get back to the question of whether there is another criterion of truth and validity, apart from the internal relationships in a work of art.

Moderator Motherwell: It would be very difficult to formulate a position in which there were no external relations. I cannot imagine any structure being defined as though it only has internal meaning.

Reinhardt: I want to know the outside truth. I think I know the internal one.

Moderator Motherwell: Reinhardt was emphasizing very strongly that the quality of a work depends upon the relations within it. Between Ferber and Reinhardt the question is being raised as to whether these internal relations also relate externally to the world, or better as to what this external relation is.

Tomlin: May I take this back to structure? In what was said about the parts in relation to Brooks' work, the entire structure was embraced. We were talking about shape, without relation to one possibility of structure. I would like to say that I feel that geometric shapes can be used to achieve a fluid and organic structure.

Hofmann: There is a fluidity in the elements which can be used in a practical way, which is often used by Klee. It is related to handwriting— it often characterises a complete personality. It can be used in a graphic sense and in a plastic sense. It leads a point to a relation with another point. It is a relationship of all points considered in a plastic relation. It offers a number of possibilities.

Reinhardt [to Hofmann]: Do you consider the inter-relationships of the elements in a work of art to be self-contained?

Hofmann: It is related to all of this world—to what you want to express. You want to express something very definitely and you do it with your means. When you understand your means, you can.

Moderator Motherwell: I find that I ask of the painting process one of two separate experiences. I call one the "mode of discovery and invention," the other the "mode of joy and variation." The former represents my deepest painting problem, the bitterest struggle I have ever undertaken: to reject everything I do not feel and believe. The other experience is when I want to paint for the sheer joy of painting. These moments are few. The strain of dealing with the unknown, the absolute, is gone. When I need joy, I find it only in making free variations on what I have already discovered, what I know to be mine. We modern artists have no generally accepted subject matter, no inherited iconography. But to re-invent painting, its subject matter and its means, is a task so difficult that one must reduce it to a very simple concept in order to paint for the sheer joy of painting, as simple as the Madonna was to many generations of painters in the past. An existing subject matter for me—even though I had to invent it to begin with—variations gives me moments of joy. . . . The other mode is a voyaging into the night, one knows not where, on an unknown vessel, an absolute struggle with the elements of the real.

Reinhardt: Let's talk about that struggle.

Moderator Motherwell: When one looks at a Renaissance painter, it is evident that he can modify existing subject matter in a manner that shows his uniqueness and fineness without having to re-invent painting altogether. But I think that painters like Mondrian tend to move as rapidly as they can toward a simple iconography on which they can make variations. Because the strain is so great to re-invent reality in painting.

Reinhardt: What about the reality of the everyday world and the reality of painting? They are not the same realities. What is this creative thing that you have struggled to get and where did it come from? What reference or value does it have, outside of the painting itself?

Moderator Lippold: I should like to find where I think I am. It is the general impression that it is a great problem as to what to paint, and with what to begin. Unfortunately, it is never a problem for me. I have material for the next ten to fifteen years in my sketch books We have talked about formal relationships. This is not a new thing with the abstractionists. It would seem to me that people of Mondrian's school have been interested in exploring formal relationship internally. Other schools have been concerned with the relationship of art to propaganda. Others

seem to explore the areas of a dream world. If we are aware of the things which happen to us in our immediate past, those things come into our consciousness and into our work. We cannot pretend to sit down with no idea as to what has happened before, and to create something entirely new which has never happened before. I feel that all I am doing is synthesizing something which has happened in the past. My materials are not new; my relationships are not new.

Moderator Motherwell: We have some questions which have not been read—they are by people who came in late:

Stamos: Is automatic painting conscious or not? In the early 1900s Ernest Fenellosa wrote an essay with an introduction by Pound on the Chinese character as a medium in poetry. Are the artists today familiar with it, or are such characters or writing unconscious? There is an amazing connection between the two. Are certain artists working closer with the tradition of the Hudson River School in the sense of the organic esthetics? If they are, what are the binding factors of both?

Lewis: Is art a form of self-analysis?

Moderator Motherwell: Are you saying that art is not a form of analysis, and that we should not be here analyzing what is going on? Or that art is a way of analyzing the world?

Lewis: Yes, psychoanalysis.

de Kooning: If we talk in terms of what kinds of shapes or lines we are using, we don't mean that and we talk like outsiders. When Motherwell says he paints stripes, he doesn't mean that he is painting stripes. That is still thinking in terms of what kind of shapes we are painting. We ought to get rid of that. If a man is influenced on the basis that Mondrian is clear, I would like to ask Mondrian if he was so clear. Obviously, he wasn't clear, because he kept on painting. Mondrian is not geometric, he does not paint straight lines. A picture to me is not geometric—it has a face. . . . It is some form of impressionism. . . . We ought to have some level as a profession. Some part of painting has to become professional.

Newman: De Kooning has moved from his original position that straight lines do not exist in nature. Geometry *can* be organic. Straight lines do exist in nature. When I draw a straight line, it does exist. It exists optically. When de Kooning says it doesn't exist optically, he means it doesn't exist in nature. On that basis, neither do curved lines exist in nature. But the edge of the U.N. building is a straight line. If it can be made, it does exist in nature. A straight line is an organic thing that can contain feeling.

de Kooning: What is called Mondrian's optical illusion is not an optical illusion. A Mondrian keeps changing in front of us.

Gottlieb: It is my impression that the most general idea which has kept cropping up is a statement of the nature of a work of art as being an arrangement of shapes or forms of color which, because of the order or ordering of materials, expresses the artist's sense of reality or corresponds with some outer reality. I don't agree—that some expression of reality can be expressed in a painting purely in terms of line, color and form, that those are the essential elements in painting and anything else is irrelevant and can contribute nothing to the painting.

Ferber: It seems that Gottlieb is making the point that non-objective art is a relationship that is internally satisfactory.

Gottlieb: That's not satisfactory.

Moderator Motherwell: It is not the real issue. All of the people here move as abstractly or back to the world of nature as freely as they like to, and would fight at any time for that freedom.

Newman: We are raising the question of subject matter and what its nature is.

de Kooning: I wonder about the subject matter of the Crucifixion scene— was the Crucifixion the subject matter or not? What is the subject matter? Is an interior subject matter?

Hofmann: I think the question goes all the time back to subject matter. Every subject matter depends on how to use meaning. You can use it in a lyrical or dramatic manner. It depends on the personality of the artist. Everyone is clear about himself as to where he belongs, and in which way he can give esthetic enjoyment. Painting is esthetic enjoyment. I want to be a "poet." As an artist I must conform to my nature. My nature has a lyrical as well as a dramatic disposition. Not one day is the same. One day I feel wonderful to work and I feel an expression which shows in the work. Only with a very clear mind and on a clear day I can paint without interruptions and without food because my disposition is like that. My work should reflect my moods and the great enjoyment which I had when I did the work.

Reinhardt: We could discuss the question of the rational or intuitional. That might bring in subject matter or content. We have forms in common. We have cut out a great deal. We have eliminated the naturalistic, and among other things, the super-realistic and the immediately political.

Rosenborg: We are also trying to cut out by still putting in everything.

Reinhardt: You're putting in everything about yourself, but not everything outside yourself.

Rosenborg: The object is not to put yourself in the middle and say, "That's me."

Ernst: I know I can't paint when my mother-in-law is in the house.

Moderator Motherwell: Thus we go on with the practical questions:

Reinhardt: What is your work (of art)? Do you consider the production of it a professional activity? Do you belong to Artists' Equity? Why, or why not?

Barr: What is the most acceptable name for our direction or movement? (It has been called Abstract-Expressionist, Abstract-Symbolist, Intra-subjectivist, etc.)

Smith: I don't think we do have unity on the name.

Rosenborg: We should have a name through the years.

Smith: Names are usually given to groups by people who don't understand them or don't like them.

Moderator Barr: We should have a name for which we can blame the artists—for once in history!

Moderator Motherwell: Even if there is any way of giving ourselves a name, we will all still be called abstract artists. . . . Do you regard painting as a profession?

Reinhardt: All of us exhibit in large exhibitions alongside of artists who consider themselves "professionals" or commercial artists and business men, such as the members of Artists' Equity.

Moderator Motherwell: Do you regard it as a profession to earn your living as a painter?

Reinhardt: You could be unemployed and still be a "professional" or a member of Artist' Equity.

Moderator Motherwell: If you define "profession" in terms of what you do most often, of what is your major activity, then everybody here is a "professional" painter.

Reinhardt: Then should or shouldn't we belong to Equity?

Ernst: I joined because I was tired of being asked why don't I belong.

Newman: The thing that binds us together is that we consider painting to be a profession in an "ideal society." We assume the right of insisting that we are creating our own paradise. We should be able to act in a professional way on our own terms. We go out into normal society and insist on acting on our own terms.

Smith: I exist in the best society possible because I exist in this time. I have to take it as the ideal society. It is ideal as far as I am concerned. I can not go back, I cannot admit that there is any history in my life outside of the times in which I live. Nothing can be more idealistic for work than right now—and there never will be an ideal society.

Moderator Motherwell [to Newman]: You mean that we are not acting in relation to goals that most people in our society accept?

Newman: Yes.

Smith: This is the time in which I live and have to function. Therefore, it has to be ideal. How can I consider an ideal society as ideal in one that I can't possibly live?

Moderator Motherwell: What distinguishes these people is that they are trying to act ideally in a non-ideal society.

Pousette-Dart: It is an ideal society, but only the artist realizes it.

de Kooning: You can't call yourself "professional" unless you have a license, such as an architect has. There are differences, we can make money without a license, but to call ourselves "professionals," we can't do that; you must be a "professional" to someone else—not to yourself.

Smith: It is just an attitude of mind.

Reinhardt: Does not one have to remove oneself from the business world in order to create "fine" art or to exist as a "fine artist"?

Moderator Motherwell: Can we say that every one here accepts the fact that in most societies people have a "career" of one kind or another? To choose painting as career and, at the same time, to insist on the integrity of one's own expression, is really to make an idiotic choice of a career.

Ernst: Can we say that no one here is an amateur?

Rosenborg: I wouldn't advise anyone in the outside world to be an artist, but if I had to do it all over again I would do it.

Brooks: "Professional" conveys, to the outside world, that people spend a great deal of time in what they are doing.

Newman: ''Professional'' for me means ''serious.''

Moderator Motherwell: In relation to the question of a name, here are three names: Abstract-Expressionist; Abstract-Symbolist; Abstract-Objectionist.

Brooks: A more accurate name would be ''direct'' art. It doesn't sound very good, but in terms of meaning, abstraction is involved in it.

Tomlin: Brooks also remarked that the word ''concrete'' is meaningful; it must be pointed out that people have argued very strongly for that word. ''No-objective'' is a vile translation.

Newman: I would offer ''Self-evident'' because the image is concrete.

de Kooning: It is disastrous to name ourselves.

Western Round Table on Modern Art (1949)

Edited by Douglas MacAgy

Preface

The following abstract of proceedings of the Western Round Table on Modern Art aims at a balanced treatment of topics covered and a fair representation of individual contributions to each topic. For the convenience of writers who may wish to comment on the symposium, material in this abstract is grouped by topic. All direct quotations in the present digest have been checked in transcript and approved by each contributor, but the indirect quotations, omissions and re-arrangement are the sole responsibility of the editor.

Introduction

The Western Round Table on Modern Art met in San Francisco April 8, 9, and 10, 1949. Three sessions were scheduled for the first two days; an unscheduled fourth session was added the third day at the request of some participants. Conference time totalled nine hours. The second session was open by invitation to the public and to members of the San Francisco Art Association; the three other sessions were closed.

All sessions were transcribed by two court reporters and also recorded on wire. The typed transcript was then corrected and approved by each contributor.

A special exhibition of modern art was assembled for the event and shown concurrently at the San Francisco Museum of Art, where the meetings were held.

This article originally appeared in *Modern Artists in America* (1950): 26–37.

Sets of photographic reproductions of works in this exhibition were made in advance and sent to members of the symposium for preparatory reference. During the discussion, points were illustrated from time to time by examples in the exhibition. At the outset, however, it was decided that lengthy devotion to analysis of specific works of art would emphasize individual preference and idiosyncrasy at the expense of ideas with possibilities of wider and deeper implication.

A list of works in the exhibition is appended to this abstract.

The Round Table and its Exhibition were sponsored and financed by the San Francisco Art Association, a non-profit corporation, with the assistance of the Art Commission of the City and County of San Francisco.

A list of the boards, commissions, committees and officials involved in this sponsorship is appended.

The Round Table and its Exhibition were organized by Douglas MacAgy, then Director of the California School of Fine Arts.

The object of the Round Table was to bring a representation of the best informed opinion of the time to bear on questions about art today. A set of neat conclusions, as the outcome of the conference, was neither expected nor desired. Rather, it was hoped that progress would be made in the exposure of hidden assumptions, in the uprooting of obsolete ideas, and in the framing new questions.

Two quotations may emphasize this intention. Alfred North Whitehead pointed out, in discussing the basic assumptions by which we live, that ". . . assumptions may appear so obvious that people do not know what they are assuming because no other way of putting things has ever occurred to them." Pursuing this statement, Suzanne Langer wrote that "a philosophy is characterized more by the formulation of its problems than by its solution of them. Its answers establish an edifice of facts; but its questions make the frame in which its picture of facts is plotted."

Judgment of what was said at the Round Table is invited in terms of these general purposes:

Describing the meetings later, one of the participants put it this way: "There in that room, were a bunch of guys trying to think. We were most of us prima donnas, and from time to time we stopped thinking to try to pull off an epigram. But still—a bunch of guys trying to think. Still more difficult, we were trying to think aloud and trying to communicate with each other—trying to get things clear which have never been gotten clear."

Participants

George Boas (Moderator): Philosopher; Professor of History of Philosophy, Johns Hopkins University; Trustee, Baltimore Museum of Art.

Gregory Bateson: Cultural anthropologist, Lecturer, Langley Porter Clinic of the University of California Medical School; authority on Bali and New Guinea.

Kenneth Burke: Literary critic, philosopher, novelist; Professor, Bennington College, Vermont.

Marcel Duchamp: Artist.

Alfred Frankenstein: Critic; Music and Art Editor, *San Francisco Chronicle.*

Robert Goldwater: Critic and art historian; Editor, Magazine of Art; Associate Professor of Art, Queens College.

Darius Milhaud: Composer and conductor; Professor of Composition, Mills College.

Andrew C. Ritchie: Art historian and critic; Director, Department of Painting and Sculpture, Museum of Modern Art.

Arnold Schoenberg: Composer.
(Note: Mr. Schoenberg, prevented by ill health at the last minute from personal attendance, contributed a statement by means of a wire recording and typescript.)

Mark Tobey: Artist.

Frank Lloyd Wright: Architect.

The Proceedings

(Note: Quotation marks are used for all statements made directly by members of the symposium. Editorial paraphrases and indirect quotations appear outside quotations marks.)

[Early in the discussion Mr. Duchamp made a sharp distinction between "taste" and what he termed the "aesthetic echo." He claimed that, at any given time, the former could be experienced by many and the latter by few. Frequent reference was made to these assertions as the talk progressed.]

Duchamp: Taste gives a sensuous feeling, not an aesthetic emotion. . . . Taste presupposes a domineering onlooker who dictates what he likes and dislikes, and translates it into "beautiful" and "ugly." . . .

Quite differently, the "victim" of an "aesthetic echo" is in a position comparable to a man in love or a believer who dismisses automatically his demanding ego and helplessly submits to a pleasurable and mysterious constraint. . . .

My personal conclusion is that, generally speaking, very few people are capable of an aesthetic emotion—or, an "aesthetic echo." While many people have taste, only a few are equipped with aesthetic receptivity.

The Cultural Setting

Intelligibility and Communication

Bateson: My job is not so much with modern or contemporary painting, but with art products of cultures that haven't got themselves into quite such a confused state—in New Guinea, Dutch East Indies and such places. And if you go there, you find that the people who make and who look at the works of art, live, for them, in a world which is totally intelligible. They would know that a sky is blue; they know why water is wet. They do not live in a culture of which most of what happens is mysterious, or is concealed in the Encyclopaedia Britannica, or in more obscure places even. They feel they know the world they live in, and the art objects which they see are produced out of that homogeneous world. . . .

In Mr. Duchamp's "aesthetic echo" terminology, the "aesthetic echo" is a thing which can be shared by a very large number of people in that group.

But we live in a culture which is changing very rapidly, and the "aesthetic echo" that is carried in modern art, as far as I can see, tends to be the aesthesia—if that be the word—of a changing world. Very often it is the aesthesia of nostalgia for an unchanging world, or the aesthetics of trying to resist the change—feeling anxious about the change. . . . A very much more complicated story than the sort of thing that I professionally deal with.

Burke: Does not the problem center in the specialized nature of our modern culture? As regards possibilities of communication, a specialized culture has one notable embarrassment, which we might illustrate by comparing, say, a bridge-builder with a poet or painter.

The bridge-builder must understand the particulars of his craft, while laymen who use his bridge need know nothing of this specialized lore. . . . You get a sufficient act of communication in scientific and technological production by merely carrying out the appropriate specialized operations.

The artist too is a specialist, in his fashion. . . . But insofar as the public does not understand his special language, his *act* of communication is ineffective. Does he not, as a specialist, thus face an extra problem of communication which technological specialists are spared?

So I take it that our culture, with its high degree of specialization, will always be shifting between the norms of universal appeal on one side, and the requirements of specialization on the other. Occasionally you can expect a happy accident where the work meets both tests at once, but these moments will be comparatively rare. . . .

Goldwater: What Mr. Burke has just said seems to me to bring up one problem. He has referred to special kinds of communication . . . I think that might be carried further. . . . There is a general assumption on the part of the public that though there are specialists in the various fields, it is possible not only to understand, but also to have that 'aesthetic echo' towards all kinds of art—particularly all kinds of contemporary art.

Couldn't it be said that this assumption is mistaken? That precisely as there are specialists in creation, there are also special tastes in appreciation? And that we need feel no concern, and the public need feel no bewilderment or shame, if there are certain kinds of contemporary works towards which they feel attracted, and other kinds towards which they do not? This by no means would rule out the varieties of contemporary art as a group.

Burke: There is always communication. . . . The communication is there the minute the painting is done.

Tobey: But the artist, when he is painting, is not thinking of communication. . . .

Wright: Not if he is a true artist.

Tobey: I think the artist is concerned with his art, not with himself. He may later on have to be concerned with himself . . . but he is only concerned with himself when his position is attached in relation to this thing which is sacred to him. . . .

Goldwater: Isn't this the result of the apparent identification of self-expression and communication? . . . What is held against the modern artist is his so-called unintelligibility. If you talk to the modern artist about that, you find he feels he is being true to himself, and will allow nothing to disturb the integral expression of his own personality as he conceives it— be it dealers, be it patrons, be it the concept of society in general.

The problem I would like to propose here is whether that division between communication on the one hand, which presupposes a public to whom the artist is talking, and integrity on the other, which presupposes that the artist is concerned only with himself, is not something wider than a purely aesthetic problem. Is it not a basic problem, not only for the artist in contemporary society, but for the individual—as individual—whether artist or not?

Burke: My general notion as to what is going on in the world hinges about the shift from a theological vocabulary of motives to secular terms. As our

culture has become increasingly secularized, and the theological or religious terms for human motivation have fallen into relative disuse, creative vitality in the symbolizing of motives is more likely to be found in secular expressions.

And basically, the reason that I watch modern art with such avidity and earnestness is: Here is an area where the motives of our world are being enunciated profoundly. For motives are being enunciated not merely intellectualistically, but with their emotional and ethical ingredients. Hence, the full range should be present here. That's why we should take modern expression so seriously—because it is concerned with the basic motives of life, with the things over which men will lurk, and mull, and linger, and for which they will seek new statements.

The Heritage

Tobey: When I was a young man, I never heard of Byzantine art. . . . Now, above the horizon has come the beauty of Byzantine art—not only that, but the art the colored people have, and the art of the Coptics, and all of the Orient and everything has flooded the world.

Now it seems to me that we are in a universalizing period. . . . If we are to have world peace, we should have an understanding of all the idioms of beauty because the members of humanity who have created these idioms of beauty are going to be a part of us. And I would say that we are in a period when we are discovering and becoming acquainted with these idioms for the first time. . . .

Burke: I have one little notion to offer on that. It refers to a possible way of introducing the matter of the museum. Could we think of our times as a kind of second-level civilization? I mean, could this civilization flourish under conditions that might have been fatal to another culture?

Consider technology, for instance. It allows for certain kinds of rationalization. And these kinds of rationalization in turn allow for compensatory or antithetical cults of irrationality. A similar percentage of irrationalism in other societies might have pulled them apart. We have so much coordination, so much regularization, in technology and its routines, that we can tolerate a high degree of aesthetic latitude without a corresponding degree of risk. . . .

There is an Alexandrian, cosmopolite motive here. . . . There are opportunities indigenous to such a situation, too, in this culture of libraries, collections, exhibits, surveys, compendia, encyclopaedias, outlines, botanical gardens, zoos, schools, museums. And you really have a "second-

level'' of living here, with a perspective that may culminate in world-mindedness. We transcend time and space—that is, our peculiar time and space. . . .

I would propose to tie that in with another aspect of our ''museum culture.'' Once you have the museum you have the possibility of other tests. For instance . . . here you can consider a kind of art representing such distresses and disturbances as a person might not want to have on his walls—to live with every day. The museum can thus, for our times, exhibit turbulent kinds of art that were, in earlier ages, usually confined to churches. And all such motivation could be expressed, as vital aspects of the human psyche.

Wright: I guess we are all living a kind of museum life today.

Burke: Well, out of this you may derive a paradoxical possibility; a balance of imbalances. You can take a group of artists, each in his peculiar way extreme, and you can get your poise as a result of the lot—out of their ''mutual cancellation.'' Put them all together, and you might thus have a kind of New Liberalism / for in this respect I think there is an essential ''liberalism of museums''./ The balance may come from the total exhibit, rather than from balance in the single artists.

Wright: What is the museum now but a kind of morgue? Is it anything else?

Burke: Well, to live a dying life—the Christian culture, for instance, was built on this injunction, to ''live a dying life'' / as enjoined in *The Imitation of Christ/.* And I think the secularization of that principle is a very important motive in the modern world, underlying even the motives of science.

You can detect it in the whole cult of abstraction, as you see if you consider the dialectics of Plato. For abstraction, as a transcending of the sensory, is a way of dying and yet living.

Goldwater: One of the characteristics of 19th and 20th century civilization has been its sense of historicity; and the critic, as well as the contemporary artist, cannot avoid that sense of history. . . .

The reaction against the qualities and values of the art of our western culture, at least since the Renaissance, takes the form, in a great many (modern) works, of an overtone of ironic restatement of the qualities of some previous art. . . . When we look at this Magritte, which is called—already ironically in its title—*The Portrait,* what we have in our minds is the whole 17th and 18th century still-life tradition of Chardin . . . and that

adds a great deal to the depth of reference and the emotional quality—the emotional tensions—which such a picture carries.

Ritchie: More and more, we are coming to believe that art museums are not simply storehouses of the art of the past. They must exhibit both past and present art together, if one is to illuminate the other. . . .

Moderator Boas: Well, isn't that, Mr. Bateson a peculiarity of modern occidental culture?

Bateson: I am not sure that it is. It is some sort of piling up and of exhibition of the spiritual heritage of the culture; you will find it everywhere, or almost everywhere. Bali is as near to a place with no history— with no interest in its own history—as can conceivably be imagined. They feel that time is circular and not progressive, and that the past was undoubtedly like the present. . . . In general, they reconstruct the past in terms of the present, if they pay attention to the past at all. But in Bali you still have collections of the past, magpie habits of various kinds, and I think it's important.

Moderator Boas: I mean, are these used as Mr. Ritchie was saying they use our modern museums?

Bateson: Well, they are used as affirmations, which is not quite the same thing. We live in a culture which is changing, where the things and the collections are used almost as methods of exploration, rather than as affirmations.

The Beautiful

Wright: I think that what passes for a work of art in a true culture—in a civilization that we might call worthy of the name—would be something that would give an impression to whoever beheld it of what he or she would call "the beautiful." And I think the test of that work of art, so far as the person was concerned would be the extent to which he could respond to it with the feeling it was a thing of beauty. . . .

Ritchie: I think Mr. Wright is perhaps begging the question. At least, he is putting it in a very circular way: a work of art must be beautiful, and only the beautiful is a work of art. We are right back where we started from and we must define what is beautiful and what is a work of art.

Wright: Then we arrive at the conclusion that the only man who can define it is the man for himself, and not for anybody else.

Duchamp: We aren't dealing with any absolutes, are we, in this life? We are dealing only with that which is in motion, not which is an absolute and fixed. . . .

Moderator Boas: Well, of course, even though these things change from age to age, Mr. Wright may be quite right in saying, in each age, the artist is seeking the beautiful.

Bateson: There are many cultures that classify together the two extreme ends of the sacred-secular scale. The word "sacer" in Latin, from which we get our word "sacred," is a word for the extremely beautiful and desirable end of the magical scale. In contrast, there is a middle range of that, which is secular, which is everyday, which is normal. And at the other extreme, you come again to the "sacer," the sacred, which is the supernatural and horrible.

Now it seems to me that art is very much concerned with both ends of that scale.

In conversation last night, Mr. Wright, we agreed that love and hate are very closely mixed emotions—or, especially, love and anger, perhaps. Now that means the artist is not, in fact, out to destroy love; he has got to accept the facts of hate as well as the facts of love.

Wright: I think the expression of hate, as tragedy, could be beautiful as Hamlet was.

Principle

Wright: I think every artist, great or worthy of the name, has his feet on what he considers principle, and from that his work, his utterance, his realization of his feeling proceeds. . . .

Ritchie: Mr. Wright, whose principle?—the artist's own independently arrived at principle?

Wright: Principle is. Man doesn't make it, he perceives it. Principle is not designed. Principle *is*. God to me is the heart of cosmic principle.

Goldwater: One important thing to keep in mind is that the problem of "eternal principle," doesn't exist for the modern artist. . . . The modern artist begins with a notion that principles—as eternal—are not something to be accepted; rather he must make his own discoveries or re-discoveries. And that is why we have such a continuous succession of styles, and why

we place so much importance on individuality and the newness of a particular communication. . . .

Bateson: Would you say that the modern artist is in search of principles, rather than engaged in reiterating the principles of former cultures?

Moderator Boas: Mr. Wright has maintained that there is a distinction between real artists and fake artists. The real artists express in their works of art, eternal unchanging principles. . . .

Duchamp: There are several kinds of basic principles: first, the basic principles that change with every generation, like the concept of the "beautiful". . . . But I don't believe in the existence of eternal laws governing art metaphysically.

Bateson: I think the "eternal principles" have got to come out on the mat and be faced. Now, obviously, if you take two societies—even the English and the French, or the English and the American—you are going to get pretty different evaluations of good and bad. But let's say that there are different ways of listing the things, but that the notions of good and bad are more or less the same, somehow. Now, unfortunately, that isn't true either, because the principles on which principles are built vary enormously from culture to culture; and that begins to be serious.

Wright: Mr. Bateson, that is where I think you make an initial mistake. It is only the use or abuse that varies.

Bateson: Could you consider the difference between the occident and China on the one hand, and Japan on the other?

Wright: You are talking about ethnic eccentricities, not about a difference of principle.

Bateson: No, I don't think so. We deal very much in dualisms of one sort or another, and we think that you can choose one end of a dualistic contrast. You can choose democracy in preference to communism, or you can choose good in preference to evil, day in preference to night, and so on. But among the Chinese, you find an assumption that the opposing ends of a polarity are functions of each other. The good is a necessary development out of evil . . . as you feel that love and hate are related.

Wright: And yet, a man who is nearest, who has come nearest, to expressing in philosophy the truth and the principles which animate organic architecture did so five hundred years before Jesus. His name as Laotze.

Bateson: There is a case for saying that we are changing—that the principle on which we have built our principles is changing much more closely

towards the Chinese position. You find it among the psychiatrists, can recognize it in Jung, and so on.

Wright: Because Laotze was the man (the prophet) who first declared that the reality of the building did not consist of four walls and a roof, but in the space within—to be lived in—and that's our organic architecture today. That's the basic principle on which we perform our miracles, and miracles they are. . . . All the buildings that really have had quality unconsciously derived their essence and their validity from the unknown-to-them Principle. . . .

Science and Art

Wright: May I say here that a scientist *cannot* see this innate thing. That's what sets the scientist apart from the creative artist. Now these twain some day shall meet, but not for centuries. . . . The scientist . . . is the enemy at the present time of all the artist would represent. . . . The scientist doesn't mean to be that enemy. He thinks he is benefactor. . . . Religion by way of science has virtually disappeared so far as real vitality is concerned. . . . Artists have all been "had" by science and education. . . . We have tried to substitute sanitation for civilization. Our redemption does not lie in the hands of scientists, because they can only give us tools in a tool-box; the scientist gives us magnificent tools, but he can't tell us what to do with them or how to do what we most need.

Moderator Boas: What do you say for your craft, Mr. Bateson, after that?

Bateson: I would say, first of all, that I think Mr. Wright is referring to a scientific epoch which was wholly materialistic. It was concerned with causal sequences in straight lines—A sets off B, B sets off C. In such a system I could manipulate you and you will manipulate somebody else. . . . That scientific epoch is, I think, very rapidly coming to an end.

Mr. Duchamp's position for example, is one which recognizes the phenomena of circular causal systems—most of the circle being inaccessible to us. In such a system, there is not the opportunity of manipulation because we are *inside* the system.

Wright: That is altogether too dramatic a figure. . . . You miss the new romance as a scientist would—as he would himself have to miss it. . . . But he would become a much greater scientist if he *would* get inside and see from the inside outward, rather than from the outside inward. And right there is the difference, I think, very nearly expressed between what I would call the creative Artist and the Scientist. The creative Artist is, by nature, inside the thing and his vision outward. The Scientist is outside looking in, trying to take the thing apart to see what makes it click. And he would fail to put it together again, were he to try.

Bateson: No, the scientist is not outside. . . . The scientist is part of the thing which he studies, as much as the artist. And it is that move—the discovery that the observer is a significant part of the thing observed—that marks the change of epoch.

Degeneracy and Primitivism

Wright: I thought we could come together here, perhaps, and do something for the public in their confusion concerning this thing we call "modern art"—to clear the thing up a little bit and explain why this portrait of a time, of this generation of a civilization, where this particular art of painting is concerned, is also degenerate. . . .

Bateson: As I see the age in which I live, I think it's a very difficult and very confused age. And I think there are several patches in it which are laboring and sweating and striving to get towards a clarity—often in very confused ways, but still laboring and sweating and I think these pictures are a part of that sweating and striving. I don't believe they are on the way down. I believe, on the whole, they are on the way up.

Frankenstein: I don't suppose anyone in Rome knew they were in a decline. . . .

Tobey: I presume there were some, but they were called Christians!

Moderator Boas: I ask the privilege of the gentlemen to participate a bit in this discussion as a historian of ideas . . . I suppose I'm the only person present who knows anything about the history of man's appraisal of his own civilization. I started a four-volume work some years ago which is now at the end of its second volume, and we have only got up to the 13th century. You find that, beginning with Homer and running straight down to "Joachim of Florus" a constant succession of people who say every single age they are living in is not only bad, but the worst of all ages; and they give precisely the same reasons for it.

In Homer, you find old Nestor says to the heroes: "You people don't know what men were like in my day. Heroes were real men". . . .

Wright: Where are these civilizations now?

Moderator Boas: I think they are still alive. I don't believe that civilizations die, as Toynbee does. . . . We have a lot that is Egyptian in our present civilization; a lot that is ancient Greek; a lot of Rome—Louisiana is still living under Roman Law.

Milhaud: I want to hear about what that artist called "degenerate art," because we heard that term not so many years ago from another artist called Adolph Hitler.

Wright: We instinctively hark back to the primitive. We find it in Negro sculpture, in those things Picasso presents to us, which could hang on the wall in any of the primitive African performances. I like to think we find either Picasso despairing, or in absolute collapse, spiritually speaking. . . .

Duchamp: Why do you call it "degeneracy"? You seek in the primitive what might be good to take.

Milhaud: And healthy.

Wright: Would you say homosexuality was degenerate?

Duchamp: No, it is not degenerate.

Wright: You would say that this movement which we call modern art and painting has been greatly, or is greatly, in debt to homosexualism.

Duchamp: I admit it, but not in your terms. . . . I believe that the homosexual public has shown more interest or curiosity for modern art than the heterosexual: so it happened, but it does not involve modern art itself.

Wright: But no man in his confusion, in his inability to conduct his life and himself on a plane more of less of manhood as we understand it— maybe it's a mistake—feels the need of this refreshment, and goes to the darkie, goes to the primitive, wherever he can find it, and feeling strengthened by it begins to copy it, begins to imitate it . . . this thing that belonged like a property of childhood to the early days of the race. . . .

Milhaud: I don't understand the word "copied."

Bateson: I was going to challenge exactly the same point. I have seen in Bali an Indian dancer, a Hindu from India, who went to Bali to learn Balinese dancing. . . . He had one of the top Balinese dancers as a teacher. And you see the Balinese trying to copy the Indian. The two things cannot copy each other. The bodies aren't put together the same way. The notions of beauty and human relations are deeply and implicitly different in the two creatures. And the same applies to us: the possibility of copying when you go to a primitive society is not there.

Wright: Isn't this true: that primitive man— . . . that earlier periods in the art life of the savage races were more childlike?

Duchamp: No.

Moderator Boas: No.

Bateson: No, no, no; they think we are children.

Frankenstein: I wonder if you are not referring to what I often call the "evolutionary fallacy." That is to say, first of all, the idea that the evolution of society proceeds in a straight line; secondly, that that which comes at the end—at our end of the line—is somehow greater in quality, more significant, than that which comes at the lower end of the line.

It seems to me that the whole line of thought involved there is completely fallacious, and furthermore overlooks an obvious fact . . . that that which we frequently call "primitive" culture is infinitely more sophisticated in terms of different experiences than we ordinarily admit it is.

Moderator Boas: Isn't the very term "primitive" a relic of the evolutionistic period?

Bateson: I find it a very useful term to separate these cultures which have not got script from those cultures which have got script. . . .

It means, and it's relevant to this problem about progress that you are raising, that the addition of script to a human community—the fact that they can record, they can time-bind, they can send messages of various kinds—is a shift in the order of complexity. . . .

Now this is what we are all fighting about. Those of us who are on the side of the 20th century and see a lot of these things as striving toward new degrees of awareness, new principles of awareness that come up from the guts—I am not saying they are intellectual strivings, they are deep strivings—have a case, I think, for saying that that is a shift in order of complexities.

Moderator Boas: Now if I can express my own opinion flatly, I don't think the present age is any worse than any other age. . . . I am very, very deeply moved by modern painting, much more so than by most classical paintings; and by modern music much more than classical; and by modern architecture much more so than by architecture of the Beaux-Arts. . . . I think it's a perfectly swell age. I see nothing degenerate, and I don't care what the sexual life of its inmates is, or anything of the sort.

Ritchie: The greatest pleasure I have received from modern art is basically its extraordinary freshness. Looking back, we have spoken of the feeling for history, which is certainly a part of us; but I think the most exciting thing in our day is the tremendous break with all past periods of civilization in an attempt to search for new forms. . . .

Art and Artist

Art in a Changing Culture

Bateson: Looking at these pictures [exhibition of modern art selected for the symposium], I see a culture in a state of change—changing its very deep premises. If you take the Villon. . . . What he has done is to say something like this: "Cartesian coordinates, perspective—hm" and then he has put this free-flowing line on top of them to say: "Yes but—as against those rigid coordinates, the point can still go for a walk."

All right, he has stated a protest against the rigidities of 19th century science which come into the culture via the rectangularity of every room we sit in, and so on. All those coercions are essentially *static* coercions, and the Villon, the Matta, the Surrealist Ernst, the Duchamp "Nude," this Mondrian which flickers—all are making statements about process, movement and dynamics. I think there is an extraordinary uniformity actually in what these people are trying to put down. And it is a strife with a large number of fronts, fighting all sorts of battles in different directions, but with a common theme that we are not going to be coerced in certain forms.

Now . . . if you consider a thing like the famous picture of Ophelia—is it Burne-Jones?—with green weeds and flowers on her nose. That picture, or the artist when he makes the picture, says essentially: "If you have tears to shed, prepare to shed them now!"—to quote Mark Anthony, and Mark Anthony was a sentimental fake too. And the position of the modern artist, as I see it as an anthropologist, is a shift in our notions of human relations in which we refuse to accept that sort of coercion and are reverting to something much closer to Greek tragedy. Greek tragedy does not say: "If you have tears to shed, prepare to shed them," it says: "It's thus, and it's thus, and maybe the gods not only laugh at it, maybe they cry at it—that's your affair." All they are concerned to say is "That's how it goes."

Or take T. S. Eliot's *The Waste Land,* which is neither funny nor tragic. It is a grim, diagnostic statement, and you can laugh at it, or you can cry at it, but there it is. And its sincerity is the sincerity of diagnosis of an age of which *The Waste Land* is a description. It is an expression of that age swallowed into the deep interior. "Crime without passion"— yes, sir [Mr. Wright had so characterized "modern art"]; but the corruption of passion is the thing with which we are striving; and we have to fight that battle, I think. That is what I think modern artists feel.

Art as Magic

Bateson: I would like to use the word "magic" in a sense which is not ortho-
dox in anthropology, but which has been suggested by R. G. Collingwood.
I would say that an action, a ritual, a work of art . . . contains magic in-
sofar as it lays down in the actor or participant— usually unconsciously—
some essential value premise. Maybe a premise of mockery, conceivably.
I am not saying it is a *plus* premise. It might be plus or minus. It may be
a hatred or a love or a capacity for hatred or love . . . but the distinction
which I would like to make is between those acts and objects which have
that effect . . . versus those which are essentially entertainment. . . . The
business of catering to spectatorship is entertainment. . . . You see a movie;
the movie is done; you have been through something and you haven't
got any more emotion than you had before. There has been no change—
no force in you laid down or liberated by the thing you have seen. . . .

Perhaps an important point we ought to think about, is to think about
the question of whether these pictures are laying down something of that
order.

Burke: There's an element that I think is relevant to this matter. I refer to
Diderot's remarks on the "positions of pantomine," his view of all human
society as pantomine. I would relate this idea to the Klee pictures, recalling
how at one period Klee worked with masks, and then went from masks
to a subtler kind of mask—for his objects themselves are masks, the images
that the painter uses are "positions of pantomime." Here is where the
magic of these images enters. That is, they bear on an underlying hier-
archic structure. And such hierarchic structure is the formative factor in
the world today, as we go from nature to real estate, and next would go
from real estate to what we could call nature—but what is really nature
as approached through real estate. Or similarly, we go from nudity, to
clothing, to nudism. / For, as a matter of fact, the nude in painting is far
from being merely an unclothed creature. In his "philosophy of clothes,"
Sartor Resartus, Carlyle depicts all sensory appearances as kinds of
"clothing," and accordingly the nude would be but a highly generalized
"uniform." /

Now, "mystery" arises when there is communication between dif-
ferent kinds of beings. Thus, there is "mystery" in the relation between
the sexes, or between youth and age, or between persons of markedly dif-
ferent social status . . . and it seems to me that the basic motives infusing
the images of a work are "enigmas" of this sort, as these images, or the
objects corresponding to them, are "masks" standing for the complexities
of our social structure. . . .

It seems to me that such motives are gradually disclosing themselves in our society where, because of its strongly democratic tradition, we have tended to think in individualistic terms—looking upon the work of art primarily as the artist's means of self-expression.

But I see a different emphasis emerging here. "Very well, the artist is expressing himself, but he must use some kind of language"—and such a language will be a language of "enigmas" of objects as "masks," as "positions of pantomime," as a pageantry, while the mystery of the whole pageant goes by.

Bateson: To extend, in fact, the word "magic" to cover not only affirmations about the artist's insides, or the spectator's insides, but also affirmations about the world in which we live.

Burke: Yes, and the objects of our sensory experience, as imaged in art, are infused with a "divine" essence. When Thales said, "the world is full of gods," he was not just talking outmoded polytheistic nonsense. He was making a fundamentally correct statement about objects and images. The world *is* full of gods—it's full of different "spiritual" entities in the sense that each of the forms with which the artist deals has a spirit, and it is the spirit of hierarchy. There are kingly objects, judicial objects, policeman objects, salvation objects—there are hell objects— and in this respect, they are "enigmatic."

Bateson: Could I put on record the name of Wallace Stevens, the poet who has made works of art, poems, dealing specifically with this problem.

Magic and Non-Coercive Art

Bateson: I landed myself in a contradiction yesterday. . . . When we were talking about magic . . . I praised the magical, which is, in a sense, the preachment. And, on the other hand, I said that the great virtue of modern art is that it does not do that—it does not take the spectator by the button-hole and say that you shall feel such and such. There is some slide in the levels of abstraction in those two statements, and I don't know how to resolve it.

Burke: Might we try a somewhat roundabout approach, and see if that will help? I approach these matters first from the literary point of view, but I would look for the corresponding elements in the motives of painting. . . .

I have in mind the distinction, in literary theory, between rhetoric and poetic. . . . Poetic deals with the work in itself, its kind, it properties, the internal relations among its parts, etc. Rhetoric deals with the work's persuasiveness, its appeal, and eventually involves ethical considerations. . . .

But note what happens along about the beginning of the 19th century, as regards theories of art and literature. Here the study of aesthetics came to the fore. It had many good results. It gave new vitality to the analysis of artistic excellence. But it also had one unfortunate result. Aesthetics was conceived largely in terms of a flat antithesis to the practical. Hence, if the practical realm included the useful and the moral, then the aesthetic became, by the dialectics of the case, useless and nonmoral.

But another important development was involved—and I believe that here, Mr. Bateson, is where your position would figure. Precisely as the concern with the rhetorical aspects of expression was dropped from the formal study of literature and art, it was informally welcomed elsewhere. The new sciences—such as sociology, social psychology, anthropology, and, now recently, semantics—took in these same fields of inquiry which art theory / aesthetics / had thrown out. Thus, for instance, with your word "magic." Anthropology reaffirmed in terms of "magic," the motive of persuasion that fell into neglect with the neglect of the rhetorical / as the aesthetic stress upon expression had slighted the elements of appeal, communication, and the like. /

Bateson: I think I have squashed my own contradiction, with some help from you. Would it be fair to say the Klee exhibit is even a valid or very intense affirmation of some sort of the proposition: "Thou shalt not coerce me. I have the right to my own retinal view, and you have the right to your own retinal objective receptiveness," so that the Klee paintings are on the magical side, inasmuch as he makes that particular affirmation?. . . . There is not only no coercion, there is an insistence on non-coercion, which is a step toward the positive.

The Work of Art

Duchamp: We don't emphasize enough that the work of art is independent of the artist. The work of art lives by itself, and the artist who happened to make it is like an irresponsible medium. No artist can say at any time: "I am a genius. I am now going to paint a masterpiece."

Bateson: Now, Mr. Duchamp, what you are saying is that the artist is the picture's way of getting itself painted. That is a very serious and reasonable thing to say, but it implies that, in some sense, the work of art exists before it is there on canvas.

Duchamp: Yes, it has to be pulled out.

Frankenstein: I should like to ask Mr. Milhaud if he feels that the creation of works of art in his own case is the result of a mysterious and completely incomprehensible suggestion?

Milhaud: Not completely, but there is enough of it. When you start a work, sometimes you feel it is not ready to be started. Why? Because the work is still far away from you. One day, it comes, Why? Because it is ripe.

Bateson: We have just the same experience with a new scientific theory.

Milhaud: And even sometimes, as Mr. Duchamp said—and I agree completely—the work guides you. Often a creator, in another work, contradicts himself completely. And thanks be to God! Otherwise, he remains under one label. But he is led, not only by his thought, but by—call it what you like, inspiration, if you are not afraid of such a word. There the work guides you too of course, but if you don't have a responsive technique, then it begins to be pretty bad.

Ritchie: Then, in other words, Mr. Milhaud, the work might run away with itself?

Milhaud: Certainly it might. And so much the better, because if it runs away, probably it should not have been started in the first place.

Duchamp: It is a kind of race between the artist and the work of art.

Schoenberg: In the creation of a work of art, nothing should interfere with the idea. A work of art must elaborate on its own idea and must follow the conditions which this idea establishes.

This does not mean that an artist must have principles which he obeys and which he carries out under all circumstances. Such principles would probably, in general, be external; and their application would certainly deprive a work of art of its natural condition.

Goldwater: One of the things that psychological science in the 20th century pointed out most clearly to us is that the well-springs of art are at least nine-tenths subconscious and so it is perfectly correct that the critic shall see certain things in a work which the artist, in his one-sided passion of creation . . . had no inkling were there.

And it is a peculiarity of the American artist . . . that he likes to hold on to his work of art after it has been created, instead of allowing it to go its own way—and allowing the public . . . to find in it the total richness and complication of meanings and suggestions and allusions, whether or not the artist originally knew and intended them to be there. . . .

The Artist's Concern with the Public

Wright: Does it matter what the reaction of the public is concerning a work of art?

Milhaud: Absolutely not.

Wright: I don't think it really matters.

Wright: I think that he is talking much to himself, and especially if he is trying to talk to "the public," he is off his beat. . . .

An artist is not a missionary.

Schoenberg: There is, perhaps, only one principle to which every artist should pay obedience. That is, never bow to the taste of the mediocre—to the taste of minor people who prefer what an artist should never do. This does not mean there does not exist a popular art which has its own viewpoints and its own code of honor, even. . . . There is nothing wrong in such creation, but it is wrong for a serious composer to write or include in his works such parts which he feels would please the audience. . . .

Tobey: I would say that the modern artist . . . is trying to maintain his relationship to . . . his inspiration. . . . Now, the economic conditions and the low standards . . . come in and try to destroy the contact unconsciously, as do many, many people, including his friends, his relatives, and everybody else. If they can destroy that, they will. They do not know they are destroying it, so he fights to maintain that; and if he doesn't, he is lost, it seems to me. . . .

The Artist and Communication

Burke: Can't (the artist) create for a communication? Certainly he is not talking to himself, is he? He is using a communicative structure of terms.

Tobey: I think that the artist is not concerned with communication while he is in action; but after he is through, he likes to feel there is a communication from his work. In other words, he is pleased if someone is moved or gets something from it. How can he not be?

Frankenstein: May I ask also, if the artist, having completed the work of art, finds in it a degree, or sense of communication, to himself? That is to say, does he find in it especial qualities which he did not know were there during the moment, or at the time of, creation?

Tobey: I think that is very special. I think you are right . . . because who can say what we can get out of meditating on a work of art, or who can say how long it will take to digest a work of art? If the thing isn't a work of art, I think it is digested very quickly; but I think that a painting which

is a work of art is digested very slowly and must have been lived with a long time.

The Artist as Self-Critic

Burke: There is the critical function, there is an artistic function. We may treat them as distinct—yet what of an artist who revises his work? What is he doing? Is he not *criticizing* himself?. . . .

Duchamp: You forget that the work of the artist is based on emotion and that the work of the critic is based on an intellectual translation.

Burke: I was trying to show that the distinction between the two processes isn't as sharp as it sometimes appears to be when seen through differences of profession. The important thing is to recognize that a critical function is an integral part of the creative act. . . .

Take Mead's notion of the "generalized other." When you criticize yourself, you are "taking the attitude of the other." You are making allowance for what Freud might call the "super-ego." You are thus taking into account a social character. It is not merely yourself. You are "answering" somebody.

There is also an internal process: the artists' interaction with his own work in the course of creating it. The drawing of one line becomes a partial determinant for the next line. . . . Now, that is not a purely self-critical process, but it is related to the correcting of the work, and there is a likeness between the two processes. . . .

Duchamp: It's not criticism then.

Burke: I would go back to the Socratic idea of the internal dialogue. Once a complex world has been built up, no one is just talking to himself. Each individual contains several roles of personalities which have been built out of his situation. And he learns how to develop a thought by a process that could be reduced to alternating statements and rejoinders. . . . Mead . . . illustrates his point by such examples as this: if you are going to pick up a glass, you anticipate its weight, its resistance to your hand, etc. Thus, there is a kind of criticism implicit in your very act of grasping the glass. The object's "attitude" will be one of resistance to your way of seizing it. Hence, you grip in accordance with the attitude you anticipate.

Now, if we apply such a dialectical explanation to account for the producing of a work of art, we find that an artist is not merely expressing himself; he is considering the "attitude of the other," he is anticipating objections. There is thus a critical function interwoven with the creative function. . . .

Such a perspective would help bring these two processes together—though I admit that, like everything else in our modern world, they become separated into compartments, through professional specialization. . . .

The Critic

Cultural Circumstances

Goldwater: One of the characteristics of 19th and 20th century western civilization has been its sense of historicity; and the critic, as well as the contemporary artist, cannot avoid that sense of history . . . I don't know whether it would be going too far to say that, perhaps the critic only comes into existence at the time when this sense of historicity pervades a culture as a whole . . . because he, himself, comes in as a preacher of that sense of the historic.

Frankenstein: A very important function of criticism is to close the gap, as far as any kind of verbal exercise can, between the creative artist and the public. I believe, personally, that that gap . . . has always existed. . . .

That means that criticism is not addressed to the artist, but to the general public. . . .

Goldwater: One of the prime functions of the critic is simply to serve as a method whereby the observer is arrested by a work of art for a longer time than, were he unaided, that work of art could hold his attention. . . .

Bateson: If the critic is to bridge that gap, and to do it by *talking* about the work of art, I have a kind of suspicion that there is a danger of his killing the work of art. . . . The emotional kick, the aesthetic experience that comes out of an act, is relatively intense; but it is reduced perhaps to its square root when we *talk* about acting, and to its fourth root, when we talk about talking about acting. . . . We say: "Tout comprendre, c'est tout pardonner". . . . But perhaps to understand is merely to feel a little less intensely.

Now, then, if that is so, there is a case for saying that the critic is a very, very dangerous person—as dangerous as the scientist, and I am one of these. I smell in the critic a fox rather like myself. For me, as a scientist, this is one of the central problems which we have to deal with, the problem of how we are going to discuss such things as human emotion without destroying the life of the emotion. This seems to be a technical scientific problem which is unsolved, but conceivably soluble. And it faces the critic as much as it faces me.

Goldwater: I don't quite see how a critic pointing out the various elements of a work of art . . . can minimize the liking or disliking that the observer will have, once the exploratory lecture is finished. . . .

I think Mr. Bateson . . . would agree that, though it is perhaps true that the critical analysis of a given work of art will weaken the hearing of Mr. Duchamp's "aesthetic echo" of that particular work at that particular time, an understanding is thereby gained by . . . the layman to whom the critic is talking, which is useful in opening up avenues . . . that permit the hearing of the "aesthetic echo" . . . in another work of art at another time. . . .

Bateson: I feel the matter is more delicate and more complicated . . . I would like to say that, after all, the mind—let's say the mind rather than the material object—the mind has itself various parts and functions; and the part which we consciously understand, with which we think, in fact, is pretty different from this unconscious part out of which we have agreed that the work of art is largely created, and out of which the "aesthetic echo" springs. And we know that it is exceedingly difficult in general, to make the thing work backwards. . . . The normal dynamics operate when the pressures come from below upward; and it is exceedingly difficult to work it the other way around—to sink what one has learned consciously into unconscious levels. . . .

Ritchie: It seems to me [the critic's] chief role is to present his enthusiasm, and by exciting his public, he may finally bring that public more quickly to the work. . . .

Goldwater: All that the critic is doing is increasing depth and the acuity in the range of public perception.

Ritchie: I would like to take exception to that. . . . What we are doing in the long run is attempting to interest the public finally in the work of art. But with our criticism I don't think we necessarily increase the perception of that public. . . . But if we can excite someone to go and look at the work of art, that is our function, and that is all of our function.

Wright: I would like to see [art] . . . put up to the people that really should be allowed to react to these things quite naturally of themselves, and not because they are told, or taught, or somehow fashioned by critics into the shape of appreciation.

Judgment

Frankenstein: Criticism can change just as art changes; and it seems to me that, in an older time, criticism was an effort to judge a work of art according to certain external principles, certain basic canons, certain eternal laws. I think that modern art and modern life have taught us that, actually, there are no such things as eternal principles of art. . . .

Criticism has, in the past, attempted to set works of art against principles derived from the experience of previous eras. They never fit, and so criticism has been wrong.

Contemporary criticism, it seems to me, takes its base on a different level . . . or attitude—the attitude of attempting to discover what the principles of each given work are, and to assay that work on a basis of its own given principles. . . . That leaves the critic on fairly slippery ground. . . . In other words, the only final court of appeal which modern criticism has to work toward . . . is the general agreement of informed and intelligent people. . . .

If one is completely out of joint with one's time, it is perhaps better not to attempt to interpret one's time. Such interpretation is, after all, the only real function which criticism can serve.

Goldwater: Now, Mr. Frankenstein outlined what seemed to be the function of the critic as an explanatory one, quite apart from any evaluation . . . I think that there were in Mr. Frankenstein's words [omitted from this abstract] however, as you heard them, discrepancies which are all to his credit. You will notice that he referred to the continuing creative vitality of the world, and he indicated, when he said that, a belief in that vitality. He implied a belief in certain values of contemporary art which undoubtedly influence him in his explanations. . . .

Frankenstein: There is something dreadfully pontifical about a cleavage—good or bad; a simple separating of the sheep from the goats; a simple casting into limbo or exalting into heaven. The contemporary critic is more than likely to express his judgments in a rather roundabout way. You may say that it's a hedge, if you want to, but it is there, I think no less positive—perhaps even more positive—than the clearcut, out-and-out value-judgment would be. And certainly, as Mr. Ritchie suggested, the communication of enthusiasm . . . expresses a value-judgment.

Goldwater: I would carry that further and say that the enthusiasm must be based on a certain point of view which the critic is generally aware of. . . . A complete eclecticism seems to me to be an impossibility. These critics who pretend to complete eclecticism are actually saying that there are things which they do not like but that they would rather not come out and say so.

Milhaud: I am not at all against injustice. I rather like it. I think it is better to really stand for something, even if it is completely a pose. . . .

Frankenstein: An extremely sharp distinction should be made, at least in the critic's own mind, between a confident adverse opinion, and non-comprehension. . . . Very frequently . . . non-comprehension will express itself in terms of adverse opinion. . . .

We lash out in this way when things have been presented for our admiration and we have failed to understand them. . . . It is a kind of violent, pathological aberration of the critical sense that is exceedingly easy to spot, and which invariably means that the person involved has not perceived anything at all, but has merely perceived the affront to his own lack of understanding and has let his own egotism and his own limitations stand in the way of letting the work of art do anything for him or to him. . . .

Critic and Artist

Moderator Boas: Mr. Wright, what, after all, can an artist learn from a critic?

Wright: He can learn the futility of criticism and to avoid the critic by all means in his power.

[The critic] is of no benefit whatever to the artist unless he happens to be some way in the employ of, or subsidized by, the picture dealer with whom he makes and breaks the reputations of almost every painter. Fortunately, he hasn't got around to the architects, but the painters— and the painters, by way of the critic, come under the heel of what is called "the public."

Duchamp: I have no feeling against the critic. . . . Criticism against modern art is the natural consequence of the freedom given the artist to express his individualistic view. Moreover, I consider the barometer of opposition a healthy indication of the depth of individual expression. The more hostile the criticism, the more encouraged the artist should be.

Goldwater: Would the artists present admit that . . . however their perception about the works of others has been increased by criticism, that such criticism has, in some way been useful to them in future creations?

Milhaud: I don't think so, because . . . nobody—even the artist himself— knows exactly what is going to come about, and he won't take any element from the past. . . . I think complete moral solitude in his field is necessary and healthy.

Duchamp: I only want to add, in some cases it may have an influence and a bad effect.

Milhaud: I know, my dear Duchamp, but there is another thing and that is that you also have two kinds of creative artists. There are some who are affected by the critic and some who are not.

Duchamp: Exactly, it can't really be dismissed so simply as that.

Milhaud: And I don't know what the point of view is of the one who is affected. I have had criticism for over thirty years and it has never influenced me. . . . Sometimes you are astonished to find extremely violent reviews of a work from practically all critics. And then, then years after, everybody says: "What he is writing now is just nonsense; but that was a beautiful thing we had ten years ago". . . . Why should we bother?

Burke: I would like to try, if possible, to see whether the critic can make peace with the artist. Could we find a common ground in one respect, one notable respect, by considering the distinctive attribute of man, *qua* man?

Man is a symbol-using animal. . . . We might discern the rudiments of symbolism in domestic animals. A dog's bark might be called a kind of speech. But whereas the dog can bark, it can't bark-about-barking. It can't talk-about-talk. It can't advance to this second level of expression. . . . It is at this second level that you come upon the peculiarly human motives.

We are all, as human beings, on this second level, using systems of symbols. Some systems of symbols are used by scientists, some by philosophers, some by artists, some by critics, etc. Each of these symbolic structures is an organized vocabulary which a man learns to manipulate for purposes of expression, discovery and communication. . . . These symbols give us the dignity of ethical standards, they shape our notions of beauty and purpose. Our natural appetites, in their rudimentary simplicity, would be easily satisfied. The great goads to social activity—"ambition" generally—are provided by the vast symbolic structure that has been built above the natural appetites.

In our situation . . . we may try to plumb the resources of symbols, for guiding conduct, or expressing and communicating our experiences. . . . And besides merely exploiting the pragmatic and aesthetic resources of symbols, we must try to peer beyond all symbolism, towards a level of immediate experience that transcends any purely symbolic, or linguistic, structure.

In this search, there is no fundamental antithesis between the artist and the critic. . . . There are many ways of lining up reality, with varying degrees of accuracy and relevance. And the job for us all, I believe, is to scrutinize the work of everyone who is sincerely and earnestly seeking to use symbols. . . .

The Collector

Scarcity

Ritchie: Not nearly enough people collect pictures and sculpture. Every museum man is aware of the unhealthy concentration of collecting in museums, almost to the exclusion of private collecting. . . .

I know that there are supposedly many economic reasons why more pictures and sculptures are not bought by private individuals. In America, at least, I don't think these economic arguments hold water. . . .

There has been a general tendency in the past few years for museums to attack this problem from another direction. . . . The thought has come about that perhaps the private collector needs first to collect, not shall we say, the higher forms of art, but the more lowly ones; that is to say— furniture and furnishings in the home. . . . That explains, I think, the springing up of industrial departments in museums. It is the old pedagogic principle to start first with the familiar. . . . If one could encourage a greater understanding of the aesthetic value of these objects, then one might go on from there to painting and sculpture. . . .

Market Value

Duchamp: The great public, today, is guilty of having introduced as a criterion the quantitative evaluation of the work of art—the market value. People today often buy paintings as an investment. It seems to me that a hundred years ago, fewer painters, fewer collectors, fewer critics and fewer dealers made a little world outside the great public and gave preference to qualitative evaluation—with little or no speculation.

Goldwater: I would just like to add to what Mr. Duchamp said, this opinion: that though I agree with him that there is commercial collecting, and that there is perhaps some dealer influence in taste, it is possible to say that the dealer and such commercial collecting has had only a short-range influence on certain reputations and the personal lives of individual artists. But I doubt very much whether such commercial influences have, as has sometimes been suggested, actually put over on the public or society in general any broad style or direction of contemporary art.

The Ideal Collector

Goldwater: I wonder if Mr. Duchamp would offer the opinion, which I know he has about collecting, relating the experience of the "aesthetic echo" to the collector?

Duchamp: The collector—the real collector, the one I oppose to the commercial collectors who have made modern art a field comparable to a Wall Street affair . . . is, in my opinion, an artist—*au carré*. He selects paintings and puts them on his wall; in other words, "he paints himself a collection."

The Museum

Responsibility

Ritchie: I am quite convinced that art museums, in general, are doing a more comprehensive job than symphony orchestras or literary publishers in presenting the art of today. For this reason, art museums have taken the brunt of the attack by the conservative element of the public where modern art is concerned. Perhaps if this same public were made more fully aware of comparable experiments in the field of music and literature, the experimental or advanced visual art of today would not so readily be branded queer and unintelligible.

Certainly, also, if advances in the social and natural sciences were more generally understood, their intellectual and emotional reflections in today's art would be taken for granted. As it is, our critics are quite willing to accept the actuality and the necessity of forward seeking sciences—whether they understand the advances or not—while denying, at the same time, the right of artists to explore new worlds of emotional expression.

To be sure, there are neo-humanist romantics, who long for a comfortable return to a Hellenic or Renaissance world, glorifying the dignity of man. Their wish to deny all the consequences of the industrial revolution is pathetic; and, in this turbulent post-war period, perhaps understandable. But in the face of all the changes our century has witnessed, it is profoundly unrealistic to set the clock back.

The overwhelming materialism of our day should be resisted to the best of every man's ability. To be blind to the fact, however, that modern artists, of all people, are the very ones who are putting up the strongest fight against a dominant materialism, is either to be naively innocent of the modern artist's temperament or to wilfully misunderstand his best intentions. . . .

Moderator Boas: As trustee of a museum, Mr. Ritchie . . . I should like to ask a question myself. It costs us . . . over a hundred thousand dollars every year to show exhibitions to the people of Baltimore. Now, what in the world are we doing it for? . . . I ought to be able to tell you, I realize, but I am asking you to tell me.

Ritchie: Well, I suppose those of us who are deeply concerned have, whether rightly or wrongly, a missionary sense—that we must bring culture or bring works of art to the public's attention . . . To be sure, there are elements or activities in the museum that appeal only to the few, but any museum that attempts to be a success—that is, a museum that is attempting to get public moneys—must appeal to a wider and wider audience. . . .

Appropriateness

Wright: So far as the museum is concerned, it seems to me largely a morgue. . . .

Goldwater: Haven't you recently designed one?

Wright: I am supposed to be designing a mortuary here, but the man didn't want an architect, he wanted a grave-digger.

Goldwater: I am thinking of a museum.

Ritchie [to Mr. Wright]: I understand you are building a modern morgue?

Wright: No, I am not. I am building, in no sense, a morgue; because I believe the direction of this art which you are calling "modern art," and which—as you see exemplified here—is taking an upward trend by way of what is being called, for lack of a better name, the "non-objective art." It is a bad name. But I believe that line, form and color are a language in themselves. I think they can best express beauty independently of the physiognomy of any object in nature by way of these very qualities. You can by means of them create amazing refreshment for the human soul and the human mind.

Now this museum that I have made is . . . in the spirit of this very thing that I have just described and the only home which that veracious thing can have today. The "non-objective" can't go into the "static" of these old buildings and live. It can't go into—what do you call this thing—this layer cake we call modern building . . . it must have a new background, a quality, an atmosphere, to go with its art.

I am creating that new background, and I am creating it for what I believe to be the higher and better life which art is bound to have.

Cultural Function

Goldwater: On the one hand, what we are trying to do is to preserve what can be summed up in the word "aristocratic." That is to say: the right and the privilege of every artist to express himself completely in his own terms. That is something which the past has had. What we are adding to that is the right and privilege of every person in the public to have access to that art, and, at the same time, to allow that art to exist for itself. We feel defensive when a large audience first tries to approach an unfamiliar form, because we know the audience may be disturbed by this right of the artist to preserve his individuality, to express the world in the way in which he sees it. Unfortunate incidents, have taught us that the audience may even try to destroy the artist's freedom. Therefore, the duty of the middle man, to whom Mr. Wright has referred, be he the museum director or critic, is precisely to preserve and eventually to combine these two rights and privileges.

Introduction to the Illustrations

Robert Motherwell and Ad Reinhardt

The collecting of these illustrations was begun by us in 1949, at the start of the 57th Street exhibition season; and they are in the main restricted to 1949–50. Despite our plans for an annual covering of each exhibiting season, it turned out not to be possible—for technical, as well as more personal reasons—to publish a modern annual within the year. The completed records were somewhat enlarged towards a biennial—a more practical method for us of reporting the modern aspect of art in America.

Since then the scene continues to change, with the modern aspect better, if haphazardly reported. Thus though this volume bears the mark of its date in a few respects, it is of value for its orderly documentation and completeness. And since what is continually needed is a systematic and sympathetic treatment of our chosen area, avant-garde art in America, we intend to document similarly the seasons of 1950–51 and 1951–52 in the second series of *Modern Artists in America,* in which other artists will appear in turn. Had it been our intention to reproduce only those artists by whose work we are especially moved, they would have been fewer, and the proportions different; had our intention been wholly critical and analytical, concentrated on the problems of modern art in America, rather than documentary, the emphasis likewise would have shifted—even so, there is perhaps too much of the non-figurative. Still this is where "the pressure of reality," in Wallace Stevens' phrase, has led the majority of our most imaginative and fertile artists: "It is not that there is a new imagination but that there is a new reality." To this might be added his preceding remarks: "It is one of the peculiarities of the imagination that it is always at the end of an era. What happens is that it is always attaching

This article originally appeared in *Modern Artists in America* (1950): 40.

itself to a new reality, and adhering to it.'' It is this new reality, as it appears, that we want to document.

Selection of contemporary works of art, whether for exhibition or reproduction, is neither easy nor simple. And though it may be thankless, if not worse, in this instance, it has seemed to be an essential step—regardless of personal vanities or professional pique. Plainly an honest attempt to picture the modern aspect of painting and sculpture on 57th Street can gain from the stress of limitation and elimination, since two or three national magazines report all exhibitions. We are concerned with the modern aspect. It *is* odd that this effort to bring some order into the situation should come not from critics or scholars, but from practising artists; still, this may have its good side.

Figure 53. Aaron Siskind, *Martha's Vineyard 4C 1950*, 1950
Modern Artists in America (1951), frontispiece.
Photograph, $4\frac{7}{8}'' \times 6\frac{5}{8}''$.

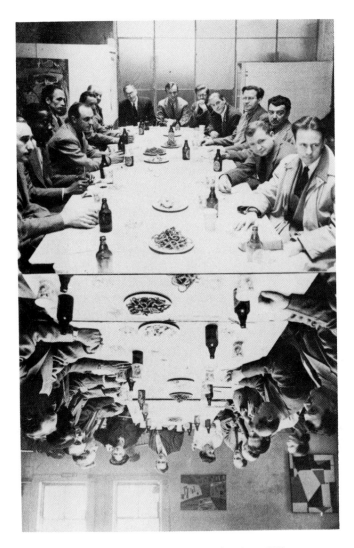

Figure 54. Max Yavno, Photograph of Artists, 1950
Modern Artists in America (1951): 8.
Artists were meeting at ''Artists Sessions as
Studio 35 (1950).'' Upper photograph, left to
right: Lipton, Lewis, Ernst, Grippe, Gottlieb,
Hofmann, Barr, Motherwell, Lippold,
de Kooning, Lassaw, Brooks, Reinhardt,
Pousette-Dart. Bottom photograph, left to
right: Brooks, Reinhardt, Pousette-Dart,
Bourgeois, Ferber, Tomlin, Biala, Goodnough,
Sterne, Hare, Newman, Lipton, Lewis, Ernst.

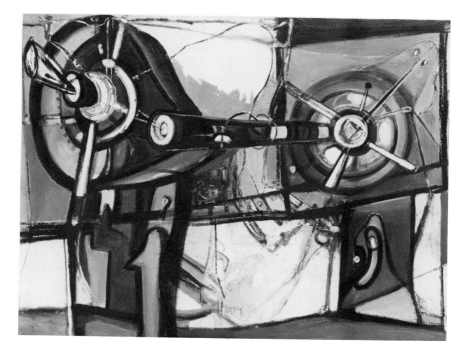

Figure 55. Hedda Sterne, *Machine*
Modern Artists in America (1951): 67.
Oil, ca. 40″ × 30″.
(Location unknown)

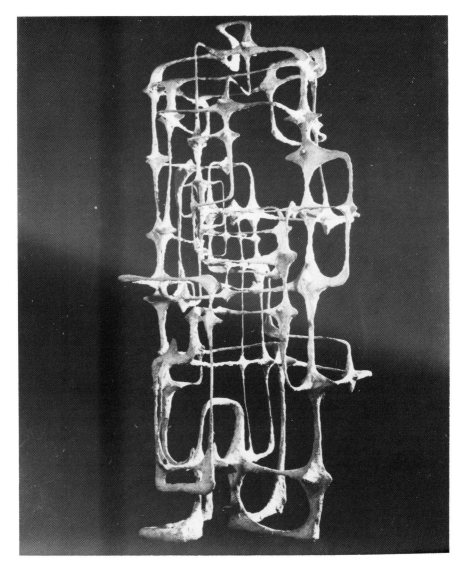

Figure 56. Ibram Lassaw, *Milky Way*
Modern Artists in America (1951): 89.
Plastic and metal, 52″ × 26″ × 24″.

Figure 57. Joan Ponç, Untitled
Modern Artists in America (1951): 160. Appeared in
''Dau Al Set'' feature.
Photograph of Antoni Tàpies with overdrawing.

Part Three

Comprehensive Index to the Periodicals

Index to the Periodicals

(Dedicated to Bouvard and Pécuchet)

Material not indexed includes most advertisements; most excerpts in "Art in the World of Events" in *Modern Artists in America,* and bibliographies in *Modern Artists in America;* biographical material from tables of contents in *The Tiger's Eye;* and most material in "The Poetry Bulletin" at the conclusion of every *Tiger's Eye.*

As in Part Two, capitalization of titles and works throughout the index has been standardized. And asterisk (*) indicates material reprinted in this volume.

Abbreviations

Ic 1	*Iconograph* 1 (Spring 1946)
Ic 2	*Iconograph* 2 (Summer 1946)
Ic 3	*Iconograph* 3 (Fall 1946)
Ic 4	*Iconograph* 4 (Winter 1946)
Ic Supp 1	*Credo, The Iconograph Quarterly Supplement of Prejudice and Opinion* (Fall 1946)
Ic Supp 2	*Iconograph Quarterly Supplement of Prejudice and Opinion,* n. d. (probably Fall 1946 or early 1947)
New Ic	*The New Iconograph* (Fall 1947)
In 1	*Instead* [1?] unnumbered, undated; possibly Winter 1948
In 2	*Instead* 2 (March 1948)

In 3	*Instead* 3 (April 1948)
In 4	*Instead* 4 (June 1948)
In 5–6	*Instead* 5–6 (November 1948)
In 7	*Instead* [7?] unnumbered, undated Note: Instead was unpaginated
MAA	*Modern Artists in America* (1951)
P	*Possibilities* (1947/48)
TE 1	*The Tiger's Eye* 1 (October 1947)
TE 2	*The Tiger's Eye* 2 (December 1947)
TE 3	*The Tiger's Eye* 3 (March 1948)
TE 4	*The Tiger's Eye* 4 (June 1948)
TE 5	*The Tiger's Eye* 5 (October 1948)
TE 6	*The Tiger's Eye* 6 (December 1948)
TE 7	*The Tiger's Eye* 7 (March 1949)
TE 8	*The Tiger's Eye* 8 (June 1949)
TE 9	*The Tiger's Eye* 9 (October 1949)

Index to the Periodicals

Abel, Lionel, "The Bow and the Gun: A Play," *P*, 68–74; Comment on "Appeal to International Opinion," *In* 7; "The Grip of the Given,"* *In* 7; "I Must Create My Creator in Order to Be Created," *In* 4; "On Interpreting a Poem," *In* 1; "The Man," *In* 7; "Meet Ernest Robson," *In* 3; "An Open Letter to Jean-Paul Sartre," *In* 4; Review of R. P. Blackmur's *The Good European*, *TE* 3, 68; "Tree Straight from New York," *In* 1; trans.: "Man and the Shell" by Paul Valéry, *TE* 2, 90; "On Mythology," by Andrea Caffi, *P* 1, 87–95; with Yvan Goll, *Cahier d'un retour au pays natal*, by Aimé Césaire, reviewed *TE* 3, 125

Abstract Expressionism: as name of movement, "Artists' Sessions at Studio 35 (1950),"* *MAA*, 21

Abstraction: "Artists' Sessions at Studio 35 (1950),"* *MAA*, 10, 19; Blaine, Nell, statement, *Ic Supp* 1, 5–6; Constant, George, statement, *Ic Supp* 1, 4; Seuphor, Michel, "Paris–New York 1951," *MAA*, 118–22

Ackerman, Gerald, "A Dream Story," *TE* 9, 11–17
"Advancing American Art," *MAA*, 146, 148
Age of Reason, The (Sartre). *About:* "To Be or Not: Five Opinions on Jean-Paul Sartre's Novel *The Age of Reason*," *TE* 1, 40–46
Agrippa, Henry Cornelius: Chap. LXVII from *Three Books of Occult Philosophy*, *TE* 6, 130
Aiken, Conrad, "Voyage to Spring," *TE* 5, 6–9; *The Kid* (review), *TE* 2, 101
Albers, Josef, painting, *MAA*, 69
Albright, Ivan Le Lorraine, *That Which I Should Have Done I Did Not Do*, *TE* 9, 57
Ambellian, Harold, sculpture, *MAA*, 94
Americans, Native: Abel, Lionel, "The Bow and the Gun," *P*, 68–74; Amerindian issue of *Dyn*, advertised, *In* 2, 26; Beaudoin, Kenneth, "Oscar Collier" [Navajo], *Ic* 3, 18; Beaudoin, "Six Young Female Painters"* [Sekula], *Ic* 2, 3; Beaudoin, "This Is the Spring of 1946"* [Pre-Columbian], *Ic* 1, 3; Calas, Nicolas, "The Essence of Tragedy,"* *TE* 3, 112; Dolan, James, "Typography" [Pre-Columbian], *In* 1, 8–9; "The Girl Who Fed a Raven" [Northwest Coast], *Ic* 3, 6–7; Martinelli, Ezio, *Bison*, *TE* 8, 38; Motherwell, *Indians*, *P*, 74; Schanker, Louis, *Elemental Forces* [Northwest Coast], *Ic* 4, 26; Sylvester, A. D. B., "Auguries of Experience" [Mexico] [in "The Ides of Art: Six Opinions on *What Is Sublime in Art?*"],* *TE* 6, 49; "Three Haida Tales," *Ic* 4, 28–30; *Thunderbird and Killer Whale* [Nootka], *TE* 2, 80; Weatherby, Meredith, "Curve 24 Lulu" [Jivaros, Ecuador], *Ic* 3, 8; Williams, W. C., "Part of Patterson III," *TE* 8, 1–4; United States Bureau of Ethnology, "Three Haida Tales," *Ic* 4, 28–32. *See also* "Andes, The"; Primitivism
"Andes, The," a special section in *TE* 5, 77–122 [*textiles:* late Nazca textile, Peru, 77; detail of a Paracas fabric, 78; detail of a Tiahuanaco shirt, 81; details of zoomorphic figures, Paracas fabrics, 82; detail of a painted border of a mantle, Paracas, 83; tapestry square, *The Blue Condor*, Tiahuanaco, 86; poncho of islands, Lake Titicaca, Bolivia, 87; Paracas fabric, 88; Paracas fabric, 89; detail of a Paracas fabric, 90; textile, Peru, 91; *sculpture:* gold anthropomorphic figure, Venezuela, 79; Paracas bowl, 79; carved monolith of animals near Cuzco, Peru, 84; pre-Inca pictograph on canal wall, Peru, 85; stones, Palace of the Inca, Cuzco, Peru, 85; water jug, Chimu, 92]. *See also* Aymara legend; *Canto Kechwa*; Von Hagen, Victor; Arguedas, José Maria; Neruda, Pablo; Sarmiento de Gamboa, Pedro
Apollinaire, Guillaume, "I Raise Up Too a Monument . . ." *In* 4; "Je me regarde . . . (I See Myself . . .),"* *In* 4; "A New Humanity . . . ," *In* 4

"Novalis and the Principle of Contradiction," *In* 4; Webster, Harvey Curtis, "Hardy as Thinker," *TE* 2, 50-51, 54, 58; "Western Round Table on Modern Art (1949),"* *MAA,* 34

Diebenkorn, Richard, painting, *MAA,* 78

Differender, William, painting, *MAA,* 83

Diller, Burgoyne, painting, *MAA,* 55. *About:* Seuphor, Michel, "Paris–New York 1951," *MAA,* 121

Dinero, Robert, painting, *MAA,* 81

Dionysus: Beaudoin, Kenneth, "The Christ Urge," *Ic* 3, 4

Dixon, James B., painting, *MAA,* 80

Dodson, Owen, "Crazy Woman to the Virgin," *TE* 1, 17; "Six O'Clock," *TE* 5, 14

Dolan, James, "Typography,"* *Ic* 1, 9-10, lettering for article,* *Ic* 1, 9

Donati, Enrico: Seuphor, Michel, "Paris–New York 1951," *MAA,* 122

Dondero, George [Representative]: *MAA,* 151-52

Dubuffet, Jean, *Head, TE* 8, 32; painting, *MAA,* 49

Ducasse, Isadore. *See* Lautréamont

Duchamp, Marcel, "Chocolate Grinder," *In* 3; statement, *In* 7; Duchamp et al., "Western Round Table on Modern Art (1949),"* *MAA,* 26-37

Duncan, Robert, "The Helmet of Goliath," *TE* 4, 50

Dudley, John: Prager, Samuel Kishler, "A Thing or Two," *Ic* 4, 22

Dunsmuir, Nessie, "The Night Walking Men Taken into the Dark," *TE* 9, 7

Dürer, Albrecht, *St. Jeronimo, TE* 9, 53

Eberhart, Richard, "Chant of the Forked Lightning," *TE* 6, 63; "How Is Your Ditentive 'I' Persona?" [essay on Dr.Trigant Burrow's *The Neurosis of Man*], *TE* 9, 128-32

Echaurren, Roberto Matta. *See* Matta

Economics. *See* Pound, Ezra

Eielson, Jorge E., "Ode to Winter," *TE* 1, 3; "Park for a Sleeping Man," *TE* 1, 4

Eliot, T. S., "To Walter De La Mare," *TE* 6, 16. *About:* Blazek, Clarisse, "In Gardens," *Ic* 4, 10; Fearing, Kenneth, "A Note on a Note in Poetry," *TE* 8, 11-13; Norse, Harold, review of Blackmur. *See also* Form/structure

Elliott, George P., "Red Feather Week," *TE* 8, 111-19

Eluard, Paul, *Pablo Picasso,* trans. by Joseph T. Shipley, *TE* 3, 126

Energy: Lipton, Seymour, "The Web of the Unrhythmic" [in "The Ides of Art: Fourteen Sculptors Write"],* *TE* 4, 80

England, Paul, *Lady with a Fan, Ic* 1, 6

Enwright, D. J., "Ways of Telling Time," *TE* 9, 101

Léger, Fernand. *About:* Hauser, Marianne, comment on Henry Miller's *The Smile at the Foot of the Ladder*, TE 5, 70

Leonid, *Pecheries et viviers*, TE 2, 79

Lévinas, Emmanuel, and Jean Wahl, "An Essential Argument within Existentialism,"* *In* 7

Lewin, Ruth, *The Dreamer*, Ic 1, 2; *Kenny's Truck*, Ic 2, 5; untitled woodcut,* Ic 3, 5. *About:* Beaudoin, Kenneth, "Six Young Female Painters," Ic 2, 3–4

Lewis, Norman, "Artists' Sessions at Studio 35 (1950),"* MAA, 8–9, 12, 16, 20; painting, MAA, 57

Libert, Jack, "The Three Pigs," TE 3, 39–51

Light: Merton, Thomas, "The Gift of Understanding," TE 6, 42

Limón, José. *About:* Stoakley, John, "Dance," New Ic, 27–28

Lipchitz, Jacques, *Exodus*, TE 4, 91; sculpture, MAA, 96; statement [in "The Ides of Art: Fourteen Sculptors Write"],* TE 4, 80

Lippold, Richard, "Artists' Sessions at Studio 35 (1950),"* MAA, 8–12, 15, 17, 20; "I to Eye [in "The Ides of Art: Fourteen Sculptors Write"],"* TE 4, 79–80; *New Moonlight*, TE 4, 98; sculpture, MAA, 96

Lipton, Seymour, "Artists' Sessions at Studio 35 (1950),"* MAA, 8–9, 12, 17–18; *Moloch #3*, TE 4, 104; "The Web of the Unrhythmic" [in "The Ides of Art: Fourteen Sculptors Write"],* TE 4, 80–81

Lissitzky, El, *Praun 98*, MAA, 45

List, Kurt: "Edgard Varèse and Alexei Haieff Questioned by Eight Composers," P, 96–100

Lobdell, Frank, painting, MAA, 79

Loew, Michael, painting, MAA, 70

Lorca, Garcia: Solomon, Marvin, "Sunday," TE 6, 107; Stoakley, John, "Dance," New Ic, 28

Love/sex: Aiken, Conrad, "Voyage to Spring," TE 5, 6–9; Barrell, Lloyd, "The Power of God," New Ic, 17–18; Berne, Stanley Lawrence, "Miracle Valley," New Ic, 26; Boyt, John, "Moonlight on the Wall," New Ic, 5–8; Brinnen, Malcom, "The Double Crucifixion," TE 6, 66; Deutsch, Babette, "The Door," TE 4, 32; Fowlie, Wallace, "Mallarmé's *Afternoon of a Faun*," TE 7, 9–23; Ghiselin, Brewster, "Of Love and Thirst," TE 3, 11; Lamantia, Philip, "It Is Summer's Moment . . . ," TE 5, 15; Moss, Stanley, "Sea Drift," TE 5, 13; Neiman, Gilbert, "Words for the Morning Mist," TE 5, 11; Patchen, Kenneth, "As Frothing Wounded Roses," TE 3, 2; Sappho, "To Aphrodite," TE 3, 1; Seligmann, Kurt, "The Hollow of Night, Observations on the Right Wing of the Tryptich, *The Garden of Delights*, by Jerome Bosch," TE 9, 61–67; Simon, John, "Aves," TE 3, 12; Smith, William Jay, "Morning at Martha's Vineyard," TE

4, 52; Strongen, Josephine, "The Green Dunes," *TE* 3, 5; Tyler, Parker, "My Alcestis," *TE* 3, 115–16

Lye, Len, "Knife Apple Sheer Brush" [on Stanley William Hayter's *White Shadow*], *TE* 7, 67–68

MacAgy, Douglas, ed., "Western Round Table on Modern Art (1949),"* *MAA*, 26–37

Macdonald, Dwight. *See* Matta

MacIver, Loren, *Blue Votive Lights*, *TE* 6, 26; painting, *MAA*, 56; *Shade at Night*, *TE* 9, 58

Maclaine, Christopher, "From a Work in Progress," *TE* 8, 101–10

Madness: Artaud, Antonin, *Van Gogh, the Man Suicided By Society* (excerpts),* *TE* 7, 93–94, 97–115

Magritte, René, *Le Regard intérieur*, *TE* 2, 78; *TE* 7, 85. *About:* Shelley, Robert, "On a Painting, *Le Regard intérieur*, by René Magritte," *TE* 7, 84

Malevich, Kasimir: ["Black Squares on Black," mentioned] Alfred Russell, "The Garden of the Machines during the Neo-Heroic Age,"*Ic* 4, 27

Mallarmé, Stéphan. *See* Fowlie, Wallace

Mannheim, Ralph, "An Existentialist Visitor," *TE* 3, 35–38; *trans:* Queneau, Raymond, "At the Edge of the Forest," *TE* 2, 6–16; Arp, Jean, "A Sweet Voice Sings in the Hump of Glass," *P*, 16; Huelsenbeck, Richard (Charles B. Hulbeck), "Possibilities: Poe and Dada: A Debate," *P*, 40–43

Margo, Boris, "The Cellocut as a Graphic Medium," *TE* 8, 53–55; *The Chapel*, *TE* 6, 31; *Moon Entrance*, *TE* 9, 45; *Ocean at Dusk*,* *TE* 8, 23; statement [in "The Ides of Art: The Attitudes of Ten Artists on Their Art and Contemporaneousness"],* *TE* 2, 42–43

Marin, John, installation shot, *MAA*, 58. *About:* Seuphor, Michel, "Paris–New York 1951," *MAA*, 121

Martinelli, Ezio, *Bison*, *TE* 8, 38

Masks. *See* "Western Round Table,"* *MAA*, 32

Masson, André, *La Camarque*, *MAA*, 45; "Color and the Lithographer," *TE* 8, 56–58; *Hesperides*, *TE* 8, 24; *Il n'y a pas de mond achevé*, *TE* 3, 99; *Nebula*, *TE* 9, 46

Matisse, Henri, *Still Life*, *MAA*, 47

Matta Echaurren, Roberto, *The Convict of Light*, *TE* 6, 26; *Dwight Macdonald Has Switched*, *In* 2; *If One Believes*, *In* 4; *It Is Not Your Fault*, *In* 4; *The Matta of Others Mattas to Me Matta*, *In* 1; *The Mystery of Action*,* *In* 4; *Onyx of Electra*, *TE* 3, 97; *And This Despite*, *In* 4; *Usoup*, *In* 2; *Usoup, So I Make Black Balls*, *In* 7

Mayhall, Jane, "Orpheus among the Shades," *TE* 9, 10

Museum of Modern Art: "Modern Artists Speak" at the Museum of Modern Art, New York, *MAA*, 148; Seuphor, Michel, "Paris–New York 1951," *MAA*, 119–20; "A Statement on Modern Art,"* *MAA*, 152

Museum, The: "Western Round Table on Modern Art (1949),"* *MAA*, 37

Museum Acquisitions, "A Selected List of Modern Works of Art Added to American Public Collections, Fall 1949–Winter 1950," *MAA*, 132–42

Music: "Ben Weber and Virgil Thomson Questioned by Eight Composers," *P*, 1, 18–24; Cage, John, "Forerunners of Modern Music,"* *TE* 7, 52–56; Deren, Maya, "The Artist as God in Haiti," *TE* 6, 116; Hillyer, Robert, "Poems for Music," *TE* 2, 104; Konigsberg, Lion Judah, "Prelude in C Sharp Rigor Mortis," *Ic* 2, 8; Lee, Francis, "Interview with Miró," *P*, 66; Murray, Philip, "Serenade," *TE* 2, 69; Murray, "Sonnets in Progress," *TE* 4, 33–35; Stern, Colin, "Slow Song," *Ic* 4, 15; Tucker, Tui St. George, "Cassation," *Ic* 4, 17; Valéry, Paul, "Man and the Shell," *TE* 2, 90. *Atonal:* Sylvester, A. D. B., "Auguries of Experience" [in "The Ides of Art: Six Opinions on *What Is Sublime in Art?*"],* *TE* 6, 49; "Ben Weber and Virgil Thomson Questioned by Eight Composers," *P*, 18–19. *Blues:* Hayden, Robert, "Homage to the Empress of the Blues," *TE* 4, 36; "Mean Old Bedbug Blues," *MAA*, 116. *Dissonance:* Russell, Alfred, "The Garden of the Machines during the Neo-Heroic Age," *Ic* 4, 27. *Jazz:* Thomson, Virgil, "Ben Weber and Virgil Thomson Questioned by Eight Composers," *P*, 24

Myth: Artaud, Antonin, *Van Gogh, the Man Suicided By Society* (excerpts),* *TE* 7, 99; Caffi, Andrea, "Machine and Myth," *In* 3; Caffi, "On Mythology,"* *P*, 87–95; Caffi and Chiaromonte, "The Myth and Politics," *In* 2; Deren, Maya, "The Artist as God in Haiti," *TE* 6, 123, 124; Graves, Robert, "To Be or Not To Be: Four Opinions on Robert Graves' *The White Goddess*" [essays by Joseph Campbell, Francis Golffing, John L. Sweeney, Thomas Cole], *TE* 7, 24–31; Heilman, Robert, *Metamorphosis and Myth*, advertisement, *TE* 8, 137; Honig, Edwin, "The Merciful Fraud in Three Stories by James," *TE* 9, 83–96; Kochnitsky, John, "Music and the Stage," *TE* 9, 81; Murray, Philip, "Sonnets in Progress," *TE* 4, 33; Rosenberg, Harold, "Three Stages," *P*, 58; Schapiro, Meyer, "The Myth of Oedipus,"* *In* 1; Stephan, John, "The Myth Is Sublimity" [in "The Ides of Art: Six Opinions on *What Is Sublime in Art?*"],* *TE* 6, 56

Naming: Stephan, Ruth, "The First Use of a Name,"* *TE* 2, 61

Rand, Paul, cover,* *P*

Raymund, Bernard, "Doctor Burgood," *TE* 5, 39–48

Read, Herbert, essay [in "To Be or Not: Six Opinions on Dr. Trigant Burrow's *The Neurosis of Man*"], *TE* 9, 115–17. *About:* Hayter, Stanley William, "Interdependence of Idea and Technique in Gravure," *TE* 8, 42–43; Newman, Barnett, essay* [in "To Be or Not: Six Opinions on Dr. Trigant Burrow's *The Neurosis of Man*"], *TE* 9, 124

Real, The: "Artists' Sessions at Studio 35 (1950),"* *MAA*, 20

Reality: Deren, Maya, "The Artist as God in Haiti," *TE* 6, 124; Hare, David, statement [in "The Ides of Art: Fourteen Sculptors Write"],* *TE* 4, 78–79; Merton, Thomas, "The Gift of Understanding," *TE* 6, 41; Motherwell, Robert, and Ad Reinhardt, "Introduction to the Illustrations,"* *MAA*, 40; Stephan, John, statement [in "The Ides of Art: The Attitudes of Ten Artists on Their Art and Contemporaneousness"],* *TE* 2, 45–46

Reder, Bernard, *Giant Escaping the Flood*, *TE* 8, 37

Redon, Odilon, "Odilon Redon on Lithography," *TE* 8, 64–72; . . . *Une Femme revêtue de soleil*, *TE* 8, 25

Reinhardt, Ad, "Artists' Sessions at Studio 35 (1950),"* *MAA*, 8–10, 12, 14–21; *Bits of Information*,* *TE* 6, 18; painting, *MAA*, 54; with Bernard Karpel and Robert Motherwell, "A Statement,"* *MAA*, 6–7; with Robert Motherwell, "Introduction"* to "Artists' Sessions at Studio 35 (1950)," *MAA*, 9; "Introduction to the Illustrations,"* *MAA*, 40. *About:* Seuphor, Michel, "Paris–New York 1951," *MAA*, 121

Religion: Barrell, Lloyd, "The Power of God," *Ic* 5, 17–18; Bataille, Georges, "The Torture," *TE* 6, 33–40; Beaudoin, Kenneth, "The Christ Urge," *Ic* 1, 3–4, 24; Calas, Nicolas, "The Essence of Tragedy,"* *TE* 3, 112; Carrier, Warren, "The Devil and Monsieur Gide," *TE* 4, 17–18; Dodson, Owen, "Crazy Woman to the Virgin," *TE* 1, 17; Gregory, Horace, "A Foreigner Comes to Earth," *TE* 1, 18–19; Holzhauer, Robin, "Coitus Decadence," *TE* 5, 10; McLaughlin, Richard, "As Existentialism," *TE* 1, 46; Merton, Thomas, "The Landfall," *TE* 1, 1; and "The Gift of Understanding," *TE* 6, 41–45; Nerber, John, "John the Baptist," *TE* 2, 36; Seligmann, Kurt, "The Hollow of Night, Observations on the Right Wing of the Tryptich, *The Garden of Delights*, by Jerome Bosch," *TE* 9, 61–67; Sokei-an, review of *The Cat's Yawn*, *TE* 2, 112; Valle, Carmen, "The Via Crucis Series by André Racz," *TE* 7, 75–76. *Judaism:* Wolfskehl, Karl, review of *1933: A Poem Sequence*, *TE* 2, 114. *See also* Weathers, Winston